SOUTH AFRICA'S

Vineyards of the Cape

GERALD HOBERMAN

THE GERALD & MARC HOBERMAN COLLECTION

CAPE TOWN · LONDON · NEW YORK

TEXT BY MARGUERITE LOMBARD

PHOTOGRAPHS CELEBRATING THE SPIRIT, ESSENCE AND DIVERSITY
OF THE WINELANDS FROM CAPE POINT TO THE ORANGE RIVER

GERALD HOBERMAN

Winelands of the Cape

SOUTH AFRICA'S

Concept, design and production control: Gerald & Marc Hoberman
Photography: Gerald Hoberman
Reproduction: Marc Hoberman
Text: Marguerite Lombard
Editor: Roelien Theron
Layout: Christian Jaggers
Proofreader: Ethné Clarke
Indexer: Hilda Hermann
Cartographer: Peter Slingsby

www.hobermancollection.com

ISBN 1919734-98-8

South Africa's Winelands of the Cape is published by The Gerald & Marc Hoberman Collection (Pty) Ltd
Reg. No. 99/00167/07. PO Box 60044, Victoria Junction, 8005, Cape Town, South Africa
Telephone: 27-21-419 6657/419 2210 Fax: 27-21-418 5987 e-mail: office@hobermancollection.com

International marketing, corporate sales and picture library
Laurence R. Bard, Hoberman Collection (USA), Inc. / Una Press, Inc.
PO Box 880206, Boca Raton, FL 33488, USA
Tel: (561) 883 3973 Fax: (561) 883 0482 e-mail: hobcolus@bellsouth.net

For copies of this book printed with your company's logo and corporate message contact The Gerald & Marc Hoberman Collection.
For international requests contact Hoberman Collection (USA), Inc. / Una Press, Inc.

Other titles in this series by The Gerald & Marc Hoberman Collection

ENGLISH			GERMAN	FRENCH	SPANISH	JAPANESE
Cape Town	*KwaZulu-Natal*	*Teddy Bears*	*Afrikas Wildnis*	*L'Afrique du Sud*	*Ciudad del Cabo*	*London*
England	*London*	*Washington, D.C.*	*Die Tierwelt*	*La Faune Africaine*	*Fauna Africana*	
Franschhoek &	*Namibia*	*Wildlife*	*Kapstadt*	*Le Cap*	*Sudáfrica*	**ITALIAN**
Rickety Bridge	*Napa Valley*	*Wildlife of Africa*	*London*	*Londres*		*Namibia*
D'vine Restaurant	*New York*		*Namibia*	*Namibie*		
– The Cookbook	*Salt Lake City*		*Südafrika*			
Ireland	*San Francisco*					

Agents and distributors

Australia	*Germany*	*Namibia*	*Republic of Ireland and Northern Ireland*	*United Kingdom*	*United States of America, Canada and Asia*
Wakefield Press Distribution	Herold Verlagsauslieferung &	Projects & Promotions cc	GSR Distributors Ltd	DJ Segrue Ltd	Hoberman Collection (USA), Inc.
Box 2266	Logistik GmbH	PO Box 96102	47 Marley Court	7c Bourne Road	/ Una Press, Inc.
Kent Town, SA 5071	Raiffeisenallee 10	Windhoek	Dublin 14	Bushey, Hertfordshire	PO Box 880206
Tel: (0)8-8362 8800	82041 Oberhaching	Tel: (0)61-25 5715/6	Tel: (0)1-295 1205	WD23 3NH	Boca Raton, FL 33488
Fax: (0)8-8362 7592	Tel: (089) 61 38 710	Fax: (0)61-23 0033	Fax: (0)1-296 6403	Tel: (0)7976-273 225	Mobile: (561) 542 1141
e-mail:	Fax: (089) 61 38 7120	e-mail: proprom@iafrica.com.na	e-mail: murray47@eircom.net	Fax: (0)20-8421 9577	Fax: (561) 883 0482
sales@wakefieldpress.com.au	e-mail: herold@herold-va.de			e-mail: sales@djsegrue.co.uk	e-mail: hobcolus@bellsouth.net

Printed in Singapore

CONTENTS

ACKNOWLEDGEMENTS

To photograph and produce a book on a subject as complex, geographically vast and diverse as South Africa's winelands of the Cape would be impossible without the wonderful interaction, co-operation, warmth and hospitality of its people. Without exception, they spontaneously received me and this undertaking with open arms. I was often invited to stay overnight and provided with egte boerekos *(robust country fare) while hosts recounted their family histories. They were happy to rise before first light and drive me around their farms while showing me their favourite viewpoints and often offering to help carry my equipment. I had the privilege of being invited into their world as a friend for a few hours and gained invaluable insight into their lives as wine farmers. As a token of their gratitude, I was very often sent on my way with a bottle or two of their best wine or brandy to share with my family and friends.*
To the winemakers of the Cape and their families and staff – thank you.

To Cassie du Plessis, editor of WineLand *magazine, thank you for your guidance and expertise. I am indebted to Marguerite Lombard whose inspired text and tireless efforts were so graciously and professionally rendered.*

I am appreciative of the tenacity and expertise of my trustworthy editor of longstanding, Roelien Theron. I am grateful to my son Marc, our managing director, who was responsible for the exceptional reproduction of the images and who played an important role in the production and design of the book. I would like to extend my thanks to Christian Jaggers, a valued member of our creative team, for his talents and specialist expertise. I am grateful also to our management and members of our staff who ran the show so ably while I journeyed far and wide.

To my wife Hazel, thank you so much for your encouragement and sterling support.

I acknowledge the excellent co-operation we received from the various tourist and information offices and their staff. There is no substitute for the local knowledge and invaluable assistance they provided.

ACKNOWLEDGEMENTS

To those listed below and the many other people of the winelands I met along the way, thank you so much.

AFRIKAANS LANGUAGE MUSEUM: Catherine Snel, Ansie de Villiers, Jack Louw, Isabeau Joubert
ALTO WINE ESTATE: Mr & Mrs Danie Malan
ALLESVERLOREN WINE ESTATE: Lynette Harris, Alisna Krige, Bernard Devey, Danie van Zyl, Tanya Jordaan
ANDRÉ AGRICO: Louis Andrag
AUDACIA: Elsa Carstens
BARBERSDALE CELLAR: Willie Burger
BAREYDALE WINE CELLAR: Riaan Marais
BASSE PROVENCE: Robin & Angela Ducret
BELLINGHAM: Lochner Bester
BERGKELDER: Jackie Thiron
BIRKENHEAD HOUSE: Liz Biden, Daniel Cocuiescu, Lien Boshoff
HESTIA FOURIE: Jeanne Hugo, Devon Matthews, Garth Roux, Jefferson Wicks
BLAAUWKLIPPEN AGRICULTURAL ESTATES
BLUE CRANE VINEYARDS: Henk Jordaan
BOLAND KELDER: Louise Koize
BOTHA CELLARS: Dassie Smit
BOUCHARD FINLAYSON: Peter Finlayson
BREDELLOOF WINE AND TOURISM: Jurgens Schoeman
CAPE POINT VINEYARDS: Tracy James, Sybrand van der Spuy
CAPE WINE 2004: Deidre Cloete
CELLARS-HOHENORT HOTEL: Liz McGrath, Rey Franco, Fredrik Aspegren
CHRISTINAL CELLARS: Johan Human
CLOS MALVERNE: Seymour Pritchard
COL'CACCHIO PIZZERIA: David Foster, Dries Lloyd
COLIAANE WINES: Mr & Mrs Clive Kerr
COWLEY, NEL & ASSOCIATES: Annette Cowley & Jeremy Nel
DE COMPAGNIE: Riana Scheepers, Johann Loubser
DE GRENDEL: Sir David & Sally Graaf, Johnny de
DE DOORNS WINE CELLAR: Danie Koen
FLANNIGH
DE KELDER: Dirk Jansen, Tertius Theart
DE KRANS: Boets Nel
MARCEL DE REUCK
D'OUWE WERF: Cobus Venter
DEVON VALLEY HOTEL AND VINEYARDS: Lizette Basson, Craig Seaman
DIEMERSBOTTEN WINE AND COUNTRY ESTATE: Di Ringrose, David & Sue Sonnenberg
DIEMERSFONTEIN WINES: Bertus Fourie
DIGITAL FOREST STUDIO: Albert Lord, Andrew RawBone-Viljoen, Reza Williams, Jongi Nishunishe, Peter RawBone-Viljoen
DISTELL: Chris Edge, Tommy Masuret, Martin Moore, Alet Morgan
DOMBEYA VINEYARDS AND YARNS: Pippa Petersen, Rob Sainsbury

DORNIER WINES: Raphael Dornier, Ansgaar Flaatten
DOUGLAS GREEN: Jeanne de Villiers
DROSTDY-HOF: Brigitte Berg
DWARS RIVER VALLEY TOURISM
ENDRACHT BOUTIQUE HOTEL: Daniel Luiz
ERNIE ELS WINES
EVERGREEN MANOR: Riel & Christine Mynhardt
FRANSCHHOEK WATER COMPANY: Rob McKee, Dr Werner
PRIKLOPIL: Rikki Pillay
FRANSCHHOEK WINE VALLEY TOURISM ASSOCIATION: Felicity Rennie, Jo Sinfield, Sue Snyman
BOLLIE Ganief
GRAND ROCHE: Elmine Nel, Frank Zlomke, Hans Allagaier
GRUNDHEIM: Danie Grundling
GURRUN CLARK COMMUNICATIONS: Leanne Loots
HEX RIVER TOURISM: Melanie Viljoen
HAMILTON RUSSEL VINEYARDS: Anthony Hamilton Russell
Mr & Mrs Chard du Toit
HILDENBRAND WINE AND OLIVE ESTATE: Reni Hildenbrand
HOOPENBURG: Gregor Schmitz, Higgo Jacobs
INSTITUTE FOR THE DEAF: Rev. Attie Smit
INSTITUTE FOR THE BLIND: Johan Heyl
INTOUCH SA: Wanda Voigt
JA CLIFF: Derek Cliff, William Cliff
JC LE ROUX
JONKHEER WINERY: Elsabe Matthee
Kobus Joubert
JOUBERT-TRADAUW PRIVATE CELLAR: Cobus Joubert-Tradauw
KANONKOP ESTATE: Johann Krige, Yngvild Steytler
KAAPZICHT ESTATE: Danie Steytler, Yngvild Steytler Schumacher
KAYSERS PRIVATE CELLAR: Rencia Uys, Mignon du Plessis,
KALAHARI WATER: Dirk & Hettie Malan
KAGGA KAMMA: Hein de Waal
KEN FORRESTER VINEYARDS: Mr & Mrs Ken Forrester
KLEIN CHAMPAGNE: Marietta de Wet, Mike Bosman
KLEIN KAROO WINE ROUTE: Ellen Marais
KLEINPLASIE LIVING OPEN AIR MUSEUM
KWV HOUSE OF BRANDY: François Bruwer
KWV PAARL: Sterik de Wet
L'OMARINS: Danie Botha, Jo-Ann Mettler, Riaan van der
LA BRIE: Basil Landau
LA COURONNE HOTEL: Corlien Conradie, Colin Morris, Kerrin Titmas
LA COURONNE WINE ESTATE: Dominic Burke
LA MOTTE WINE ESTATE: Conari Laregan, Hanneli Rupert
LA PETITE FERME: Carol, Josephine, John & Marc Dendy
LA RESIDENCE: Liz Biden, Jeanine Hugo
Young
LA ROCHELLE: Arnoldus du Toit
LANGEBERG WINERY: Paul Marais
LE QUARTIER FRANÇAIS: Lisa Marie Luis
LE QUARTIER FRANÇAIS: Linda Coltart, Susan Huxter
MADIBA FRIENDLY TOURS: Aubrey Mpemnyama

MARC'S MEDITERRANEAN CUISINE AND GARDEN: Marc Friederich
MONTAGU COUNTRY HOTEL: Gert Lubbe
MONTMARTRE: Peter Jackson, Rikki Pillay, Rob McKee, Dr Werner Priklopil
MONTPELLIER ESTATE: Lucas van Tonder, Anton Krynauw, Linda Niemöller
MOOIBERGE: Mr & Mrs Dennis Zeder
MORGENSTER: Idelette van den Heerik, Gerrie Wagener
Miranthe Annatjie Melck
NEDERBURG WINE AUCTION: Bennie Howard
NEETHLINGSHOF ESTATE: Tanya Jordaan
NELSON'S CREEK WINE ESTATE: Alan Nelson, Jean van Rooyen
NEW BEGINNINGS
NEW CAPE WINES: Christiaan Groenewald
NEWTON JOHNSON WINES: Dave Johnson
NUY VALLEY GUEST HOUSE: Irma Conradie, Pieter Conradie
OAK VALLEY ESTATE: Anthony RawBone-Viljoen
OCHRE MEDIA AND PUBLISHING: Louise Brodie
OLIFANTS RIVER WINE ROUTE: Sereza Kersop
OOM SAMIE SE WINKEL: Annatjie Melck
OPSTAL ESTATE: Stanley Louw
ORANGE RIVER WINE ROUTE: Gabi & George Josling
ORANGE RIVER WINE CELLARS: Koos Visser, Tinus van Niekerk
OUDE WELLINGTON WINE AND BRANDY ESTATE: Dr Rolf Schumacher
PAARL MOUNTAIN NATURE RESERVE: Albertus van der Gerhard van der Wath
PAARL VINTNERS: Pieter de Waal
MERWE, Rickus Swanepoel
PAARL WINE ROUTE: Lydia Harrison
PLAISIR DE MERLE
PROJECTS & PROMOTIONS: Raymond & Monica Spall
RED HOT GLASS STUDIO: Elizabeth Lacey, David Jackson
RICKETY BRIDGE WINERY: Marian Dawson, Butch McEwan, Duncan Spence, Willem van Rooyen, Kobus WEYERS
RIDGEBACK WINES: Vernon & Leslie Cole, Gerry Parker, Elizma Hanekom, Cathy Marshall, Du Toit Wessels
ROBERTSON WINERY: Johann Meissenheimer
ROBERTSON WINERY: Bonita Malherbe, Lettie van Zyl
RONDEBOSCH CELLAR: Dr Alvi van der Merwe
RUPERT & ROTHSCHILD VIGNERONS: Debra Savage,
RUST EN VREDE ESTATE: Jean Engelbrecht, Pieter Roos, Louis Strydom
SANTÉ WINELANDS HOTEL & WELLNESS CENTRE: Cindy Beyers, Gerhard Louw, Angela Mitchell, Luis Rodriguez, Beverley Sims, Margaret Smit, Sunette Viljoen

SARONSBERG CELLAR: Mr & Mrs Dewald Heyns
SASOL ART MUSEUM: Lydia de Waal
SAWIS: Yvette van der Merwe, Debbie Wait
Klaus & Beate Schnack
SCHOONBERG
SEIDELBERG WINE ESTATE: Roland Seidelberg, Guy Kedian
SIGNAL HILL WINERY: Jean-Vincent Ridon
SOUTH AFRICAN BRANDY FOUNDATION: Pietman Retief
SOVERBY: Dolly Hanekom
STELLAR ORGANICS WINE CELLAR: Lee Griffin, Willem Rossouw
STELLENBOSCH ART MUSEUM: Dr Lydia de Waal
STELLENBOSCH UNIVERSITY BOTANICAL GARDEN: Sandra Krige
STELLENBOSCH HISTORICAL SOCIETY: Deon Koize
STELLENBOSCH MUNICIPALITY: Pieter Loftus
STELLENBOSCH TOURISM: Willie Slabber
STELLENBOSCH VILLAGE MUSEUM: Dinah Davids
STELLENBOSCH WINE ROUTE: Nicolette de Kock
STELLENZICHT ESTATE: Guy Webber, Ilse van Dyk
STELTERY WINERY: George Botha
SUGARBIRD MANOR: Cathryn Treasure
SWARTLAND TOURISM AND WINE ROUTE: Jolene Rabe
SWARTLAND WINERY
THE BARN: David & Lorna Reade
TUKULU WINES: Lynette Harris, Hennie van der Westhuizen
TULBAGH TOURISM: Patty Nieuwoudt
TULBAGH WINE ROUTE: Patty Nieuwoudt
TULBAGH WINERY: Marius Burger, Danie Scholtz
UITKYK: Lisa Marie Luis
UNIVERSITY OF STELLENBOSCH: Susan van der Merwe, Martin Viljoen
VAN RYN BRANDY DISTILLERY AND CELLAR: Miles Gooding, Desmond Lewis
VAUGHAN JOHNSON'S WINE & CIGAR SHOP: Vaughan Johnson
VREDE EN LUST WINE ESTATE: Dana & Cara Buys, Ilse Aneen
VREDENHEIM: Piet Jordaan
WARWICK WINE ESTATE: Lezanne Hugo, Louis Nel,
WATERFORD WINE ESTATE: Kevin Arnold, Werner
WEYERS
Ian Ord, Mike Ratcliffe
WELLINGTON TOURISM: Melinda van der Merwe
Bredenhann, Lombard Loubser, Fiona McPherson
WESTCORP INTERNATIONAL: Fanie Augustyn
Wendy Toerien
WILLOW CREEK OLIVE ESTATE: Andrés Rabie, Louise Rabie
WORCESTER WINELANDS: Deonie Basson, Celeste Roux, Bridget Ziekkiewicz
ZANDVLIET ESTATE: Paul de Wet
ZEVENWACHT WINE ESTATE: Denise Johnson
ZONNEBLOEM: Jackie Thiron
ZORGVLIET WINE ESTATE: Sumari Kuhn

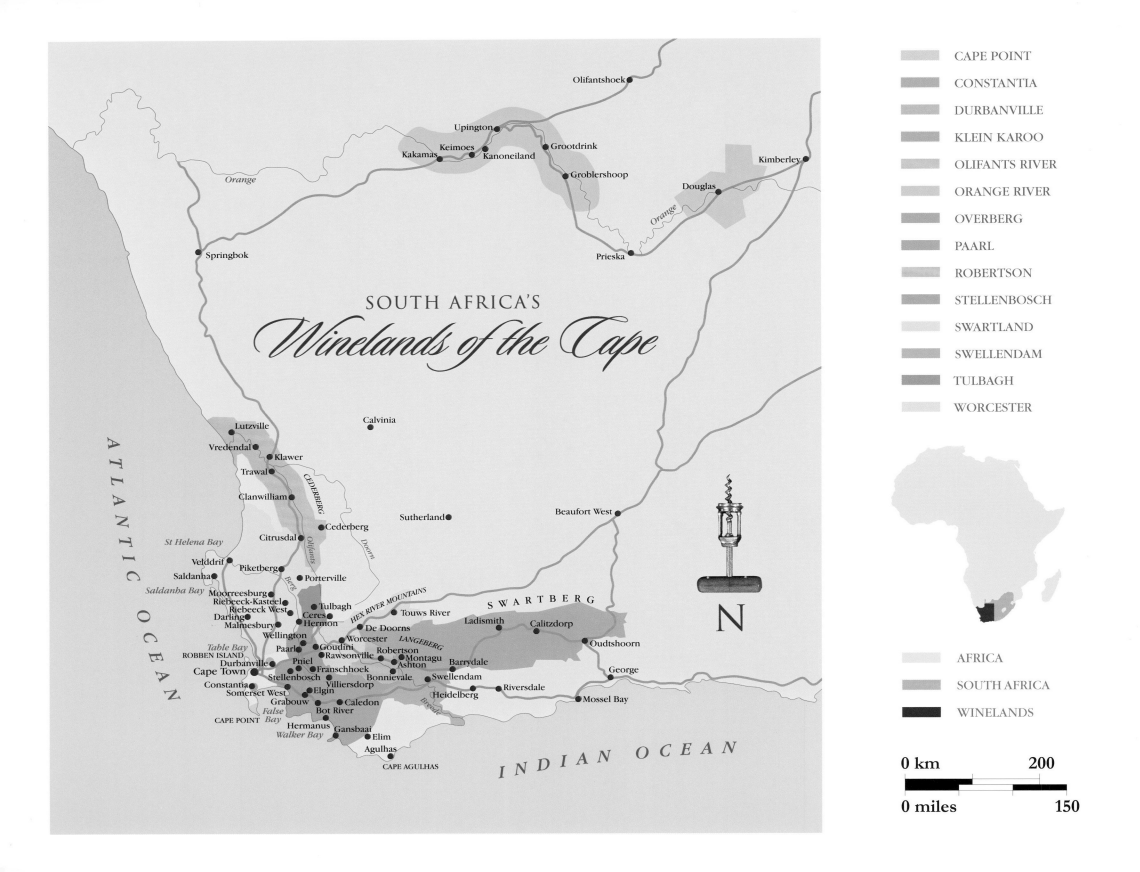

SOUTH AFRICA'S
Winelands of the Cape

CAPE POINT
CONSTANTIA
DURBANVILLE
KLEIN KAROO
OLIFANTS RIVER
ORANGE RIVER
OVERBERG
PAARL
ROBERTSON
STELLENBOSCH
SWARTLAND
SWELLENDAM
TULBAGH
WORCESTER

AFRICA
SOUTH AFRICA
WINELANDS

N

0 km — 200
0 miles — 150

ATLANTIC OCEAN
INDIAN OCEAN

Orange
Orange

Olifantshoek
Upington
Keimoes
Kakamas
Kanoneiland
Grootdrink
Groblershoop
Douglas
Kimberley
Prieska
Springbok

Calvinia
Lutzville
Vredendal
Klawer
Trawal
Clanwilliam
CEDERBERG
Cederberg
Sutherland
Beaufort West
Citrusdal
Olifants
St Helena Bay
Velddrif
Piketberg
Porterville
Saldanha
Berg
Saldanha Bay
Moorreesburg
Riebeeck-Kasteel
Riebeeck West
Tulbagh
Doorn
Darling
Ceres
Hermon
HEX RIVER MOUNTAINS
Touws River
SWARTBERG
Malmesbury
Wellington
De Doorns
Ladismith
Calitzdorp
Goudini
Worcester
LANGEBERG
Oudtshoorn
Table Bay
Paarl
Rawsonville
Robertson
ROBBEN ISLAND
Pniel
Montagu
Barrydale
George
Durbanville
Franschhoek
Ashton
Cape Town
Stellenbosch
Bonnievale
Swellendam
Riversdale
Constantia
Villiersdorp
Heidelberg
Mossel Bay
Somerset West
Elgin
Caledon
Breede
CAPE POINT
Grabouw
Bot River
False Bay
Hermanus
Gansbaai
Elim
Walker Bay
Agulhas
CAPE AGULHAS

FOREWORD

BY CASSIE DU PLESSIS

> We shall not cease from exploration
> And at the end of all our exploring
> Will be to arrive where we started
> And know the place for the first time.

These words by TS Eliot often sprang to mind during the course of this project, as new impressions, moods and realities of the Cape winelands were revealed through the lens of Gerald Hoberman.

Day after day, as he traversed the vast expanses of South Africa's incredibly diverse wine-growing regions, he shared his discoveries, and I could not help but be inspired by his infectious enthusiasm and excitement for the project. From Franschhoek ('French Corner') and the historical gems of Paarl and Stellenbosch to the riverscapes of Vredendal and Upington in the north-west; from the valleys along the south coast and the 'Valley of Wine and Roses' at Robertson to the semi-arid Little Karoo town of Oudtshoorn, nestled in the foothills of the rugged Swartberg, Gerald Hoberman's photographs are anything but familiar or backneyed views of places and landmarks found along well-beaten tracks. This is largely the charm and uniqueness of this collection of images.

The observer will delight in the images of dramatic and awe-inspiring vistas, magical interiors of wine cellars, the personalities behind the brands, rare architectural masterpieces, the fascination of old-world shops such as Oom Samie se Winkel, the Nederburg Auction extravaganza, and a thousand and one other parts of the tapestry that make up the wonderful winelands that have evolved through 346 harvests!

When I originally became involved as a consultant at the end of 2003, I had some reservations about the mammoth task of attempting to capture the spirit of the winelands in what was going to be a 176-page volume. But I did not reckon with the tireless energy, determination and professional drive of father and son Gerald and Marc Hoberman and their internationally renowned Hoberman Collection creative team. Gerald, I found, was skilful at capturing the moment, using every dash of daylight to change even the mundane into a magical moment. He was out there at the crack of dawn to capture the perfect play of crisp morning light and again at the end of the day as the last rays of sunlight cast their long shadows over the vineyards.

The result is more than 300 pages of photographs that will delight wine people the world over. As you page through this collection you will come to view this part of the world and its superb wines differently forever.

The beauty of this coffee table book lies not only in the creativity and unique individual interpretation evident in the images but also in the truthful and honest portrayal of the wine world here at the tip of Africa, straightforward and real. The well-researched and entertaining text by Marguerite Lombard, born and bred in Paarl, is an important ingredient of this book.

My task as consultant was to guide the photographer with knowledge of the Cape winelands. In the process he taught me how much there is to know.

CASSIE DU PLESSIS
Editor Wineland magazine

Dedicated to my special longstanding friend, Jonathan Volks,
who was born and raised in and loved South Africa's winelands of the Cape.

INTRODUCTION

It has been wonderful to have experienced the magic of South Africa's winelands in all its seasons firsthand. I have sampled the best of its extraordinary wines, met many of the personalities who passionately pursue excellence in winemaking in their vineyards and cellars and photographed the essence of what I saw from dawn to dusk. On reflection, this has been a mammoth and complex undertaking, yet it's been a special privilege that I shall always treasure. I take great delight in sharing with you my interpretation of South Africa's winelands of the Cape as you turn the pages of this book.

South African wines are appreciated for their excellence by an ever-increasing number of wine lovers around the world. These world-class wines have benefited enormously from the sheer variety of terroir, the proliferation of new vineyards, and the fusion, influence and investment of winemakers from abroad, and an ever-growing sophistication and personal pride in the individual brands by South African winemakers, on the other. The establishment of black empowerment partnerships in the wine industry has also added 'spice to the gingerbread'.

The pursuit of photographic excellence has many similarities to the pursuit of excellence in winemaking. Both are dependent on the seasons and the whims of the weather. In photographing the wide outdoors, the camera's position in relation to the subject and the sun and its angle of elevation at the time are vital to the lighting quality playing on the landscape. Some of the challenges of an assignment such as this one include the critical timing of the seasons and the elevation and the angle of the terrain relevant to the subject. Other challenges such as rain, high winds, overcast skies, heat shimmer, dust, haze, mountain mist covering valleys, high winds and lightning, shadows cast by nearby mountains, early morning pollution near big cities, excessive contrast, early fires, the practice of controlled burning on farms, as well as treacherous, muddy farm roads and vehicle-punishing potholes, steep mountain slopes, precarious cliffs, narrow bridges and aggressive insects near water at dusk, are but some examples of what I had to deal with on this assignment.

This book is not an inclusive catalogue of wine farms nor is it a wine guide. Its purpose is to showcase the best attributes of South Africa's winelands of the Cape, highlighting the spirit and the essence of its rich cultural heritage, diversity and scenic splendour. It is hoped that this volume will add an important new dimension to the appreciation and enjoyment of our wines both locally and internationally.

Gerald Hoberman

GERALD HOBERMAN
Cape Town

"Wine...offers a greater range for enjoyment and appreciation than possibly any other purely sensory thing which may be purchased."

ERNEST HEMINGWAY

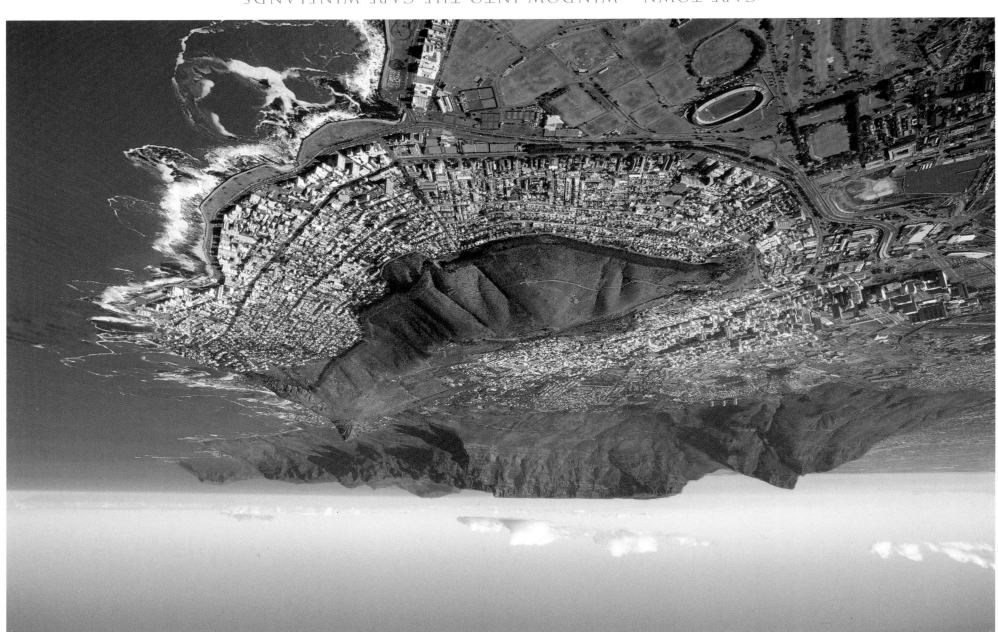

CAPE TOWN – WINDOW INTO THE CAPE WINELANDS

Coming in to land at Cape Town International airport, visitors from across the world are treated to a rare bird's-eye view of a ruggedly beautiful peninsula. Cape Town was settled as 'The Cape of Good Hope' in 1652 by the Dutch East India Company as a ship's victualling station. It has a history of winemaking dating back to 1659, which was when Commander of the Cape Jan van Riebeeck made this notation in his diary: 'Today, praise be to God, wine was made for the first time from Cape grapes, and from the virgin must, fresh from the vat, a sample taken – pressed from the three young vines that have been growing here for two years.' From these humble beginnings has grown a modern, internationally competitive wine industry.

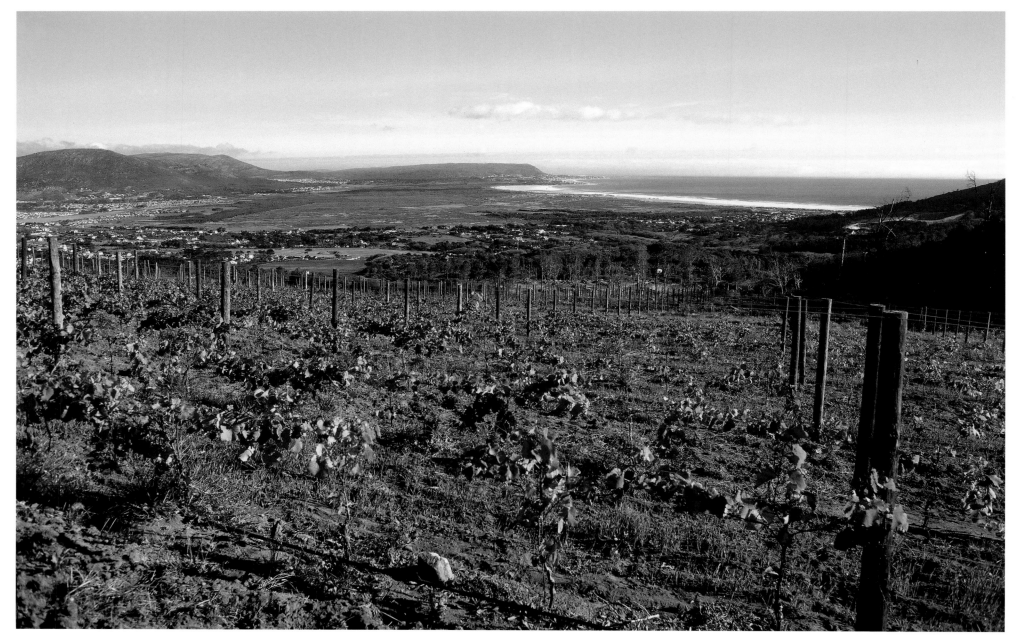

WINES FROM THE SEA

The Cape Peninsula is only 11 kilometres across at its widest point and is bathed in cool sea breezes. It's home to a unique wine-producing area called the Cape Point ward. Cape Point Vineyards is the only winery in this ward and produces award-winning Sauvignon Blanc, Chardonnay, Sémillon and Noble Late Harvest wines. Grapes are sourced from just over 30 hectares of vineyards in Noordhoek and Red Hill. The first vines were planted in Noordhoek in 1752, and in 1996 the vineyards were re-established by Cape Point Vineyards. The vineyards' unique terroir offers unrivalled views of the Cape's rugged and unspoilt coastline.

CAPE OF STORMS

In the fifteenth century Portuguese seafarers sailed south to look for a sea route to the East. As the fleet of Bartolomeu Dias neared the southern tip of Africa, a storm blew them off course beyond Cape Point. The sailors returned home with fearful stories of the dangerous *Cabo Tormentoso* ('Cape of Storms'). A decade later Vasco da Gama sailed around the peninsula to the East, and the Cape was renamed *Cabo da Boa Esperança* ('Cape of Good Hope'). The Portuguese poet, Luís Vaz de Camões (1524–580), celebrated his countrymen's achievements in his epic poem *The Lusiads* in which Adamastor, a Titan, became the spirit of the Cape of Storms that guarded what was then believed to be the stormy tip of Africa.

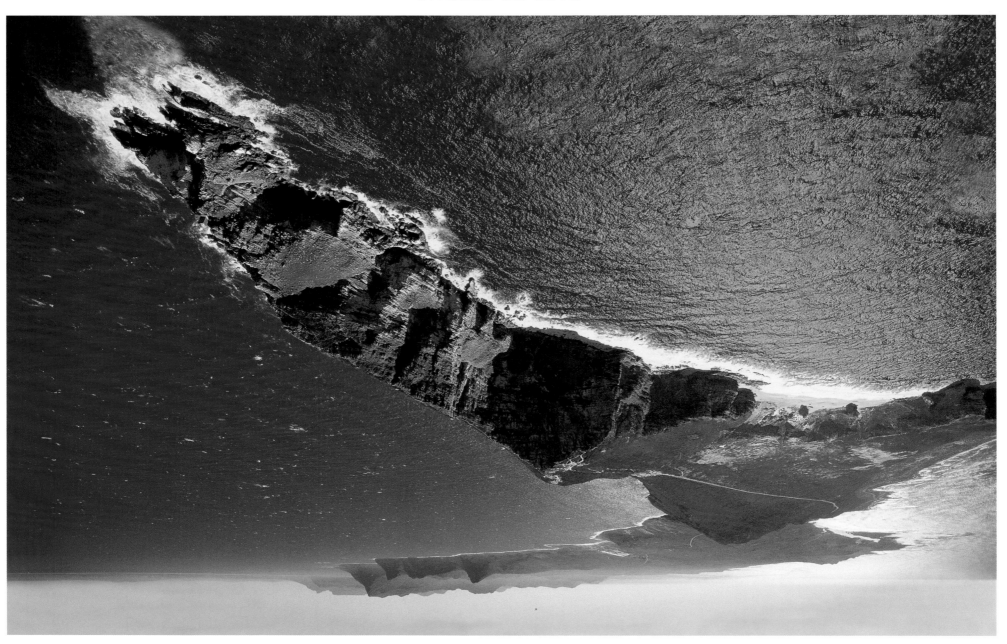

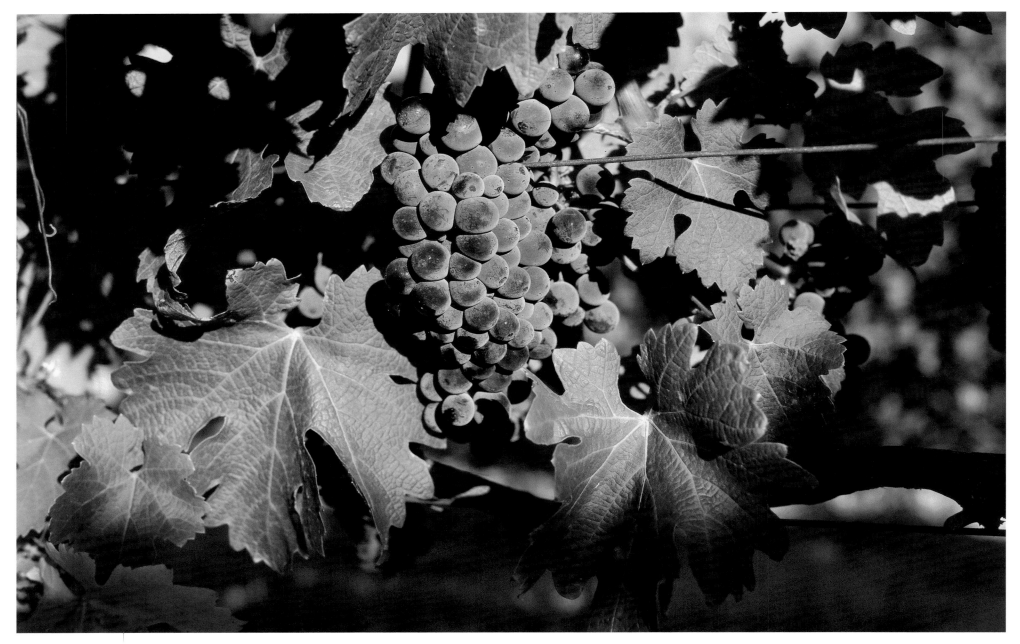

INNOVATION THROUGH RESEARCH

The production of great wine starts in the vineyard, and good vineyards are established with vines that have been carefully selected for their inherent varietal qualities as well as virus-free status. In nurseries clones are matched with the correct rootstock to perform optimally under specific soil conditions. Researchers use tissue culture technology to remove harmful viruses from propagation material. Stellenbosch University plays a dominant role in this field of research and has established a successful plant propagation programme. The university has over the years developed several new wine grape cultivars, of which Pinotage, developed in the late 1920s by Professor AE Perold, has been the most successful.

SIGNAL HILL WINERY

Ebullient young French vintner Jean-Vincent Ridon is taking Cape winemaking back to its roots. Besides winkling out historic vineyard sites (and some ancient rootstock) in Cape Town's City Bowl suburbs on the slopes of Table Mountain, he's also planted a minuscule, stone-terraced vineyard à la Burgundy called Clos d'Orange on a tiny city plot. His urban renewal crusade is symbolically run from an inner-city cellar in the renovated old Culemborg station where he makes small parcels of often exceptional yet little-known wines following age-old winemaking methods. His speciality is undoubtedly dessert wines: botrytised Sauternes styles, Hungarian Tokay types, *vins de paille* (straw wines) and ice wine (from coldroom chilled grapes).

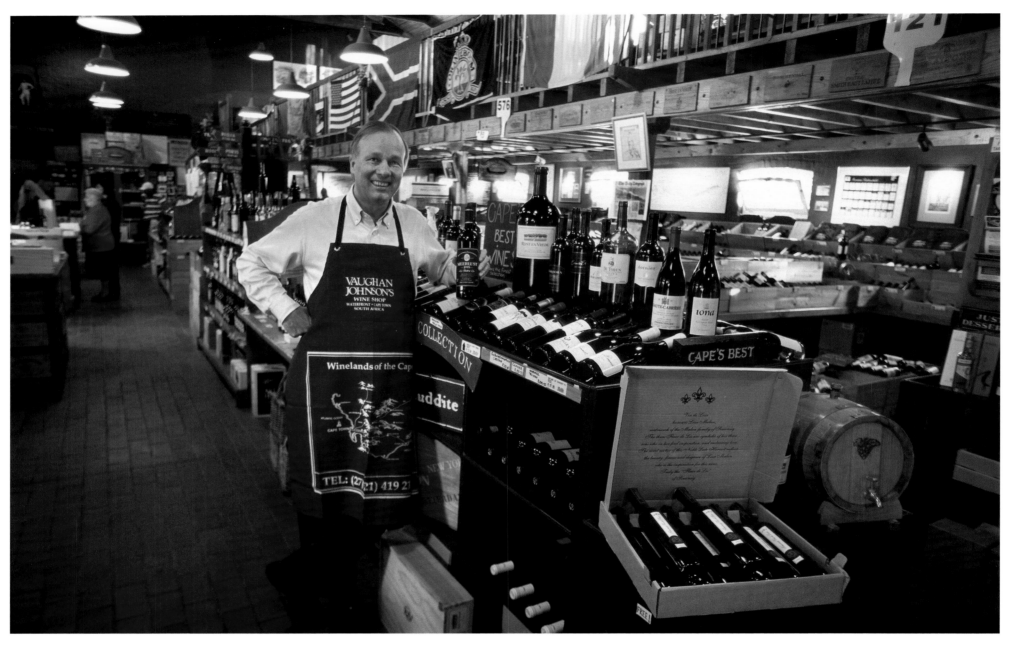

VAUGHAN JOHNSON'S WINE & CIGAR SHOP

Vaughan Johnson's is an institution in Cape Town's V&A Waterfront, the famous tourist destination and working harbour. Urbane, be-aproned Mr Johnson, with his wit and intimate knowledge of wines and winemakers, is the epitome of the High Street shopkeeper (Dublin boasts two of his franchised wine bar/shops). Wooden shelves and bins overflow with the Cape's vinous bounty, from top names like Rust en Vrede to Johnson's own quirkily named quaffers (Seriously Good Plonk and Good Everday, Really Good and Sunday Best wines). It's also an emporium of life's little indulgences: a connoisseur's collection of cigars, gourmet cheeses, olives and olive oils, books on food and wine, and an array of accessories for wine aficionados.

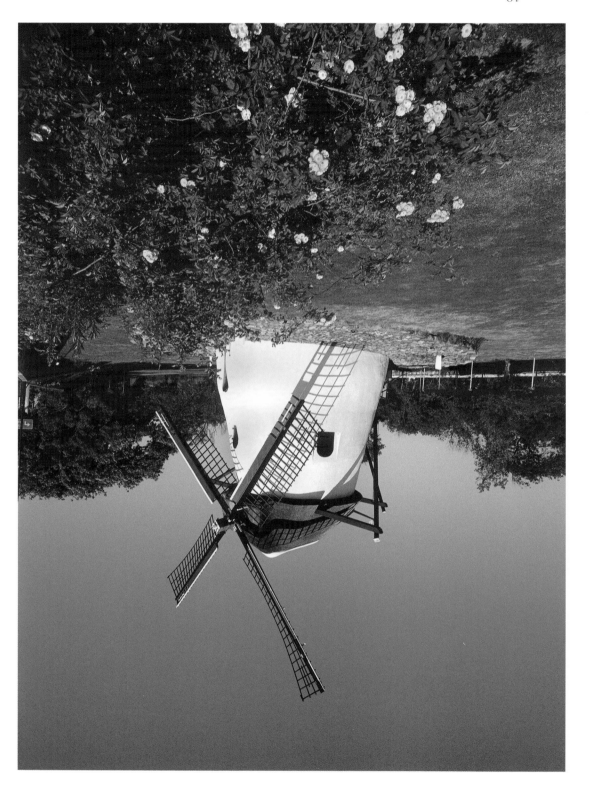

MOSTERT'S MILL

The oldest surviving windmill in South Africa, Mostert's Mill, was built in 1796 on Welgelegen, the farm of Gysbert van Reenen. Communal mills, where farmers could grind their wheat, were controlled by the Dutch East India Company, and Van Reenen had to obtain special permission for the construction of his privately owned mill. The mill was named after Van Reenen's son-in-law, Sybrand Mostert, who inherited Welgelegen after the death of Van Reenen. Overtaken by modern technology, Mostert's Mill fell into disuse in the latter half of the nineteenth century. In the 1930s the South African government commissioned a millwright from Holland to restore it to working order. Mostert's Mill is situated at the top end of Mowbray, on the way to the winelands of the Constantia Valley, and can be viewed from Rhodes Drive.

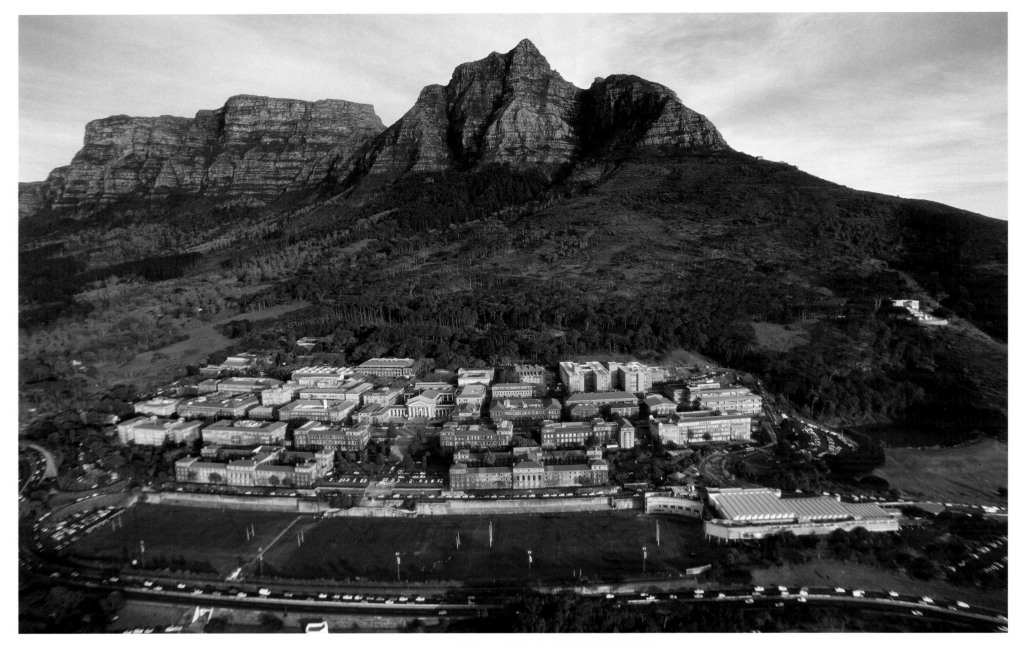

UNIVERSITY OF CAPE TOWN

In 2005 the University of Cape Town (UCT) celebrated the 175th anniversary of the founding of the first formal institution of higher education in South Africa, the South African College, in which UCT, the country's oldest tertiary seat of learning, has its roots. Marketing honours students at UCT recently undertook an important research project on the South African wine industry, and the results will be of great benefit to both the South African and international wine industries. The magnificent Sir Herbert Baker-inspired UCT building complex graces the slopes of Table Mountain's Devil's Peak. The original historic South African College city campus today houses UCT's Michaelis School of Art.

KIRSTENBOSCH NATIONAL BOTANICAL GARDEN

Kirstenbosch, on the eastern slopes of Table Mountain, overlooks the vineyards of Constantia and False Bay. The gardens are devoted mainly to indigenous plants; although most are from the winter rainfall region, there are also many hardy species from elsewhere in the country. The thoughtfully laid-out gardens include a fragrance garden, a braille trail and sections planted with cycads, aloes, euphorbias, ericas and proteas. A special section contains 'muti' plants, used by traditional healers (sangomas). There are also signposted walks guiding the visitor around the forests and fynbos areas surrounding the cultivated sections.

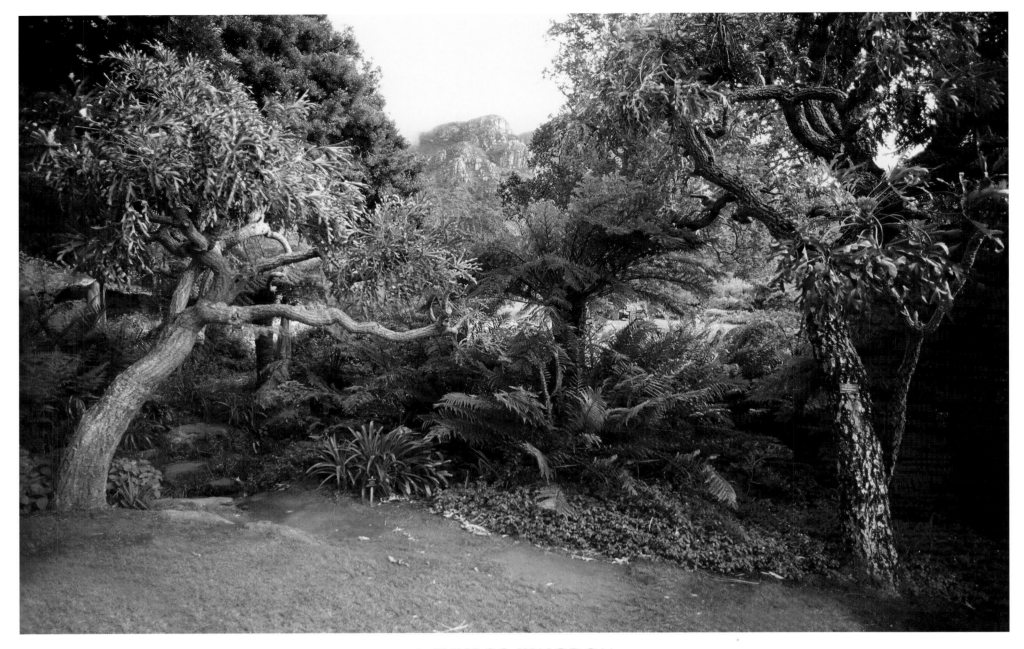

A FYNBOS KINGDOM

The indigenous plants of Kirstenbosch National Botanical Garden straddle two of the six plant kingdoms of the world, the Palaeotropical floral kingdom, which includes the plants of most of sub-Saharan Africa, and the Cape floral kingdom, the smallest plant kingdom, incorporating plants from the Cape's winter rainfall region. There are 8 500 species in the Cape floral kingdom, and the Cape Peninsula has 2 600 of these.

THE ORANGEBREASTED SUNBIRD

The tiny orangebreasted sunbird is found only in a small area of southwestern and southern South Africa, mainly in mountainous parts where the natural vegetation has remained undisturbed. The male is iridescent, while the female has an overall greenish-yellow colour. The sunbird enjoys a symbiotic relationship with ericas and proteas, part of the Cape's rich flora, which it pollinates as it moves from flower to flower. Gregarious, except when breeding, these sunbirds are sometimes found in flocks of up to a hundred birds at a time.

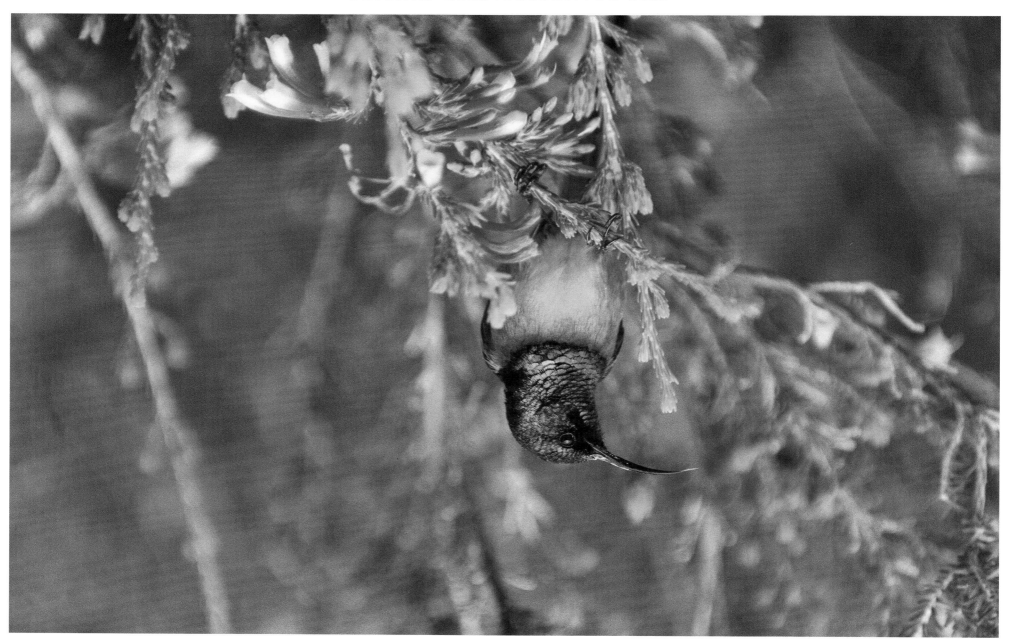

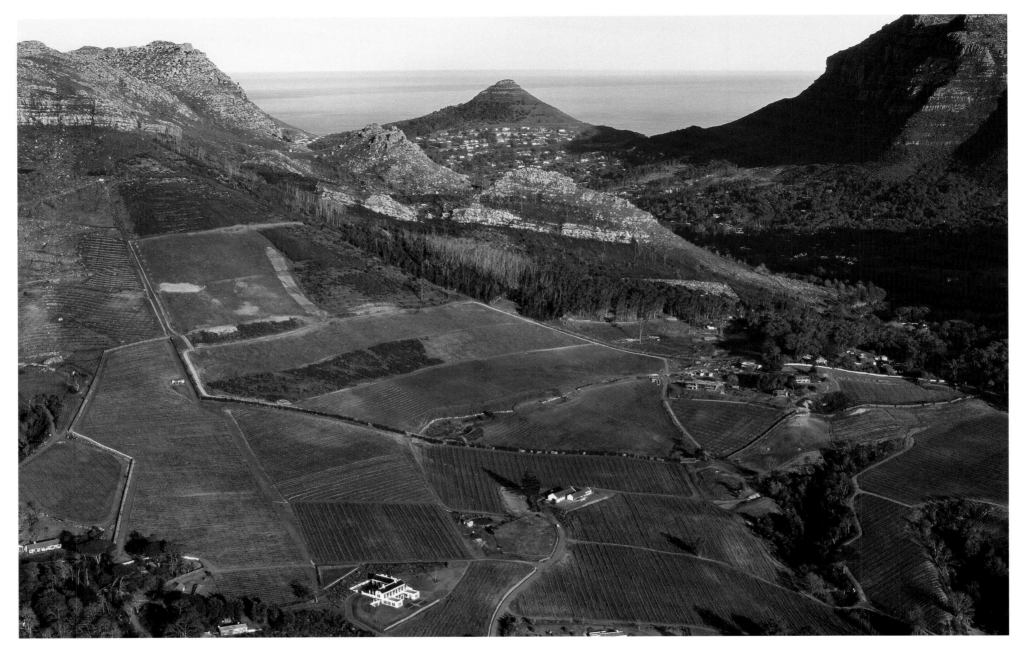

CONSTANTIA VALLEY

Although small due to urban encroachment, the Constantia Valley is one of the oldest and finest wine-producing areas. Cool sea breezes, wet winters and long summer days provide ideal growing conditions. Simon van der Stel, appointed Commander at the Cape in 1679, had a keen interest in viticulture, and played an instrumental role in improving the quality of wine produced at the Cape during the seventeenth century. His employers rewarded him in 1685 with a farm, which he called Groot Constantia. He had chosen the site carefully by closely examining the soil and looking for an area that would be protected from the south-easterly wind. His farm stretched from Wynberg Hill to Steenberg – 760 hectares in total.

THE CAPE'S FIRST VINE NURSERY

Jan van Riebeeck, Commander of the first Dutch settlement at the Cape, was eager to plant vines at the Cape, and in the summer of 1654 the first vines arrived from Holland; another batch arrived in February the following year. The cuttings were probably planted in the Company's garden, but few survived as it was the height of summer. More cuttings arrived in July 1655 and this time, the cuttings took root. Two years later a vine nursery was established at Rustenburg on the eastern slopes of Table Mountain. Van Riebeeck soon had enough plant material to establish a vineyard at Boschheuvel – today's suburb of Bishopscourt – and the nursery supplied 1 200 vines for the project.

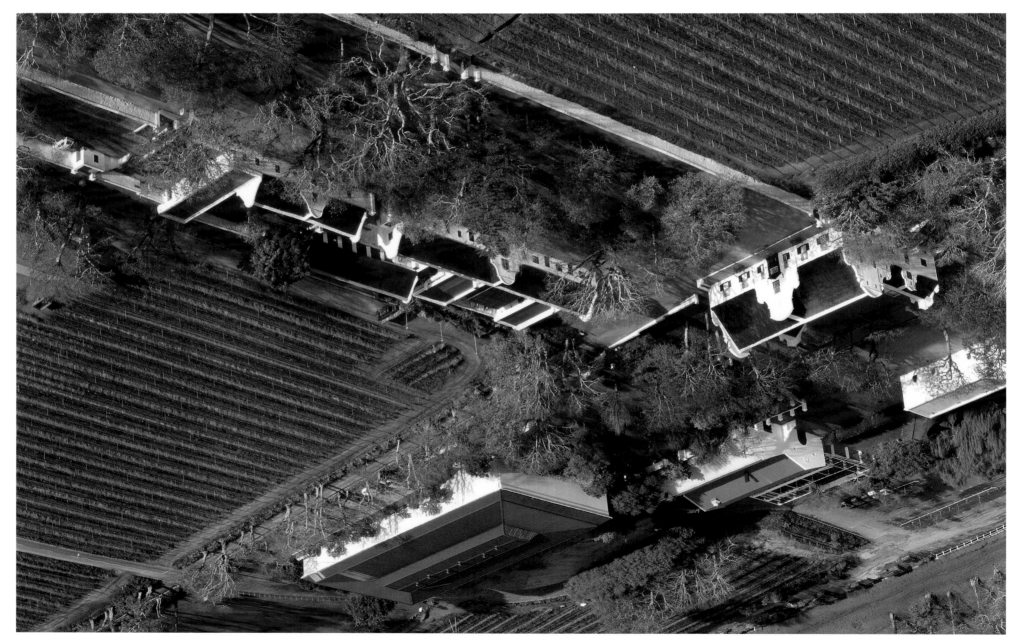

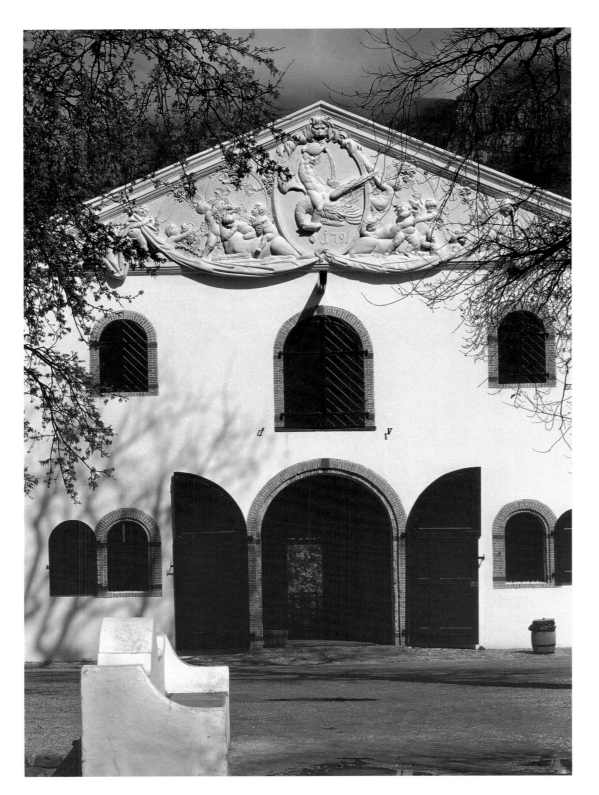

GROOT CONSTANTIA

Commander Simon van der Stel was not impressed with the quality of wine he tasted at the Cape on his arrival in 1679. He immediately imposed a fine on any farmer harvesting immature grapes and appointed inspectors to visit farms, dispense advice and administer fines as required. Until then, farmers routinely harvested green grapes because flocks of birds would descend on the small vineyards to eat the ripe berries. Van der Stel also improved cellar practices and stressed the importance of hygiene. Religious turmoil in France gave him the opportunity to settle experienced wine growers in the Cape, and the French Huguenots were welcomed with open arms.

Groot Constantia – Simon van der Stel's own farm – is a monument to these early efforts to establish a viable wine industry at the Cape. Hendrik Cloete bought Groot Constantia in 1776 and soon made wine that was enjoyed in all the courts of Europe. Cloete then set about renovating his farm in keeping with his stature. In 1791 he appointed the French architect Louis Michel Thibault to refurbish the manor house and build a new cellar. Anton Anreith, a German sculptor who also lived in the Cape at the time, was commissioned to decorate the neo-classical pediment.

DIGITAL FOREST STUDIO

Situated in the heart of the historic Constantia Valley, 'Huis in Bos' (literally, house in the forest) is home to Digital Forest Studio which provides audio recording and post-production editing facilities for the film, television and radio industries. The studio did the post-production audio work on *34 South*, directed by Maganthrie Pillay. Award-winning Hollywood sound specialist, Albert Lord, known for his work on the television series *Law and Order* and movies such as *The Preacher's Wife*, worked with the team on the soundtrack. He also helped to train young filmmakers from historically disadvantaged communities. From left to right are Reza Williams, Jongi Ntshunushe, Albert Lord, Peter Rawbone-Viljoen and Andrew Rawbone-Viljoen.

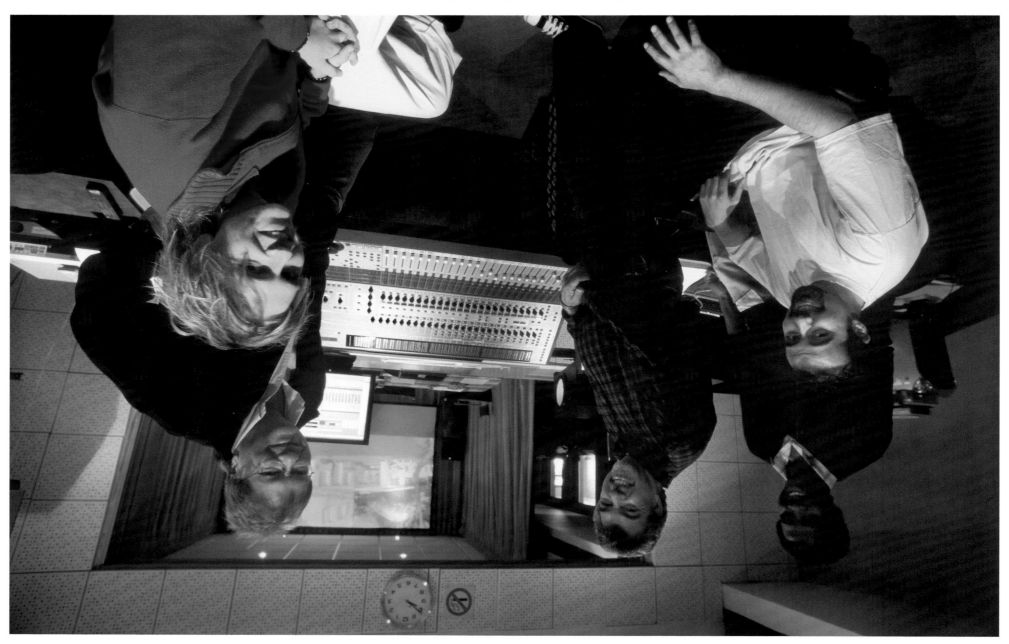

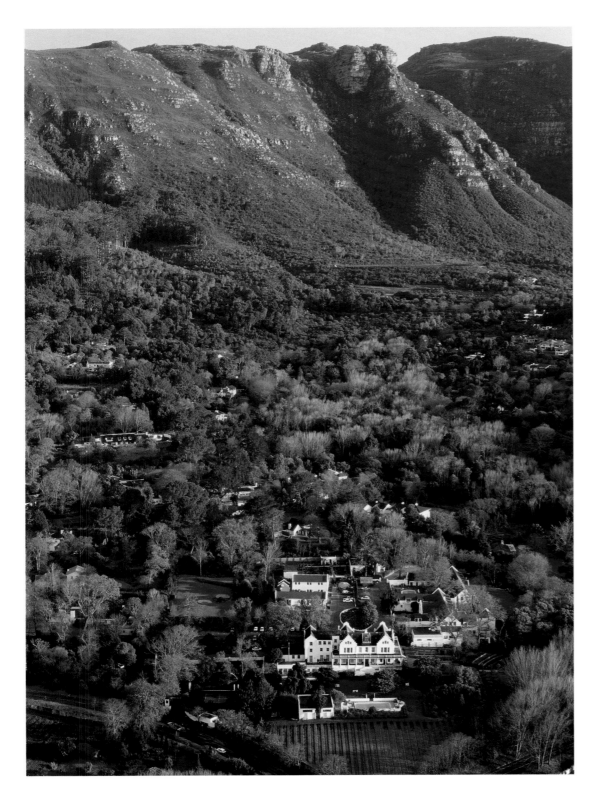

CELLARS-HOHENORT HOTEL

An elegant country hotel, the Cellars-Hohenort lies on the eastern slopes of Table Mountain in the heart of the Constantia Valley. The property dates back to 1693, when it was granted to Hendrik ten Damme, a chief surgeon with the Dutch East India Company. It later became part of a historic seventeenth-century estate known as Claasenbosch.

Arnold Wilhelm Spilhaus, a silver trader, bought the property in 1906 and commissioned the architect E. Seeliger to design a new home for him and his family. The old Claasenbosch farmhouse was demolished and in its place the imposing Hohenort manor house was built. When Spilhaus died in 1947, the property was sub-divided and sold. Almost 50 years later, in 1992, Liz McGrath bought the original Claasenbosch cellars, which had earlier been converted into a country guesthouse. The historic property was further consolidated with the purchase of the magnificent Hohenort manor house in 1993.

The Cellars-Hohenort is now a five-star hotel and part of the internationally renowned Relais & Châteaux Association. The hotel complex includes two swimming pools, a fully equipped spa, a tennis court, and a chipping and putting golf green. It also has two world-class restaurants – The Cape Malay Restaurant and The Greenhouse Restaurant.

A TRIBUTE TO FINE WINES

The historic wine cellar at the Cellars-Hohenort Hotel is a tribute to the Constantia Valley and its heritage. In this valley Governor Simon van der Stel established his model farm Groot Constantia in the late seventeenth century, and devoted much of his time to the improvement of the standard of winemaking at the Cape. Today his home is a museum and a national heritage. The Cellars-Hohenort Hotel lies within easy reach of the many wine cellars found throughout the Constantia Valley today. Other nearby destinations include the Kirstenbosch National Botanical Garden, Cape Point, Table Mountain and the V&A Waterfront. The popular False Bay, where whales can be seen from the end of winter through spring, is a stone's throw away.

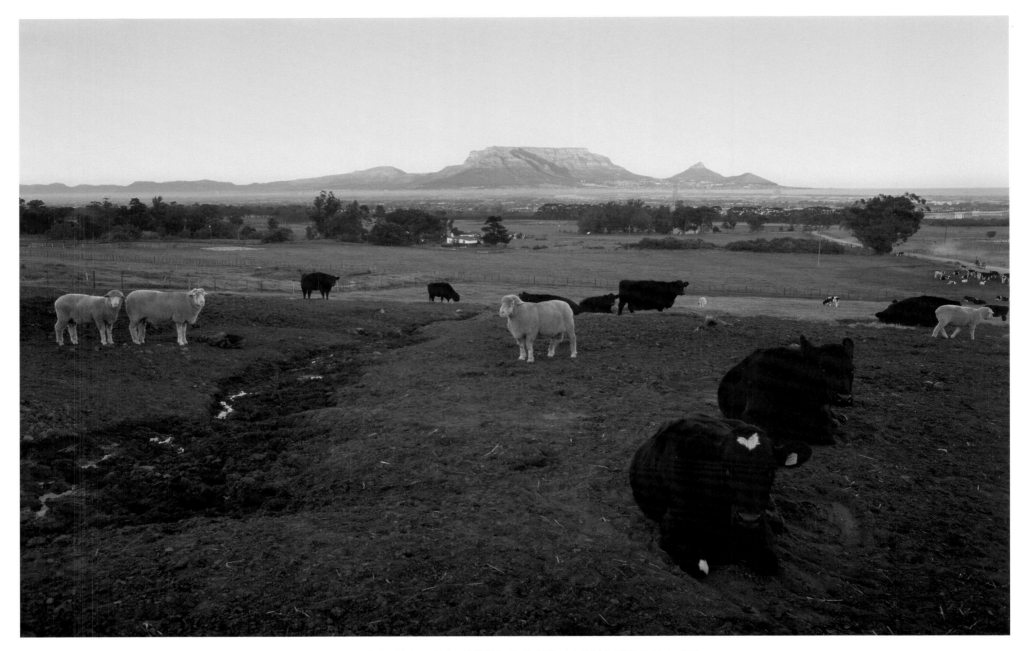

DE GRENDEL EXPLORES NEW TERROIR

Former table grape farmer, Sir David Graaff, scion of an old Cape family, has established a new wine farm on the west-facing slopes of the Tygerberg Hills with views of the Cape Town landmarks of Table Mountain, Lion's Head and Signal Hill. The 100 hectares of selected varieties on virgin soils include: Bordeaux classics, Cabernet Sauvignon, Merlot, Cabernet Franc, Petit Verdot and some Malbec; Rhône specialities, Shiraz and Viognier; southern France favourites, Mourvèdre and Grenache; Pinot Noir and Pinotage; and Sauvignon Blanc, Chardonnay and Sémillon. A supplier of grapes to premium producers, Neil Ellis and Graham Beck, David Graaff has also bottled small quantities of Sauvignon Blanc, Shiraz, Merlot and Cabernet under the De Grendel label. A 500-ton cellar is in the pipeline.

DURBANVILLE'S VINOUS HISTORY

The views from the Durbanville Hills across the valley towards the distant Simonsberg, a Stellenbosch winelands landmark, and Table Bay and Robben Island are breathtaking. Although breaking modern-era viticultural ground on the Tygerberg foothills, farms in this area have a vinous history. An 1812 insert in the *Cape Gazette*, the official record of the times, notes the sale of 10 000 vines by one of the farm owners in this area. It is suspected that whatever vines existed on these farms were later wiped out by the phylloxera epidemic, which reached the Cape in 1885 after decimating vineyards in Europe. *Phylloxera vastatrix* is a bug that attacks the vine's wood and can only be combated by planting vines grafted onto virus-immune rootstock.

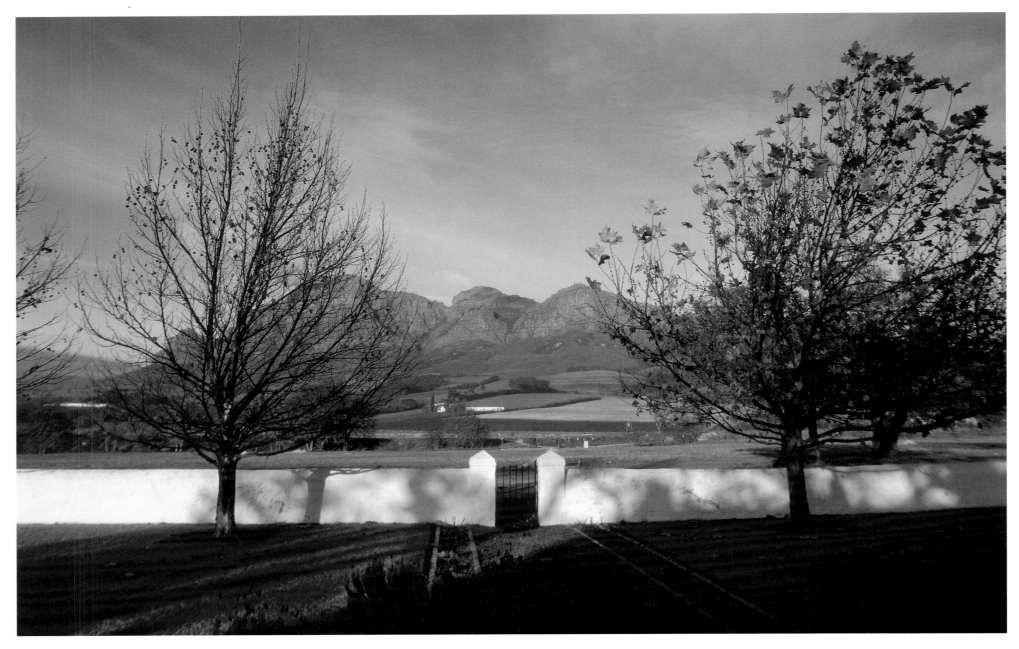

FREDERICKSBURG

The historic French Huguenot farm Fredericksburg, home of the Rupert & Rothschild partnership, is situated on the north-westerly slopes of the picturesque Simonsberg. Fredericksburg was founded in 1690, more than three centuries ago, by the brothers Jean and Daniel Nortier. The manor house, built around 1711, was originally a simple two-roomed home, which was transformed over the next two centuries by its respective owners. The late Anthonij Rupert, youngest son of Dr Anton Rupert, acquired Fredericksburg in 1984. His aim was to produce wine of the highest international standard. Replanting of noble varieties started in 1986 and restoration of the original buildings commenced in 1991 after extensive research into the history of the farm.

RUPERT & ROTHSCHILD VIGNERONS

Rupert & Rothschild's classically elegant underground barrel maturation cellar, completed in 1998, is complemented by a sophisticated production cellar. The unique partnership between the Rupert family of South Africa and Baron Benjamin de Rothschild, son of the late Baron Edmond de Rothschild of France, was formed in 1997. The Rupert family also owns two other wine estates in the Franschhoek Valley, namely L'Ormarins and La Motte. With the love of wine as a common interest, and with Fredericksburg's past firmly rooted in two cultures – French Huguenot and Cape Dutch – the Rupert & Rothschild families share one goal: to produce world-class wine.

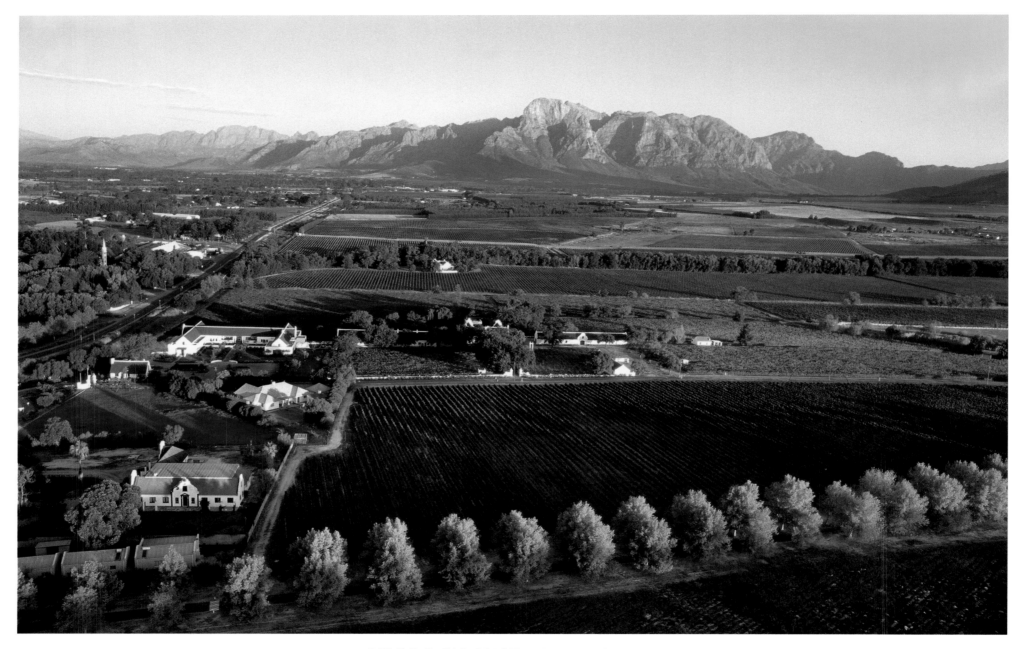

VREDE EN LUST WINE ESTATE

On a clear day all roads lead to Franschhoek. Every weekend hundreds of people descend on this little town in the winelands in search of good food, outstanding wine and lots of sunshine. By midday the town is packed with motorists, motorbikes and bicycles. The route to Franschhoek goes through the hamlet of Simondium, and past a specialist cheese deli, Cotage Fromage, at the entrance to Vrede en Lust Wine Estate. Through a number of acquisitions, the current owners have restored the farm to its original boundaries. The *werf* (farmyard), manor house, cellar and outbuildings have also been restored.

TAKING CARE OF THE LAND

Vrede en Lust lies in the picturesque Franschhoek Valley, a place of unsurpassed natural beauty. Here premium wines are created from healthy vineyards grown in soils that are given constant care. Fertilisation and irrigation programmes require strict monitoring and samples are taken at regular intervals to record the soil's nutrient and moisture content. Leaf samples indicate what nutrients were available in the soil. Fertilisation programmes are often supplemented by foliar sprays of micro-nutrients.

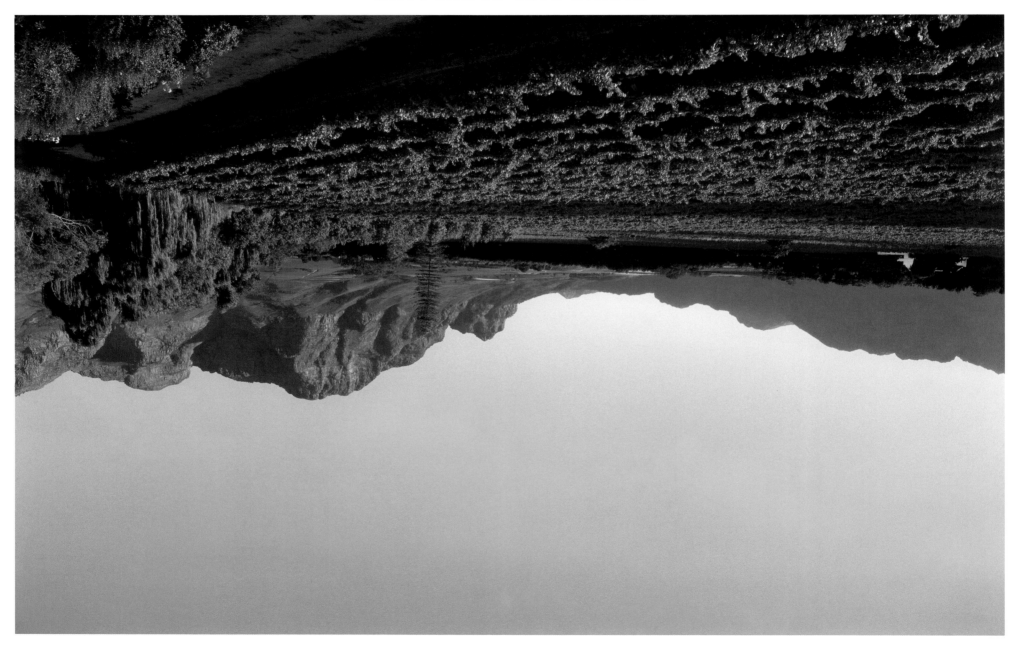

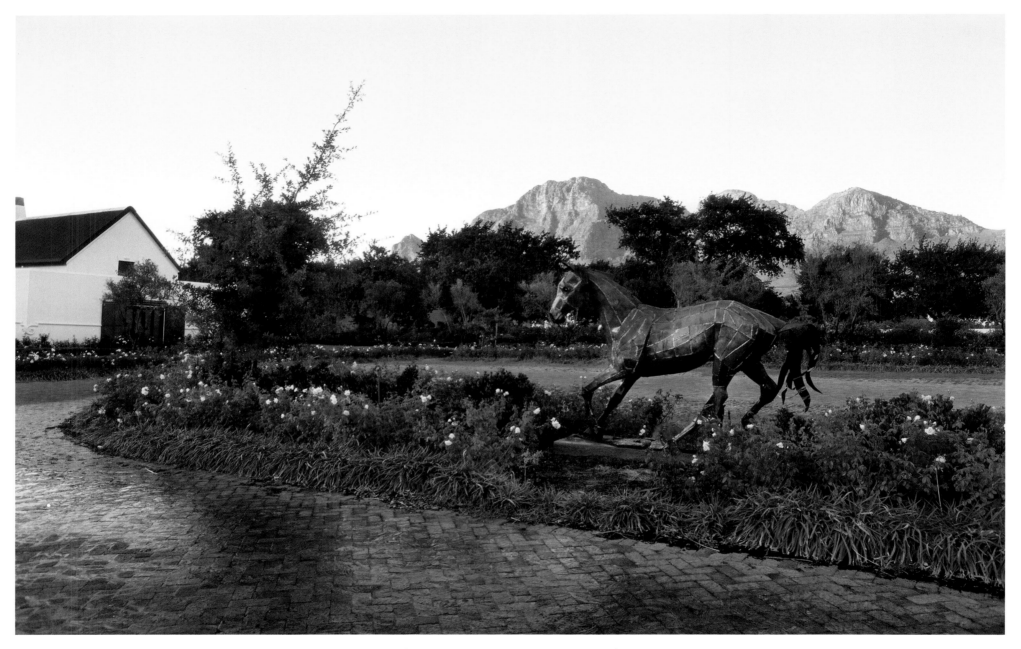

'LIFE WITH ATTITUDE'

Vrede en Lust is a magnificent farm on the slopes of the Simonsberg between Franschhoek and Paarl. A life-size steel and copper statue of a stallion stands at the entrance to the farm. Farm owners Dana and Cara Buys first saw the statue at an exhibition in White River in Mpumalanga. The copper stallion was created by the Pretoria-based artist, Arend Eloff, who had a studio in White River at the time. It took another six months of deliberation before the couple finally decided to buy the work. According to Dana Buys, he and his wife had fallen in love with the horse because it seemed to exude motion from all angles, symbolising 'life with attitude'.

PRANCING IN THE SUN

Late afternoon sunlight catches the sleek tension of a young horse's muscles as it prances in a paddock at Vrede en Lust near Franschhoek. Before the arrival of motorised transport, horses, mules and donkeys played an important part in the economy of the winelands. Horse riding remains a popular leisure activity, and horse trails are offered throughout the winelands to give visitors an opportunity to enjoy the sport and to appreciate the beauty of the region.

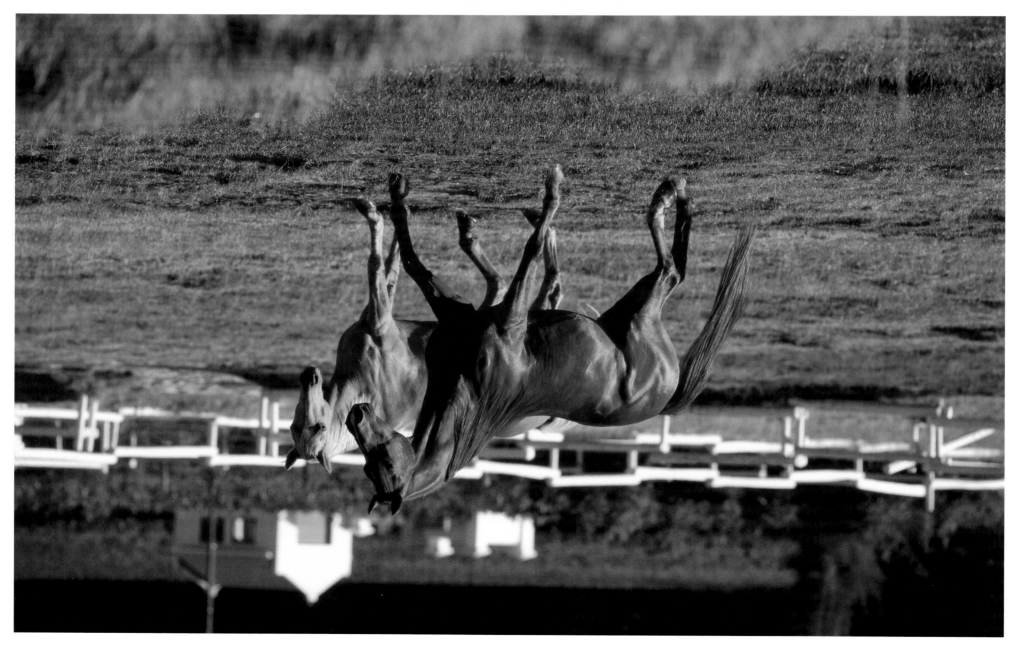

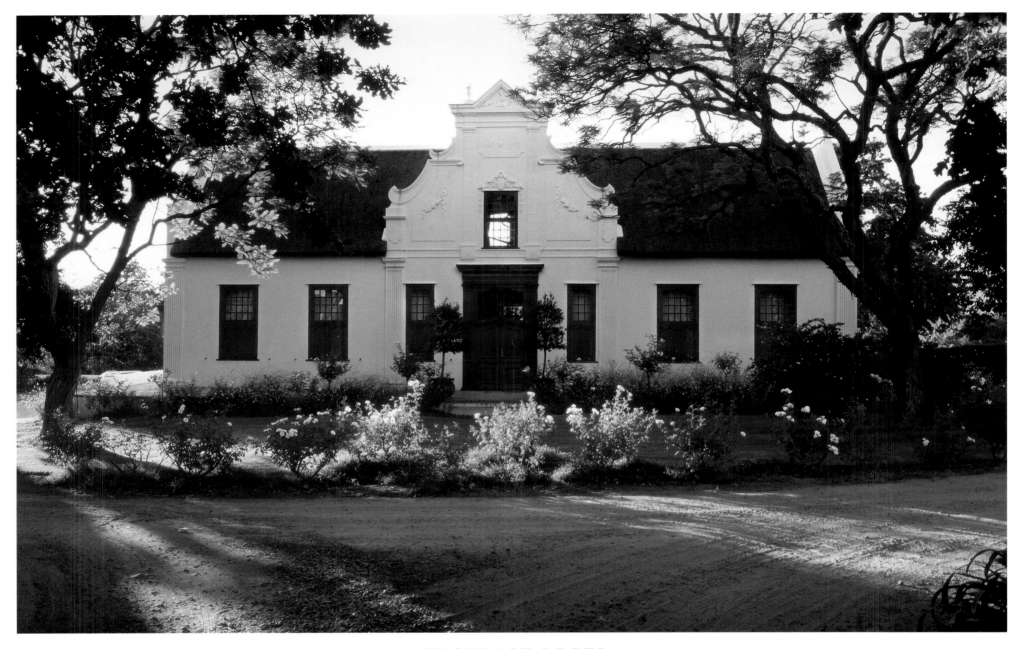

HUGUENOT ROOTS

The farm today known as Vrede en Lust was granted to Jacques de Savoye, a French Huguenot, in the late seventeenth century. De Savoye was a wealthy merchant who settled at the Cape with his wife, Marie-Madeleine le Clercq, his mother-in-law, three children and three servants. De Savoye played a leading role in the politics of the fledgling Dutch colony at the Cape. For his part in opposing the corrupt Governor Willem Adriaan van der Stel, De Savoye was jailed and spent some time in the Cape Town Castle's notorious dungeon. De Savoye was a better trader than a farmer. In 1701 he sold Vrede en Lust to pay his creditors to once more earn a living as a trader.

PLAISIR DE MERLE

Jan Corewijn's magnificent frieze (after the style of Anton Anreith) above the entrance to Plaisir de Merle's cellar is a tribute to the Hugo and Marais families that once owned the farm. The chain and crescent moon are elements from the Marais family crest. The horse, essential to early rural life, is a reminder that Jacob Marais, who had the manor house built in 1764, was a wealthy man and owned 12 horses. The lion, a traditional heraldic symbol associated with both the Netherlands and Britain, is also a symbol of Africa. The cherubs and bunches of grapes celebrate abundance, pleasure and the enjoyment of wine. The farm's name literally means 'pleasure of the blackbird' – a reference to the Hugo family crest.

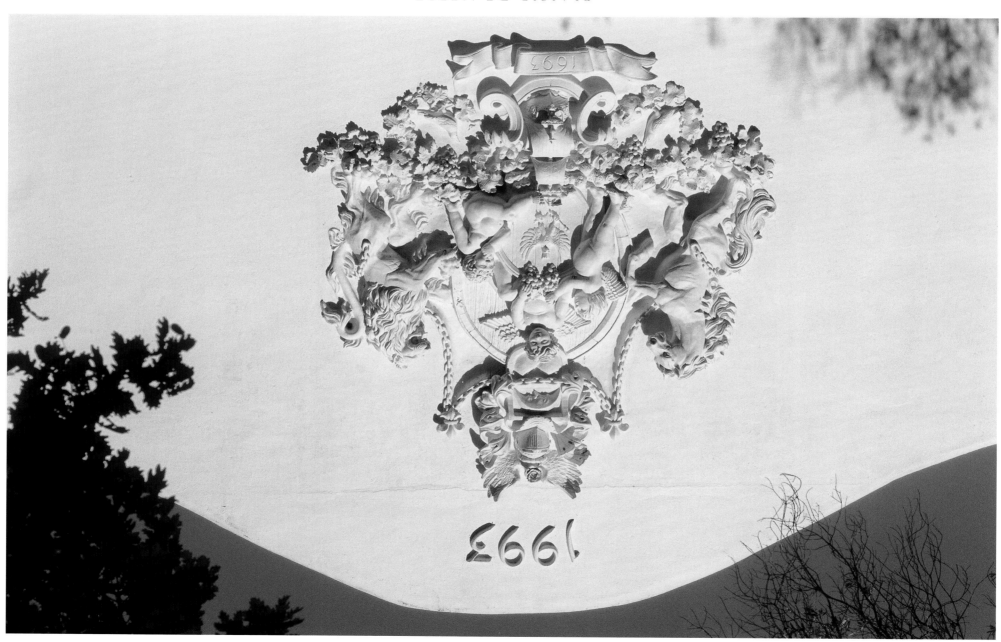

QUEST FOR QUALITY

At L'Ormarins vines grow on terraced slopes between 250 and 350 metres above sea level. A major redevelopment programme started in 2001 with the objective of setting new standards in world-class wines. Since its implementation, varietal clones and rootstock have been carefully matched with soils and slopes, and marginal soils have been excluded from production – all in the quest for quality. The estate is famous for its classic French varietals such as Sauvignon Blanc, Chardonnay, Merlot and Cabernet Sauvignon, as well as the Italian varietals such as Sangiovese and Pinot Grigio.

GRACIOUS SYMMETRY

The beautifully restored L'Ormarins manor house and outbuildings are an excellent example of the wealth, prosperity and gracious lifestyle enjoyed on wine farms at the Cape during the Napoleonic Wars (1800–1815) when Britain imported all its wine from the Cape. The original owner of the farm known today as L'Ormarins was the French Huguenot, Jean Roi, who received his grant in 1694. He named the farm after his hometown of Lourmarins in Provence. The present homestead dates back to 1811 and the cellar to 1799. By 1825 L'Ormarins was a well-established wine farm and a regular prize-winner at local agricultural shows, especially for its Cape Madeira. Today the farm is owned by Johann Rupert.

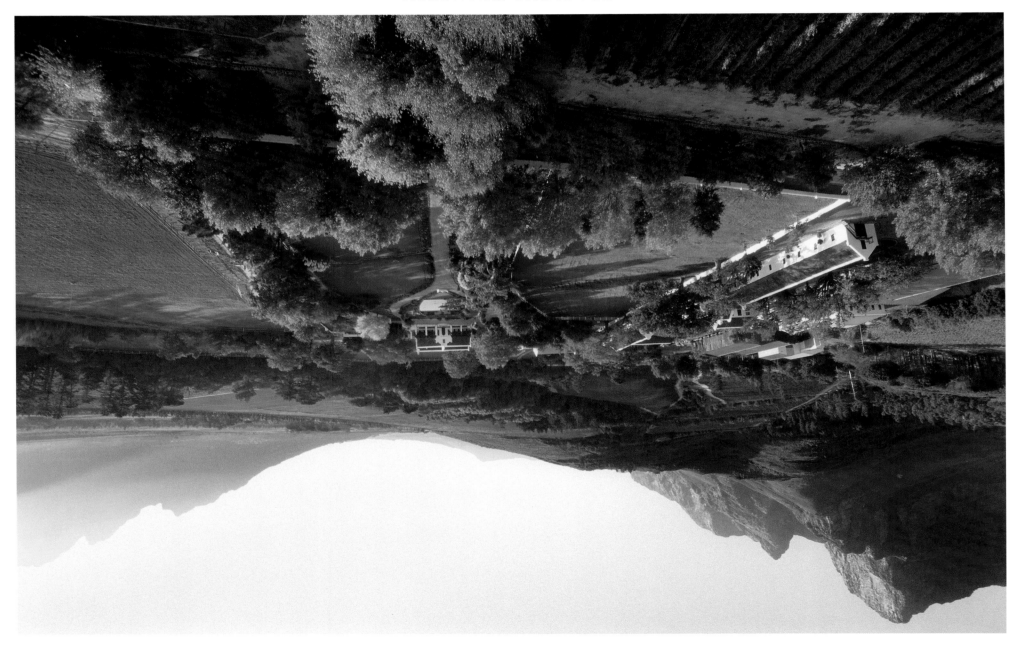

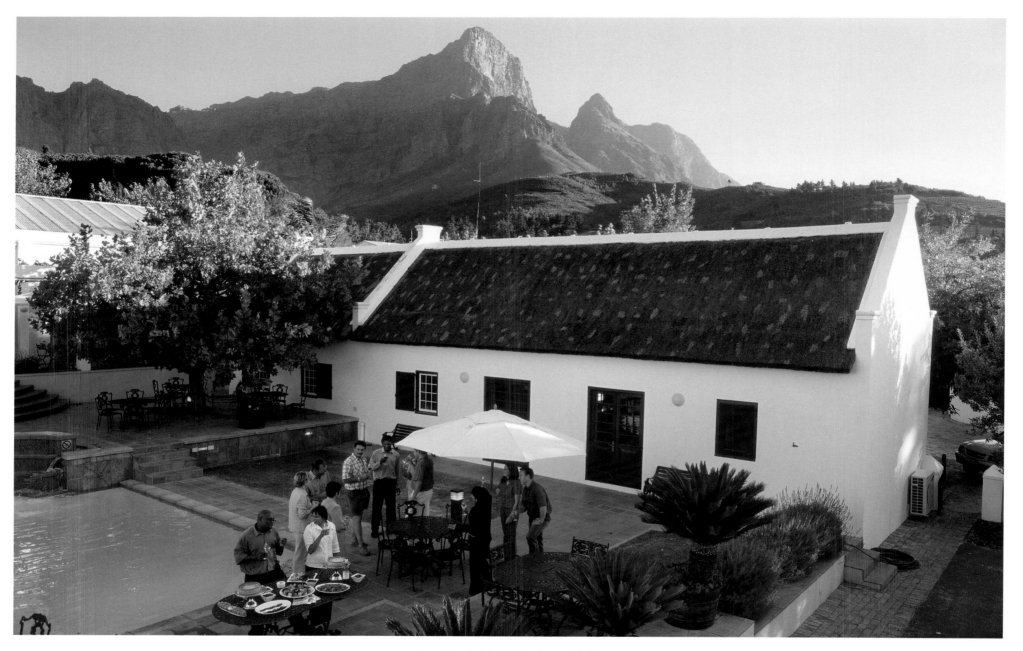

SEASONAL EXTRAS

A journey into the heart of the winelands provides an opportunity not only to taste some of the best wines in South Africa, but also to discover the many culinary delights the region has to offer. L'Ormarins Estate, situated on the doorstep of Franschhoek, the gastronomic capital of South Africa, is famous for its delightful cheese platters served throughout summer. The tasting room, decorated with antiques and original Pierneef etchings, is situated adjacent to the poolside courtyard, where guests can sip superb wines, complemented by regional cheeses, while taking in the beauty of the breathtaking scenery.

LA MOTTE WINE ESTATE

La Motte – situated on the southern and south-western slopes of the Wemmershoek Mountains – is one of the largest of Franschhoek's farms and was originally used as grazing ground. The estate was first developed as a wine farm when Pierre Joubert bought it in 1709. Today La Motte is owned by the internationally acclaimed mezzo soprano, Hanneli Koegelenberg née Rupert, and is one of three Rupert-owned wine farms in the Franschhoek Valley. Cooled by morning mists and afternoon breezes, the grapes ripen slowly in summer, creating the farm's signature Shiraz wines. La Motte also sources grapes from the Rupert Farms in Darling and Bot River. The farm's blend of wine, quality and excellence is celebrated with monthly classical music concerts in the historic wine cellar.

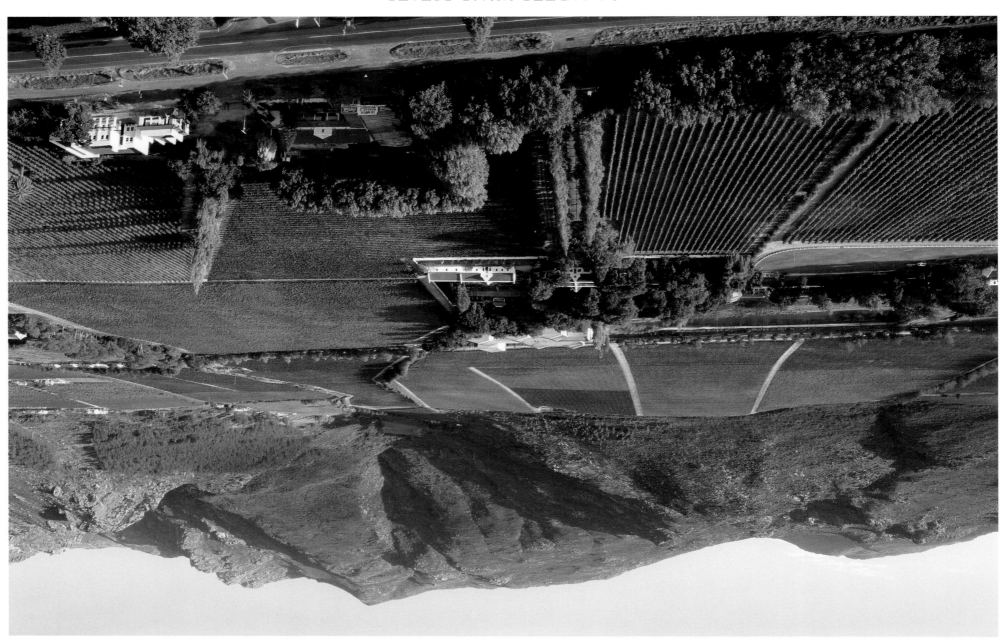

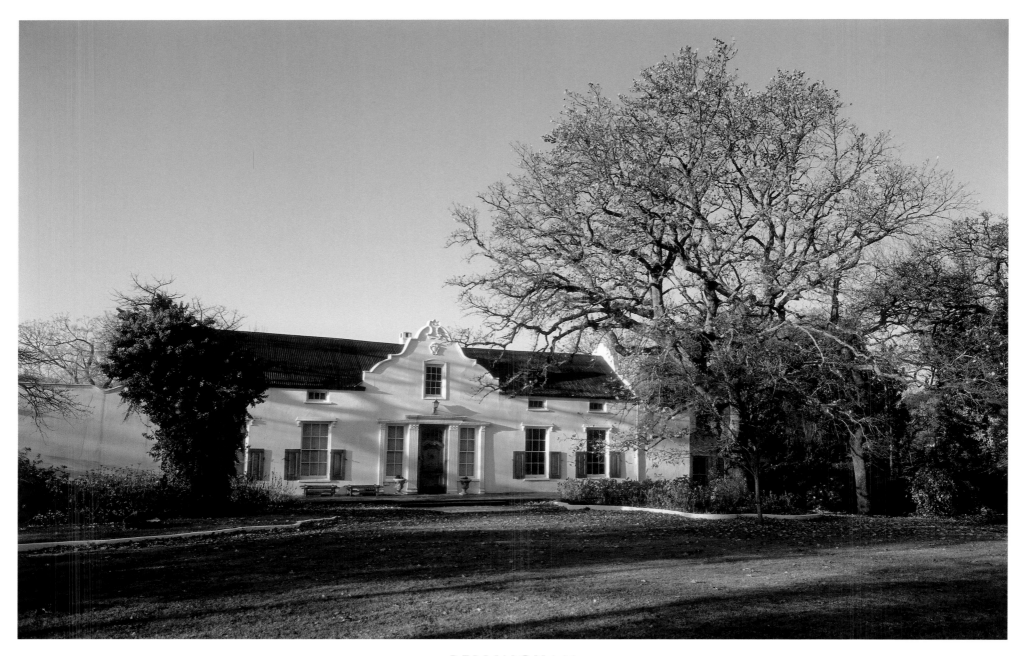

BELLINGHAM

The first vines were planted at Bellingham in 1693, and the farm has been associated with the wine industry ever since. Bernard Podlashuk, a pilot by training, retired from the air force following an injury and bought the estate in 1943. Despite his lack of experience and only a sketchy knowledge of wine farming, he tackled the renovation of Bellingham with passion and enthusiasm. He also visited France to increase his technical and theoretical knowledge. The result was that Bellingham was soon at the forefront of innovations in the local wine industry, producing new blends and creating new wine categories. Today Bellingham farm belongs to DGB (Pty) Ltd, an independent wine and spirit producer and distributor.

ABOUT A PEAK, A GABLE AND A BOTTLE

The road to Franschhoek follows the railway line through orchards, vineyards and stands of gnarled oaks. The homestead of Bellingham lies just short of the Berg River, and the gable of its old cellar echoes the shape of Hutchinson's Peak in the background. Soon after purchasing the farm, Bernard Podlashuk began producing South Africa's first Rosé, Premier Grand Cru and Shiraz wines. Bernard's wife, Fredagh, a painter and jewellery designer, created Bellingham's distinctive gable-shaped bottle. For some time, the bottle was used for all Bellingham wines. Today the bottle is used only for Bellingham's semi-sweet blend, Johannisberger. The famous gable, however, lives on in the design of the Bellingham wine label. Podlashuk is honoured in two wine ranges – The Maverick and Our Founders.

AUTUMN GARDEN

The garden at Bellingham offers a space for quiet contemplation. This tranquil setting is a far cry from the derelict farm bought by Bernard and Fredagh Podlashuk in 1943. With the assistance of 13 Italian prisoners of war assigned to live and work out the war years at Bellingham, the Podlashuks set about restoring the manor house and gardens and replanting the vineyards. Today the manor house is a provincial heritage site and has been a popular retreat for politicians, celebrities and writers. The adjacent cowshed, which once housed the prisoners of war, has been immaculately restored and now serves as a guest cottage for local and international guests of Bellingham.

A PHILOSOPHY OF RESPECT

In midwinter the vines are pruned by hand into long canes, ready to be cut back just before the first buds appear in spring. Bellingham sources the finest quality grapes throughout the winelands, from Stellenbosch and Paardeberg to as far afield as Walker Bay and Darling, to best achieve optimal expression of variety and terroir. Bellingham's vinification philosophy is a simple one of minimal intervention and ultimate respect for the intrinsic characteristics of each cultivar. This philosophy is clearly expressed in the wine producer's Maverick, Our Founders and Spitz labels.

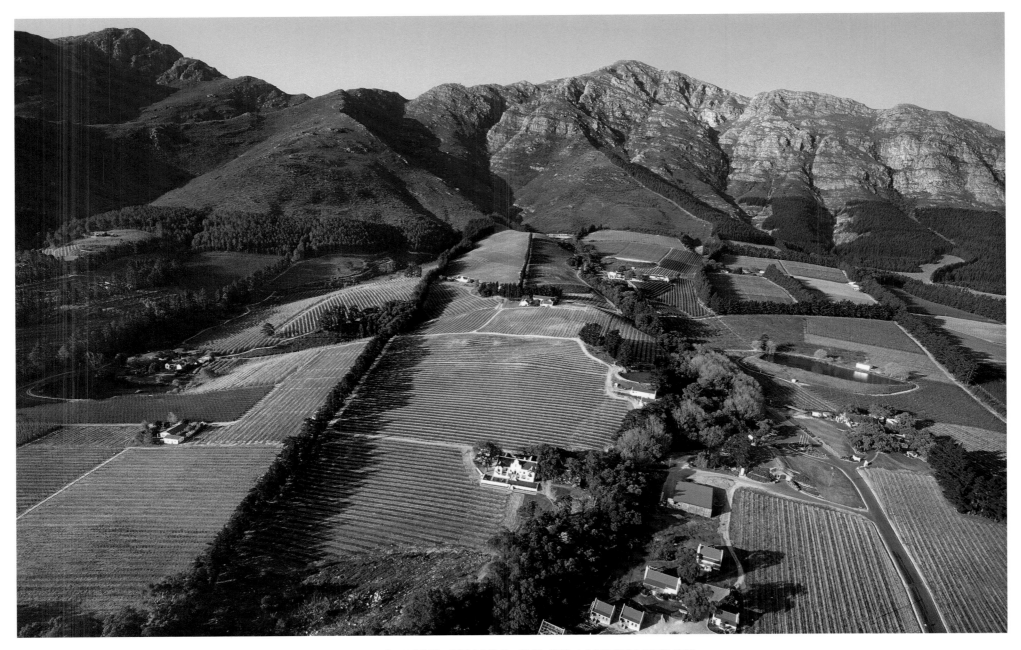

WINES AND VINES OF FRANSCHHOEK

Franschhoek has an average annual rainfall of about 900 millimetres. Climate and soil conditions vary from farm to farm – vines are cultivated on the banks of the Berg River and on the slopes of the high mountain ranges that cradle the valley. The differing terroir means than a wide range of wines is produced in the valley. Most of the farms are small – between 8 hectares and 15 hectares, producing anything from 4 000 to 15 000 cases. Over the past few years Franschhoek has seen a shift away from white wine cultivars to reds such as Cabernet Sauvignon and Shiraz, although Sauvignon Blanc is still widely planted.

49

BASSE PROVENCE

The spacious *werf* (farmyard) exudes an atmosphere of quiet confidence. La Provence was one of the first farms allocated to the French Huguenots on their arrival at the Cape in the late seventeenth century. The original owner of La Provence, Pierre Joubert, prospered and soon owned several farms in the valley. One of his descendants, Piet Joubert, distinguished himself as a Boer leader during the South African War (1899–1902). Basse Provence was originally part of the Joubert farm, and is a working farm with a delightful country guesthouse. Today guests can play croquet on the lawn in front of the guesthouse and boules under the 300-year-old oaks. The tradition of country hospitality lives on.

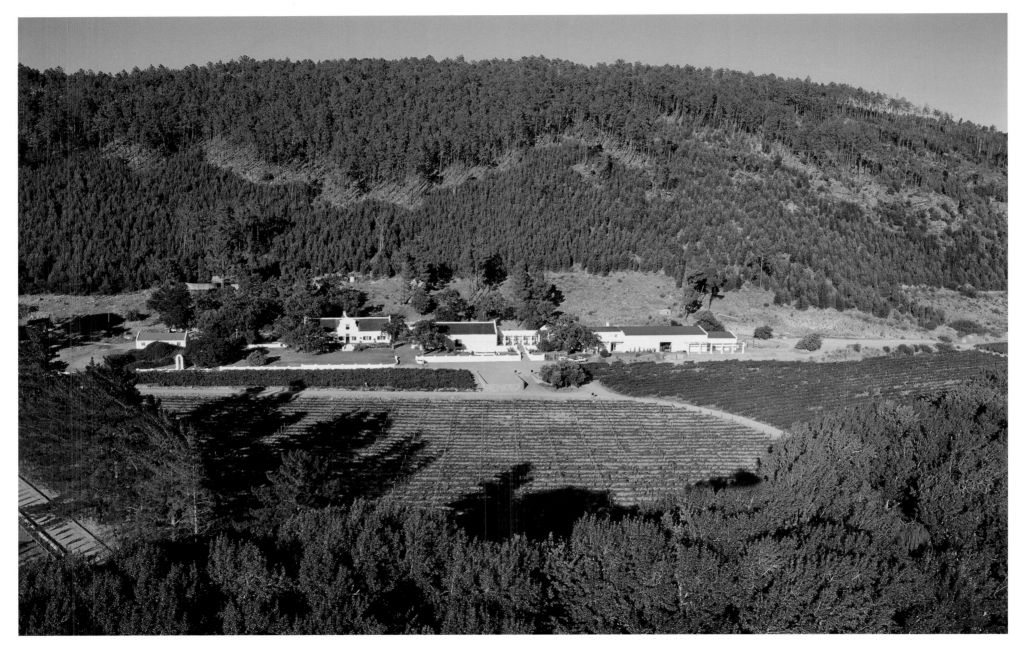

RICKETY BRIDGE WINERY

Rickety Bridge Winery was once part of La Provence, one of the early Huguenot farms, and lies against the slopes of Dassenberg on the outskirts of Franschhoek. In recent years Rickety Bridge Winery has undergone extensive renovations. The old manor house was renovated in 1995, and the new wine cellar was completed two years later. The old cellar was converted into a barrel maturation cellar. Vineyards were also replanted. All this activity meant that the original narrow, rickety bridge made from sleeper beams had to be replaced with a more functional but less romantic concrete bridge. Remains of the bridge can be seen in the office as a nostalgic reminder of the history of the farm.

WINE TASTING ON HORSEBACK

The stable yard fills with last-minute instructions, the dull weight of stirrups and bits, and the scent of oiled leather. The horses file out into the fresh morning and break into a trot. A horse shies at a farm dog and there is a distant chatter of guinea fowl. Outrides through vineyards such as these at Rickety Bridge in Franschhoek have become very popular among tourists and locals alike. Horse trails range from three-day treks through mountain reserves, vineyards and olive orchards to short, fun-filled wine-tasting excursions. The winelands also offer numerous hiking and mountain-biking trails, as well as 4x4 and quad-biking tracks.

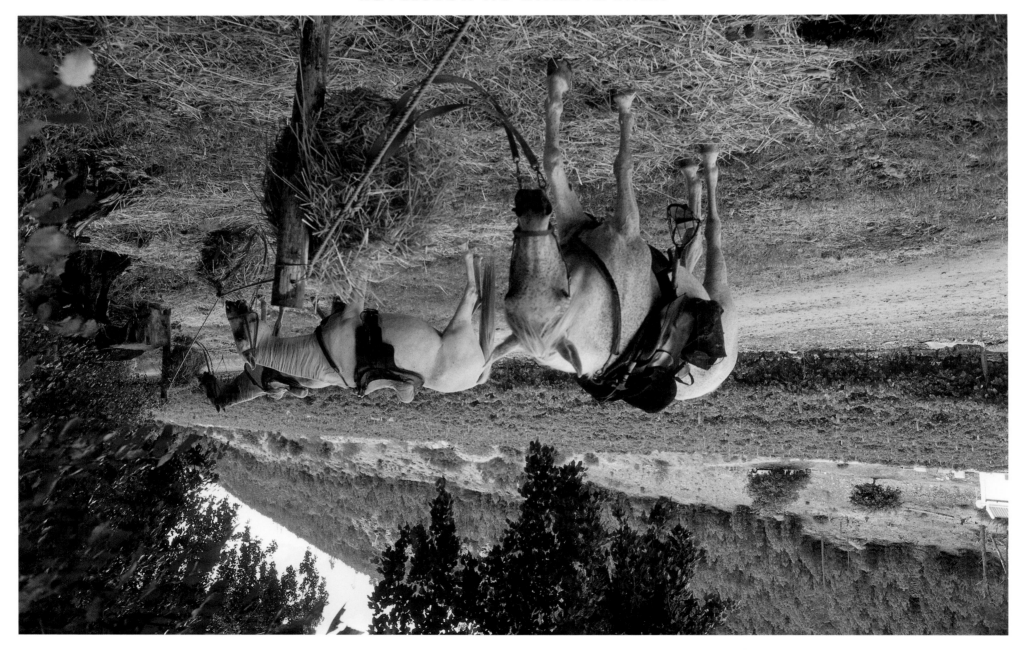

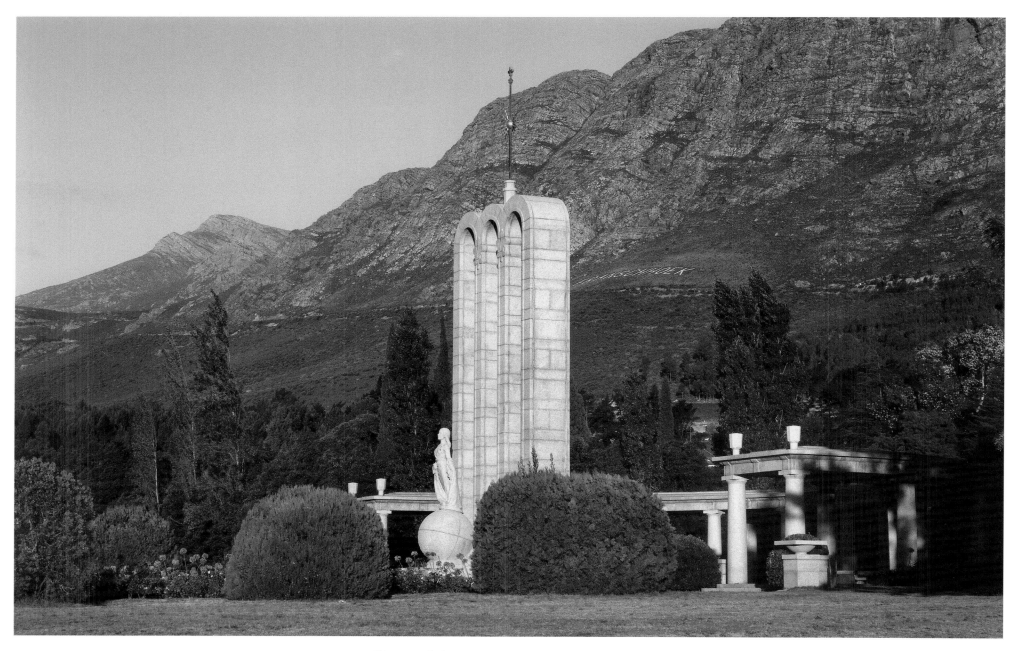

FRANSCHHOEK MONUMENT

The Lady of Franschhoek enjoys a commanding position at the top end of the main street of Franschhoek. The monument was designed and sculpted by Coert Steynberg, a South African sculptor who received many public commissions during his lifetime. The monument is rich in meaning. The woman carries a bible and broken chain, which symbolises the Huguenot's religious freedom, and the *fleur-de-lis* on her dress, their nobility of spirit. The Huguenot's contribution to art and culture, agriculture and industry is represented by a harp, ear of wheat and vines, and a spinning wheel. The lady is framed by three arches, denoting the Christian Trinity. The sun of justice and a cross rise above the arches. The monument was built by Paarl stonemasons, JA Clift, with local granite, and was inaugurated in 1948.

DRAKENSTEIN VALLEY

Charles Darwin's visit to the Drakenstein Valley during June 1836 presents one of the great ironies in the botanical world. The HMS *Beagle* docked in Table Bay during its famous world tour, and Darwin decided to take a closer look at the local fauna and flora. His trip to Franschhoek and Paarl was undertaken in midwinter, which could explain his terse comment that the region 'left him cold'. Little did he know that the Cape is the world's richest floral kingdom and the smallest. It takes up less than half a per cent of the earth's surface of the earth but contains more than 8 500 plant species, known collectively as *fynbos*. In 2004 the Cape floral region was declared a World Heritage Site.

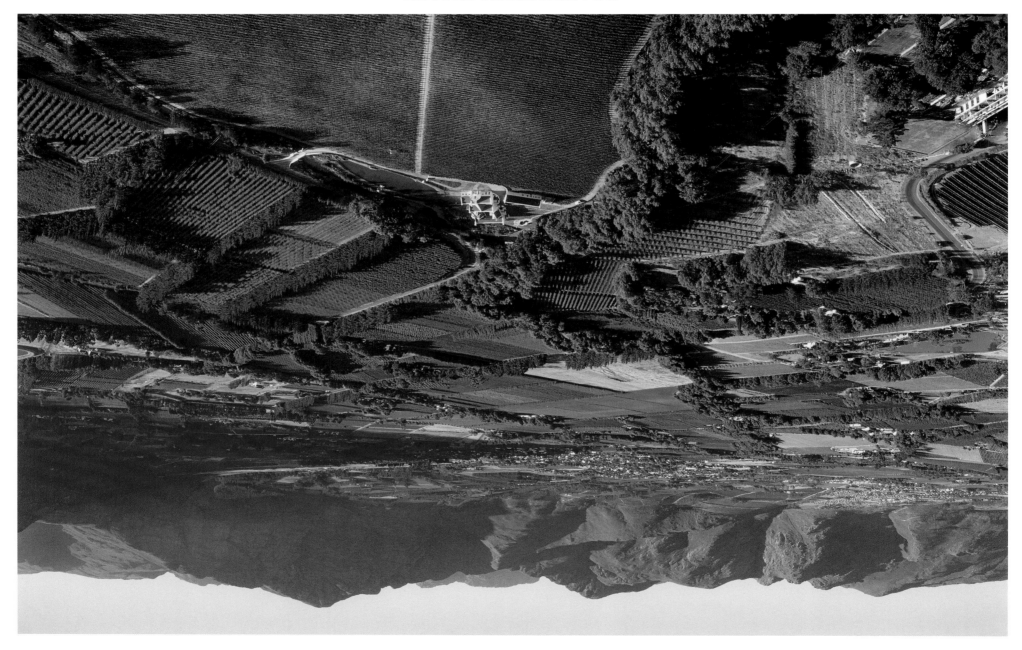

A DAY OF CELEBRATION

Franschhoek celebrates Bastille Day every year in July. It's a festive occasion: balconies are draped in red, white and blue banners and French flags are etched against the winter sky. Visitors and villagers join in the spirit of the festival by wearing berets. The festival is also an opportunity to showcase Franschhoek's culinary skills and famous restaurants. David Hoffman from Le Mouillage Restaurant donned a beret and baked pancakes outside the office of the Franschhoek Wine Valley Tourism Association for the thousands of visitors who attended the weekend festival.

BASTILLE DAY

On Bastille Day boules players gather in Franschhoek to compete for the Bordeaux Street Gallery Floating Trophy. The competition, sponsored by Veuve Clicquot Champagne, attracts teams of experienced players as well as enthusiastic amateurs. The festive day also gives visitors an opportunity to sample the village's great wines, cheeses, olive oils, homemade breads and chocolates in the Food and Wine Marquee to the sound of the La Fromagerie Jazz Band. The Bastille Day festivities include a fly-fishing competition, an exhibition of vintage cars, and a relay race for waiters.

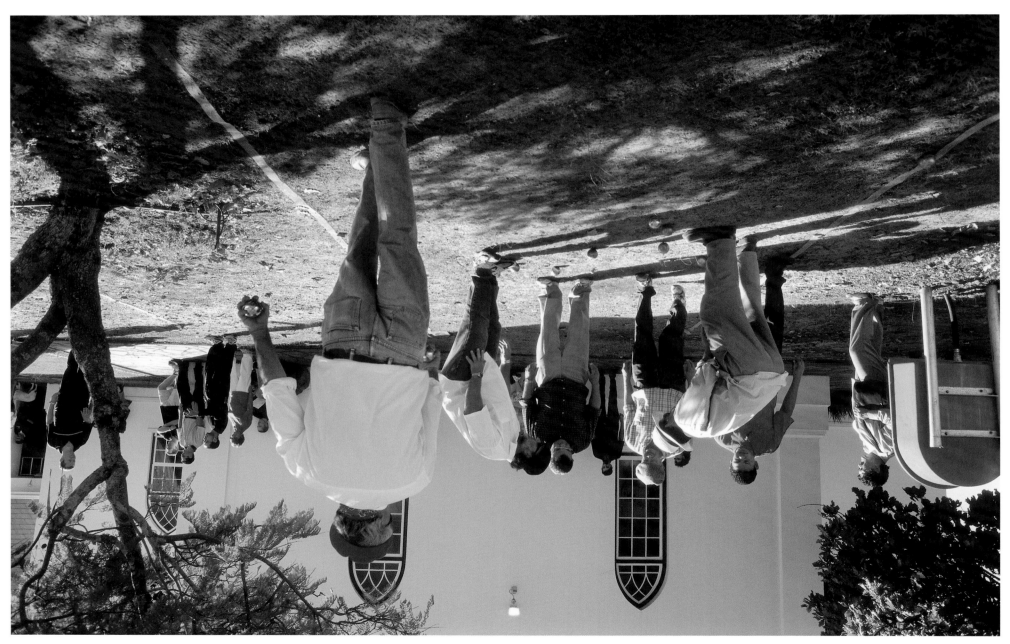

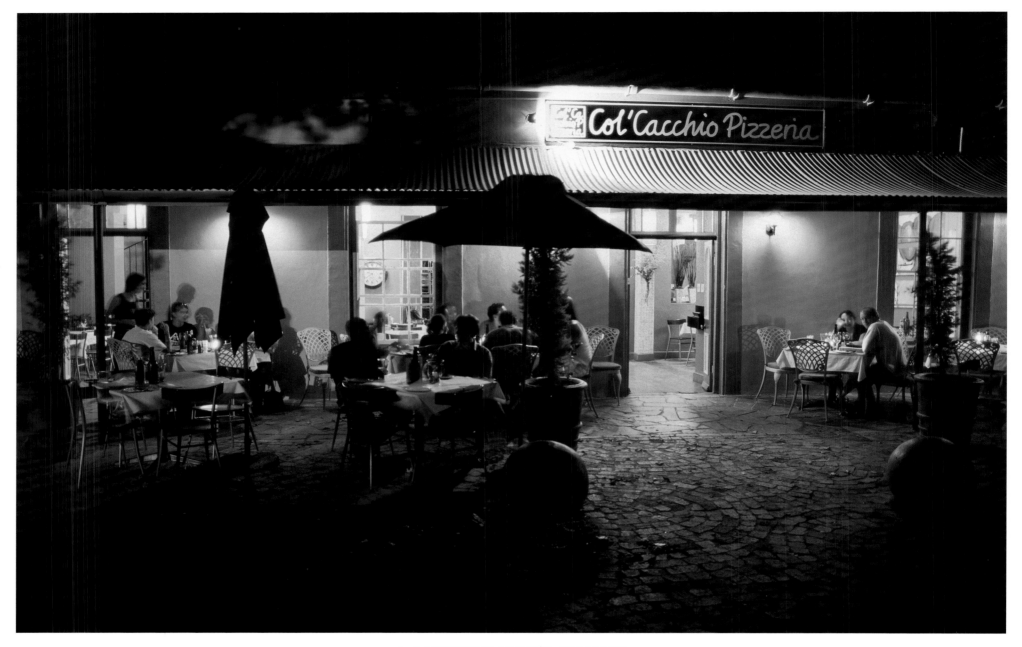

A MIDSUMMER'S NIGHT

Midsummer is peak tourist season in the Cape winelands. While sun-drenched grapes ripen on the vine, tourists suntan on pristine white beaches, join wine-tasting tours through picturesque towns or simply play a round of golf on one of the Cape's outstanding scenic golf courses. Evenings are spent in a leisurely fashion in one of the many restaurants in the region. In towns such as Franschhoek balmy evenings are filled with the soft murmur of voices, laughter and the aroma of good food.

HOSPITALITY IN THE WINELANDS

At sundowner time, Col'Cacchio's cocktail bar opens to serve frozen margaritas, lemon twists and strawberry daiquiris. The winelands' hospitality industry has been growing exponentially as more foreign tourists discover its natural beauty, cuisine and fine wines. The region is steeped in tradition, gracious Cape Dutch manor houses and historic towns, and the atmosphere is vibrant and friendly. During the high season, between September and May, winelands establishments, such as Col'Cacchio, will double their staff to accommodate the influx of visitors.

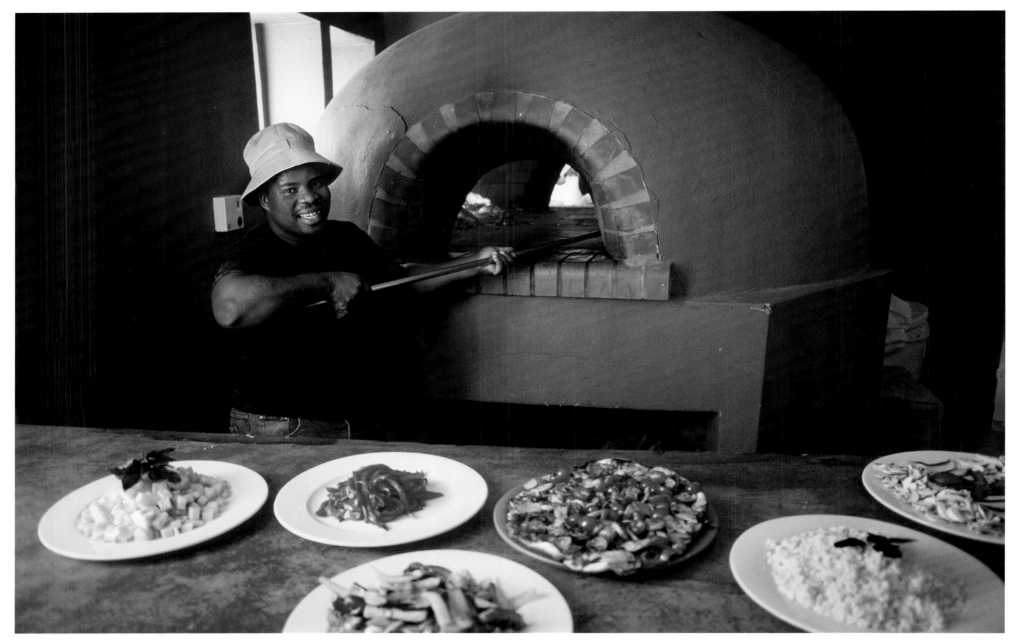

COL'CACCHIO PIZZERIA

The best pizzas are made in a wood-fired oven and have a thin, lightly toasted crust. Toppings can range from the simple *margarita* – mozzarella cheese with tomatoes – to *quattro formaggi* – a mix of mozzarella, gorgonzola, provolone and parmesan cheese – and the elegant *tre colori* – smoked salmon, sour cream and caviar. Pizzas and pastas are possibly Italy's most recognisable export, and popular throughout the world. At Col'Cacchio Pizzeria in Franschhoek, pizza makers are trained for a year to make Italy's signature dish. Making, turning and browning the flat bread in a wood-fired oven takes a great deal of concentration. A skilled pizza maker can turn out 200 pizzas in a single evening.

SOUTH AFRICA'S GOURMET CAPITAL

The Franschhoek experience has become synonymous with good food and wine, and the town is host to some of the best restaurants in the country. There are some 28 restaurants in Franschhoek, many of which jostle with pubs and galleries for position along the town's busy main street. The town caters for every whim and taste, from casual, rural hospitality to fine dining that would satisfy the most fastidious gourmands, all complemented by the finest of local wines. There are also specialist shops such as a *fromagerie*, which offers a fine selection of local cheeses, and a chocolate shop where handcrafted chocolates are made.

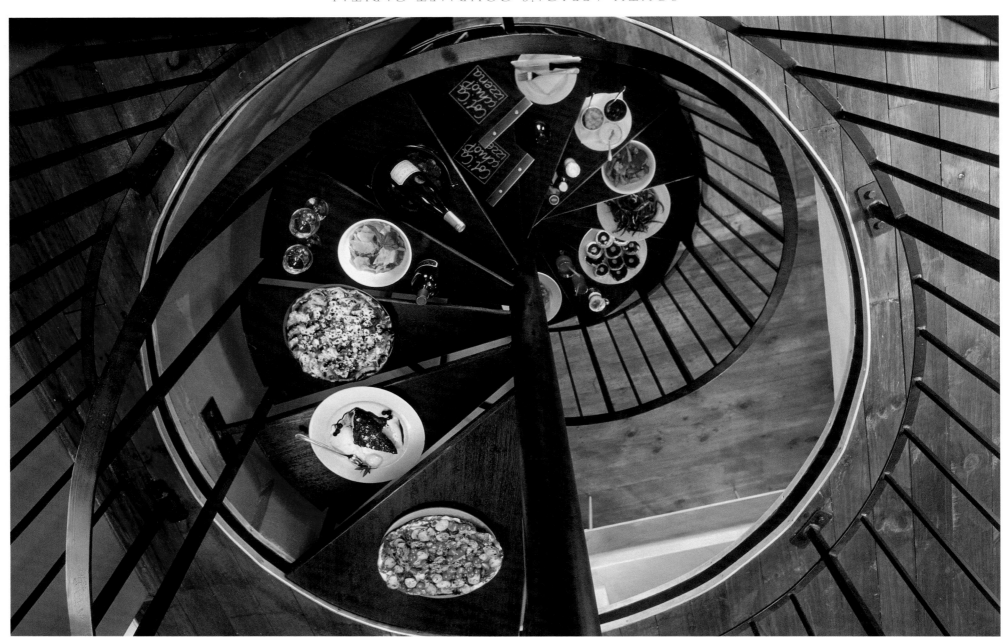

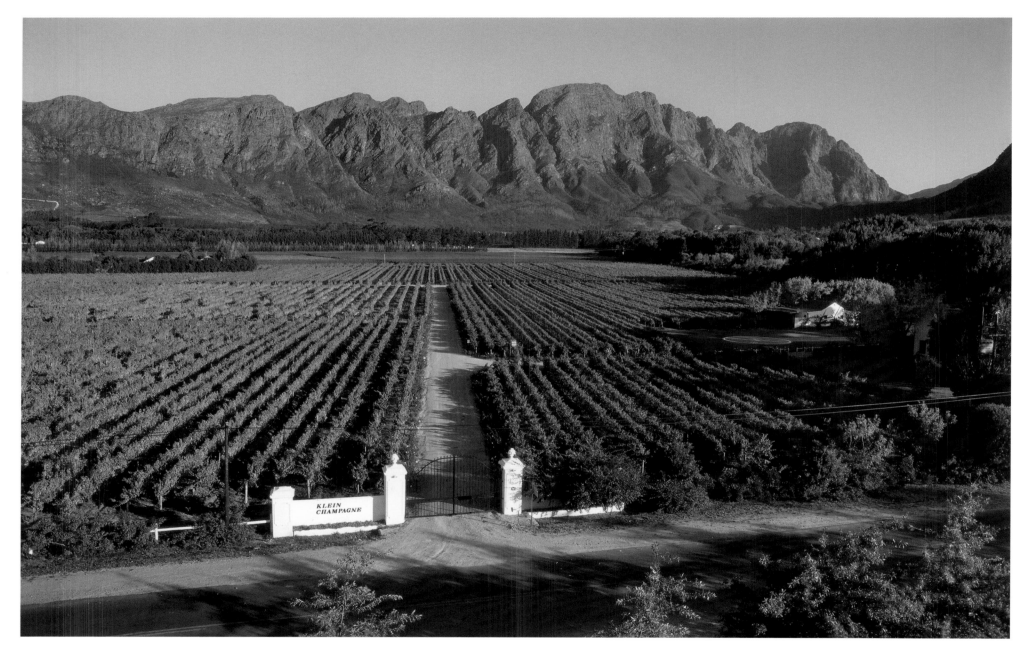

KLEIN CHAMPAGNE

When Mike and Sabine Bosman moved to their farm Klein Champagne in 2002, they made an unexpected discovery. They knew that the original farm, known as Champagne, was granted to Abraham de Villiers in 1694. What they did not expect to find was a Bosman connection. In 1707 De Villiers invited the Drakenstein district's young sick-comforter, Hermanus Bosman – the first Bosman to settle in South Africa – to live with him and his family. Predictably, Bosman fell in love with De Villiers' daughter Elizabeth and married her shortly afterwards. During this time, Bosman applied for a land grant close to his new church – the site of the present-day Strooidak Church in Paarl. His farm De Nieuwe Plantatie is now home to the Grande Roche Hotel.

LA BRIE

In Franschhoek the vineyards thrive in the hot summers tempered by the cool, moist air that billows over the mountains when the Southeaster – fondly referred to as the Cape Doctor – blows. The red wines produced in this cooler climate are more elegant in structure. La Brie was originally cultivated by French Huguenot Jacques de Villiers and today wine varieties such as Sauvignon Blanc and Sémillon continue to thrive on the farm. A vine census done in 1822 showed that 93 per cent of all plantings were Sémillon. Locally, the varietal is known as *groendruif* (green grapes) – a reference to its light green foliage during spring. La Brie still retains a vineyard of 100-year-old Sémillon bush vines.

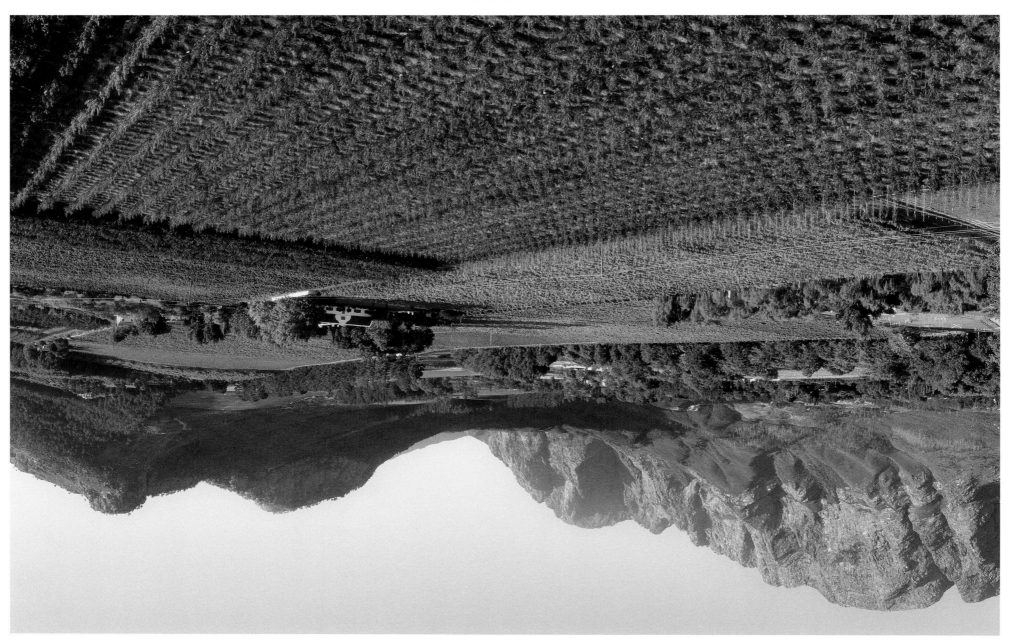

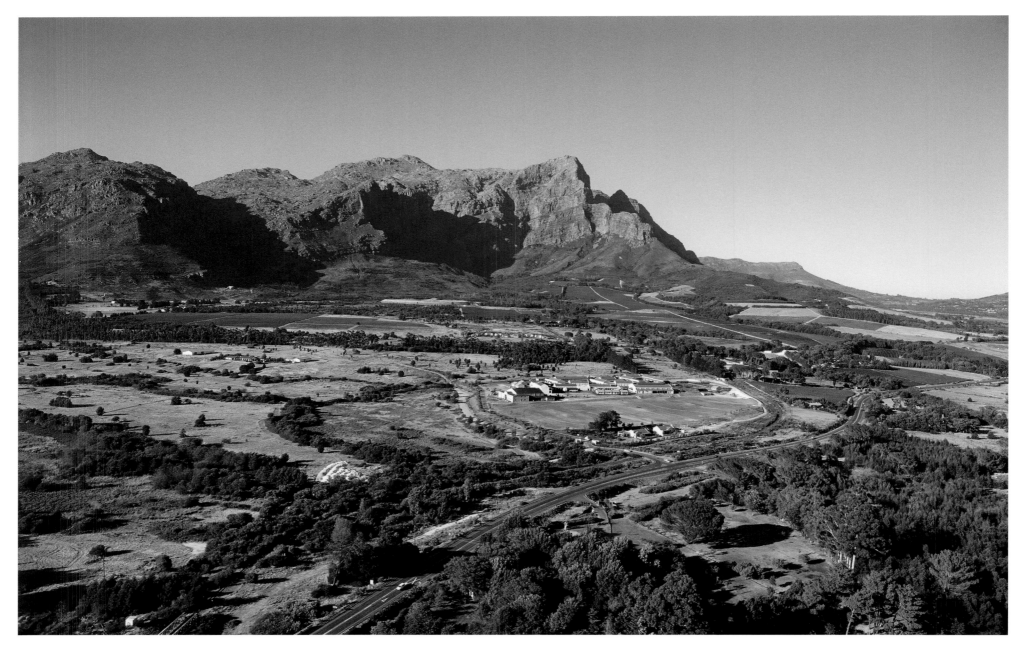

BRIDGE HOUSE

From Franschhoek in the south to Wellington further north, the Drakenstein Valley takes pride in the fact that some of the best schools in the Cape lie within its boundaries. Bridge House School in Franschhoek is one of the new additions to this list of schools. The school is set against the rural backdrop of towering mountains and vineyards. Bridge House is flanked by historic wine farms such as Bellingham, and was built on land donated by Waterfall Farm. The first phase of the building project was completed in July 1998.

LA RESIDENCE

La Residence is a magnificent boutique hotel situated on the private wine and olive estate of Domaine des Anges (Estate of Angels) near the village of Franschhoek. It started off as a private residence for the owners, Phil and Liz Biden. When they bought the property, they set about converting an old fruit-packing shed into a gracious home. Further extensions followed the renovations, and soon the building evolved into its current form. The property has retained the intimacy of a private residence and a secluded retreat.

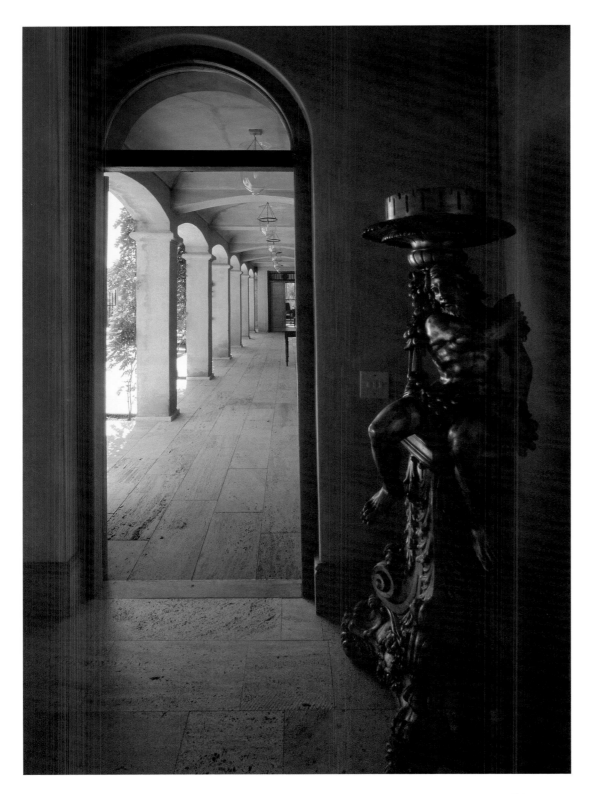

A TRANQUIL HAVEN

The villa La Residence exudes an atmosphere of Tuscan romance and tranquillity. The light is the colour of sandstone, and the interior suggests quiet opulence. The air is filled with the scent of lavender and crushed olives. The doorway, guarded by a tall gilded wooden statue, leads from La Residence's sitting-room to the courtyard. The distance hints at Domaine des Anges' vineyards and olive trees.

LUNCH AMONG THE VINES

In the summer, lunch at La Résidence is often alfresco, with olive trees, rows of lavender and lush vineyards forming a perfect backdrop. The Mediterranean climate provides an abundance of fresh fruit and vegetables, wines and olive oils from nearby estates, cheeses, organic herbs, pickles and smoked salmon trout.

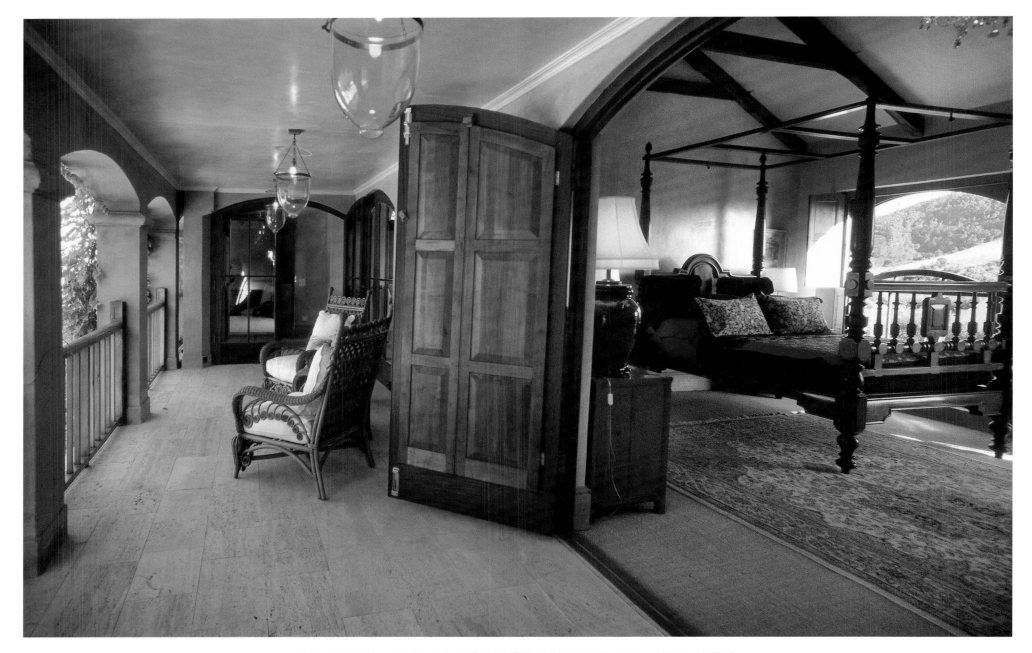

LUXURY AND ELEGANCE IN THE WINELANDS

The main suite at La Residence is upstairs and looks down onto the swimming pool and courtyard. The rooms are individually decorated with an eclectic mix of Eastern furniture, Persian rugs, Victorian-style baths and French antiques to create an atmosphere of French colonial elegance. The villa is small and exclusive, and guests are generally families or groups of friends travelling together, who often book the whole house. The guests are mainly from the United States and the United Kingdom, but there is the usual mix of German, French, Swiss and Italian visitors.

COUNTRY RETREAT

At night the lights of La Residence's five luxury suites are reflected in the courtyard swimming pool, creating an intimate ambience. In ancient mythology life emerged from the primal waters. This creative energy was honoured by placing a bowl of water in the home, or a fountain in a courtyard. La Residence's tranquil pool evokes the healing and restorative powers of water.

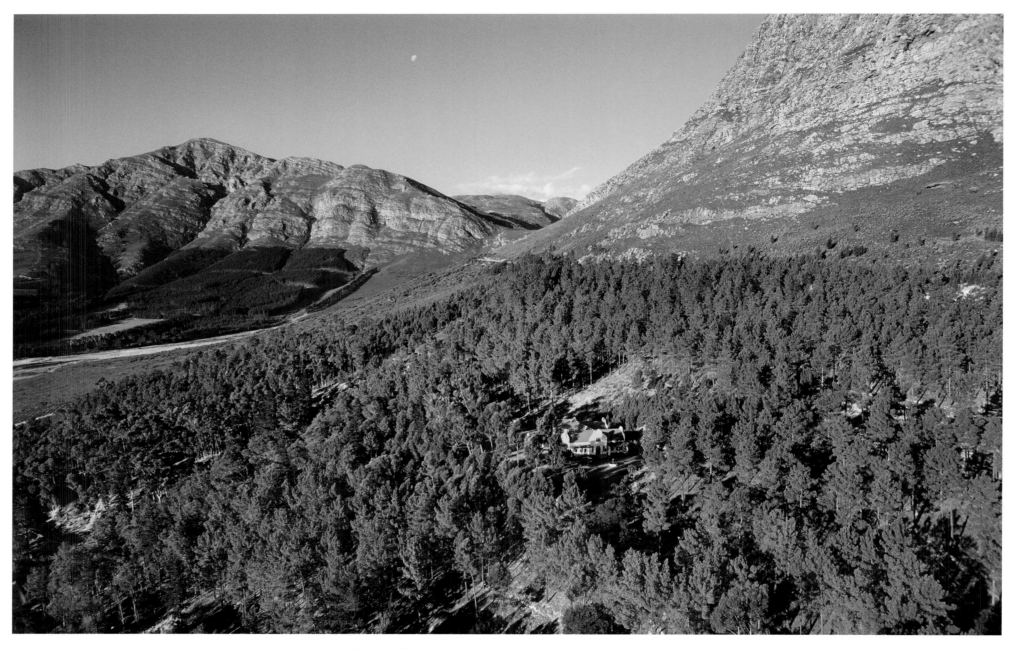

FRANSCHHOEK WATER COMPANY

The Franschhoek Water Company sources its water from a natural spring on its L'Aubade Estate. The spring was used by the early settlers, following an old elephant track out of the valley. Artefacts found in the area suggest that the spring was an ideal place to water animals and to repack ox-wagons for the slow and arduous trek across the mountain. The spring was rediscovered while preparing the foundations for a residential development in the late 1980s. The Franschhoek Water Company became the first in Franschhoek and one of the first in South Africa to bottle water at source. The property now belongs to an Austrian investor, who also has an interest in other properties in the valley including Montmartre, La Couronne and Normandie.

CULINARY WEALTH OF THE WINELANDS

The restaurants and vineyards of Franschhoek reflect the town's French roots. Many of South Africa's finest restaurants and hotels are here at the foothills of the Franschhoek Mountains. The Mediterranean climate is also conducive to olive production, cheese making and, of course, the creation of excellent wines. Balmy summer evenings or crisp winter days, the Franschhoek experience always includes a meal and a bottle of good wine in a great country setting.

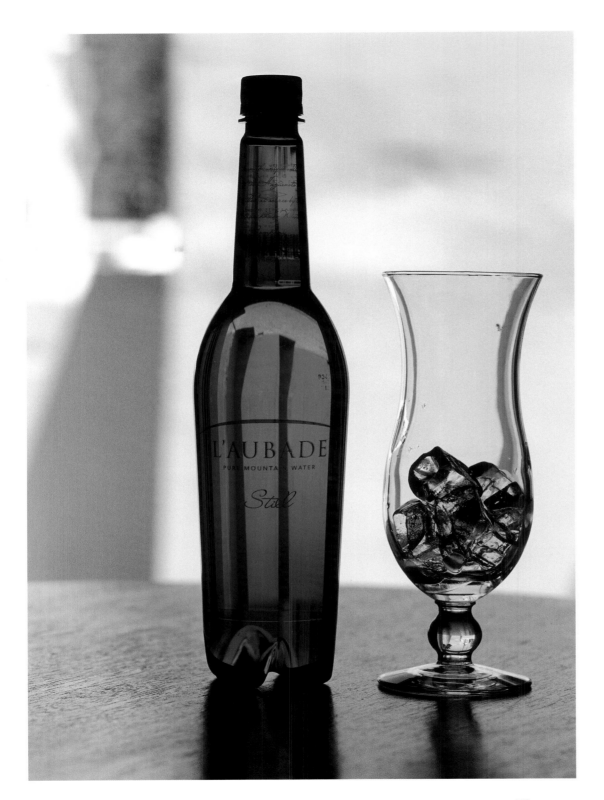

BOTTLED AT SOURCE

The winter rains in the Cape winelands sometimes fall in drifts of grey mist; on other days the rain arrives on the back of a strong north-westerly that lashes and blasts through oak avenues and lime-washed Cape Dutch homesteads. The retreating winter leaves the mountains covered in snow. Rivulets of melting snow and rainwater find their way through layers of sandstone – nature's own filtration system – into deep, mysterious underground caverns and streams. Sometimes the water resurfaces as spring water. The L'Aubade water is collected in the Mont Rochelle Nature Reserve catchment area, and is bottled on the slopes of the Franschhoek Mountains. The mineral water market has grown apace and in South Africa there are more than 200 competing brands.

TURNING WATER INTO WINE

A visitor to the magical village of Franschhoek might well think the small town in the Drakenstein Valley has found a means of turning water into wine. Its crystal clear spring water is as famous as the liquid gold created by local wineries, some of which rank among the best in the Cape winelands. During Franschhoek's annual Bastille Day festivities, local spring water merchants sell bottled water, including the Franschhoek Water Company's famous pure mountain water, L'Aubade, while the town's wineries entice visitors to sample their best vintages.

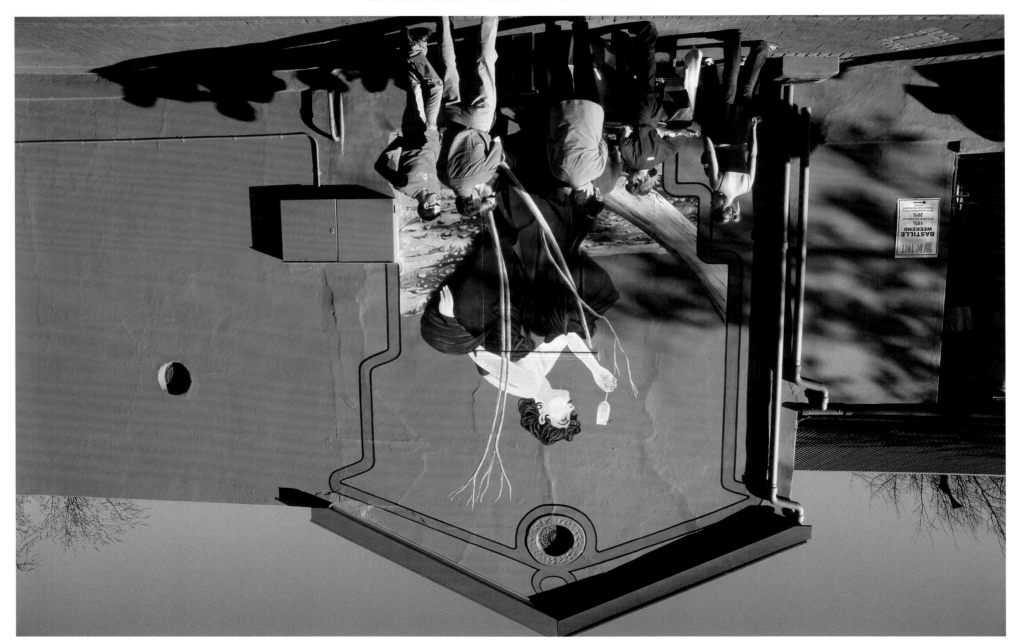

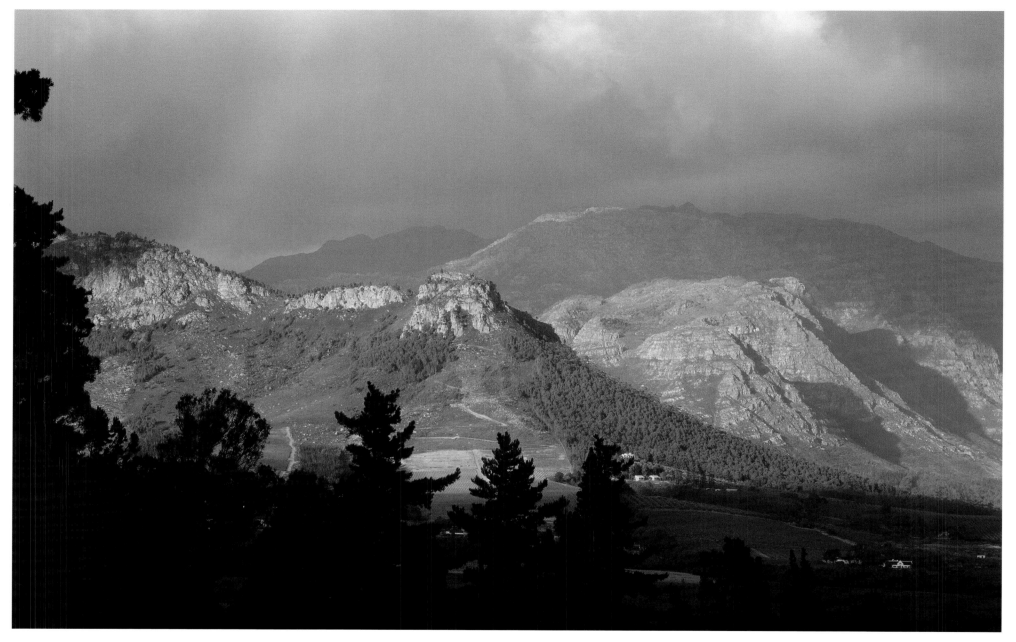

FRANSCHHOEK MOUNTAINS FROM MONTMARTRE'S LODGES

The early inhabitants of the Cape used an elephant path to cross the Franschhoek Mountains into the interior by foot or on horseback. Attempts to create a safe passage across the mountains failed until the 1820s when the colonial government finally decided to construct a pass. Two companies of soldiers from the Royal Africa Corps, waiting to be shipped out to Sierra Leone, supplied the labour. The pass was eventually completed in 1825 and was used for almost a hundred years, before it was reconstructed in the 1930s. A bitumen surface was added 30 years later. Franschhoek Pass was the first engineered pass to be built in South Africa and contains the country's oldest stone-arch bridge.

MONTMARTRE LUXURY LODGES

Montmartre's luxury lodges lie on the northern slopes of the Franschhoek Mountains and overlook the Franschhoek Valley. The lodges are at an altitude that make them a cool retreat during the hot summer months; in winter, log fires keep the wooden cabins warm and cosy. Montmartre is ideally suited to the needs of the fly-fishing enthusiast – the dam near the lodges is well stocked with trout.

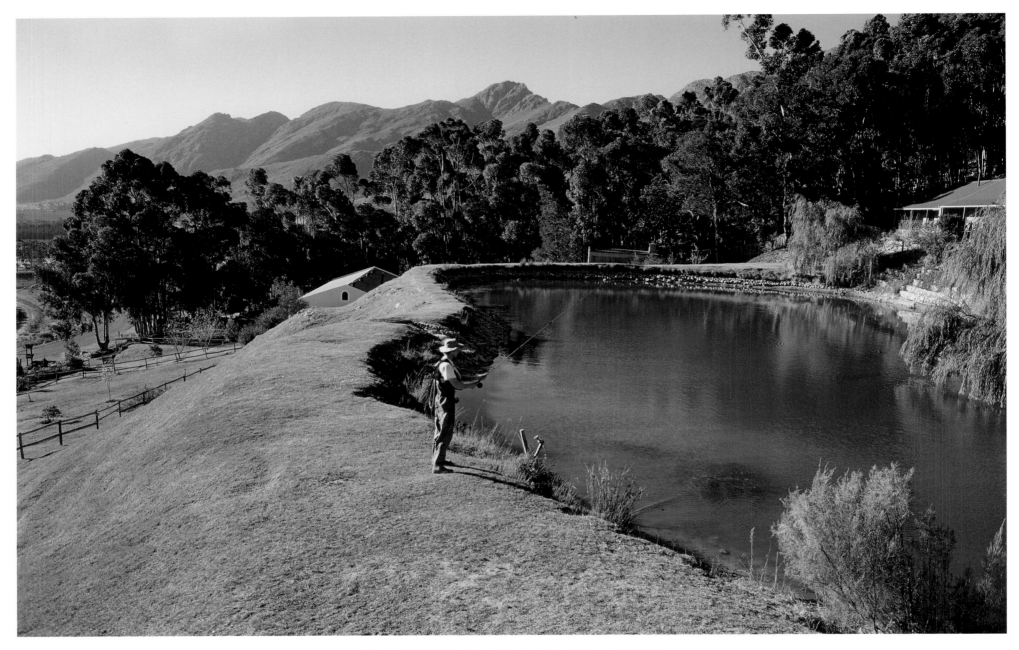

FLY FISHING AT MONTMARTRE

In July, fishing enthusiasts and Francophiles head towards Franschhoek for two big events on the town's calendar – the annual Fly-fishing Festival and the Bastille Day celebrations. Dams – such as this one at Montmatre – are stocked with tagged and untagged rainbow trout. Each day participants are allowed to choose two fishing venues – one for the morning and one for the afternoon. Those lucky enough to land a tagged fish become eligible for the day's prize. Franschhoek's cool climate and crystal clear mountain water have made it ideally suited to trout farming. Steamed, grilled, seared or smoked, salmon trout is one of Franschhoek's culinary delights.

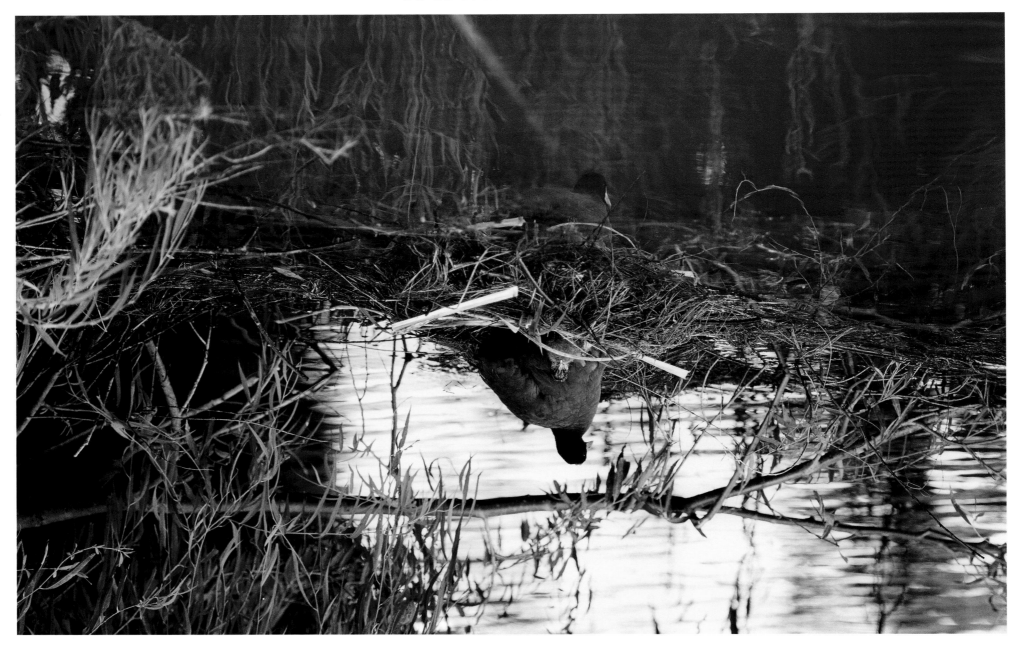

AT THE WATER'S EDGE

The dam near Montmartre's luxury lodges in Franschhoek is home to several species of bird including this red-knobbed coot nesting on a mound of rushes. One of the more common waterfowl, the red-knobbed coot is often seen on lakes and dams and along estuaries in the Western Cape. A female lays between four and six eggs at a time. Once the eggs have hatched, it takes 60 days for the chicks to become fully grown. During this period the adult birds will spend much of their time fending off raptors such as the African fish eagle. The red-knobbed coot is named after the two distinct dull red knobs on its forehead, which become more pronounced during the breeding season.

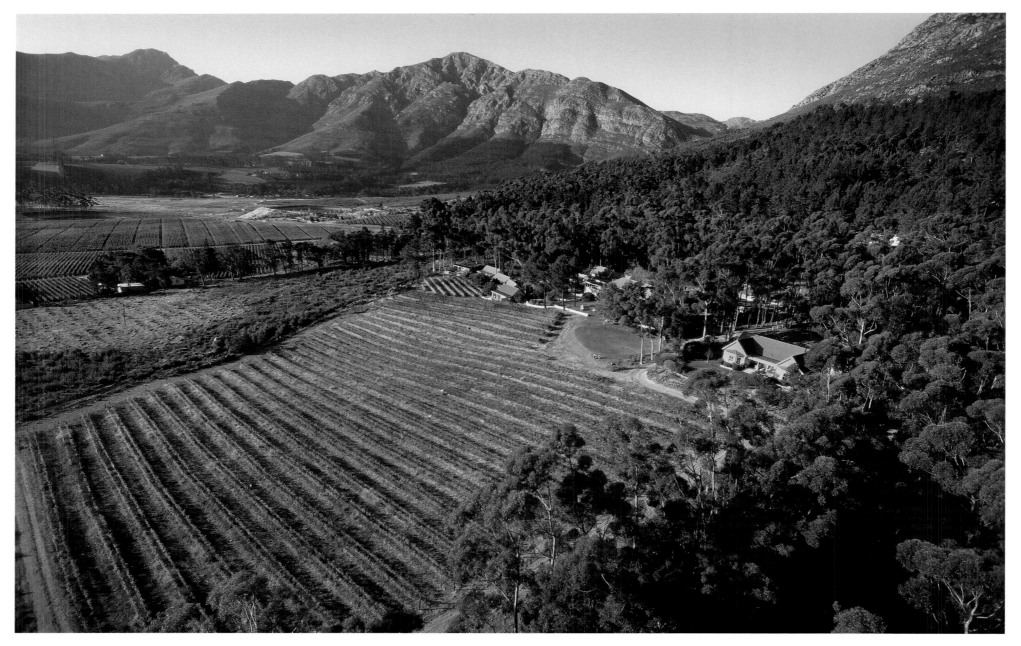

LA PETITE FERME

La Petite Ferme lies midway up the Franschhoek Pass, and from here the view of the undulating hills, orchards and vineyards of Franschhoek is unsurpassed. The restaurant's famous signature dish is whole, de-boned rainbow trout, oak-smoked on the farm. The kitchen sources most of its ingredients locally to create dishes that echo the winelands' Malay and African influences. The farm almost lost its first vintage in a fire that destroyed the restaurant. The winery was saved, which was just as well: the 1996 Sauvignon Blanc and Blanc Fumé wines received gold and double gold at the Veritas Awards wine competition.

LA COURONNE WINE ESTATE

Rural charm, breathtaking views, and superb restaurants have turned the once sleepy little town of Franschhoek into the most sought after real estate in the winelands. The Franschhoek experience is more than just enjoying its superb hotels and restaurants. Horse riding, hiking trails, mountain-bike routes and bird watching give visitors an excellent opportunity to experience the natural beauty of the valley. Situated in this valley is the magnificent La Couronne. The wine farm produces a highly rated Bordeaux-style blend and an award-winning Chardonnay.

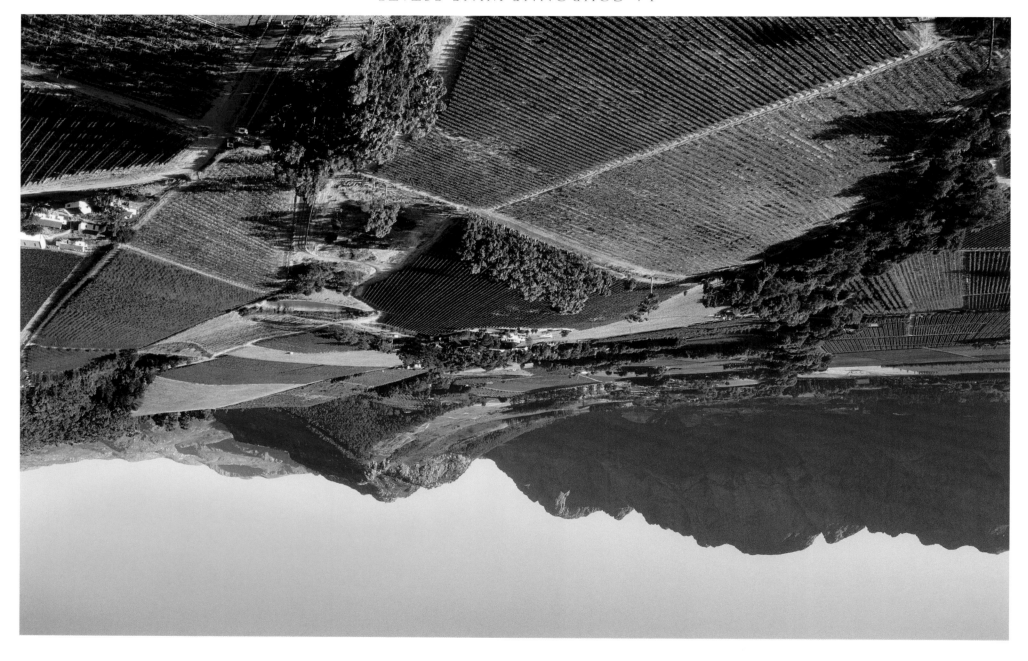

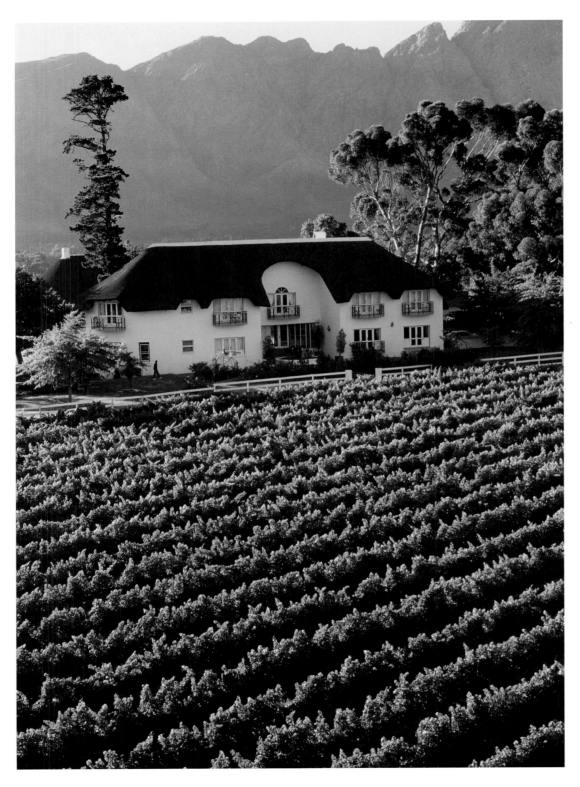

HOTEL IN A VINEYARD

La Couronne Hotel is situated among lush green vineyards on a hill away from the bustle of life. Here the emphasis is on comfort and warm hospitality, in an atmosphere of quiet luxury. The hotel's management staff pride themselves on the fact that guests see the hotel as a rural retreat and usually extend their stay to five days on average.

The hotel is a perfect place to use as a base from which to explore the winelands. Franschhoek is flanked by Stellenbosch and Paarl, and some of the best wine is produced within a short drive from the hotel. For the nature lover, Hermanus is another popular destination, especially during the whale season when large numbers of southern right whales arrive in Walker Bay to calve. Golfing enthusiasts enjoy the fact that there are nine first-rate golf courses within just over an hour's drive of Franschhoek. In Europe they would have had to travel that long just to get to work!

A PROUD HISTORY

La Couronne Wine Estate's history is closely linked to the history of the wine industry at the Cape. La Couronne was originally part of the Huguenot farm Champagne owned by Abraham de Villiers. De Villiers and his two brothers, Pierre and Jacob, arrived at the tail-end of the Dutch emigration policy. The three brothers were highly experienced viticulturists and the authorities hoped that they would be able to improve the general standard of winemaking at the Cape. Today the highly regarded La Couronne wine is produced using state-of-the-art technology.

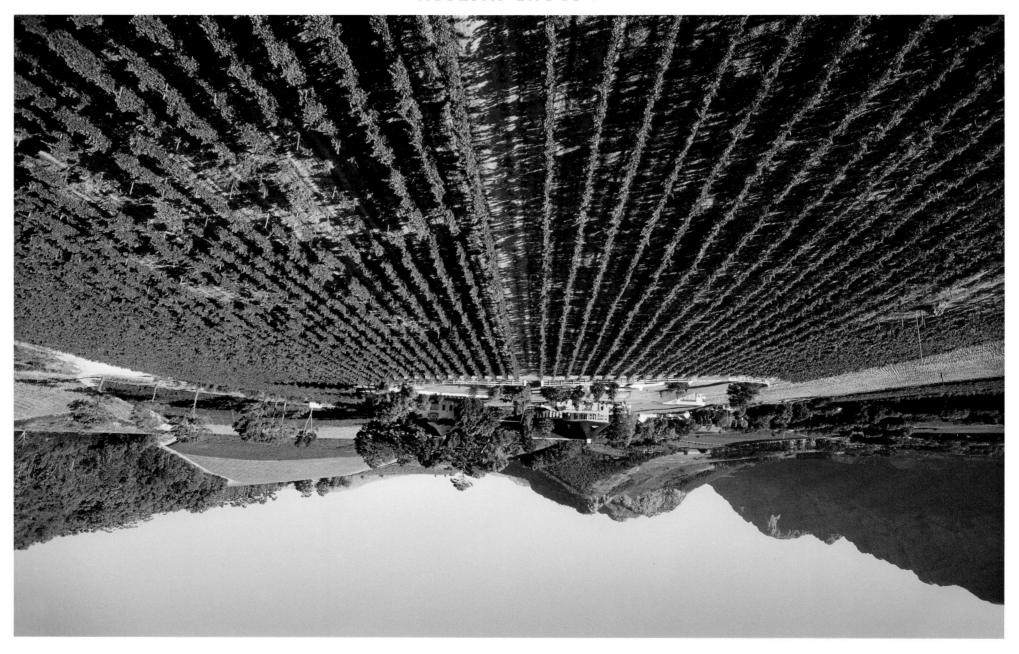

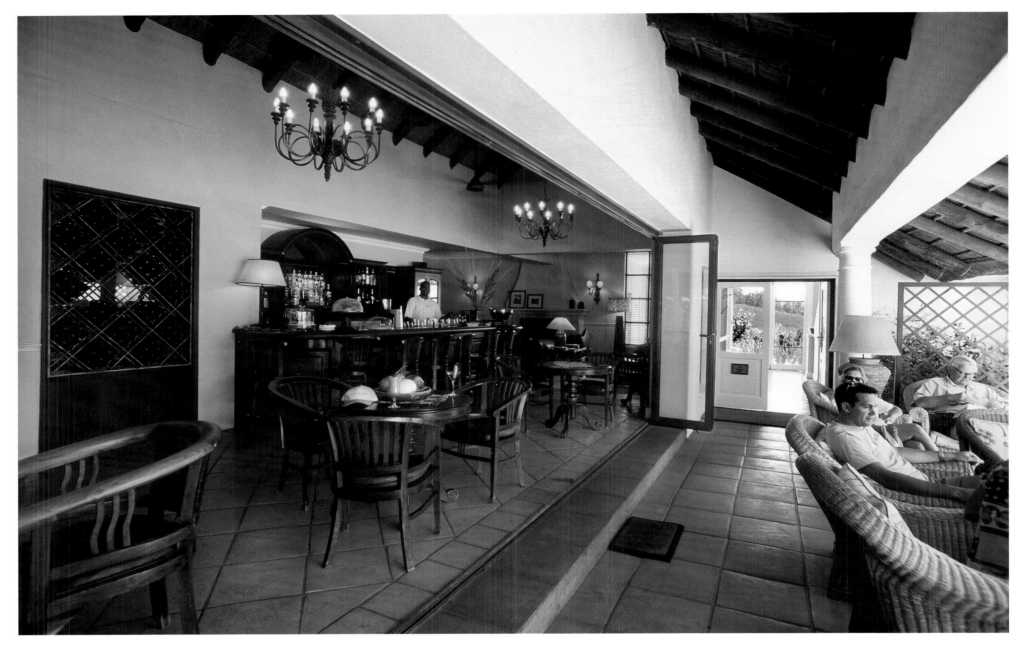

COLONIAL LIVING IN FRANSCHHOEK

La Couronne Hotel's Colonial Wine and Cigar Bar offers guests a view of the picturesque Franschhoek Valley and a quiet venue for a glass of wine, a cocktail or a light lunch, or simply a place to read a newspaper. Today the hotel is surrounded by vineyards, but there was a time during the previous century when tobacco was grown there. Tobacco leaves grown on the farm were used in the then popular brand of cigarettes called 'Cape to Cairo'.

ROOM WITH A VIEW

La Couronne Hotel is situated on a working wine farm, which adds to the ambience of a rural retreat. In summer guests take their meals on the terrace, and in the evening dinner is served to the accompaniment of a classical pianist playing in the background. In winter a crackling fire sets the scene.

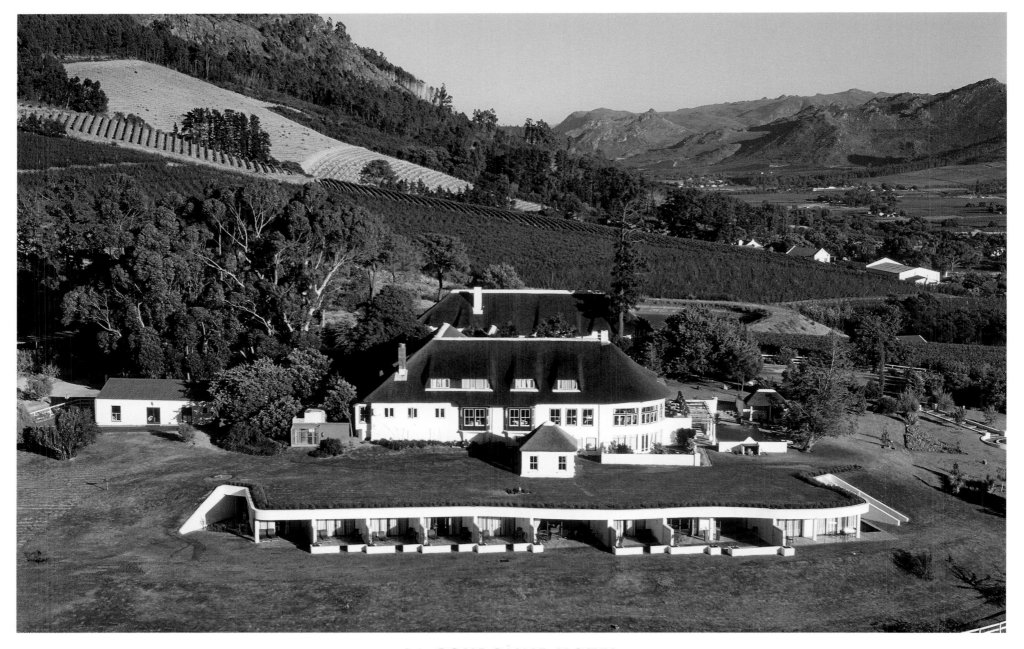

LA COURONNE HOTEL

In 1700 a cairn of stones on the farm marked a beacon that was lit to welcome prominent guests or to announce the arrival of the *dominee* (church minister) to the then remote district. The arrival of the *dominee* was an occasion for settlers, labourers and slaves to gather for prayers and blessings, and a festive opportunity for weddings and christenings. Horses, carts and carriages would all converge on the *werf* (farmyard) for the duration of the visit. La Couronne Hotel continues this tradition of welcoming guests and visitors with typical Cape hospitality.

ZEVENWACHT WINE ESTATE

A duck swims into view in this postcard picture setting of an elegant Cape Dutch manor house against a backdrop of vineyards. Zevenwacht produces the aptly named Zevenwacht Tin Mine Red and Tin Mine White White wines – a reminder of the days when tin and tungsten ore were mined here. The estate's *fromagerie* makes its own traditional English-style cheddar from Friesland milk sourced from a neighbouring farm. Zevenwacht's proximity to Cape Town has made it a popular venue for picnics and wine and cheese tastings, and its restaurant, set in the restored manor house, is an ideal venue for leisurely lunches. The Zevenwacht Country Inn and vineyard cottages provide luxury accommodation for visitors.

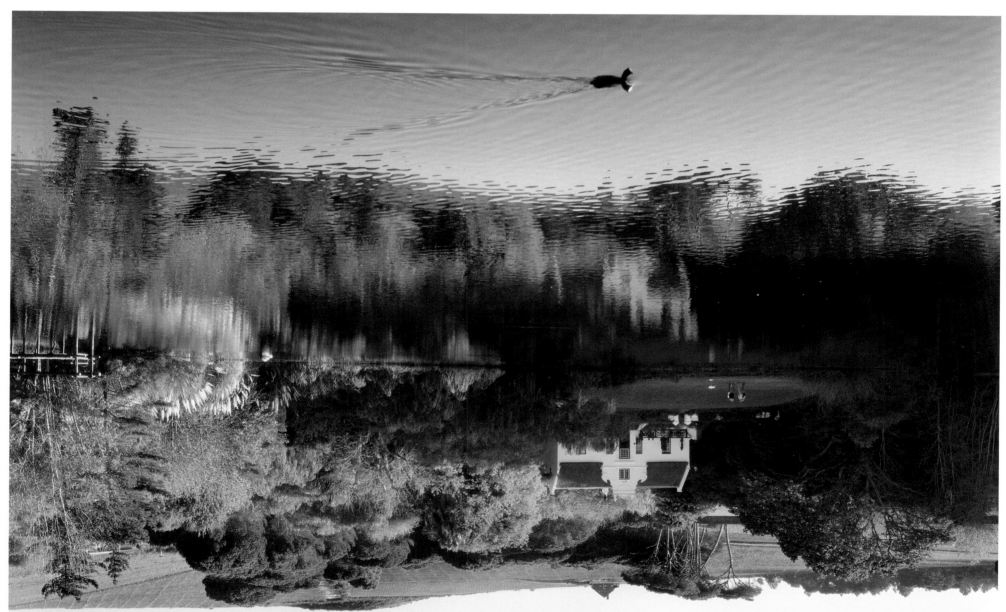

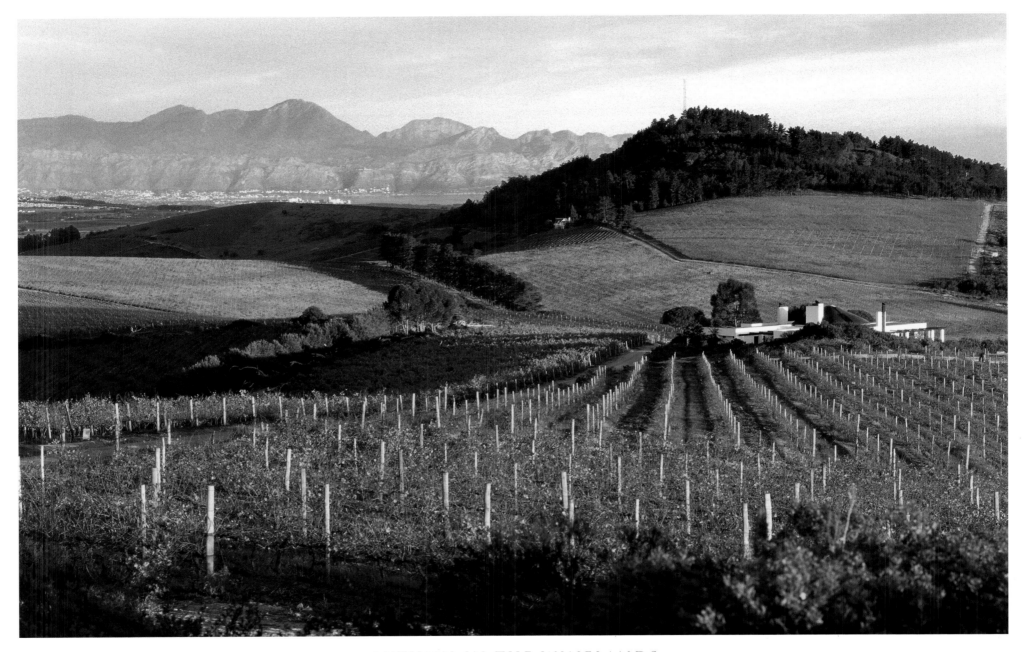

AUTUMN IN THE WINELANDS

In late summer the vineyards of Zevenwacht display their russet symmetry. The vineyards lie on the slopes of the Bottelary Hills midway between Stellenbosch and Cape Town. Bottelary Hills' promixity to both False Bay and Table Bay gives it a cool microclimate, making the area ideal for the production of quality wines. The soils vary from decomposed granite to the Hutton and Clovelly forms.

ZONNEBLOEM

Autumn repaints the landscape in russet and gold. Zonnebloem has a winemaking tradition that dates to the early eighteenth century. In keeping with this tradition, the greater part of the grapes sourced for these fine wines comes from vineyards tended by wine farmers who have been producing grapes for Zonnebloem for over three generations. Produced at wine giant Distell's Adam Tas cellar in Stellenbosch, the current Zonnebloem vintages are styled to be accessible and easy to drink, with a soft palate but structured to show varietal character, and, in the case of the reds, to last for 5 to 10 years. Zonnebloem's white wines are made by Louw Engelbrecht and its reds by Michael Bucholz.

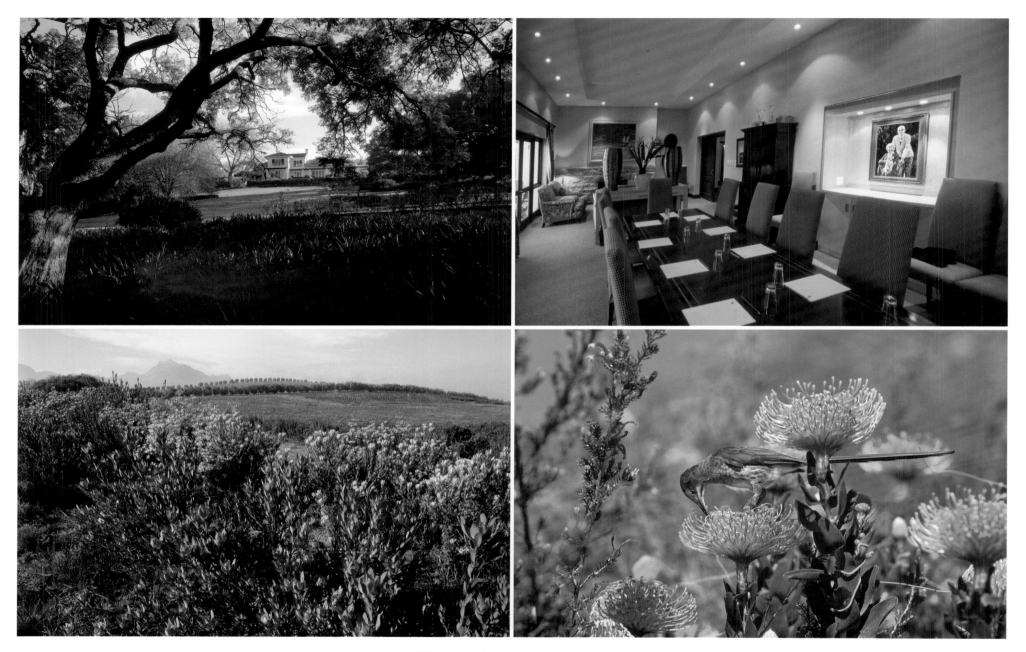

SUGARBIRD MANOR

Sugarbird Manor is a luxurious guesthouse situated on Protea Heights, a protea farm in Devon Valley on the outskirts of Stellenbosch. The farm has plantations of indigenous *fynbos* which is harvested for the export market. The guesthouse is aptly named as the flowering proteas attract many Cape sugarbirds to the area. These birds feed off the nectar of the flowers while at the same time pollinating the proteas. Sugarbird Manor is situated on property that was donated to World Wildlife Foundation (SA) and guests contribute to the organisation's conservation activities while enjoying the splendour of the Devon Valley.

DE VINE RUN

The Devon Valley De Vine Run is organised by the Devon Valley Vintners Association and takes place in March after the summer harvest. The House of JC Le Roux – a cellar noted for its sparkling wines – is one of the main sponsors of this annual 16-kilometre race through the vineyards of seven wine estates in the valley near Stellenbosch. Whether sporting a wig, a tutu or a butterfly disguise, or dressed as a bunch of grapes, participants are encouraged to bring their sense of fun along with their athletic prowess and to colour the winding tracks of the Cape winelands' best-kept secret with a kaleidoscope of amusing outfits. As one winemaker commented, 'The only serious thing about the event lies in the quality of the wines.'

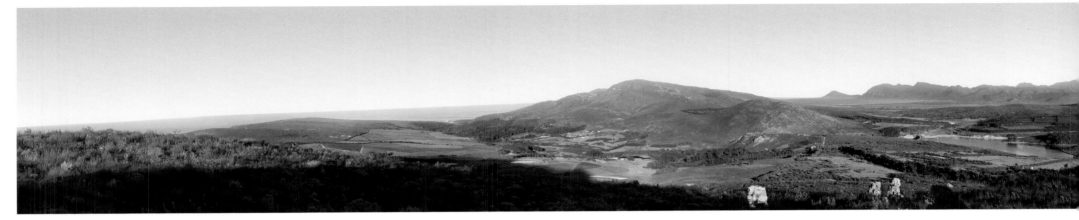

The Hemel-en-Aarde Valley, Hermanus, is home to the renowned Newton Johnson Wines.

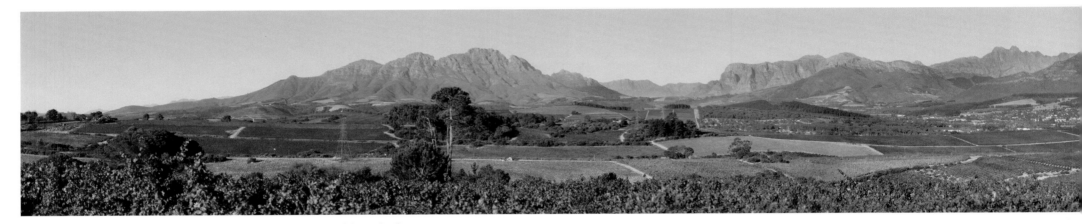

A commanding view from the beautiful historic Neethlingshof Wine Estate.

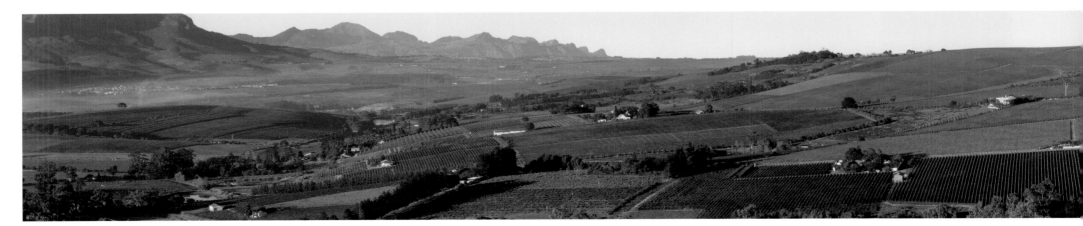

Devon Valley Hotel, renowned for its extraordinary vista.

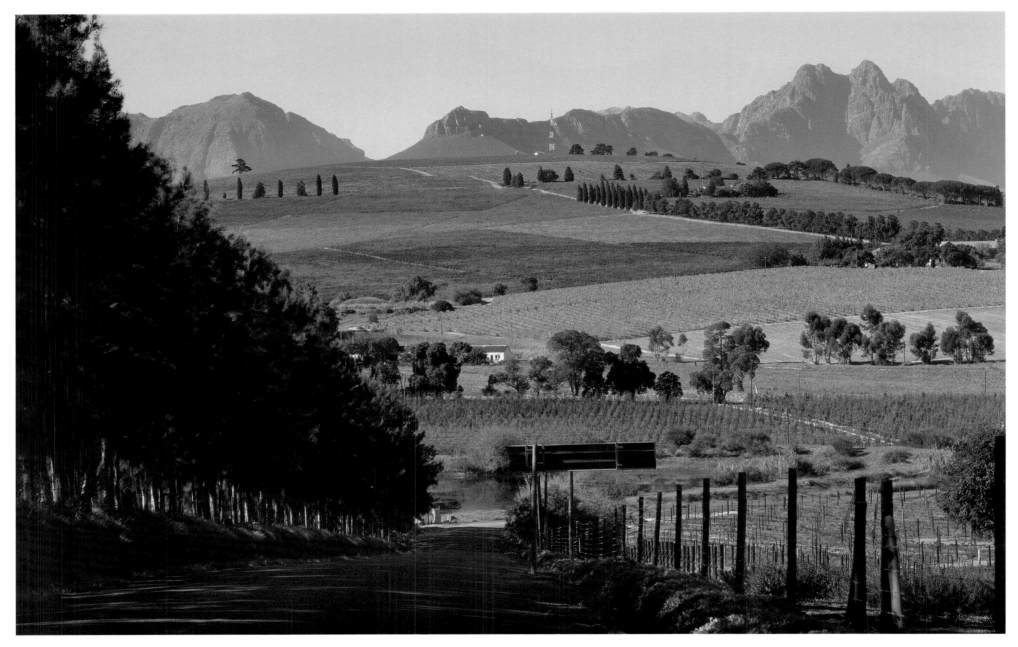

CLOS MALVERNE

In the heart of Stellenbosch's Devon Valley, red wine terroir par excellence, lies Clos Malverne. Here Seymour and Sophia Pritchard have devoted the past couple of decades to championing South Africa's endemic Pinotage grape, as an award-winning single-varietal wine and as a partner, with classic Bordeaux varieties Cabernet Sauvignon and Merlot, in their interpretation of what constitutes a traditional Cape red blend. Vines grow in deep, red clay Hutton soils on slopes facing the far-flung Helderberg mountain range. The valley's relatively cool microclimate results in fruit that is naturally well-ripened. Winemaking methods are traditional: grapes are gently basket-pressed and fermented in open tanks. Wines are matured in French and American oak barrels.

BOTTLED POETRY

The sun rises over Devon Valley and brings into focus the slow dance of terroir and vine. 'So, bit by bit, they grope for their Clos Vougeot and Lafite. Those lodes and pockets of earth, more precious than the precious ores, that yield inimitable fragrance and soft fire; those virtuous Bonanzas, where the soil has sublimated under sun and stars to something finer, and the wine is bottled poetry…' So wrote Robert Louis Stevenson (1850–1894) in *The Silverado Squatters*. Stevenson wrote about California, but it would be equally applicable to the winelands of the Cape where every winemaker is in search of that Holy Grail: the perfect wine.

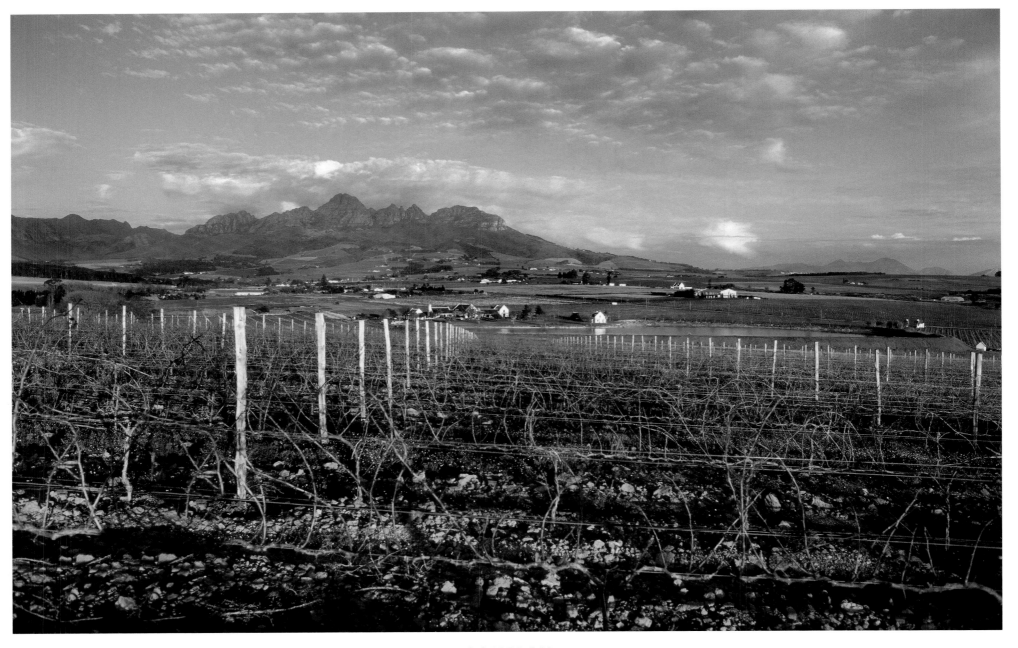

SOVERBY

The late afternoon sun casts a glowing shadow over Soverby's vineyards. The farm lies on the Annandale Road in Lynedoch on the outskirts of Stellenbosch. Gielie Hanekom bought the farm in 1988 and converted the old stable into a guesthouse with eight rooms. The stable dates to 1907 and was originally part of an old wine cellar. The farm dam is stocked with bream for anglers, and three self-catering cottages overlooking the dam provide a quiet retreat from the hustle and bustle of city life.

DOMBEYA VINEYARDS

Dombeya Vineyards lies at the foothills of the Helderberg. The farm is well known for its spinning, knitting and weaving workshop. Wool, mohair and cotton yarns are carded, spun and dyed on the premises and are used to make items such as jerseys, bags and throws. The workshop, managed by Pippa Pietersen (seen here), attracts many visitors every year. Guests can enjoy a delicious lunch or relax over tea at Dombeya's Vineyard Kitchen Restaurant. Excellent Chardonnay and Sauvignon Blanc wines are available from the farm. Red wines are due to be released in 2006.

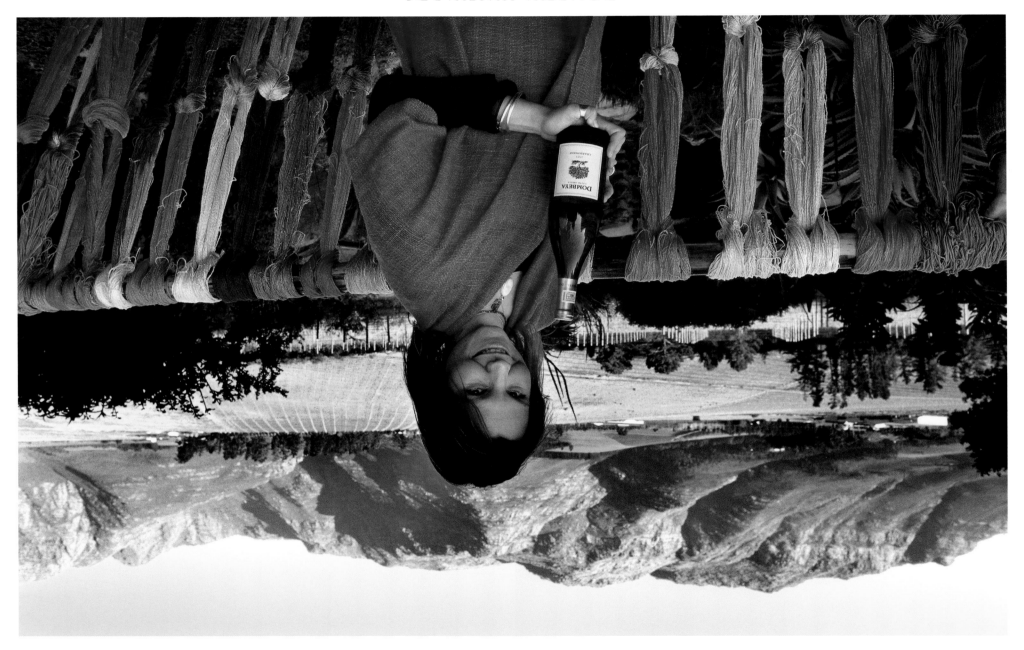

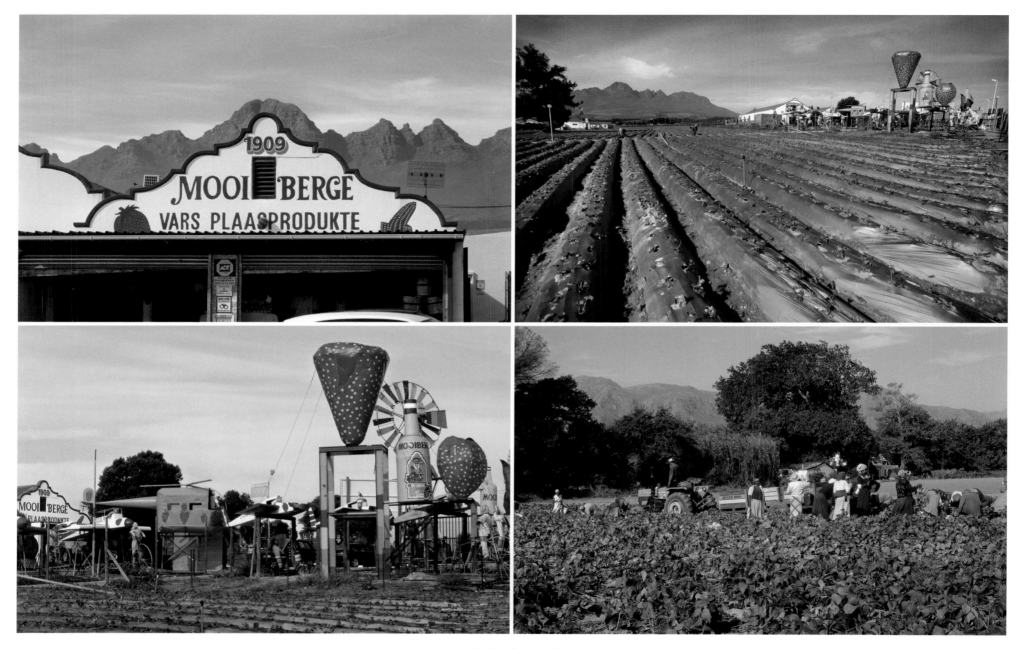

MOOIBERGE

The gable of the Mooiberge farmstall outside Stellenbosch takes the form of one of the peaks of the distant Stellenbosch Mountains. Mooiberge is surrounded by strawberry fields, and has become famous for the lifelike scarecrows that appear during the strawberry season to chase off marauding birds. In early summer, crowds of scarecrows appear to walk the fields, pushing wheelbarrows or picking strawberries. The scarecrows are made and repaired by the farm workers during the off-season. Over the years, bicycles, aeroplanes and giant strawberries made from recycled metal have been added to the colourful display. The Mooiberge shelves are filled with fresh produce, dried fruit and nuts. In the adjacent wine shop, bottles of strawberry liqueur are framed in the fire-engine-red door of an old cement wine tank.

STRAWBERRY LIQUEUR

In the low light of the cellar, a copper potstill gleams with the pink undertones of strawberries. Mooiberge strawberry liqueur is distilled from fruit grown in the surrounding fields. Owners of a number of farms in the Stellenbosch area, the Zetler brothers are one of the largest strawberry producers in the country. Strawberries are grown in the open and in tunnels and, through a careful selection of cultivars, are produced for 11 months of the year. Fresh strawberries are packed for the local and export markets, and more than 3 500 tons are frozen each year. Some of the strawberries are distilled into strawberry liqueur, and a range of kosher liqueur is produced for the export market.

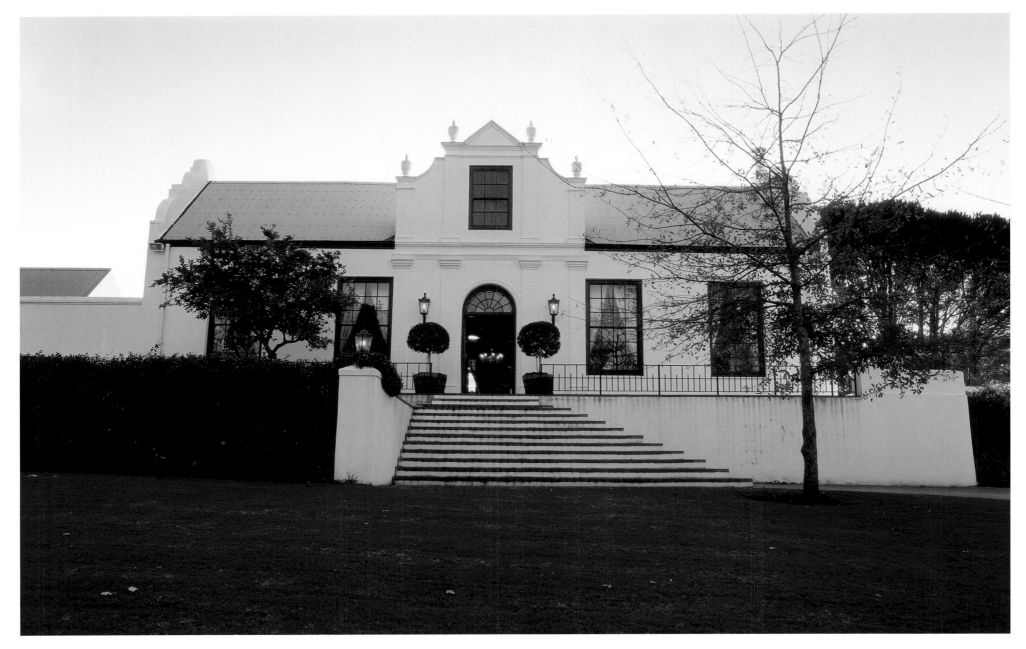

LE BONHEUR ESTATE

Le Bonheur Estate lies on the slopes of Klapmuts Hill in the Stellenbosch district. In the past the farm was at an important junction, and travellers on their way to Paarl, Stellenbosch, Malmesbury or Cape Town would stop at the freshwater spring to rest their horses and oxen. The homestead is a classic example of an early nineteenth-century H-shaped Cape Dutch manor house. The estate has 65 hectares of vines in production of which most are planted on north-facing slopes at altitudes of between 200 and 350 metres above sea level. Plantings include top-performing Cabernet Sauvignon, Merlot, Chardonnay and Sauvignon Blanc varietals.

UITKYK

Uitkyk (literally, 'lookout') lies on the south-western slopes of the Simonsberg and was first allocated in 1712. The farm came into prominence in 1776 when it was bought by Martin Melck, one of the wealthiest landowners at the Cape. Melck owned other farms including Elsenburg and Kanonkop. His son-in-law Johan Beyers had the manor house rebuilt in 1788 and added a neo-classical Georgian façade with a moulded triangular pediment, unique in style among the wine farms of the Cape. The new building was possibly the work of the highly fashionable French architect Louis Michel Thibault. Uitkyk is renowned for its fine brandy and exciting range of boutique wines.

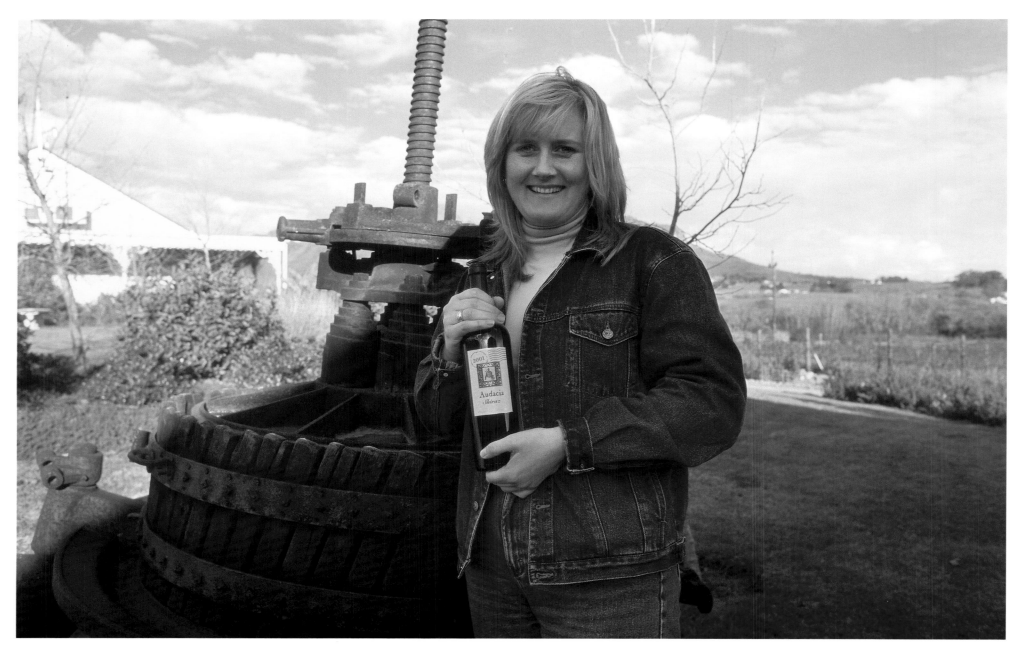

AUDACIA

Audacia, a boutique red-wine winery, is situated on the cool, southern slopes of the Helderberg in Stellenbosch's elite wine-growing area known as the 'Golden Triangle'. It has 20 hectares under cultivation, and varietals include Cabernet Sauvignon, Shiraz, Merlot, Cabernet Franc, Petit Verdot, Roobernet and Malbec. The winery's output is bought by an exclusive list of restaurants. Audacia's focus is firmly set on producing quality wines and the grapes are hand-picked, fermented in small seven-ton tanks and aged in 300-litre casks – primarily French oak. Elsa Carstens, who obtained her masters degree in wine microbiology from Stellenbosch University and lectured at Elsenburg Agricultural College, is the creative force behind the success of Audacia wines.

STELLENZICHT ESTATE

Stellenzicht Estate's assistant winemaker, Ilse van Dyk, is part of the estate's prize-winning team led by winemaker Guy Webber. Stellenzicht is one of the leading Shiraz producers in the Cape winelands and makes an award-winning Syrah from a sloping vineyard on a north-western hill the winemaker fondly refers to as Plum Pudding Hill. Stellenzicht lies within sight of the cool Atlantic Ocean and its 123-hectare vineyards have been planted at an altitude of between 100 and 400 metres on the slopes of the Helderberg on the outskirts of Stellenbosch. The original farm dates to 1692 and was once part of the farm Rustenburg. Stellenzicht also produces highly regarded Sémillon wines.

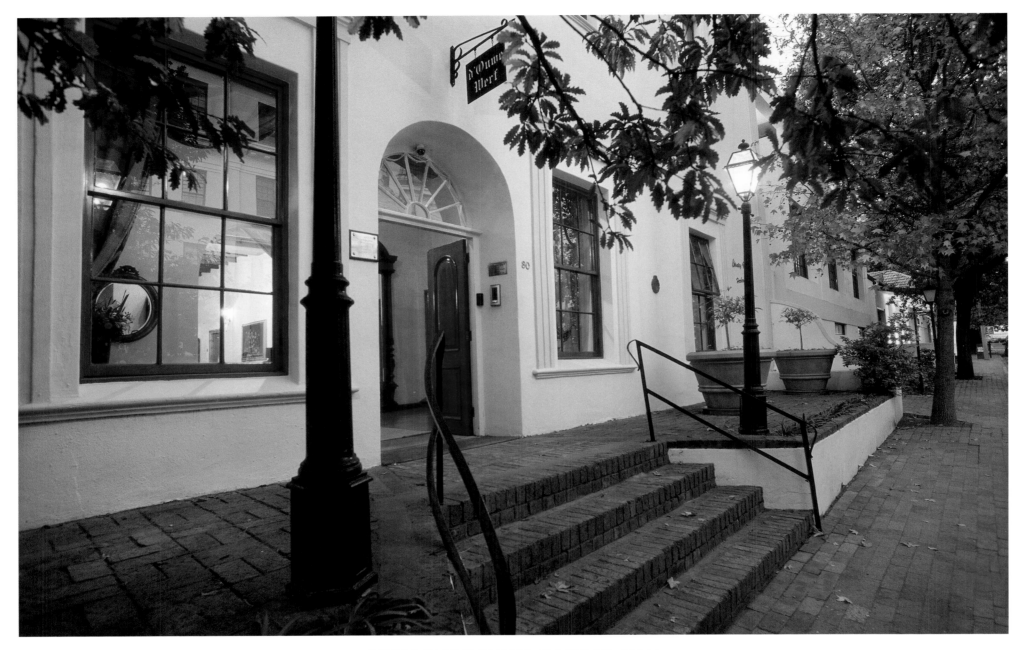

STELLENBOSCH'S OLDEST INN

For more than 200 years, travellers have walked down Church Street, past gnarled oaks and moss-lined canals, to knock at the door of d'Ouwe Werf. Today d'Ouwe Werf lies in the historic centre of Stellenbosch and is possibly South Africa's oldest surviving inn. The inn was first built in 1802 but was plagued by fires. In 1890 yet another fire damaged the building, after which it was restored in the Georgian style seen today. The archaeological remains of an even older building – a church that was built in 1687 and destroyed by a fire in 1710 – can be seen beneath the floorboards of the inn's kitchen. D'Ouwe Werf's restaurant is well known for its traditional Cape cuisine.

EVERGREEN MANOR

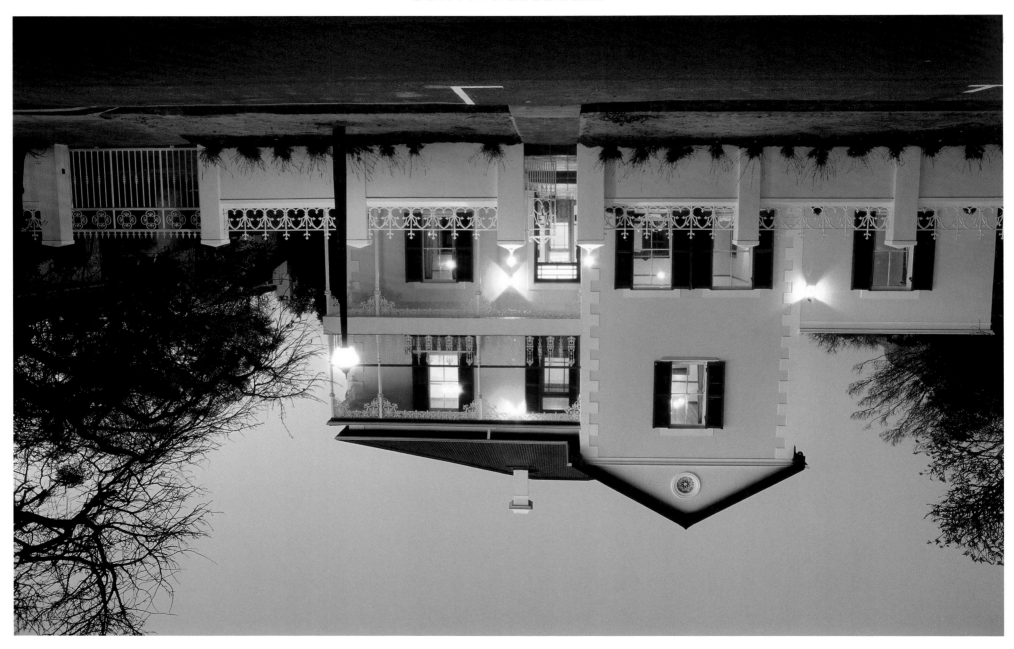

Built in 1904, Evergreen Manor is set in the heart of historic Stellenbosch, the famous university town surrounded by mountains and vineyards and bedecked with ancient oaks. The Stellenbosch University's campus, music conservatoire, theatre and botanical gardens are all within walking distance of the guesthouse. Many visitors use the guesthouse as a base from which to visit the winelands, travel to Namaqualand to see the spring flowers or take day trips to watch the whales in Hermanus. For those requiring rejuvenation, Evergreen Manor offers guests a range of wellness treatments by a qualified therapist.

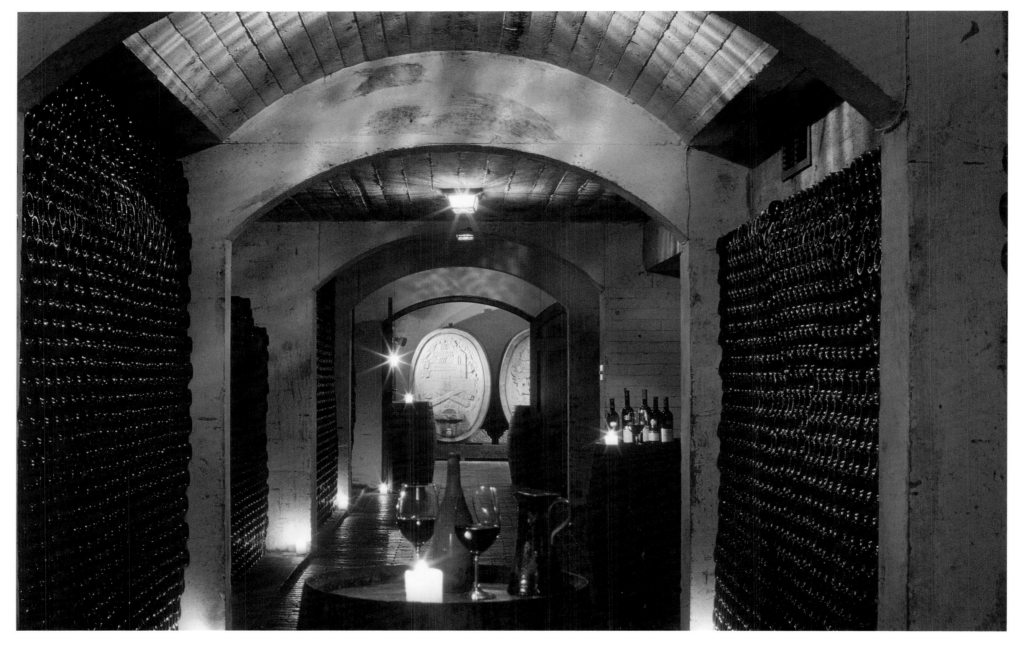

BERGKELDER

Built in 1968, Bergkelder's famous underground bottle maturation cellar was one of the first of its kind in South Africa. In the 1970s Bergkelder played a leading role in the South African wine industry. Determined to improve the standard of winemaking in the country, it encouraged growers to plant the classic noble varieties such as Cabernet Sauvignon, Cabernet Franc, Merlot, Chardonnay and Sauvignon Blanc. Bergkelder wines are made in a contemporary style and with a philosophy of minimum interference. The winery has been rewarded with myriad local and international awards including gold medals at the International Wine and Spirit Competition (London) and Intervin (Canada), Grand Gold medals at Monde Selection (Belgium), Grand Prix trophies at Vinexpo (Bordeaux), and double gold medals at Veritas Awards (South Africa).

CELLAR BY CANDLELIGHT

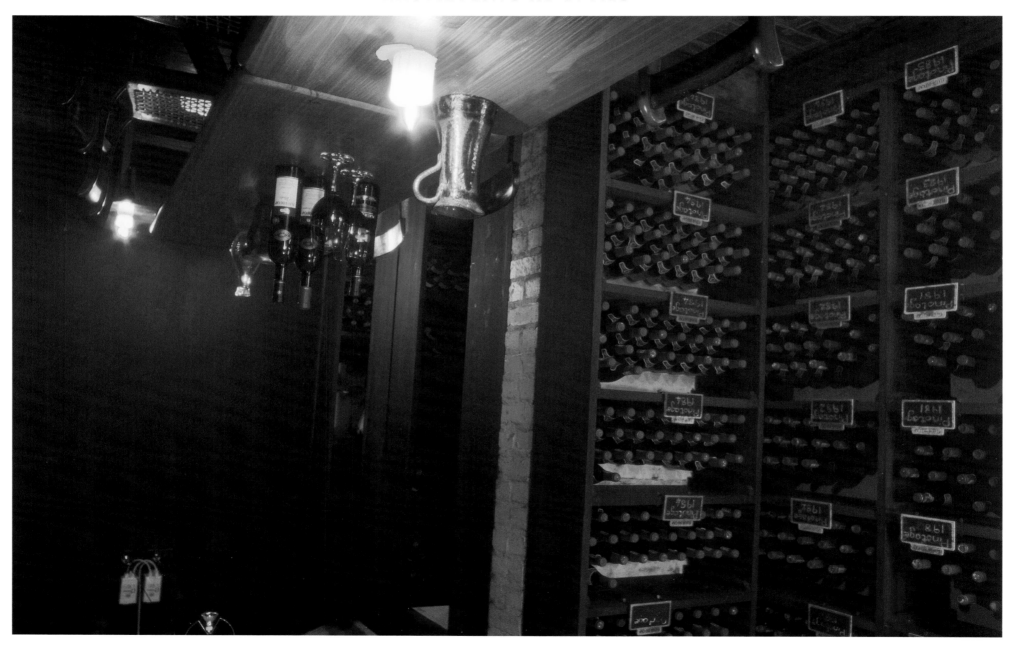

Candlelight dances off thousands of racked bottles of wine in Bergkelder's underground bottle maturation cellar. Set deep into the slopes of Papegaaiberg outside Stellenbosch, the cellar is home to the Fleur du Cap range of wines. The cellar's constant temperature and humidity provide the ideal conditions for slow maturation, and wines that need additional maturation can be left here in the tranquil confines of the Papegaaiberg. The mountain was named after an annual shooting contest held to celebrate the birthday of Simon van der Stel, Commander of the Cape, who founded Stellenbosch in 1679. The target at the contest was a parrot moulded from clay – hence the name Papegaaiberg (Parrot Mountain).

VICTORIA STREET

Student and academic life at Stellenbosch University is centred on Victoria Street with its beautiful plane-tree avenue flanked by academic buildings and student residences. Stellenbosch University evolved from several earlier bodies. In 1918 the then Victoria College of Stellenbosch gave way to the independent Stellenbosch University. Despite some 13 000 of its nearly 22 000 students living in residences on the central campus and in town, Stellenbosch has retained the atmosphere of an intimate residential university.

STELLENBOSCH UNIVERSITY BOTANICAL GARDEN

Stellenbosch University's botanical garden was established in 1922 to provide students with a living reference of indigenous and exotic plants. The densely planted garden is stocked with plants from all over the world. There are water plants from the Amazon, tropical orchids and flesh-eating plants from South America, cacti from Mexico, welwitschias from Namibia, and indigenous herbs and succulents. The garden lies at the centre of the campus and takes up little more than 1.8 hectares. Oenology student Lien Boschoff uses the tranquil garden as a retreat from the bustle of campus life.

KAYAMANDI

Perched on a hill on the outskirts of Stellenbosch, Kayamandi – meaning 'pleasant home' in Xhosa – has a view across the wealthier suburbs and many vineyards that surround the town. It's also a world in itself, with people milling about at the taxi ranks or chatting to their neighbours, and children running errands to the local shop or simply playing outdoors. Kayamandi's first houses were built in 1941.

LIFE ON THE STREET

In places like Kayamandi, much of life happens outdoors. The laughter of children playing on the street fills the air. Elsewhere, those with time to kill patiently wait for the *umqombothi* – a quick-fermenting African beer made of maize, malt, yeast and sugar – to mature. On a street corner, a bold mural addresses the HIV/AIDS crisis. There are many volunteers working in Kayamandi as AIDS counsellors. Some are students from the local university, while others come from overseas. Most stay in the township to experience the warm hospitality of Africa. Infrastructure in Kayamandi is often both rudimentary and innovative, and a wall near a hostel for single men serves as a post office.

KEEPING UP WITH FASHION

A soft hum fills the room as the barber cuts a client's hair. His profile and white apron are reflected in the mirror propped up against the wall. There is an air of functionality and expectation as the barber matches his client's fashion aspirations with reality. The wall above the mirror is lined with pictures cut from magazines showing the range of haircuts available. Haircuts in Kayamandi are relatively cheap and cost about R10.

STELLENBOSCH UNIVERSITY
ART GALLERY

The former Lutheran church building in Stellenbosch dates to the 1850s, and is the work of the architect Carl Otto Hager. Hager also designed the town's *Moederkerk* (literally, Mother Church). Many of the early settlers at the Cape were German or of German descent and belonged to the Lutheran Church. In the mid-nineteenth century they decided to establish their own congregation in Stellenbosch. However, it was a short-lived vision and by 1873 the congregation was so small that the church building was let to the Dutch Reformed Church. It was then used by the Presbyterian Church from 1900 until 1927. The Lutheran church was eventually restored and donated to Stellenbosch University. A provincial heritage site, it is now used as an art gallery.

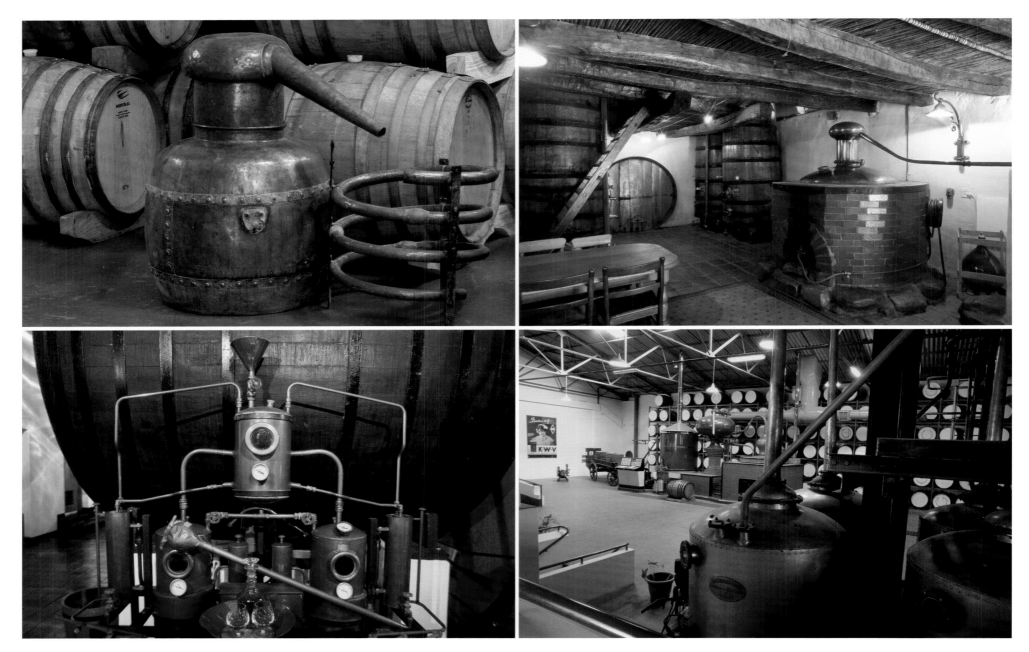

BRANDY ROUTES

The Western Cape Brandy Route was first introduced in 1997. The route starts in Stellenbosch and winds its way through the Berg River Valley to Tulbagh and Worcester, and includes familiar names such as Van Ryn, Avontuur, Louiesenhof, Backsberg, Cabriére, Laborie, Uitkyk, De Compagnie, Oude Wellington and KWV House of Brandy. A second route, the R62 Brandy Route, begins in Worcester and follows the R62 road through Montagu and Barrydale to Oudtshoorn. Brandy distillers that can be visited along the way include Barrydale Wine Cellar, Boplaas, Grundheim, Kango Wine Cellar and Mons Ruber. Many wine estates now distill their own brandies, and cellars range from the small and intimate to the large and capacious.

110

LIQUID AMBER

Cellarmasters like to say that the transformation of brandy into a fragrant amber liquid is the work of angels. Brandy distillers also say that the brandy lost during the maturation process — when the brandy 'breathes' in the cask and some of it evaporates — was taken by the angels as their share. This wine and brandy cellar has the air of a sanctuary, and it's not difficult to imagine angels flitting about in the shadows at work among the barrels.

The success of the transformation from alcohol and water to aromatic liquid is a tribute to the ancient craft and skill of the cooper. It's a skill that requires a long and comprehensive apprenticeship. Casks that are destined for brandy maturation are deliberately blistered and left rough on the inside to allow the brandy to penetrate the timber and extract the wood's distinctive flavour and colour. An experienced cooper takes seven hours to complete one cask.

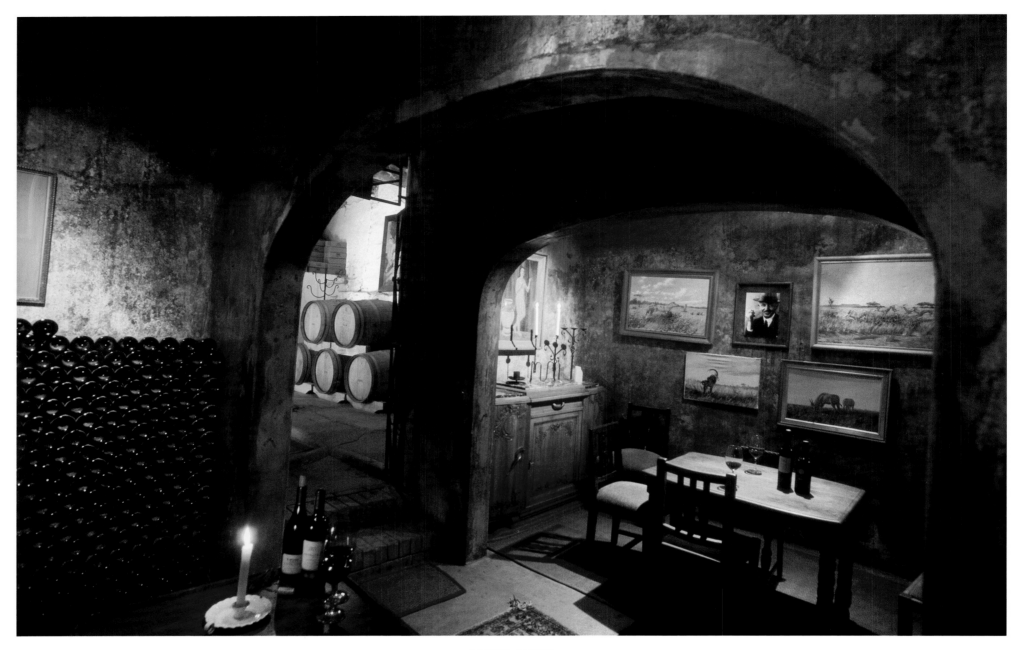

MURATIE

Muratie is one of South Africa's oldest privately owned wine estates and was the first in South Africa to cultivate Pinot Noir. At the time, the estate belonged to an eccentric German artist, George Canitz, who stumbled upon the derelict farm while riding to a party in the Simonsberg valley. He fell in love with the farm and bought it in 1925. He enlisted the help of a wine scientist, Professor Izak Perold, from Stellenbosch University. Canitz once said, 'Many an idea or image flows from a glass of Muratie wine that would never have emerged from a glass of water.' The farm was bought by the Melck family in 1988, and has retained its old-world charm.

CAPE CUISINE

The beautifully restored kitchen at Muratie near Stellenbosch reflects an ambience of warmth and generosity. It is in kitchens such as this one that Cape cuisine – a fusion of the culinary traditions of the European settlers and the slaves from Malaysia – began to take shape in the seventeenth and eighteenth centuries. One of the indigenous dishes to be adopted by the new arrivals was *waterblommetjies*. The dish refers to the fragrant shrimp-like flowers of the *Aponogeton distachys*, which grows in the shallow dams and ponds of the winelands. These edible flowers appear in winter and spring and can be cooked with mutton, or steamed with wild sorrel or lemon juice. More than 150 tons of *waterblommetjies* are harvested commercially every year.

DOC CRAVEN

Often referred to as the cradle of South African rugby, Stellenbosch University is home to South Africa's second oldest rugby club and has produced numerous provincial and national players. One of its most illustrious members was Dr Danie Craven who represented South Africa in 16 test matches from 1931 to 1938, four times as captain. 'Doc Craven' was president of the South African Rugby Board for 36 years and coached the university's first rugby team from 1947 to 1991. Craven's indomitable spirit is commemorated in a sculpture by his lifelong friend, Pierre Volschenk. The sculpture graces the garden of the Jannie Marais House – a rugby museum and the administrative home of the University's Sports Bureau.

KAAPZICHT ESTATE

The 174-hectare family farm, Kaapzicht Estate, is managed by brothers Danie Steytler (winemaker) and George Steytler (viticulturist) who have been bottling wines under the Kaapzicht Estate label since 1984. Kaapzicht is situated on the north-western slopes of the Bottelary Hills in the Stellenbosch district in an area that is well suited to producing full-bodied, fruity red wines. The estate has received many local and international accolades including the Château Pichon Longueville Comtesse de Lalande Trophy for the Best Red Blend at the International Wine and Spirit Competition in London. Kaapzicht also produces a husk brandy (grappa) and a copper potstill brandy matured in French oak for five years.

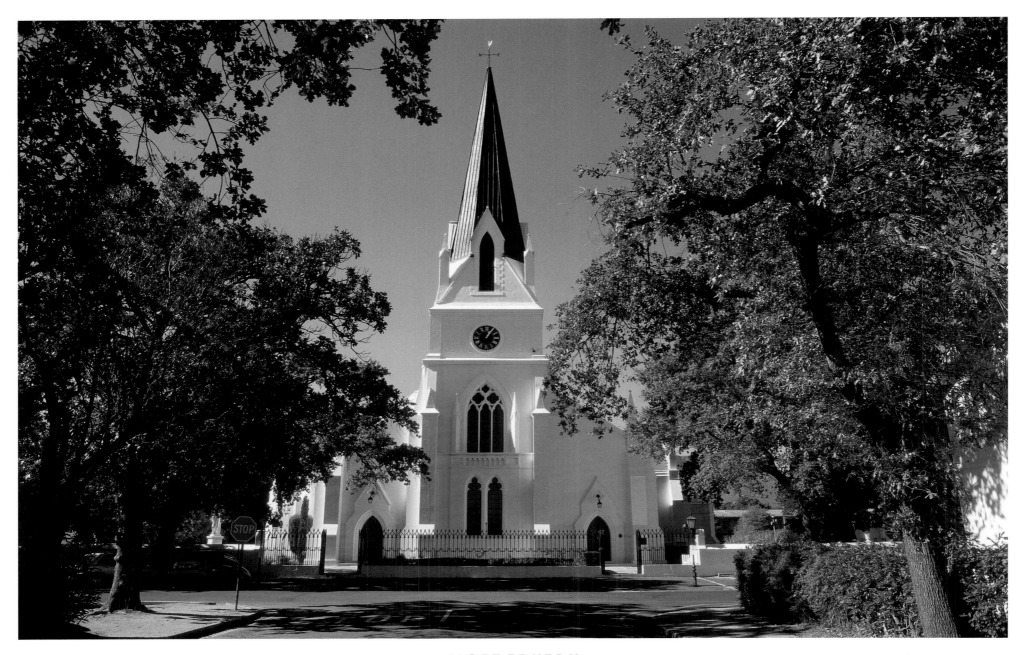

MOEDERKERK

Graduates of Stellenbosch University still return to the historic town to get married in the *Moederkerk* (Mother Church). In many ways, the church is the spiritual heart of the old town. The original church was built in 1722, and its ring wall – built a few years later – can still be seen today. Stellenbosch expanded rapidly, and in 1861 the congregation approached Carl Otto Hager, an architect who designed a number of churches during this period, to design a larger church. This church was built by English and Scottish artisans in Hager's typical Cape Gothic style. A huge fête, or *Boeren Bazaar* (Farmers' Bazaar), was held on the Braak in October 1863 to raise funds for the building project.

STEEPED IN HISTORY

The Kruithuis (powder magazine) on Stellenbosch's old market square, the Braak, is the only existing arsenal that dates to the Dutch East India Company's occupation of the Cape and is one of the few remaining buildings with the Company's 'VOC' monogram (top left and right). The Kruithuis was built in 1777 to house weapons and ammunition. Today it is a museum and used to display military uniforms, cannons and other weaponry. The Burgerhuis (bottom left) was built in 1797 by Antonie Fick and is a good example of Cape Dutch architecture. At the Stellenbosch Village Museum, tour guides (bottom right) receive visitors in traditional dress.

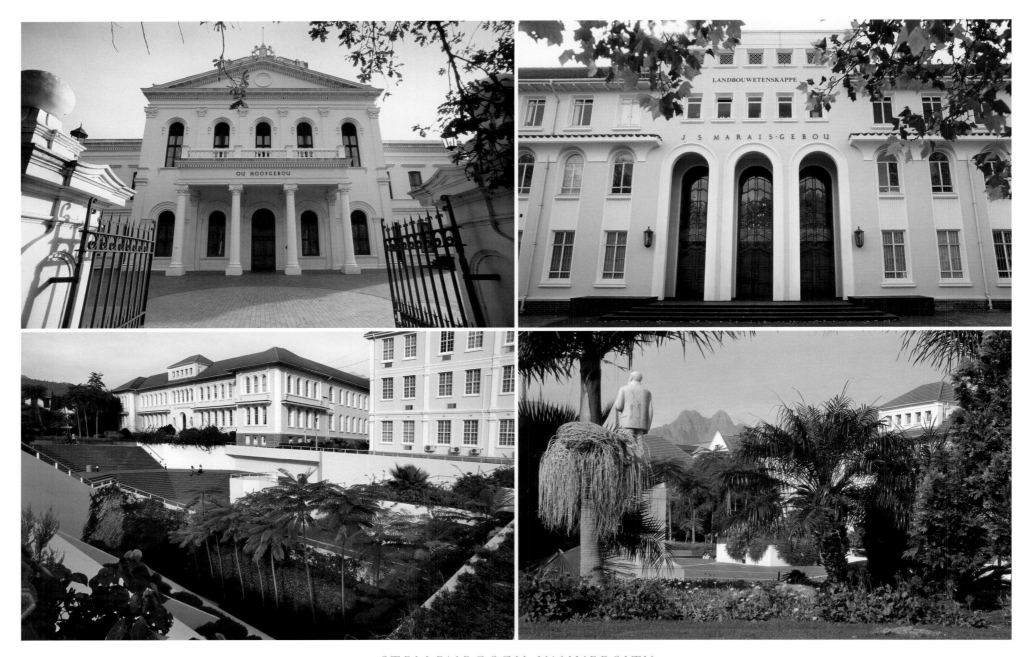

STELLENBOSCH UNIVERSITY

The Ou Hoofgebou (top left) is home to Stellenbosch University's Law Faculty. The building was completed in 1886, and was designed by the architect Carl Otto Hager. The university's Faculty of Agricultural and Forestry Sciences (top right) plays a prominent role in developing and improving plant material for the wine industry. Many of the administrative and academic buildings on the main campus surround the magnificent Jan Marais Square (bottom right), where a statue of this celebrated beneficiary of the university stands amidst the daily rush of students. To preserve the open character of the square, the Kosie Gericke Library (bottom left) was built underground. Completed in 1983, it is one of the world's biggest underground libraries.





STELLENBOSCH CAFÉ SOCIETY

Among South Africa's most historic towns, Stellenbosch is also one of the most sensitively restored. Its authentic Cape Dutch, Victorian and Georgian architecture has been seamlessly woven into the fabric of the town's modern commercial and social life. Its status as one of South Africa's oldest university towns (and the Cape's centre of viticultural training and research) is one more element helping create a colourful community which takes time out to enjoy life. On pavements beside cobbled streets beneath giant oak trees, students, professors, artists and tourists mingle with business executives, farmers and homemakers to share a snack, a coffee, a gossip, a glass of wine. Or simply sit in quiet contemplation and enjoy a newspaper.

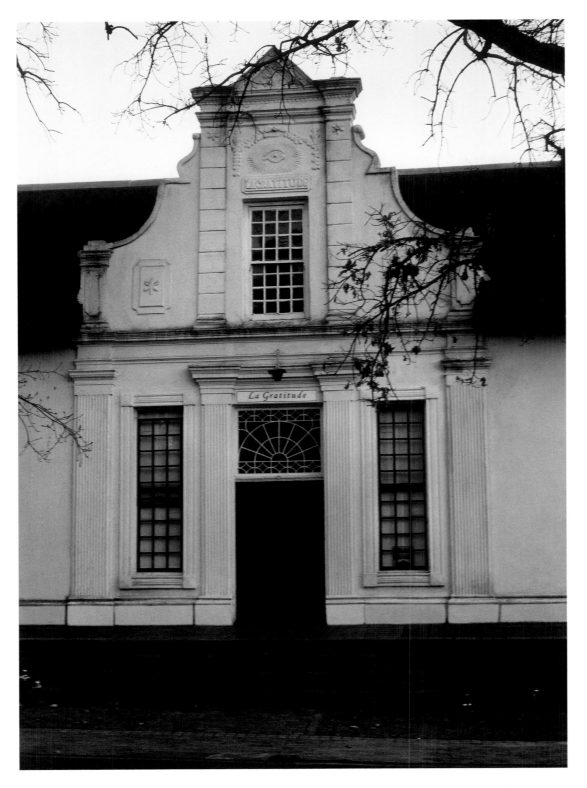

LA GRATITUDE

La Gratitude in Dorp Street, Stellenbosch, was built in the late eighteenth century by Rev. Meent Borcherds. The house's gable is unusual in that it depicts the Freemason's 'all-seeing eye' – a symbol of the creative force of the universe – surrounded by rays of the sun. The property was bought in 1932 by William Winshaw, an American entrepreneur who set up a distillery on the Eerste River in the 1920s. This distillery later became Stellenbosch Farmers' Winery (today part of Distell). A provincial heritage site, the building is now a gourmet restaurant and boutique hotel.

VILLAGE MUSEUM

The Stellenbosch Museum is a complex of six residential homes that have been restored to reflect a particular period in the town's history. Schreuder House (top left) was built in about 1709. This restored burgher (settler) cottage is possibly the oldest documented house in South Africa. The kitchen (bottom right) is sparsely furnished and the polished dung floor is also typical of the period. Living conditions for the early settlers were often modest, and early travel writers noted that the burgher's children and chickens were equally at home in the *voorkamer*, the more formal room reserved for receiving guests. The privately owned Coachman's Cottage (bottom left) near the old village common, known as the Braak, is another example of eighteenth-century architecture.

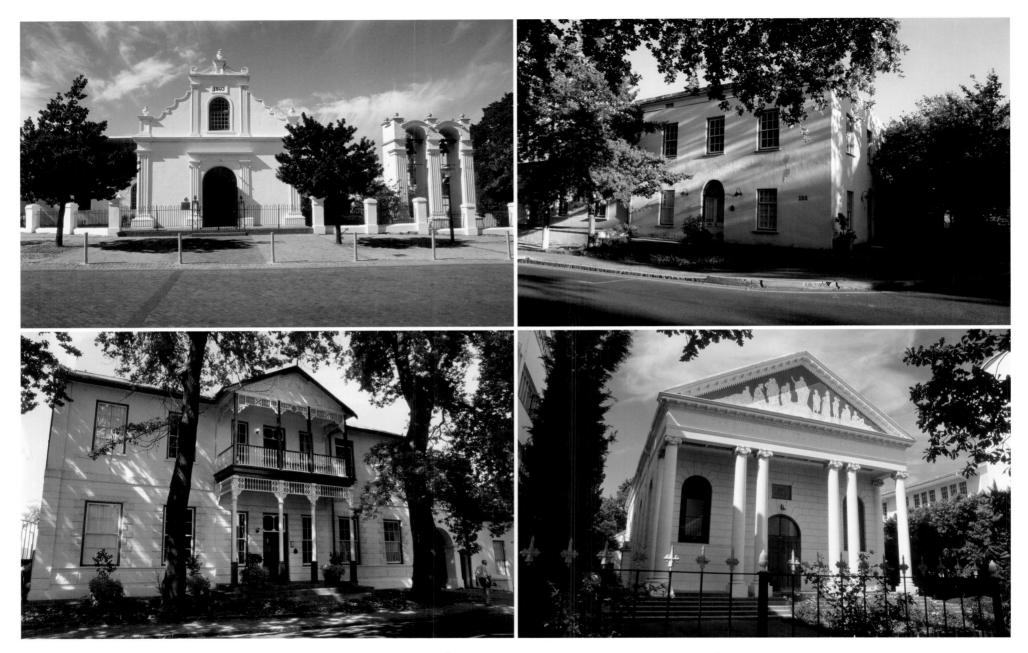

STELLENBOSCH'S ARCHITECTURAL HERITAGE

The Rhenish Mission Church (top left) is on Stellenbosch's village common, the Braak. The church building was dedicated in the early nineteenth century and served the spiritual and educational needs of slaves on the surrounding farms. Stellenbosch's oak-lined streets are a document of the historic town's architectural heritage, which varies from Georgian buildings (top right) to Cape Dutch and Victorian designs, such as Saxenhof (bottom left) in Dorp Street. Classical influences are evident in the Hofmeyr Hall in Church Street (bottom right) with its Ionic columns and Greek pediment. The hall was built in 1899 and is named after the first professor of Stellenbosch University's theological seminary, Professor NJ Hofmeyr.

DE KELDER

De Kelder is the oldest operating restaurant in Stellenbosch. The original building dates back to 1791 when it was part of Vredelust farm. De Kelder has retained its nostalgic Cape Dutch ambience with its indigenous wooden ceiling beams and wine barrels set into the wall. At the rear of the restaurant the stables and coach-house have changed little in more than 200 years. De Kelder has an outdoor beer garden, a pub as well as a formal restaurant that specialises in South African and German cuisine, and an impressive liquor emporium that showcases the wines of the region.

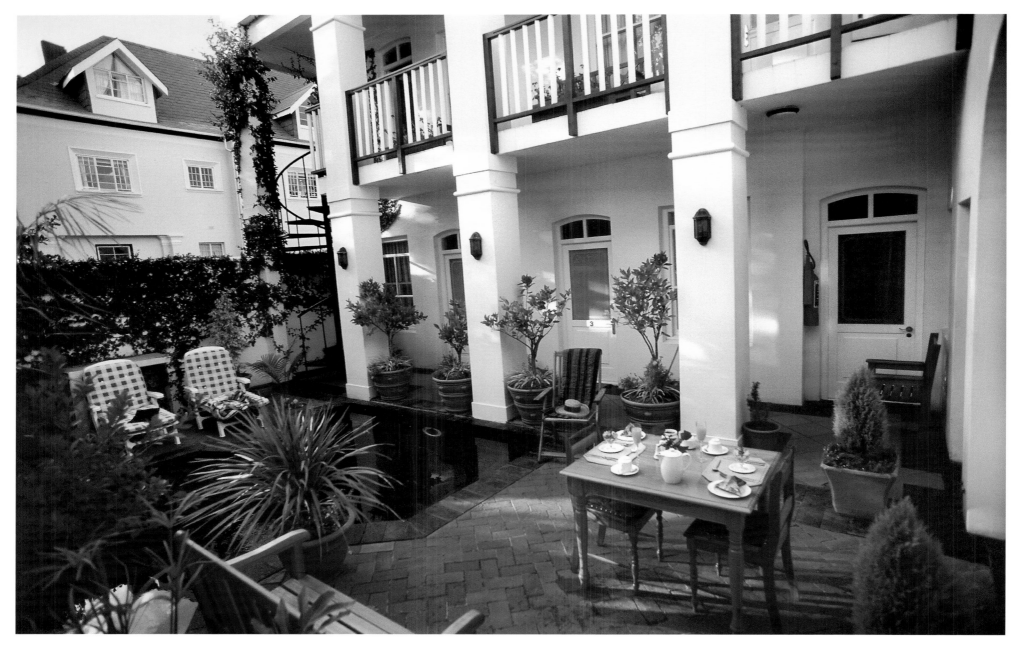

EENDRACHT BOUTIQUE HOTEL

The Eendracht Boutique Hotel in Stellenbosch's historic Dorp Street is one of the oldest Dorp Street properties. A recent archeological survey of the property revealed evidence of the original two-roomed cottage, subsequent alterations, and stables and work yards. Artefacts such as Chinese porcelain, kitchen utensils and smoking-pipe bowls were also found. In the late eighteenth century the artist Jan Adam Hartman rebuilt and enlarged the house to its more familiar square shape. The building has also served as a boarding-house for students. More recently the Lutz Trust rebuilt the valuable property to reflect its architectural heritage. The elegant hotel is within walking distance of the town's many tourist attractions.

125, HOUSES OF ART AND THEOLOGY



HOUSES OF ART AND THEOLOGY

The old Bloemhof School for Girls was built in 1907 and is an example of Dutch neo-classical architecture. Today the building (top left and right, bottom left) is the head office of Stellenbosch University Museum and is known as the Eben Dönges Centre. The centre incorporates the Sasol Art Museum, which houses the University's collection of fine art including the largest single collection of paintings by South African artist Maggie Laubser. The Theological School (bottom right) was established in 1859 and is commonly referred to as the *Kweekskool* (seminary). The façade is a replica of the main campus building of the University of Utrecht in the Netherlands. In 1963 the seminary was incorporated into Stellenbosch University to become the Faculty of Theology.

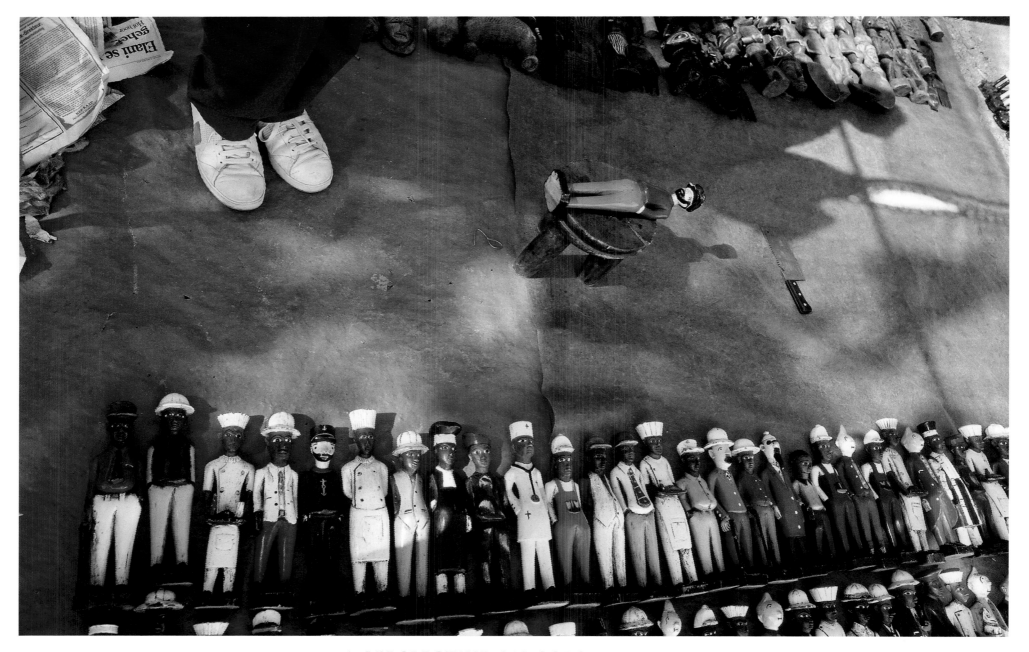

A PERSPECTIVE ON COLONIAL LIFE

Painted wooden figurines depicting doctors, traders, sailors and businessmen line up in a colourful parade at an open market on Stellenbosch's Braak, or village common. Even Tintin is there. These delightful painted figures originate from West Africa and depict European colonial life as seen through African eyes. The Braak lies on the crossroad of the flow of pedestrians through the shopping district to the station and university. Since the eighteenth century, development around the Braak has been restricted to preserve its value as a meeting and recreational space in the town. Today the Braak is a provincial heritage site.

AFRICA'S CULTURAL FUSION

Tinker, tailor, soldier, sailor, lawyer, doctor, priest and pith-helmeted businessman – a parade of wooden figurines in a kaleidoscope of vibrant colours created by immigrants and refugees from Francophone Africa. The extraordinary variety of characters in this population of highly collectable figurines give insight into the cultural fusion and diversity of Africa.

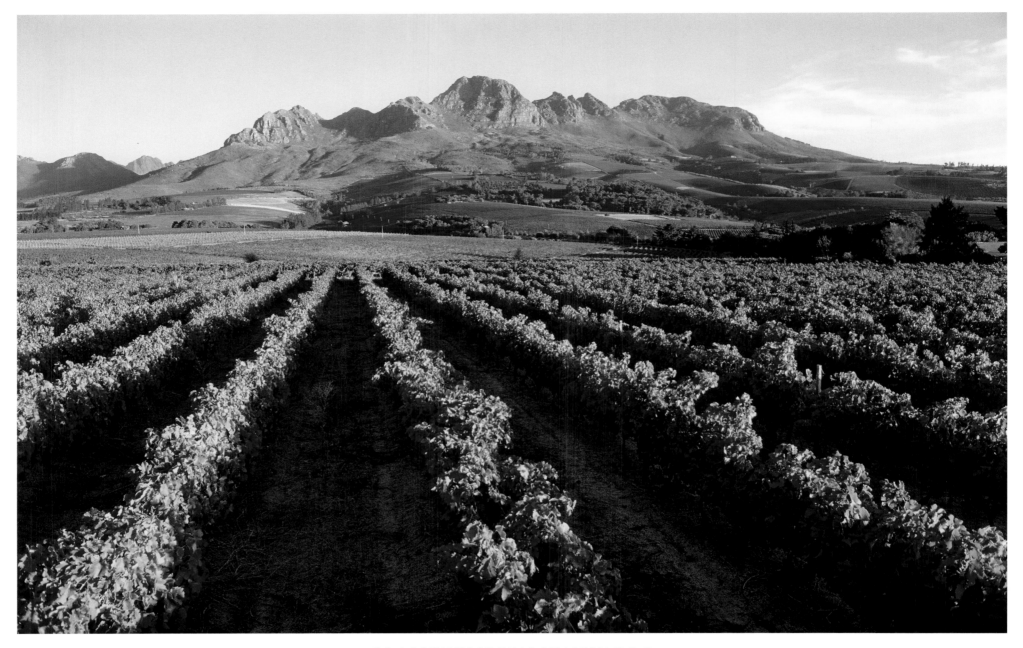

BLAAUWKLIPPEN VINEYARDS

The Stellenbosch Mountain forms a distant focal point for the vines of Blaauwklippen. The Blaauwklip (Blue Stone) River runs through the farm and into Stellenbosch's Eerste (First) River. The estate's focus is on producing premium red wines. Blaauwklippen lies on the southern and western slopes of the Stellenbosch Mountains. The farm has changed hands many times during its 300-year history. Cecil John Rhodes – premier of the Cape Colony in the 1890s – was one of its former owners. In the wake of the industry's phylloxera epidemic, Rhodes bought and converted Blaauwklippen and a number of farms in the Franschhoek Valley into fruit farms. Blaauwklippen was re-established as a wine farm in the 1970s.

CONSERVING HISTORY AND TRADITION

Horse-drawn coaches once more clip-clop along the paths among Blaauwklippen's historic buildings and through the vineyards. The sound and sight of the coaches, drawn by immaculately groomed black horses, provide the perfect backdrop to a light summer lunch at the estate. The estate has an impressive collection of vintage carriages – a reminder of unhurried times past. The elegant symmetry of a Cape Dutch homestead with its thick clay-bricked, lime-washed walls and black thatch is caught in the shadows of the afternoon light. Farm homesteads often grew organically with owners adding wings and gables as their fortunes improved.

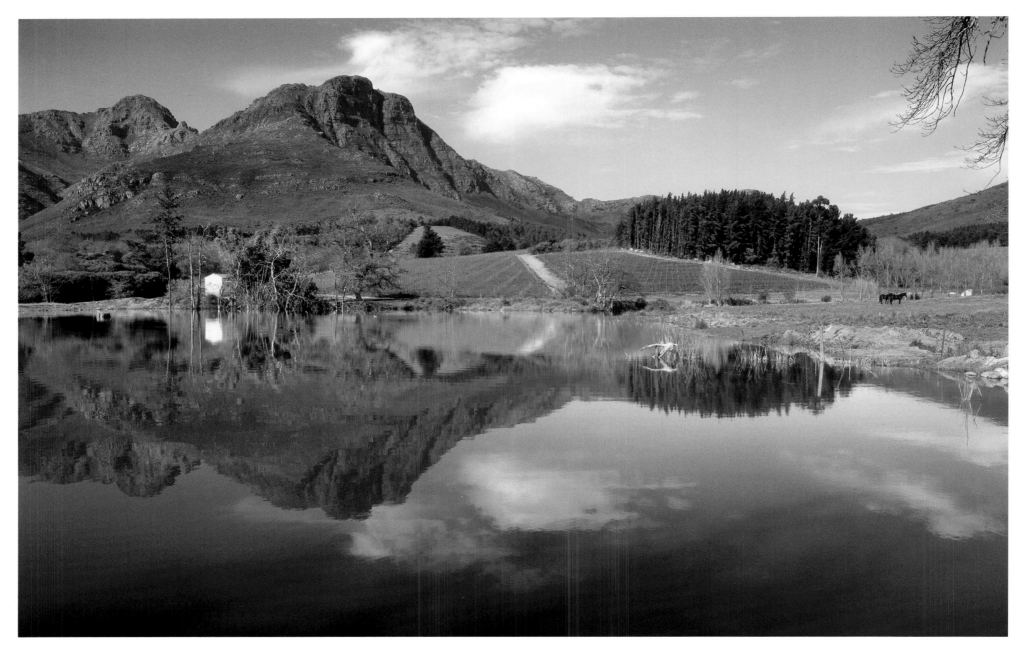

WATERFORD WINE ESTATE

Among a new wave of Cape wine farms cultivating virgin land and building custom-designed cellars, is Waterford Wine Estate. A joint venture by information technology entrepreneur Jeremy Ord and talented winemaker Kevin Arnold, Waterford's 120 hectares on the Helderberg mountain slopes near Stellenbosch, source of some of the Cape's premium wines, include 50 hectares of new vineyard. Red varieties are predominant: classics such as Cabernet Sauvignon, Cabernet Franc, Merlot and Shiraz and the more uncommon Malbec, Petit Verdot, Mourvèdre, Grenache, Barbera and Tempranillo. Arnold is looking to eventually vinify an iconic red blend. He believes his patch of earth is best expressed in wines he describes as having finesse and refinement.

WATERFORD WINE CELLAR

Waterford Wine Estate's wine cellar is an architectural delight, fusing the romance of aesthetics with the practicality of a modern working winery. Surrounded by orchards and beds of lavender, it represents a complete break from the traditional Cape Dutch winelands heritage, reflecting instead the Cape's Mediterranean climate embraced by South Africa's new-generation wine growers. Tuscan red clay tiled roofs, shuttered windows and a sunny central courtyard with its fountain centrepiece are juxtaposed with the positively monastic stone entrance archway and barrel-vaulted maturation cellar dimly lit by elegant wrought-iron chandeliers. The gravel-covered quad is the hub of harvest activities and a venue for social gatherings, outdoor dining, music events, and even the odd game of boules.

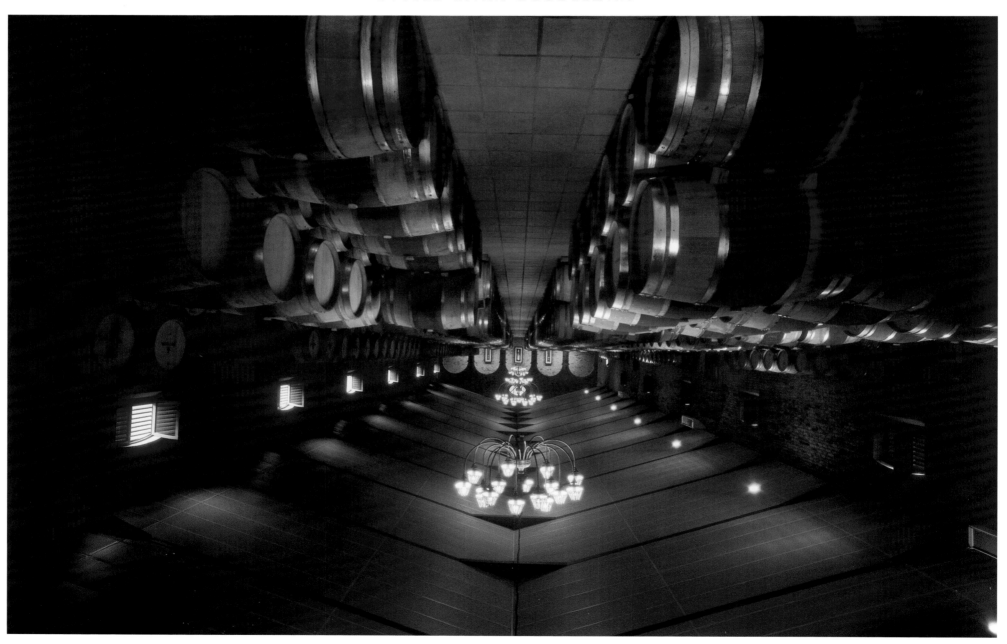

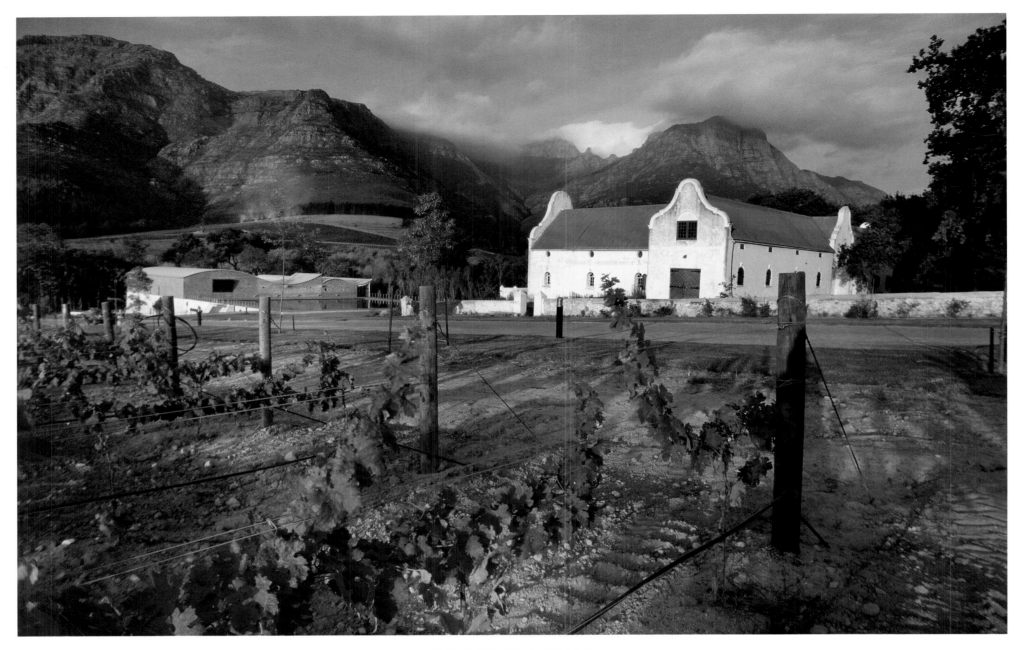

DORNIER WINES

The Dornier vineyards lie in the premium wine-growing region of Stellenbosch. Here Christoph Dornier and winemaker Ian Naudé work together to achieve a signature style that denotes complexity, a rich texture and multiple layers of flavours, balanced by a sense of fun. Ian Naudé was appointed in 2001 and immediately began the process of upgrading and extending the vineyards, establishing the cellar and improving the infrastructure. He is supported by viticulturist Lucas de Kock who brings the experience he gained in Bordeaux to the team. Grapes are harvested at different stages of ripeness, and Naudé follows a policy of micro-blending and barrel fermenting the yields from individual vineyards.

THE ART OF WINE

Dornier lies at the foothills of the Stellenbosch Mountains and was bought in 1995 by the German painter Christoph Dornier. Dornier studied fine art in Lucerne, Munich and Salzburg and exhibits his art throughout Europe and North America. His richly textured work is often described as intellectual as well as humorous, and his creative influence is evident on the farm. Dornier and Paarl architect Johan Malherbe designed the 500-ton winery for the estate. The building casts a near-perfect reflection in the pond that lies above the underground barrel maturation cellar.

KEN FORRESTER WINES

Scholtzenhof is one of the oldest wine farms in the Western Cape and was originally granted as Zandbergh in 1689. It is now home to Ken Forrester Wines and one of Stellenbosch's best-known restaurants, 96 Winery Road. The farm's first vineyards were planted in 1692. In 1994 the first wines were produced under the Ken Forrester label, and soon the award-winning wines were at the forefront of the Chenin Blanc revival. The grapes are sourced from vineyards – some of them more than 30 years old – in the cool Helderberg region of Stellenbosch. Ken and Teresa Forrester, seen here frolicking with their dog, restored the original homestead, one of the few remaining examples of a seventeenth-century farmhouse.

WARWICK WINE ESTATE

Warwick Wine Estate lies on the outskirts of Stellenbosch against the slopes of Klapmutskop. Stellenbosch's iconoclastic Simonsberg is an appropriate backdrop to the estate's cool south-facing vineyards. The estate belongs to the Ratcliffe family, and is known for its award-winning red blend made by leading winemaker Norma Ratcliffe. Louis Nel (above), Warwick's winemaker, believes the estate's terroir is equally suited to producing great Sauvignon Blanc wines. His passion for the variety was validated when Warwick's Professor Black Sauvignon Blanc received a Veritas double gold award. The wine is named after a vineyard that replaced an old orchard of 'Professor Black' peaches. Louis Nel works closely with Californian vineyard consultant Phil Freese.

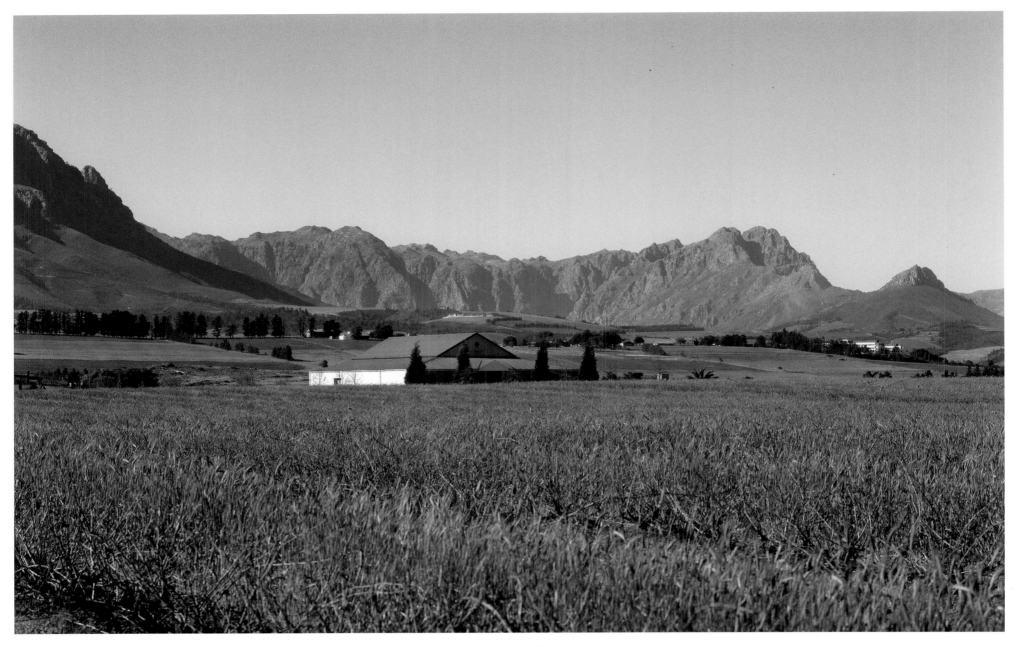

HOOPENBURG

Hoopenburg has its origins some 290 years ago in Stellenbosch, South Africa's second oldest town. In 1714 the first magistrate of Stellenbosch was granted 61 morgen of land, which he named 'Hopenburg'. Hoopenburg was placed well and truly on the map in 1814 when its first noticeable wines were harvested. The farm is perfectly positioned on the slopes of the majestic Simonsberg, which forms a dramatic backdrop to the farm. From the slopes there is a clear and panoramic view of Table Mountain, adding to the tranquillity of the homestead and gardens. Hoopenburg has established itself as one of the Cape's foremost boutique wineries.

DWARS RIVER VALLEY

Situated in an amphitheatre of mountains, the hamlet of Pniel lies midway between Stellenbosch and Franschhoek on the banks of the Dwars River. The Dwars River Valley is home to several famous wine estates. The small village developed on property bought by three farmers in 1838 to establish a mission station for emancipated slaves. Reverend Johan Stegman became the hamlet's first spiritual leader. Stegman, born on the nearby farm Babylonstoren, was only 18 years old when he took up the post. He served his community for 67 years. The historic Pniel Congregational Church – with the imposing Simonsberg as a backdrop – remains central to the small community.

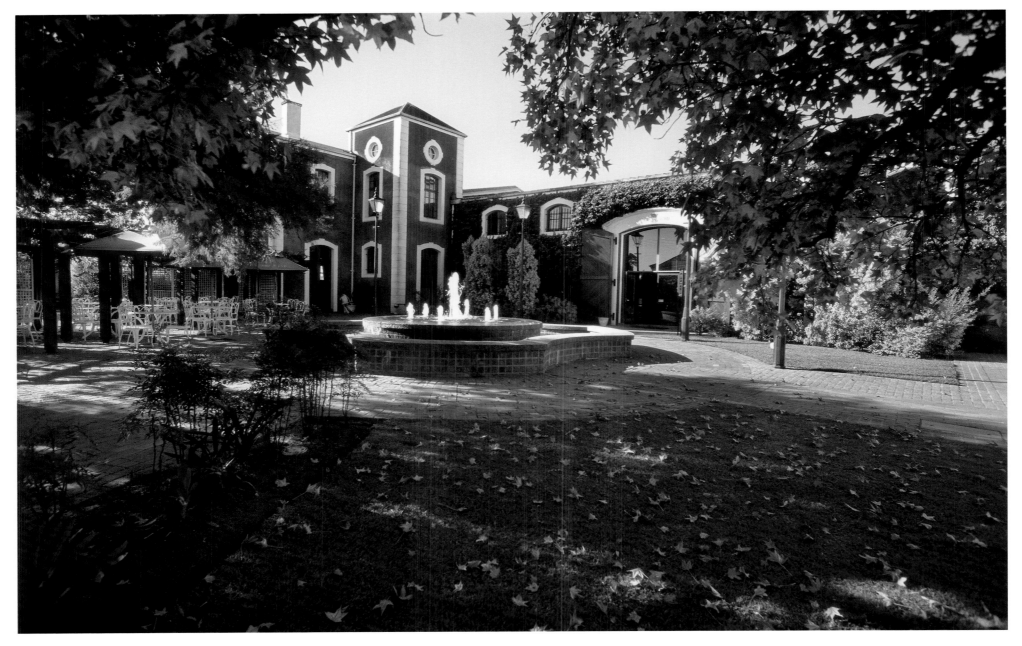

VAN RYN BRANDY CELLAR

The Van Ryn Brandy Distillery and Cellar was established by Jan van Rijn, a Dutch immigrant who arrived in the Cape in 1845. The brandy cellar, in the Vlottenberg Valley, the coldest area in the Stellenbosch district, was built with stones gathered from the Eerste River. Special water furrows were constructed to run past and underneath the maturation cellar to create the perfect microclimate – cool with a high humidity – for the brandy's slow maturation process. The cellar's buildings include Jan Van Rijn's original residence, which currently houses artefacts and heritage pieces dating back to the early 1800s.

OF POTSTILLS AND GOLDEN NECTAR

Typically, brandy has ripe quince and hazelnut tones and is made from white grape varietals such as Chenin Blanc, Colombard, Ugni Blanc and Palomino. Colombard is considered the aristocrat of brandy grapes, because of its high fruit acids and because it adds a delicate violet flavour to the distillate. A brandy cellar still resembles an alchemist's workshop, but the real alchemy happens in the barrel when the clear distillate is transformed into a rich amber liquid. Brandy distillers speak about a dialogue taking place between the wood and the brandy. The maturing brandy is said to breathe in the barrel and more than nine litres – the angels' share – is lost from the barrel each year through evaporation.

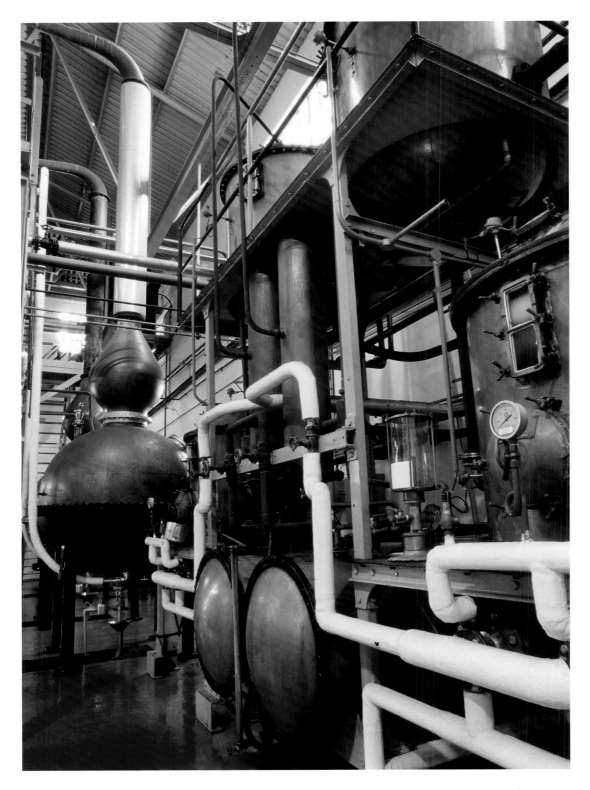

MAKING BRANDY

Brandy is distilled in two stages in large copper potstills. During the first stage, the wine is boiled at 78.3 °C and the alcohol, which vaporises three times faster than water, is cooled in a condenser. This first distillation produces a raw, unrefined spirit with an alcohol content of about 30 per cent. The distillation takes between six and eight hours, and the result is called 'low wine'. The second stage is a concentration process, which involves the delicate distillation of the unrefined spirit into a potstill brandy with an alcohol content of no more than 70 per cent. This is a much slower process and takes between 10 and 12 hours of boiling. The brandy is now ready for its final purification. A hydrometer and timer are used to measure three important fractions distilled in succession – commonly referred to as the heads, the heart and the tails. Only the heart is used for maturation. The tails and the heads are pumped back into the 'low wine' reserve.

NEETHLINGSHOF WINE ESTATE

Neethlingshof's stone-pine avenue is one of the most recognisable landmarks in the heart of the Cape's winelands. The 300-year-old farm is situated outside Stellenbosch among the gently sloping Bottelary Hills overlooking False Bay. The estate's 165-hectare vineyards are planted on high-potential soils of decomposed granite. The cooling effect of the Atlantic Ocean brings relief during the hot summers and ensures a slow ripening period for the grapes. Visitors are treated to more than just a wine tasting and a meal in one of Neethlingshof's two restaurants – the Lord Neethling and the Palm Terrace. In summer the estate also offers a tour of the vineyards on a tractor-drawn trailer. Neethlingshof is owned by Lusan Premium Wines.

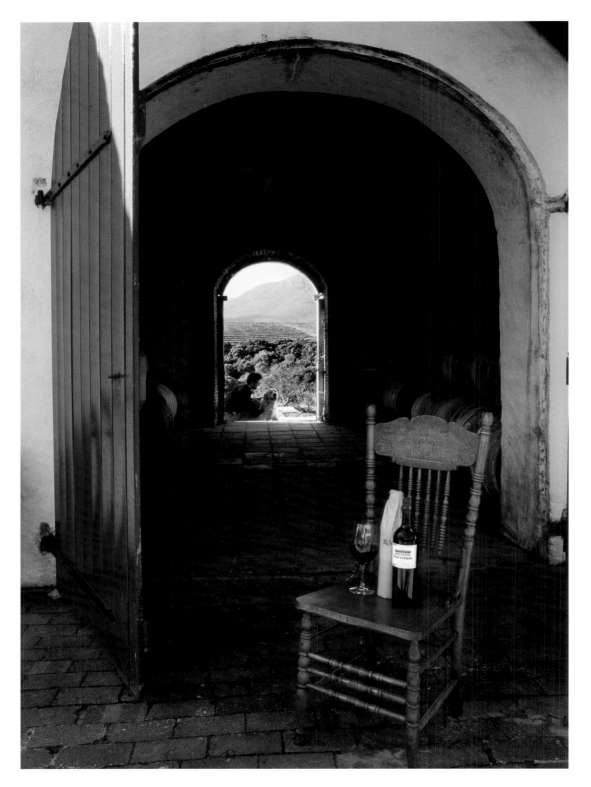

RUST EN VREDE ESTATE

In 1994 newly elected South African President Nelson Mandela chose Rust en Vrede's wine to accompany the dinner served at his Nobel Peace Prize banquet in Oslo. This, 300 years after Rust en Vrede was first established, was an apt choice in South Africa's first year of democracy. Translated from Afrikaans, *rust en vrede* means 'rest and peace'.

The Engelbrecht family bought the neglected property in 1977 and immediately set about restoring the historic homestead and replanting the vineyards. The manor house, with its high yellow wood ceilings and fourteenth-century Batavian tile floors, is one of the best examples of restored Cape Dutch architecture in the winelands. Since 1998 the estate has been run by Jean Engelbrecht, with the assistance of a team of highly motivated people.

Rust en Vrede's north-facing vineyards benefit from well-drained soils. Cool sea breezes from the Atlantic keep the temperatures low, which ensures a long ripening period for the grapes and consequently greater flavour development. The vineyards lie between 100 and 350 metres above sea level and receive an average annual rainfall of 750 millimetres. Winemaker-in-chief Louis Strydom is focused on the blending of Cabernet, Shiraz and Merlot. By means of micro-vinification, he is forging a partnership with nature that has proved successful for Rust en Vrede.

In 2000, Rust en Vrede was the first South African red wine to be internationally acclaimed as one of *Wine Spectator's* Top 100 wines of 2000. It achieved this honour again in 2001, 2002 and 2003.

ERNIE ELS WINES

Ernie Els, one of South Africa's most acclaimed professional golfers, recently acquired his own wine farm on the slopes of the Helderberg outside Stellenbosch. North-facing, the soils of this property are ideal for the growing of the premium red grapes that are used to create the award-winning Ernie Els wine, a joint venture by Els and Jean Engelbrecht from neighbouring Rust en Vrede Wine Estate. This wine, made by cellarmaster Louis Strydom (above), is the culmination of Els' dream to produce exceptional wines. Cabernet Sauvignon, Merlot, Petit Verdot and Malbec grapes are used for the Bordeaux-style wine, which, according to Strydom, is 'big in stature and gentle in character'. It's also an apt description of the man behind the winery.

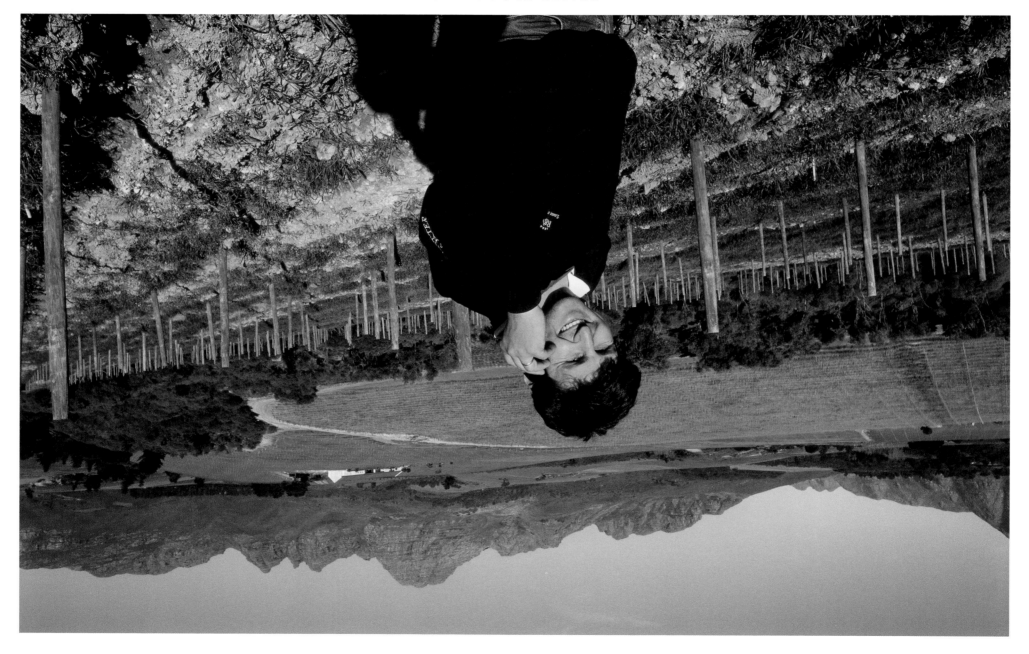

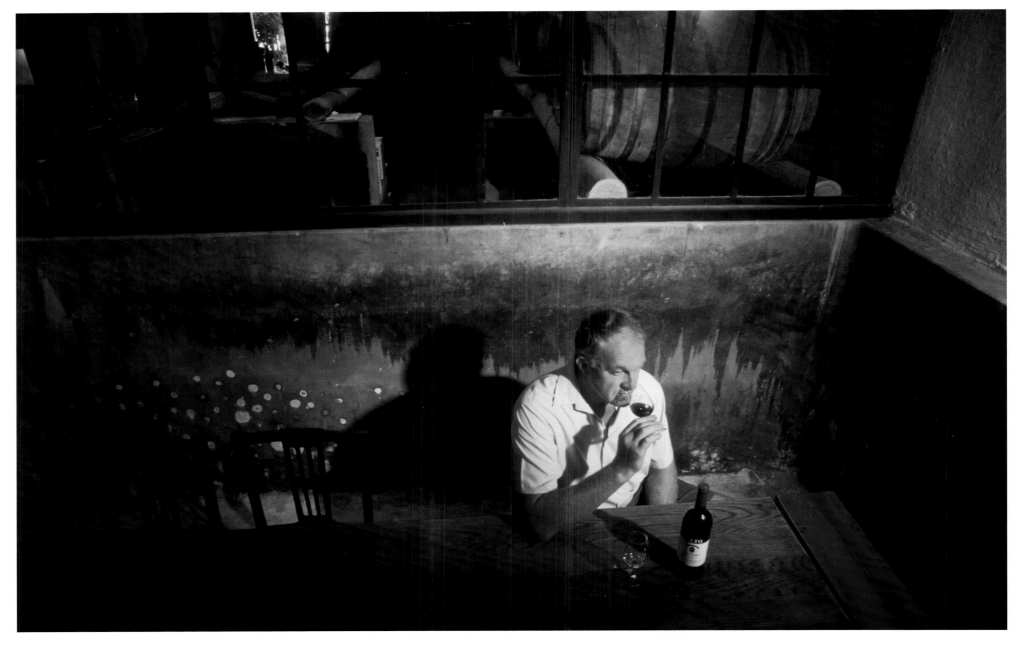

A CELLARMASTER OF NOTE

Alto's famous award-winning red wines are made by cellarmaster Schalk van der Westhuizen. A contemplative man of few words, he firmly believes that the magic of Alto's wines is produced by the vines and that he is simply there to assist the process. Schalk van der Westhuizen is steeped in the traditions of Stellenbosch's wine tradition: he was born on Alto's sister estate Neethlingshof, which his father, Gys, managed for 30 years. In 1973, newly graduated from Elsenburg Agricultural College, he took over the reins from his father to become farm manager and cellarmaster. Alto's flagship wine, Alto Rouge, is made from a blend of red varieties such as Cabernet Sauvignon, Shiraz, Merlot and Cabernet Franc.

ALTO WINE ESTATE

The Alto Wine Estate's association with wine production goes back more than 300 years; it was then part of a much larger farm called Groen Rivier. Its renaissance as a top wine producer dates back to the 1920s, when its bottles of red wine were first exported to London. Wine merchants were suitably impressed and immediately placed orders for the next five years. The overseas demand for the wine was such that the Malan family, who owned the farm at the time, were only able to release wine locally a decade later. Alto's reputation for producing award-winning red wine endures.

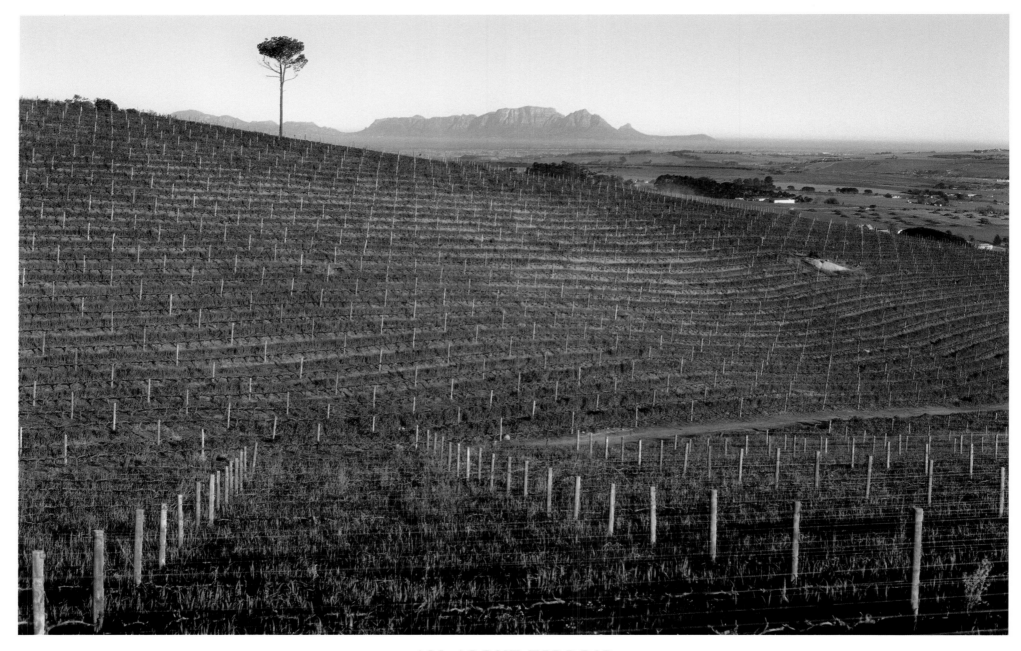

ALL ABOUT TERROIR

The Alto Wine Estate lies high against the Helderberg outside Stellenbosch, hence the name Alto, meaning 'altitude' in Latin. The dryland vineyards rise to 500 metres above sea level. In summer the estate's north-facing slopes are drenched in sunshine, and are cooled in the late afternoon by the sea breezes that blow in from False Bay. The result is vineyards that produce low-yielding, high-quality grapes that have ripened over a long period, preserving all of their complex flavours. The terroir is well-suited to the production of prizing-winning red wines. The estate's flagship wine, Alto Rouge, is made from a blend of red varieties such as Cabernet Sauvignon, Shiraz, Merlot and Cabernet Franc.

RED WINE COUNTRY

Alto Wine Estate lies in a part of Stellenbosch that local winemakers call the 'Golden Triangle', in recognition of its outstanding terroir. The Stellenbosch district is the oldest wine-growing and second oldest wine-producing area in the Cape winelands. Soon after his arrival at the Cape in 1679, Commander Simon van der Stel visited the area, then known as Wildebosch, and immediately recognised its agricultural potential. The town on the banks of the Eerste River flourished, and today the district is widely recognised as ideally suited to the production of premium red wine.

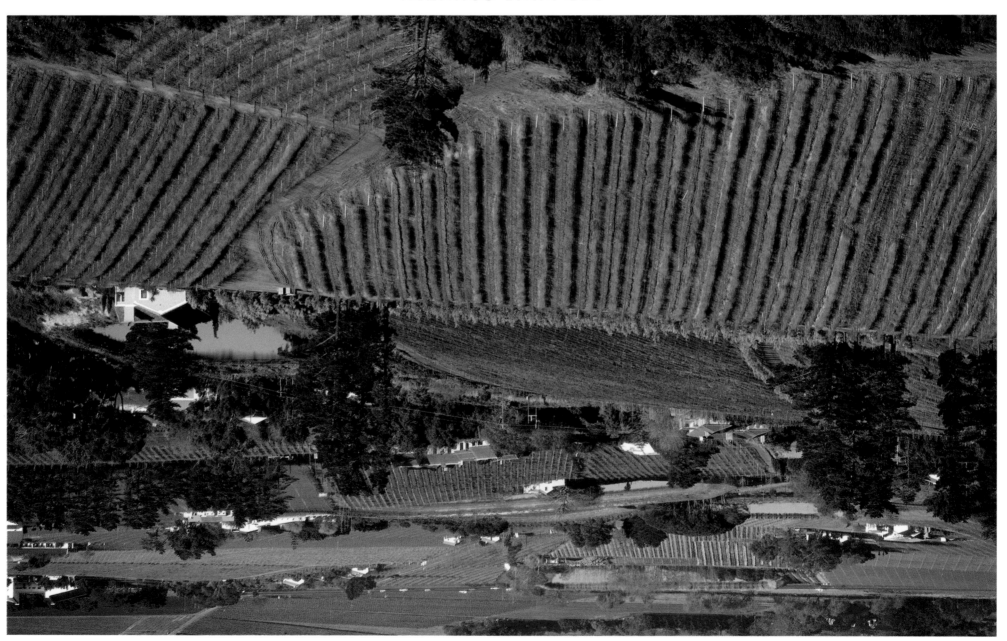

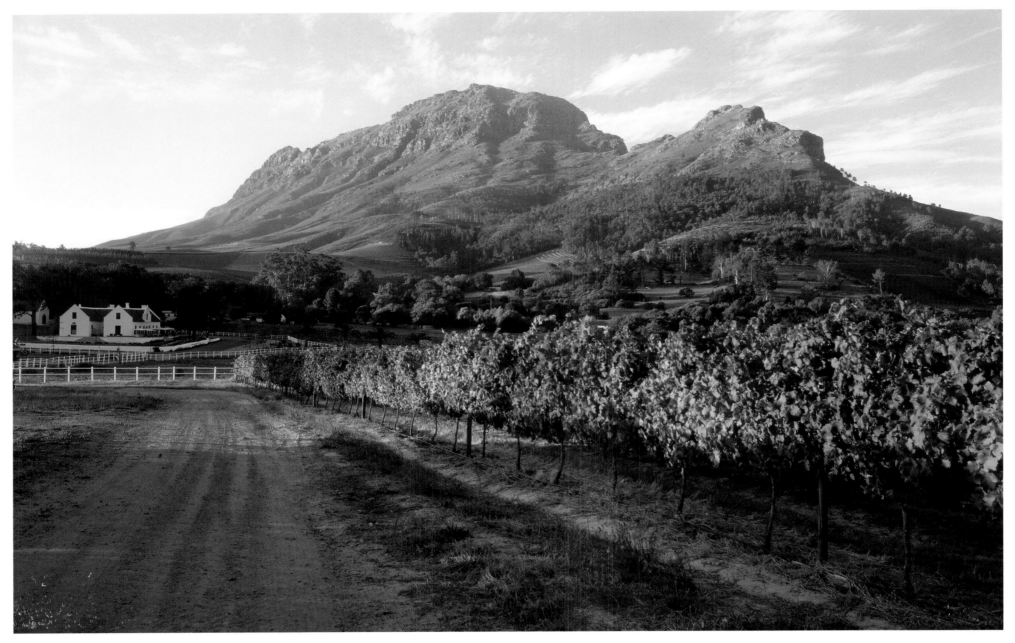

ZORGVLIET WINE ESTATE

Zorgvliet Wine Estate is in the Banhoek Valley near Stellenbosch. The farm was granted to an aspiring wine farmer, Casper Wilders, in 1692, and has a wine-producing history that dates back to the 1700s. The farm has 42 hectares under vines, of which more than three-quarters are red varietals. The estate produces wine under the Silvermyn (a reference to an old silver mine on the property), Le Pommier and Spring Grove labels.

HERENHUIS 1692 RESTAURANT

The backdrop of the Drakenstein Mountains at sunset is dramatic. The mountain range stands out in crisp relief, glowing pink, then red, then fading as night begins to fall. Zorgvliet's manor house has been restored in recent years, and is now home to the Herenhuis 1692 Restaurant. The high ceilings, wooden floors and fireplaces add to the romance of the setting. The restaurant serves traditional Cape cuisine with a more contemporary interpretation. The Boer general, CF Beyers, was born in the manor house in 1869. He later returned to Zorgvliet to take over the responsibility of running the family farm.

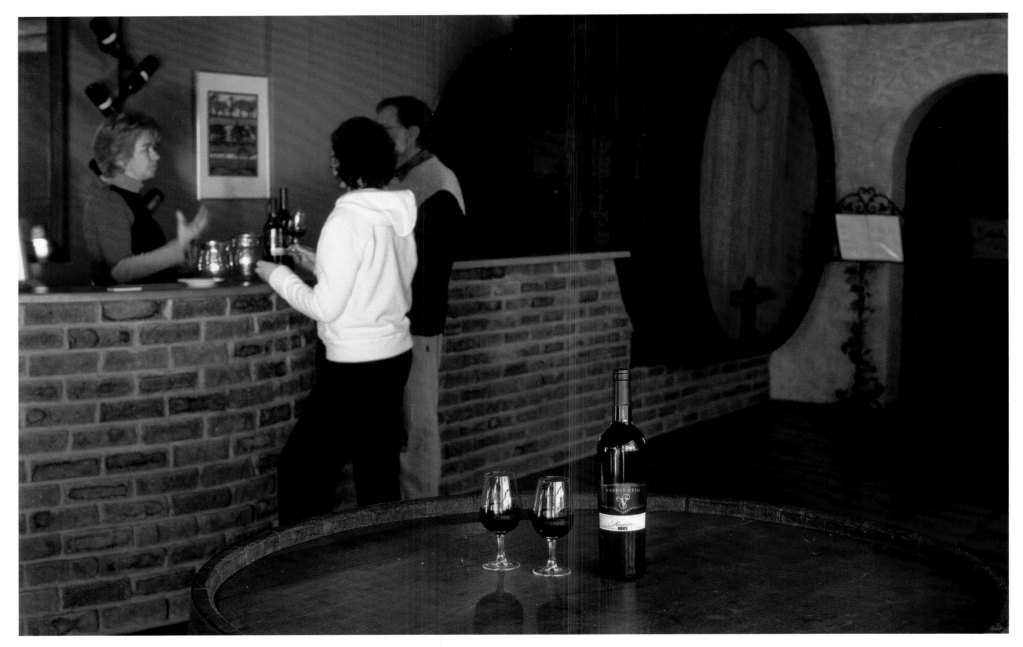

VREDENHEIM HOSPITALITY

Vredenheim's small wine production of around 15 000 cases (roughly half red, half white) is the wine of choice on this seventeenth-century Stellenbosch farm for the many who enjoy its restaurant, function and conference venues, or relax outdoors with a pre-prepared picnic. The Bezuidenhout family's consultant winemaker Fanie Cilliers caters for all tastes, from a sparkling wine to start, a Sauvignon Blanc, Chenin Blanc or Rosé to follow, Cabernet Sauvignon-Merlot-Shiraz blends for the main course, and a natural sweet dessert wine, Angel's, to finish. All the wines can be informally tasted in the historic old cellar.

A REST STOP AT VREDENHEIM

Situated 7 kilometres outside Stellenbosch, the Bezuidenhout family's rambling, rural Cape Dutch wine farm has a relaxed ambience. Angus cattle, horses, ostriches and several types of antelope dot the fields bordering the entrance driveway. The Barrique indoor/outdoor restaurant offers leisurely lunches and delightful dinners, while the coffee shop, Hudson's, prepares picnic baskets for visitors. Hudson's is also part of the Stellenbosch Arts and Crafts Route. Also at Vredenheim is Allhide - a purveyor of fine leather and game skins and a producer of a wide range of exquisite leather goods. The characterful old cellar, some 300 years old, provides a hushed ambience for tastings and hosts all sorts of festivities, from birthdays to weddings. Stroll through or say your vows in the rose garden and enjoy the views.

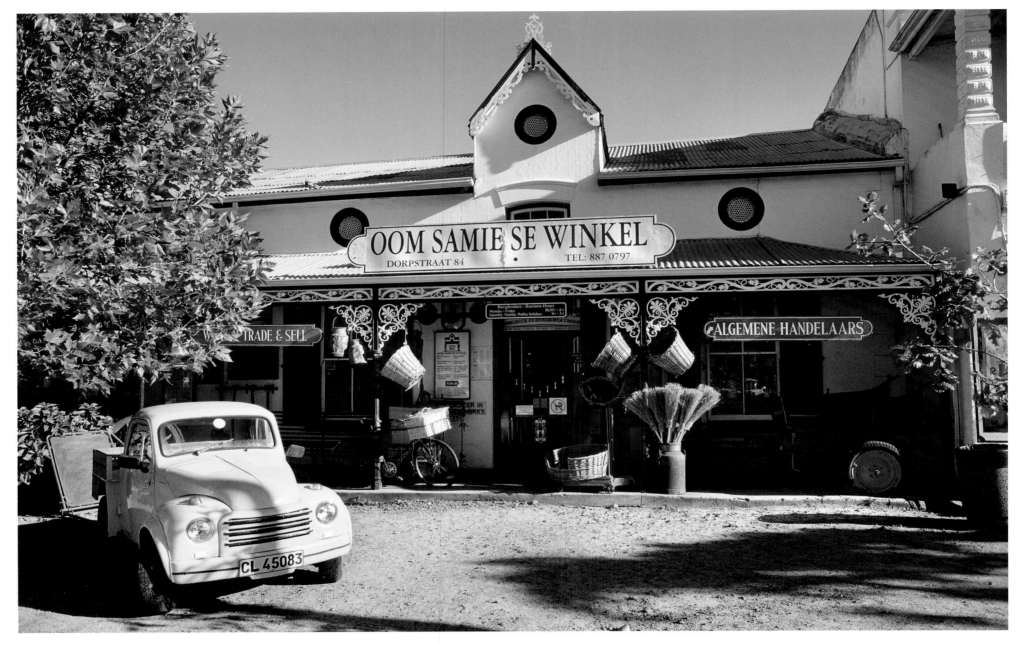

OOM SAMIE SE WINKEL

Cross the threshold of 84 Dorp Street in Stellenbosch and you step back more than a century in time. Yesterday's general dealer and today's collector's delight, Oom Samie se Winkel is magically filled with anything from antique postcards to prize-winning wines. Dried fruit, condiments, preserves and spiced rice cram the shelves. Ginger, cardamom, nutmeg, turmeric, curry and bay leaf – the scent of the spices mingles with that of tobacco and the saltiness of dried fish. It's not only visitors who browse and buy at Oom Samie's; locals too love shopping at the place – just as they have done since 1904.

OOM SAMIE'S OLD WORLD CHARM

A Stellenbosch landmark, Oom Samie se Winkel evokes childhood memories of visits to similar shops found in some towns throughout the winelands. For a brief moment, as your eyes adjust to the busy interior, you become the child standing on tip-toe against the counter. Clutching a few warm coins in a tiny fist, the child asks the lady behind the counter for a few pennies worth of boiled sweets. The sweets – with a little extra for good measure – are produced in a twisted cone of newsprint. In return, a brief 'thank you auntie' before the child disappears behind the horizon of jars and bric-à-brac.

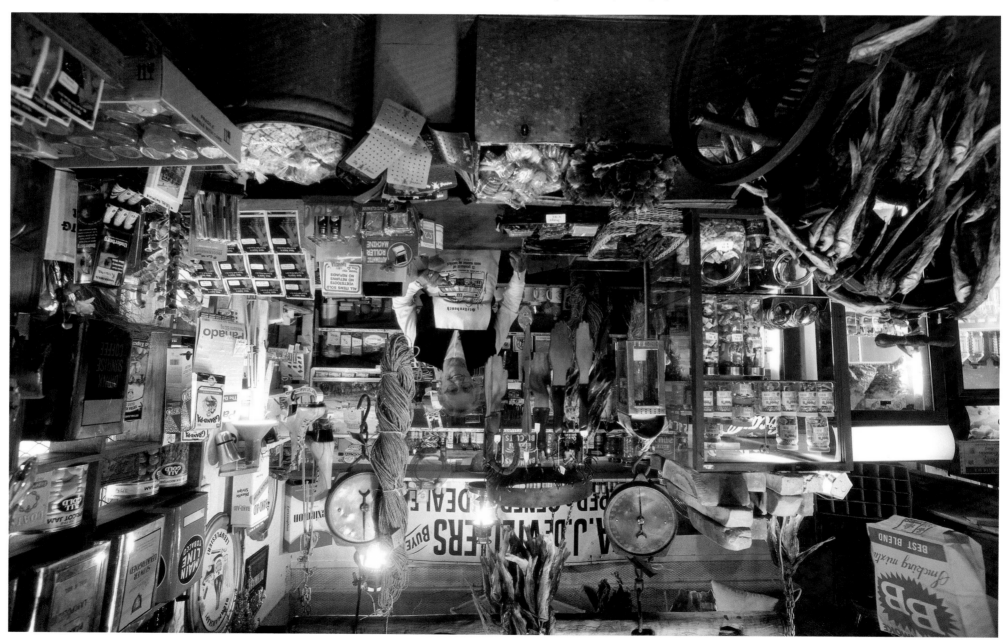

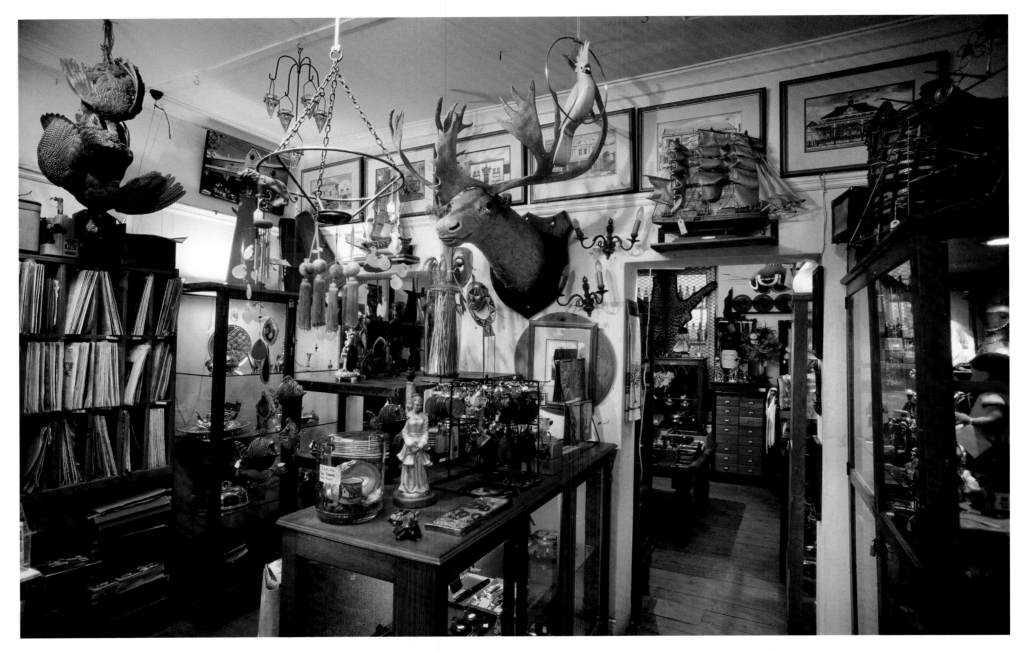

OF BOOKS, MOOSES AND OTHER HIDDEN TREASURES

This magpie's treasure trove in historic Dorp Street is filled with an eclectic mix of antiques, bric-à-brac and other hidden treasures. The legendary Oom Samie se Winkel holds a magical attraction and it's quite possible to spend hours browsing through the titles of dusty old books, read the personal notes on the backs of old postcards, or simply sit in the coffee shop and take in the atmosphere. Lovingly restored, the shop is a reincarnation of the 1904 general dealership, SJ Volsteedt Algemene Handelaar, that once belonged to Samuel Volsteedt. The charm and warmth that characterised the original shop is evident in the shop-cum-living museum established by Annatjie Melck when she bought the property in 1981.

BENCHMARK OF TRANQUILLITY

The country calm, the silent inertia of his 'companion' and the heat of midday induce a blissful catnap.

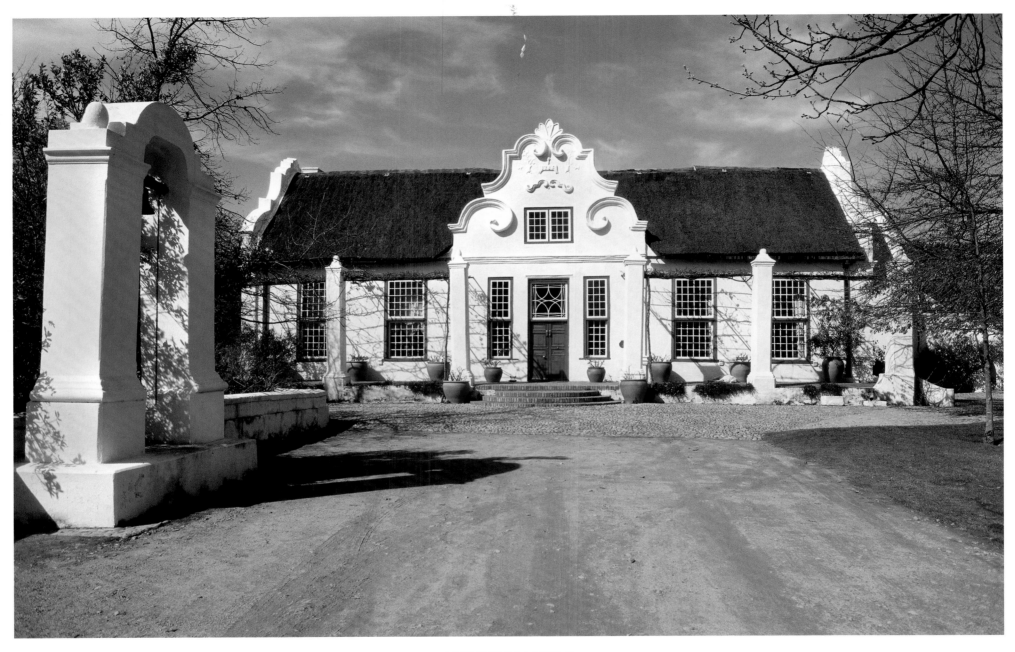

MORGENSTER

Morgenster lies in a secluded valley at the foothills of the Helderberg and Hottentots Holland Mountains near Somerset West. Three hundred years ago the farm was part of Governor Willem Adriaan van der Stel's sprawling private estate, Vergelegen. The estate was subdivided when the governor was recalled in 1708 on charges of corruption. Giulio Bertrand bought the 200-hectare farm in 1992 to produce premium olive oil and Bordeaux-style red wines under the Morgenster and Lourens River Valley labels. Morgenster's award-winning cold-pressed olive oil is a blend of Frantoio, Leccino, Coratina, Favoloza and Peranzana olives. The estate also does a white truffle-flavoured olive oil using truffles from Piedmont in Italy.

OAK VALLEY ESTATE

The Elgin Valley lies on a high inland plateau and the cool conditions are ideal for growing deciduous fruit, flowers and grape varieties such as Sauvignon Blanc, Chardonnay and Pinot Noir. The town of Elgin borders on the Kogelberg Biosphere Reserve, established to preserve the Cape's unique *fynbos* floral kingdom. At Oak Valley Estate tracts of land on the mountain slopes are also reserved to protect the *fynbos* growing on the farm. Estate owner Anthony Rawbone-Viljoen (left) and winemaker Pieter Visser (right) are behind the estate's successful Oak Valley wine label. The estate dates back to 1898, and was the property of Sir Antonie Viljoen who was knighted in 1916 for the reconciliatory role he played following the South African War (1899–1902).

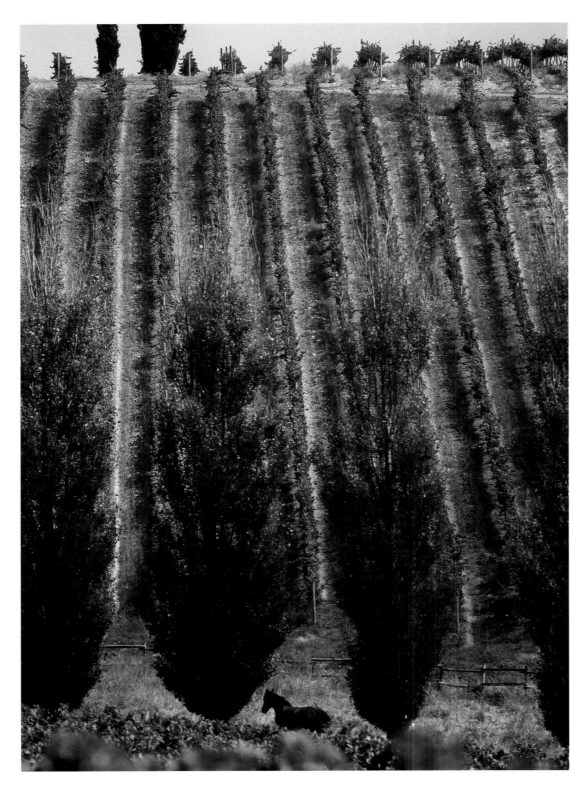

HAMILTON RUSSELL VINEYARDS

A row of Lombardy poplars waving in the breeze. Chardonnay vines marching in vertical lines up a steep, stony slope. This is the Hemel-en-Aarde Valley, a prime wine-growing enclave at Walker Bay on the Cape south coast pioneered by Hamilton Russell Vineyards in the 1970s. Producing multi-award winning and internationally acclaimed Chardonnays and Pinot Noirs that are still Cape benchmarks after three decades, Hamilton Russell, with its philosophy of terroir-driven wines showing 'individuality and expression of origin', encouraged a whole new generation of Cape vintners to return to the soil to find quality and distinctiveness in their wines. Viticultural development of Hemel-en-Aarde, now boasting several serious cellars, also brought a new cultural frisson to the valley and nearby coastal town of Hermanus. Historically a peaceful fishing village, in recent years transformed into a busy seaside holiday destination with excellent restaurants, hotels and guesthouses, and a vibrant local arts and crafts community, Hermanus is one of the best whale-watching spots along the southern Cape coast, welcoming the rejuvenated populations of southern right whales to their late-winter, early-spring Walker Bay calving grounds.

AFRICA – CRADLE OF HUMANKIND

Owner of Hamilton Russell Vineyards in the Hemel-en-Aarde Valley near Hermanus, Anthony Hamilton Russell has been an avid collector of Stone Age artefacts since he found his first Stone Age tool in 1994. He has an impressive collection of bored stones which were used as weights for San digging sticks (bottom right). Red ochre grinding stones and Acheulian hand axes were also found on the estate. The large hand axe (bottom left) was found in 1995 and was probably used by early humans to slaughter carcasses.

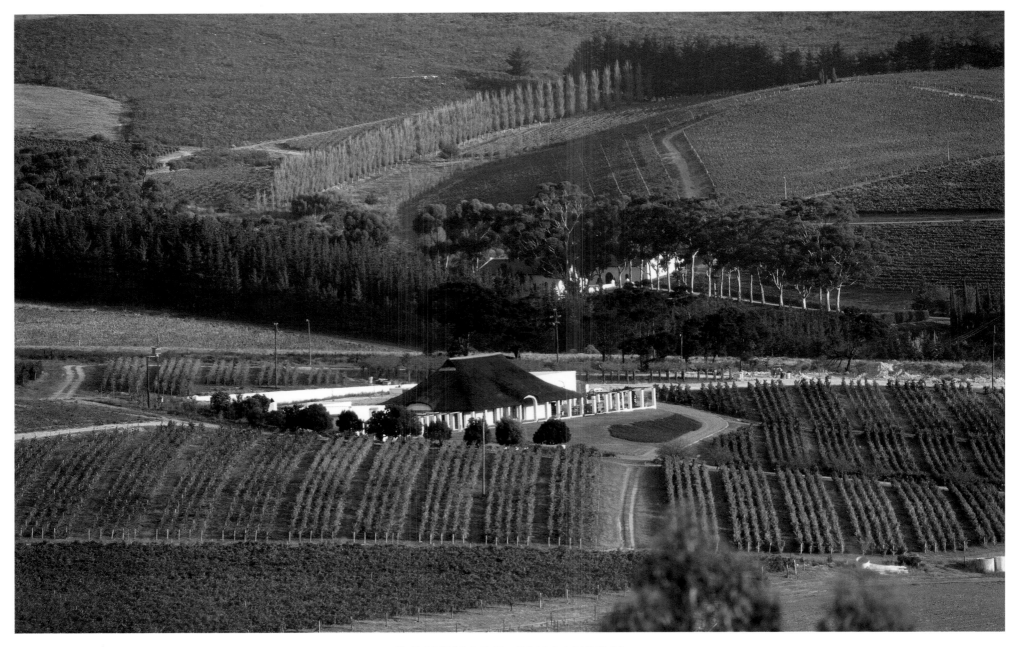

BOUCHARD FINLAYSON

The vineyards of Bouchard Finlayson lie in the western shadow of Galpin Peak in the Hemel-en-Aarde Valley, 10 kilometres from the village of Hermanus. The winery is in the centre of the maritime ward of Walker Bay – one of the coolest wine-growing regions in the Cape. The name Bouchard Finlayson evolved from the names of two of the original partners, Paul Bouchard of Burgundy, France, and Peter Finlayson, founder winemaker in the Hemel-en-Aarde Valley. The vineyards are densely planted in narrow rows, with every sixth row open to allow tractor access. The first wines of this renowned vineyard were produced in 1991.

OCEAN TRAVELLERS

At the end of every autumn, southern right whales can be seen cavorting in the sea off Hermanus near the Hemel-en-Aarde Valley. Each year they journey from their feeding-grounds in the Antarctic to the warmer waters of the Cape where they mate, calve and rear their young. In earlier times these whales were regarded as the 'right' kind to hunt: they provided high-quality oil and baleen, were easy to harpoon, and their bodies could be retrieved for processing. Since they were declared a protected species in 1935 their numbers have slowly increased. These whales have no dorsal fins, and individuals can be recognised by the pattern of the callosities (pale patches of roughened skin) on their foreheads and jaws.

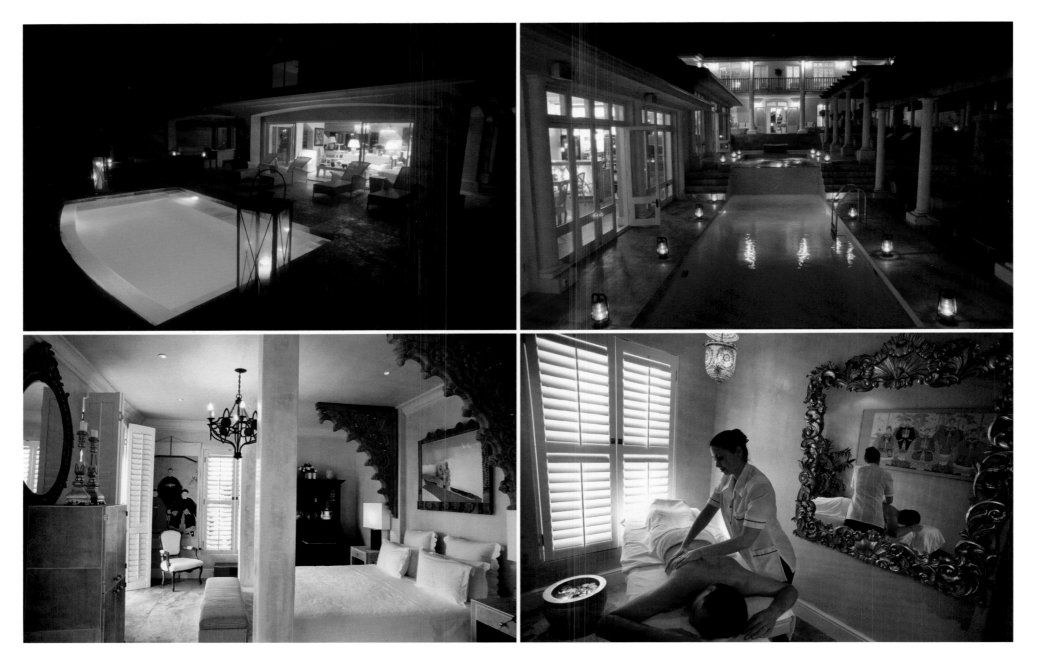

BIRKENHEAD HOUSE

If what you're looking for is tranquillity and some pampering to rejuvenate mind and spirit, the luxurious Birkenhead House on the edge of the Atlantic Ocean in Hermanus is the perfect destination. A wide selection of stylish, spacious suites, offering spectacular views of the sea and surrounding mountains, promises to restore peace of mind. Swimmers and sunbathers who prefer privacy to crowded beaches can relax amidst the elegant surroundings of a courtyard swimming pool. The cuisine, too, is world-class, with all meals prepared by an in-house gourmet chef. Those who are keen to venture further afield can stop for wine tastings at the renowned wine farms found in the Hemel-en-Aarde Valley. The hotel is named after HMS *Birkenhead*, a Royal Navy vessel that ran aground off Danger Point near Gansbaai in 1852.

A HAVEN FOR NATURE LOVERS

In the early 1900s it became fashionable in London to travel to Hermanus to take in its 'champagne air'. Once a small fishing village, the town continues to be one of the most popular holiday destinations in the Cape, especially for nature lovers. Hermanus has beautiful white beaches, rocky coves and a lagoon that attracts a wide variety of birdlife. More than 60 bird species have been recorded on the cliff paths, and 187 in the lagoon area. Birkenhead House is built on Voëlklip (literally, bird's perch) beach – a popular surfing spot. Grotto beach – the largest beach in Hermanus – lies further down the coast.

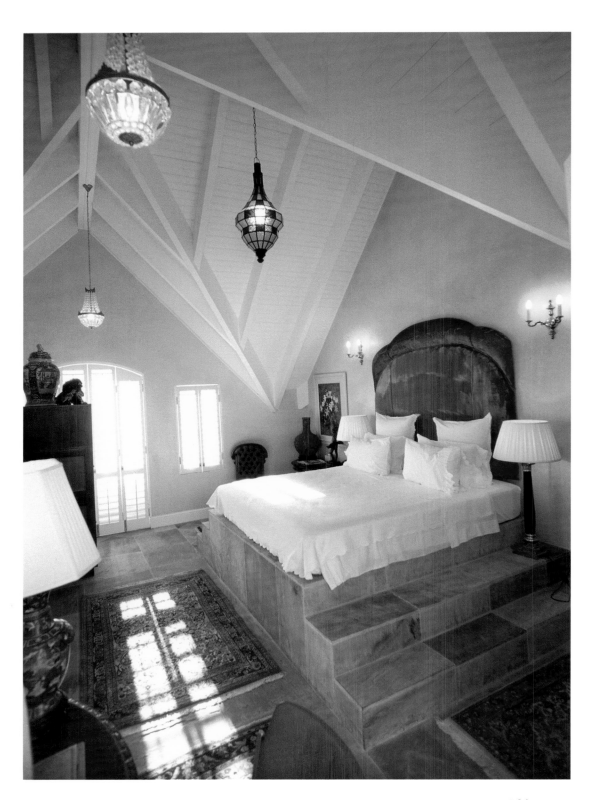

RETREAT INTO LUXURY

Birkenhead House was originally a holiday home, until the owners converted it into a boutique hotel in 2003. All the hotel's rooms are individually appointed. Broad sweeps of white echo the white beaches, surf and seagulls. The hotel also has a spa for guests and few things can beat a tranquil massage while the afternoon's sun bathes the room in diffused light.

A SACRED SPACE

A quarry-tiled floor and a free-standing stone bath echo the shapes of rocks, pebbles and the sea outside. Birkenhead House is perched on a cliff with an uninterrupted view of Walker Bay. In late autumn to spring, the bay is home to southern right whales that visit the coast to calve. Whales frequently swim just beyond the breakers of Voëlklip and Grotto beaches. They are often seen breaching in this area – launching their huge bodies out of the water, then crashing back into the sea in a huge splash of water and spray.

The town of Hermanus celebrates the arrival of the whales with a ten-day festival each year in September and October. A whale crier – as much a tourist attraction during the whale season as the whales – patrols the streets of the seaside town, and blows on a kelp horn to alert visitors to the presence of the whales. The crier writes up the day's whale sightings on a sandwich board. Each beach is listed with the number of whales sighted.

The southern right whale is a protected species; there are about 7 000 left and most of them visit the South African coast during their annual migration. Hermanus is considered one of the best whale-watching locations in the world.

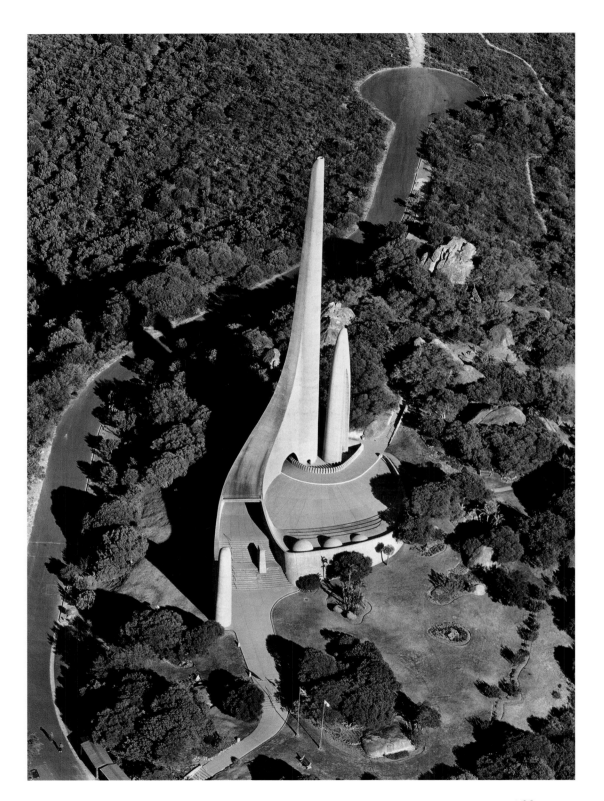

AFRIKAANS LANGUAGE MONUMENT

During the latter part of the nineteenth century, Paarl became the focal point in a debate around the issue of language and Afrikaner identity. The *Genootskap van Regte Afrikaners* – literally, Association of True Afrikaners – was founded in 1875 to unify Afrikaners around the issue of language. In 1975 the language monument was inaugurated to celebrate its centenary, as well as Afrikaans' multicultural roots.

The Afrikaans that developed at the Cape had its roots in Europe, Africa and the East. Despite the Dutch East India Company's efforts to retain the Cape's Dutch character, travellers visiting the Cape in 1671 noted that the language spoken at the Cape did not sound like the Dutch spoken in Europe.

Cape Dutch (Afrikaans) assimilated the Dutch and German dialects of the Company's soldiers, sailors, farmers and artisans, as well as the Dutch variants spoken by the Khoekhoen and the slaves.

The Khoekhoe inhabitants of the Cape had been trading with the Dutch mariners since 1595, and some spoke a variant of Dutch. The first slaves were brought to the Cape in 1654 to provide labour for the outpost. Many spoke a variant of Portuguese called Malay-Portuguese, a language that would be familiar to many of the Dutch sailors.

Cape Dutch was sometimes called Kitchen Dutch (*Kombuis Afrikaans*), in other words a language spoken by slaves and labourers.

PAARL

Paarl developed spontaneously along the banks of the Berg River and, unlike Stellenbosch, was never formally laid out. Suburbs interspersed with vineyards give Paarl its unique rural character. At first, small industries developed when seventeenth-century settlers continued to practise trades such as blacksmithing and carpentry while establishing their new farms. The road to the interior and to the newly discovered diamond fields of Kimberley also went through Paarl, and by the mid-nineteenth century Paarl had a thriving wagon-building industry. The industry also flourished during the South African War (1899–1902) and briefly at the start of World War I when the British army's demand for wagons escalated. Paarl's long Main Street and Berg River Boulevard still follow the sinuous course of the Berg River northward.

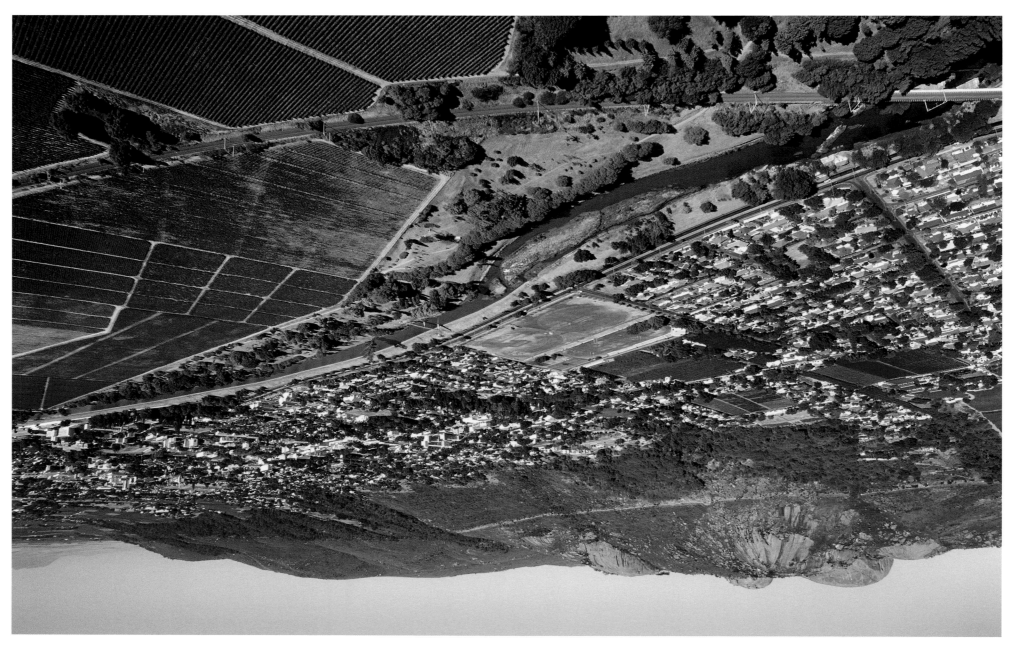

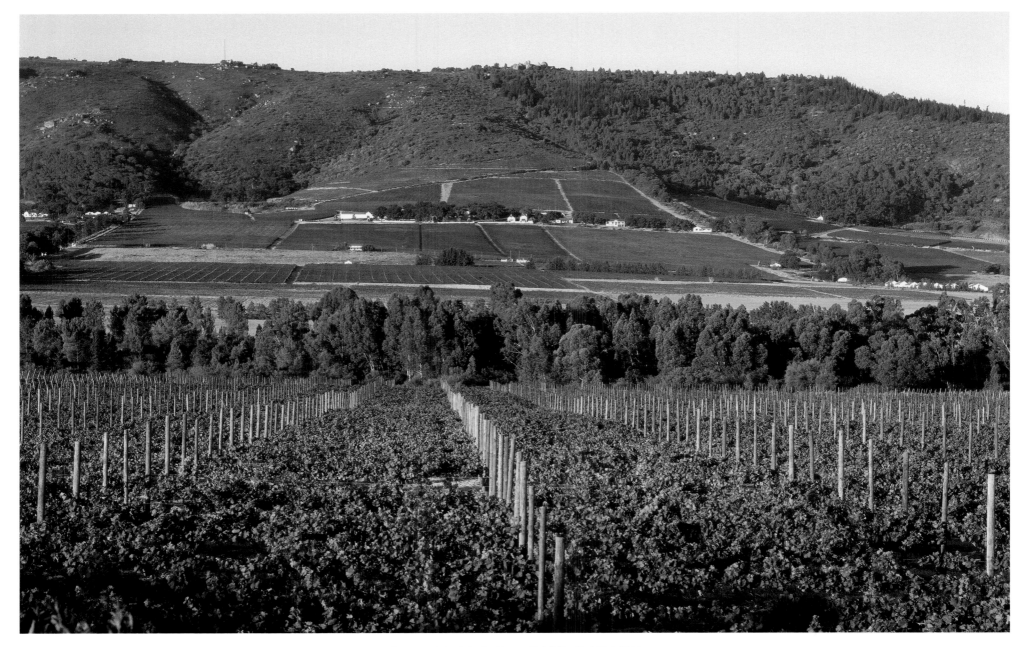

SEIDELBERG WINE ESTATE

Seidelberg farm is home to Elizabeth Lacey and David Jackson's Red Hot Glass Studio. The farm lies on the western slopes of Paarl Mountain and provides an inspiring view of the surrounding vineyards and wheat fields. The studio adjoins Seidelberg's De Leuwen Jagt Restaurant. Visitors are irresistibly lured into the studio's magical world, the translucent beauty of Venetian glass and the drama of the glass blower's art. Beyond the gallery, a furnace glows red and blue; its mouth yaws at a fierce temperature and invokes a Faustian scene of alchemy and magic. The studio specialises in installation art and has recently completed a series of totem-pole sculptures for a client in the United Kingdom.

THE RED HOT GLASS STUDIO

The ancient art of glass blowing is physically demanding – working temperatures range from 1 150 to 1 400 °C. Robert Lenner is a glass blower from the Czech Republic who works in the Red Hot Glass Studio on Seidelberg Wine Estate outside Paarl. The first blowing irons date to about 200 BC. The blowing iron is essentially a tube with a mouthpiece at one end and a knob at the other. A golden lump of molten glass is collected from the furnace and manipulated into shape on the 'marver', a polished block of iron. The glass is blown into the desired shape and then pinched and teased into more complex shapes. Once complete, the finished article is pinched off and the working stem removed.

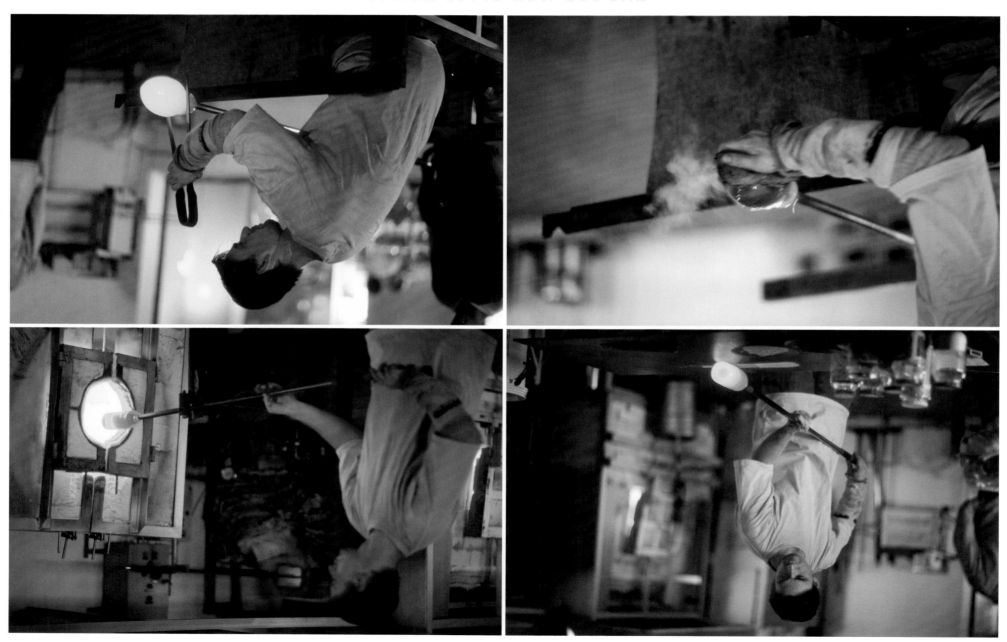

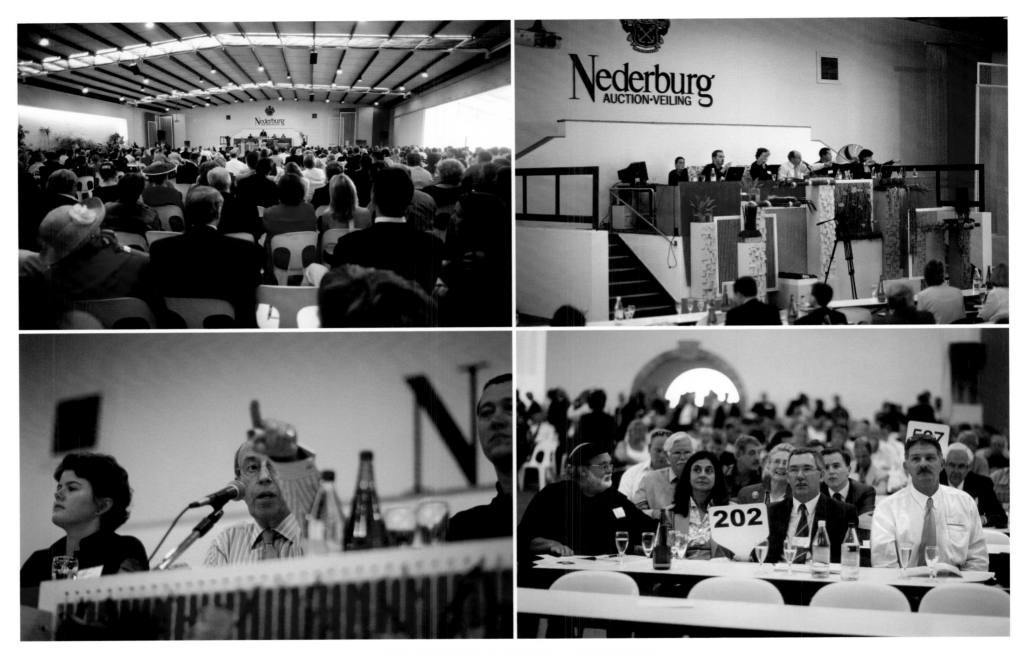

NEDERBURG WINE AUCTION

The Nederburg Wine Auction is an annual event that takes place every April on the historic Nederburg farm in Paarl. The auction is one of the oldest wine auctions in the New World, and showcases more than one hundred of the winelands' top estates, wineries and cellars. Auctioneer Patrick Grubb has presided over proceedings since its inception in 1974. The 30th Nederburg Wine Auction in 2004 attracted 1 700 local and overseas buyers from large retail supermarket groups, boutique wine shops and exclusive restaurants. At a recent auction the legendary 1974 Nederburg Auction Cabernet Sauvignon – considered one of the best red wines ever produced in South Africa – was on offer.

SANTE WINELANDS HOTEL & WELLNESS CENTRE

The Santé Winelands Hotel & Wellness Centre is a distant reflection on the opposite bank of a large dam in Simondium on the outskirts of Paarl. Here nature provides a perfect backdrop for a holistic approach to de-stressing and detoxifying body and mind. The emphasis is on wellness, relaxation, luxury and health. Vinotherapy is the centre's signature treatment. It is a specialist treatment that makes use of the health benefits of grape products. Crushed grape seeds and grapeseed oil are also applied in a massage or used as a body scrub. Grapeseed oil is believed to protect the skin from oxidation stress, and to improve circulation and rejuvenate the skin. The centre also caters for de-stressing classes in pilates, tai chi and yoga.

PAARL ROCK

The chain leads visitors to the top of Paarl Rock and is weathered and smooth to the touch. Every year thousands of visitors climb across the granite outcrop's barren and lunar-like surface for an unsurpassed view of Paarl and the Drakenstein Valley. The indigenous stock farmers who grazed their cattle in the Drakenstein Valley called the mountain Tortoise Mountain. The name that endured was Paarl – a corruption of the Dutch word for pearl. Early settlers placed a canon at the top of Paarl Rock and it was fired to summon the dispersed farmers to the Castle in Table Bay. Today the restored canon is fired on Heritage Day.

D'OLIJVENBOOM

Klaus Schrack is a master goldsmith and has his studio at D'Olijvenboom on Main Street in Paarl. He moved to the winelands from Namibia in 1995 and his work is inspired by the natural shapes and flowing lines presented by nature. Beate Schrack, also a goldsmith, manages the business side of the studio and landscapes the lavender soft lines of the garden. In the studio a string of seed pearls ends in a blister pearl. The pearl shimmers in the blues and grey shades of Paarl granite and echoes the shape of Paarl Mountain's granite outcrops. An ivory button worn by Ovambo tribesmen in northern Namibia is set in silver and 18-carat gold.

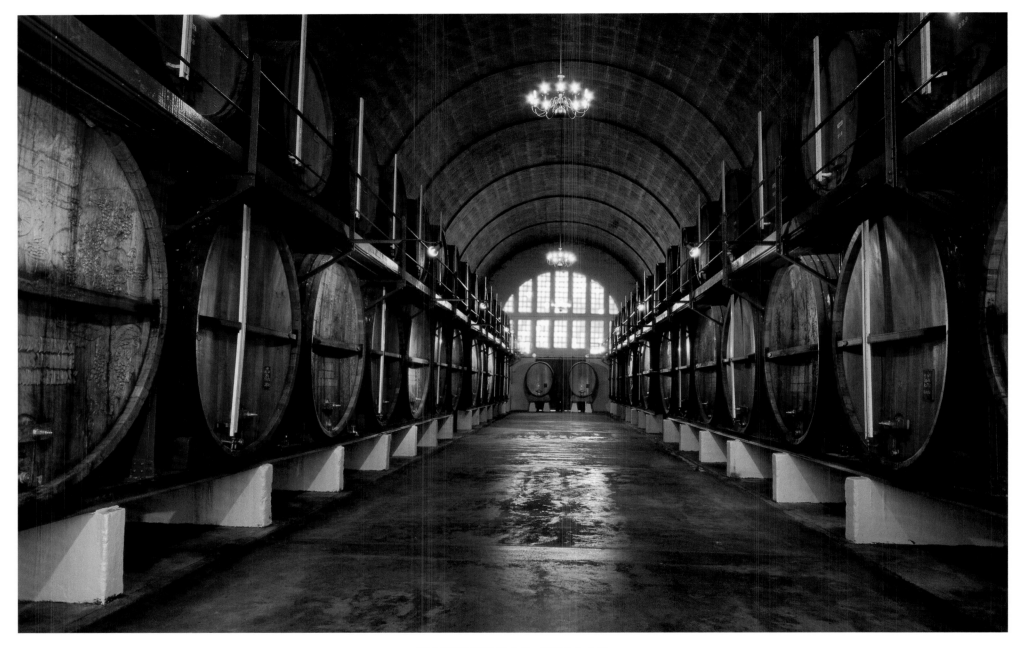

CATHEDRAL CELLAR

A Dutch poet visiting KWV's barrel maturation cellar in Paarl commented that it looked like a wine cathedral. So, ever since the 1930s, the cellar, with its dome-like ceiling, tinted windows and extraordinary acoustics, is known as the Cathedral Cellar. The double-volume cellar is used to barrel mature red wines as well as fortified wines. The original woodcarvings on the vats are the work of Karl and Karl-Heinz Wilhelm, a father-and-son team who completed the work in 1969. The carvings represent scenes from the history of winemaking in South Africa. KWV International's flagship range of wines carries the Cathedral Cellar name.

COLERAINE WINES

The Kerr's ancestry dates back more than 384 years to Roselick Farm outside Coleraine in Northern Ireland. Today, generations later, Clive Kerr produces award-winning wines on the family farm Coleraine in Paarl, South Africa. Coleraine released its maiden vintage in 1999 and produces Shiraz, Merlot and Cabernet Sauvignon under the Culraithin – a Gaelic derivative of Coleraine – label. The logo is designed after a medal awarded in 1853 by the Royal Agricultural Improvements Society of Ireland to Kerr's great-great-grandfather for 'the best crop of flax'. The 42-hectare farm also produces an easy-drinking red blend called 'Fire Engine Red' dedicated to a 1946 Dennis Fire Engine housed at the Paarl Fire Station.

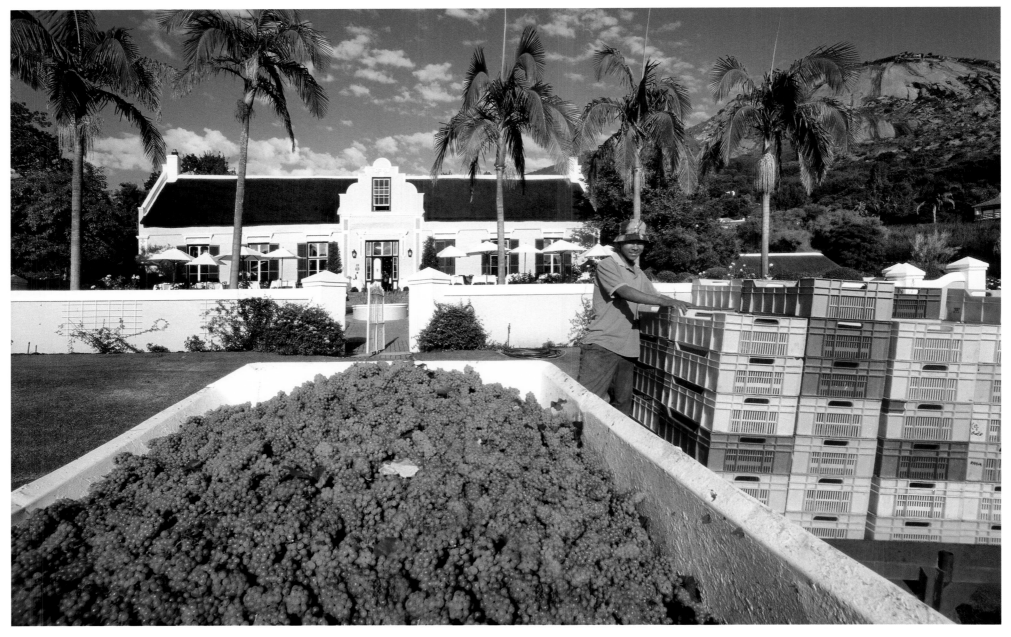

A WORKING FARM

The luxury five-star Grande Roche hotel is situated on a working wine and table grape farm in the heart of the Cape winelands of Paarl. Originally called De Nieuwe Plantatie, the farm dates back to the early eighteenth century. The lovingly restored historic buildings and surrounding farmland have been declared a provincial heritage site. Most of the table grape vineyards have now been replanted with Chardonnay, Shiraz, Merlot and Cabernet Sauvignon in anticipation of Grande Roche's very own wine.

LUXURY HOTEL SUITES IN THE VINEYARDS

Eighteen suites in terraces of three are dotted around the estate, some set in the vineyards, all with thatched roofs and shutters, in keeping with the estate's architectural character. Trailing vines overhang private terraces that have spectacular views of the vineyards and valleys surrounding the hotel. The tiny slave chapel, the quaint honeymoon suite with its rooftop private patio and the gourmet cuisine at Bosman's Restaurant have made Grande Roche a popular wedding destination both locally and internationally.

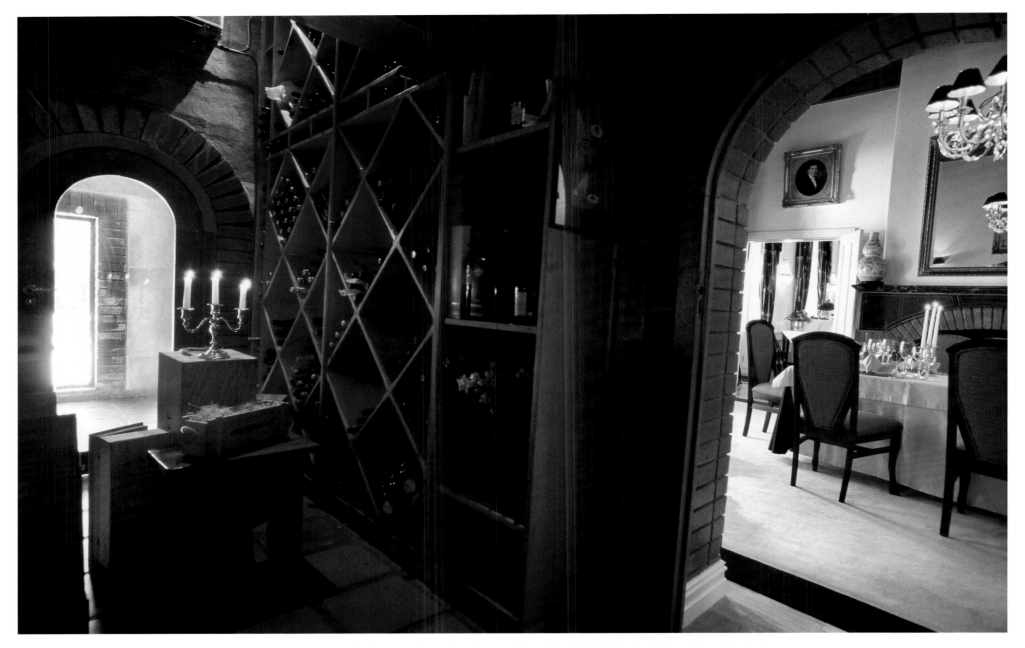

GRANDE ROCHE CELLAR AND PRIVATE DINING ROOM

This wine cellar at Grande Roche adjoins a small private dining room, the WA de Klerk Room, named after a famous Afrikaans writer and philosopher. The WA de Klerk Room makes an ideal venue for small dinner parties or conferences. Grande Roche's famous restaurant, Bosman's Restaurant, has clinched many international awards and is one of the top restaurants in South Africa. The restaurant's award-winning wine list has a selection of over 450 wines (with over 6 000 bottles in its maturation cellar). The success of Bosman's can be attributed to executive chef Frank Zlomke and his team. In 1999 he was inducted as Maître Rôtisseur into the Chaîne des Rôtisseurs, an international association of gastronomes.

BOLAND KELDER

Boland Kelder in Paarl was established in 1947 and has 96 producing shareholders. Boland Kelder's philosophy of teamwork and its market-driven focus on quality wines have paid off and the cellar has received several international and local awards. At the 2001 International Wine and Spirit Competition in London, Boland Kelder was awarded the prestigious Robert Mondavi Trophy for International Winemaker of the Year and the Dave Hughes Trophy for the Best South African Producer. At the same competition, the cellar also received the Warren Winiarski Trophy for the world's Best Cabernet Sauvignon and the Chris Hancock Trophy for the world's Best Shiraz. The Boland Kelder Shiraz repeated this performance at the 2003 International Wine and Spirit Competition.

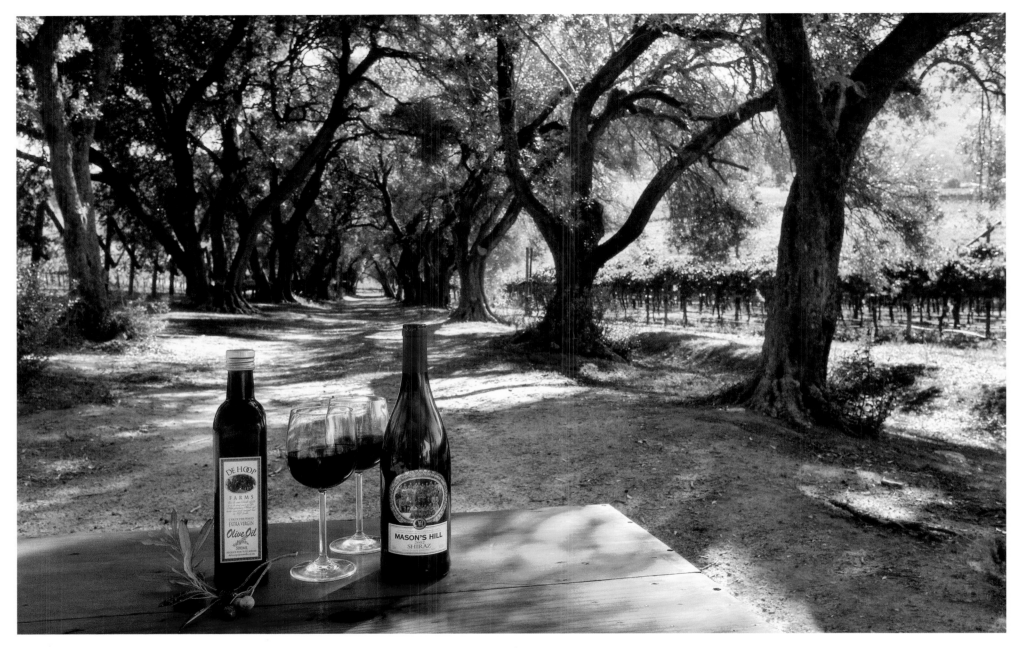

MASON'S HILL

An ancient avenue of olive trees on the farm De Hoop in Paarl bears patient testimony to many attempts to establish a viable olive industry at the Cape. Simon van der Stel tried to produce table olives from wild olive trees indigenous to the Cape, but found the berries too small and eventually declared the task impossible. Then, towards the end of the nineteenth century, Jan Minnaar, a Huguenot descendant, planted the first commercial orchards and began exporting prize-winning olives to London from his farm De Hoop. Local granite contractors – JA Clift – bought the farm in the 1960s to gain access to the quarry on the farm. De Hoop is still farmed by the Clift family and produces award-winning Shiraz – aptly called Mason's Hill.

ANCIENT CRAFT

There was a time when Paarl's streets rang with the sound of craftsmen working metal and stone. The road north passed through Paarl and it was the centre of the wagon-building industry. The blacksmith shoed horses and made wagon wheels. In the 1900s a Cornish stonemason settled in the town and became one of the first granite contractors in the country – JA Clift. The firm was responsible for the building of familiar landmarks such as the Huguenot Monument in Franschhoek and Rhodes Memorial in Cape Town. Many firms like JA Clift employed blacksmiths to keep their tools in good working order. The museum is a recreation of their old blacksmith's shop and commemorates the role the blacksmith played in the town's history.

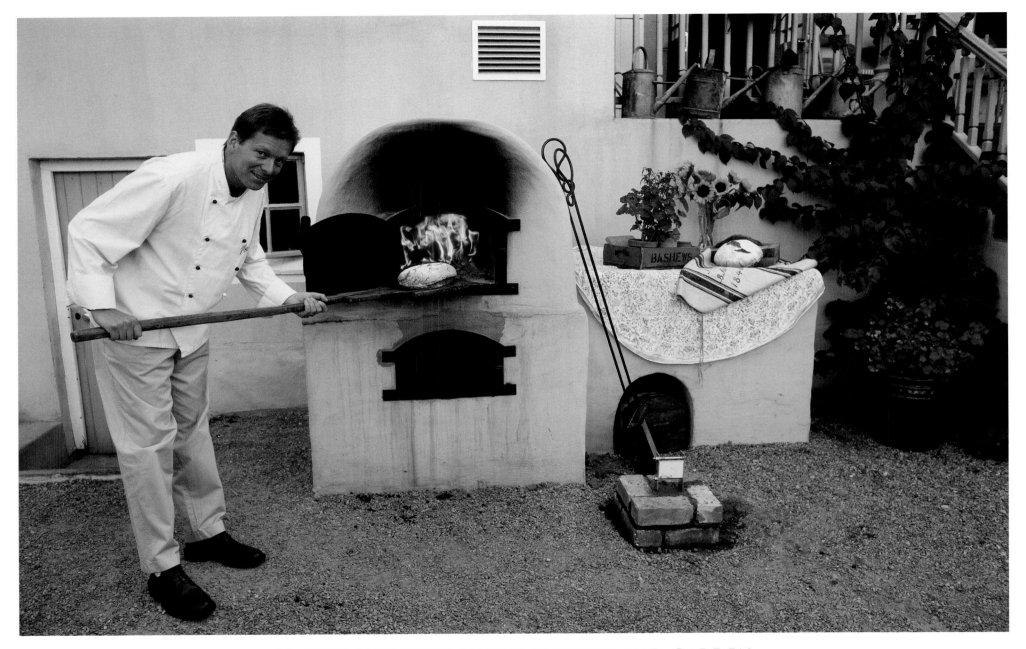

MARC'S MEDITERRANEAN CUISINE AND GARDEN

Marc Friederich loves bread and enjoys preparing meals in the outdoor oven of his restaurant situated in the shadow of Paarl Mountain's 50 million-year-old granite boulders. Good bread begins with good flour, preferably stone-ground flour, and the best bread is baked in a raw clay brick oven. The oven bakes fish in a salt crust and chicken in a clay crust to perfection. The design is hundreds of years old and still works its magic.

MEDITERRANEAN MAGIC

On entering this Provençal farmhouse-style restaurant, one immediately senses the passion that has gone into creating a truly excellent dining experience, with fine fare, superb wines and good company being the order of the day. A warm, elegant lounge and convivial wine and cigar bar provide just the right surroundings for those waiting for a table or simply wanting to take a break from the day. Owner Marc Friederich, an award-winning sommelier, has employed the services of chef extraordinaire, Thomas Talkner, originally from Austria. With a philosophy of keeping the food simple and light, it's no surprise that Marc's Mediterranean Cuisine and Garden received the Johnnie Walker Best New Restaurant in the Winelands Award for 2003.

WORKING WITH VARIETY

Andries Rabie, co-owner of Willow Creek Olive Estate and vice-chairman of the South African Olive Growers Association (SAOGA), passionately believes in the health benefits of olive oil. During the past decade, in excess of a hundred hectares of high-density plantations of olive trees under open hydroponics have been established on the estate. Cultivars include Frantoio, Leccino, Coratina, Favalosa, Noccelara, Kalamata and Mission. SAOGA is working towards setting chemical and organoleptic standards for Extra Virgin Olive Oils on the South African market.

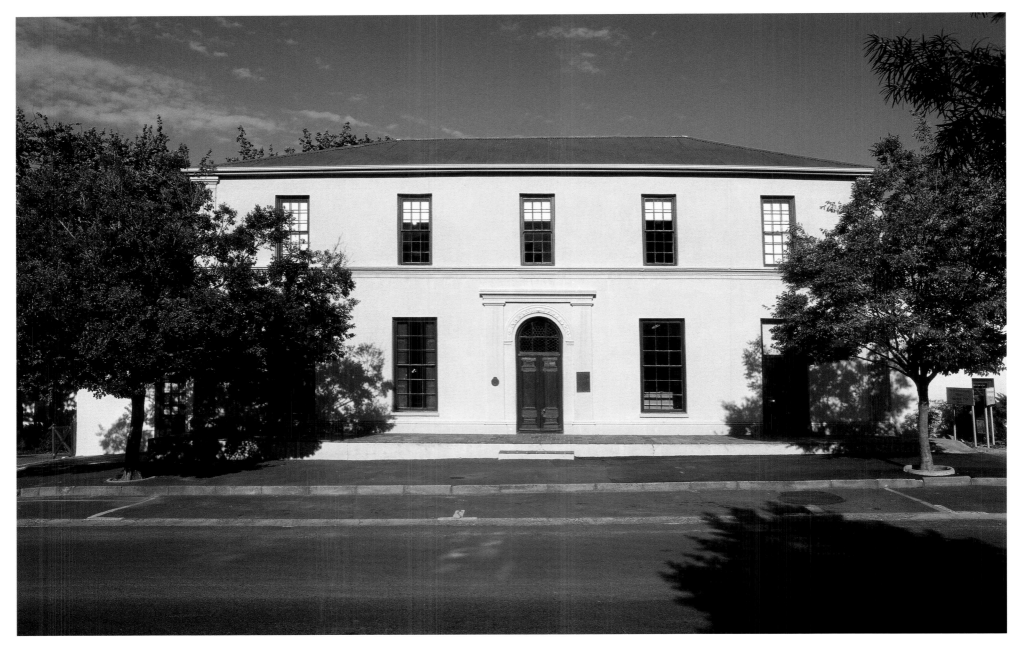

GIDEON MALHERBE HOUSE

The *Genootskap van Regte Afrikaners* (Association of True Afrikaners) was established in 1875 in the house of the Paarl wine farmer and businessman, Gideon Malherbe. Today his house is home to the Afrikaans Language Museum. The association wanted to promote the use of Afrikaans and immediately set about publishing a newspaper. The *Afrikaanse Patriot* first appeared in 1876 and had 50 subscribers. By 1880 subscriptions had increased to 1 700, and the *Patriot* was read far beyond the boundaries of the Cape Colony. The newspaper's popularity was short-lived, and it closed in 1904. The *Afrikaanse Patriot* was the precursor of the *Paarl Post*, the current local newspaper of Paarl.

SJ du Toit

SJ DU TOIT

Rev. SJ du Toit, the co-founder of the *Genootskap van Regte Afrikaners*, was born on the historic farm Kleinbosch in Daljosaphat between Paarl and Wellington in 1847. He was a descendant of the French Huguenot François du Toit who settled at Kleinbosch below the Du Toit's Kloof Pass in 1692. SJ du Toit was the first pastor of the Toringkerk and a passionate supporter of the new Afrikaans language movement. In 1875 he became the editor of the first Afrikaans newspaper in Paarl, The *Afrikaanse Patriot*, and wrote under the penname of 'Een Ware Afrikaander' or 'A Genuine Afrikaner'. Another Afrikaans newspaper called *De Bode* was already in print in Genadendal. In 1881 Du Toit accepted a post in Paul Kruger's government and moved to what was then known as the Transvaal. Ten years later he returned to Paarl and settled on the family farm Kleinbosch.

RIDGEBACK WINES

The Ridgeback dog is an integral part of the southern African farming landscape. Its ancestors followed nomadic stock farmers long before the first Europeans settled in Table Bay. The dog is often called the African lion dog – a tribute to its bravery, stamina and hunting skills. The breed was eventually standardised and is now called the Rhodesian Ridgeback. In 1997 three tobacco farmers from Zimbabwe and Malawi moved to Paarl with their Ridgeback dogs to make wine. They bought a 60-hectare parcel of land on the southern slopes of Paarl Mountain, renamed it Vansha Farms Ridgeback, and began the arduous task of replacing fruit orchards with vineyards. To date 32 hectares have been planted. Their varietal mix includes the less frequently planted Mourvèdre and Viognier.

NATURE'S NECTAR

The Ridgeback theme runs through the design of the Ridgeback wine label – a copper-foiled dog with its master's hat held firmly in its mouth against a black background. The Ridgeback Shiraz – a grape that thrives in the warm climate of Paarl – is the farm's award-winning flagship wine and is made in a soft, spicy style. A second label – Vansha Savignon Blanc – depicts two Egyptian geese in flight. Egyptian geese are usually seen in pairs in wetlands and on dams, and are sometimes also sighted in surrounding fields and vineyards.

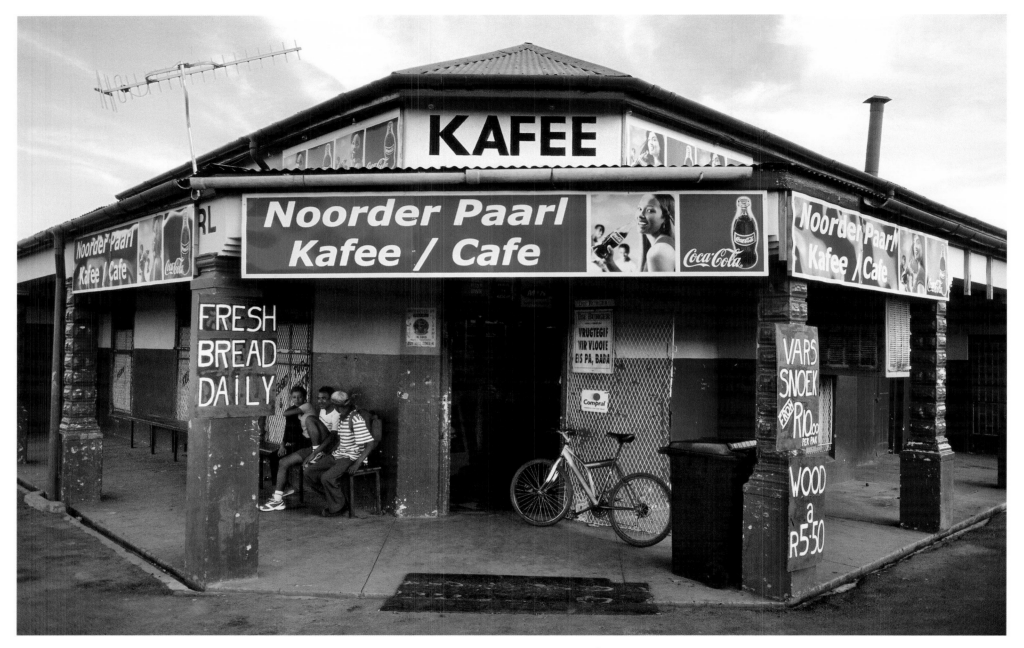

THE CORNER CAFÉ

Siesta time, a lull in the traffic. The dark interior of a village café provides a cool haven and place to stop for a gossip and a chat. Packets of crisps, sweets, pantyhose and deodorant jostle for space on the counter. This café in Noorder Paarl is a punctuation mark at the northern extreme of Paarl's 7-kilometre-long Main Street. Outside in the bright glare of the summer afternoon, handmade blackboards advertise the stock trade – fresh bread, fish and firewood.

PAARL PLEASES THE PALATE

Though a little further inland from Stellenbosch and its many False Bay-facing aspects, Paarl is also considered part of the Coastal winelands region. The south-western end of the valley is open to Table Bay, but the maritime influences from the south are tempered by mountains (Simonsberg, Groot Drakenstein and central landmark Paarl Mountain). Yet Paarl's varying sloping terroirs provide good, cool, clay-based granite and Malmesbury shale for premium-quality grape growing. And the typically Mediterranean conditions, generally hotter and more arid than Stellenbosch, favour wine styles that are fruit-rich and accessible.

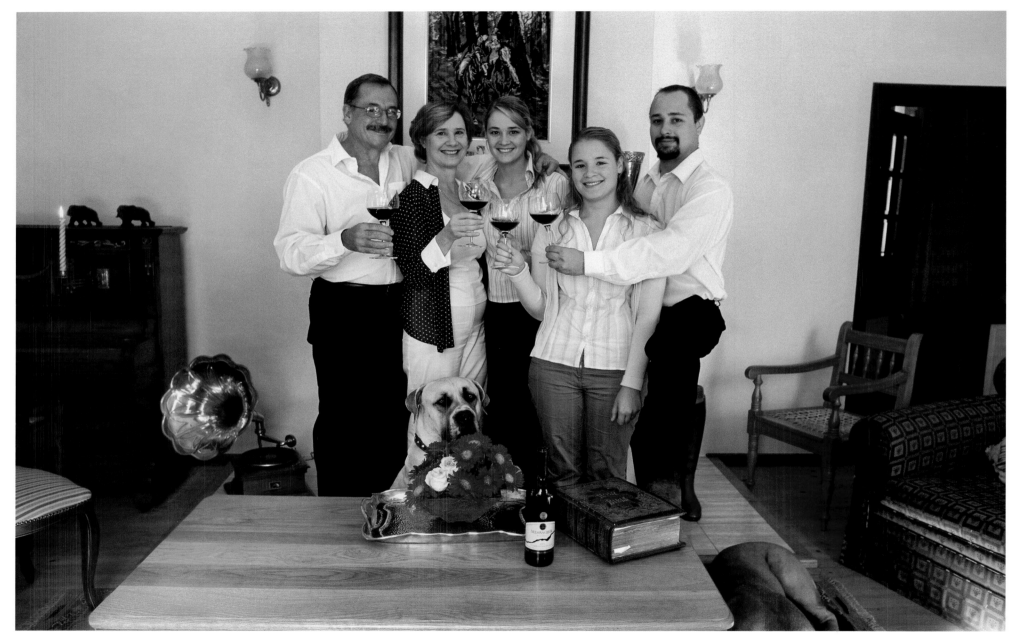

A FAMILY'S PASSION

Alan Nelson, a Cape Town senior advocate, fulfilled a lifelong dream to farm when he bought a run-down estate outside Paarl. He renamed his 132-hectare farm Nelson's Creek and set about planting 58 hectares with vines. The whole Nelson family takes a personal interest in the farm: Alan Nelson and his wife Marguerite, daughters Jo-anne and Lisha, and son Danny are passionate about the wine produced by the estate. Lisha Nelson will also play a more active role in the running of the estate when she completes her B.Sc. degree in viticulture at Stellenbosch University.

DESIGNING FINE WINE

Nelson's Creek has a unique wine label. Owner Alan Nelson was inspired by an aerial map of the farm which showed a stream bisecting the property. When his wife Marguerite saw the new label, she suggested that the design includes a 'tear' to symbolise the creek. Since acquiring the property in 1987, Alan Nelson has put the advice of prominent viticulturists to good use and replaced most of the old vines with noble cultivars. A state-of-the-art wine cellar was completed in 1995. The work was well-directed: the following year Nelson's Creek won an award for the best Chardonnay in South Africa and was named Champion Private Wine Producer in the Boland region.

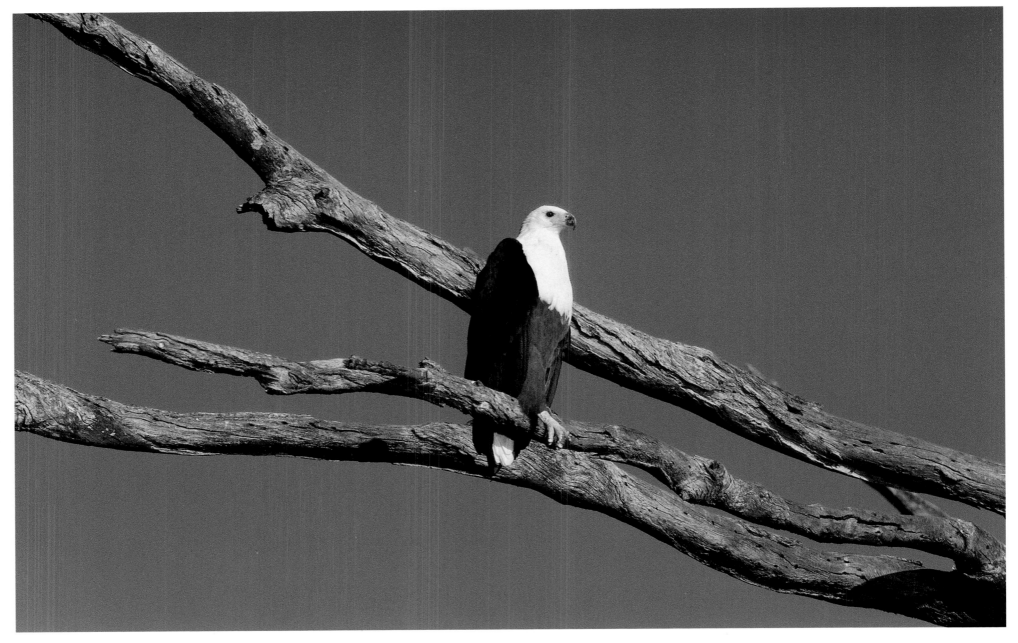

AFRICAN FISH EAGLE

An African fish eagle rests on a branch of a dead tree near a dam on Nelson's Creek. The birds are usually seen in pairs, riding the thermals high above dams and over rivers, always on the lookout for fish swimming near the surface of the water. Once a fish is spotted, the fish eagle swoops down across the water with outstretched talons, snatching the fish in a single motion, a quick spray of water the only evidence of the catch. Fish eagles have a distinctive call evocative of Africa. The birds have become a familiar sight in Paarl since a breeding pair established themselves at the nearby Paarl Bird Sanctuary a number of years ago.

NELSON'S CREEK WINE ESTATE

Nelson's Creek Wine Estate lies 65 kilometres from Cape Town in a landscape of vineyards and olive orchards. In the west, the Drakenstein Mountains form the western boundary of the Berg River Valley. The estate's vineyards thrive in soils of mixed shale and granite with a deep underlying clay structure that improves water retention. During the summer months a cool afternoon breeze blows in from the south to create an ideal microclimate for grape growing. The estate was one of the first to embark on an empowerment programme for its workers, who now produce their own wine under the New Beginnings label.

NEW BEGINNINGS

The South African wine industry has recently seen a number of empowerment projects. Alan Nelson of Nelson's Creek donated 9.5 hectares of vineyard to the farm workers on his farm in Paarl in 1997. The project was aptly named New Beginnings and was the first black empowerment project in the wine industry. The New Beginnings label is an artist's rendition of a family – underscoring the project's emphasis on community. The wine is sold in South African retail outlets as well as in the Netherlands, the United States and Japan, and more recently, France and Germany. The project has also inspired consumers to support the fledgling winery with further donations. New Beginnings won the Peace Gardens award for emerging farmers in 2000.

EMPOWERING FARM WORKERS

New Beginnings – the first black empowerment project in the winelands – received a lot of press coverage from the local and international media. Yet the media coverage was nothing compared to the transformation of the community of farm workers. As one worker put it, 'For the first time, instead of taking instructions, we are doing it our way.' Many workers were illiterate, but most had a wealth of practical experience to invest in the project. There was also much to learn about costing, patience, debt control and commitment, and about making an impact in a very competitive wine market. Now, six years into the project, New Beginnings is ready to add another 5 hectares to the Cabernet Sauvignon and Pinotage vineyards that are already in production.

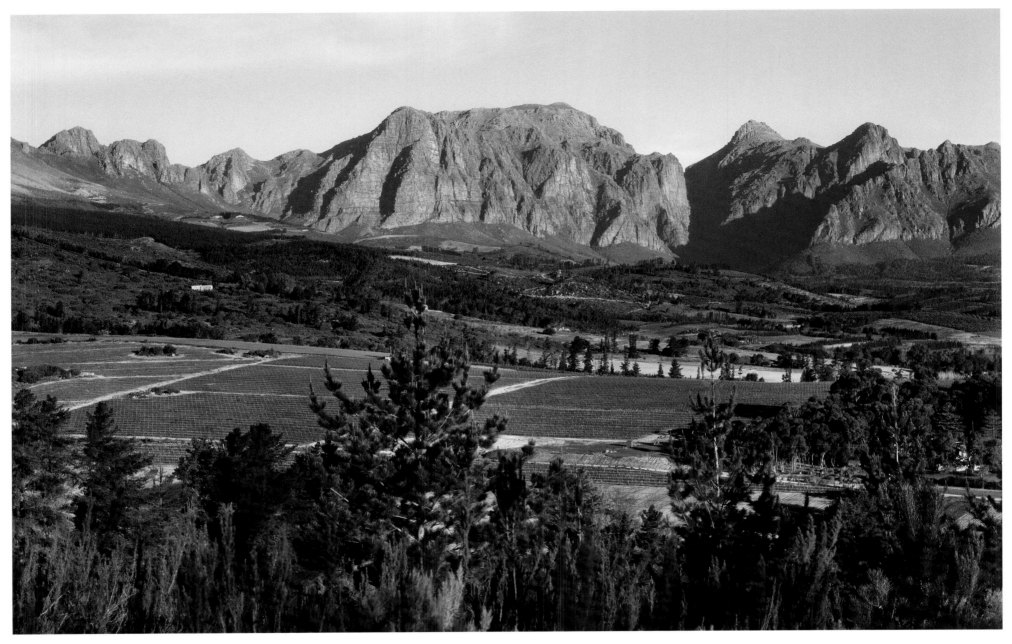

DIEMERSFONTEIN WINE AND COUNTRY ESTATE

Diemersfontein lies at the foothills of the Hawequas Mountains outside Wellington. It is owned by David and Sue Sonnenberg, the third generation of Sonnenbergs to live on the estate. The farm was originally bought by Max Sonnenberg in the early 1940s to use as a country retreat. Sonnenberg was a member of Parliament and co-founder, with his son Richard, of a leading South African retail chain store. David and Sue Sonnenberg sponsor local artists, providing them with materials and a place to work. They are also patrons of a private school – Wellington Preparatory School – housed on the estate.

CELEBRATING THE SEASONS

The rejuvenation of this eighteenth-century former fruit farm into the pride of Wellington's winelands by new owners David and Sue Sonnenberg is reflected in the contemporary new restaurant Seasons. Head chef Brigitte Rösemann creates dishes that combine simplicity and sophistication. A typical dish may be delicately grilled salmon with seasonal herbs and vegetables. Accompanying the fine cuisine, Seasons' wine list includes the Diemersfontein premium range as well as the Carpe Diem flagstone range of reds (award-winning Pinotage, Merlot, Shiraz, Cabernet Sauvignon). Overlooking the estate's farm lake and horse paddocks, with the blue backdrop of the Drakenstein Mountains in the distance, Seasons offers guests a unique food and wine experience. Recently opened, Seasons' Deli offers guests the opportunity to take home such delicacies as smoked quail, homemade pestos, olives, a variety of oils and delicious breads and cakes.

THE DUKE AND DUCHESS OF WELLINGTON

The Duke and Duchess of Wellington were the guests of honour at the Wellington Guild of Fine Wine's inaugural charity ball in 2004. The gala event was held at the Diemersfontein Wine and Country Estate in Wellington to launch the guild and its educational trust fund. Nestled in a fertile valley near Paarl in the Cape winelands, Wellington was named after the 8th Duke of Wellington's famous forefather who defeated Napoleon at the battle of Waterloo in 1815. It was the Duke's first visit to Wellington.

THE DUKE'S BLEND

The Wellington Guild of Fine Wine was launched at a charity ball in February 2004. The occasion was marked by a commemorative issue of The Duke's Blend, signed by the guest of honour, the 8th Duke of Wellington. The Guild was formed by a group of private wineries in Wellington and has 14 members including Diemersfontein, Doolhof, Hildenbrand, Klein Optenhorst, Nabygelegen, Linton Park, Siyabonga, Upland, and Welgegund. Members meet regularly to exchange information and monitor quality standards.

The Wellington Guild also launched the Wellington Wine Producers Educational Trust to improve educational facilities in the region and address fetal alcohol syndrome among local children, especially those in disadvantaged communities. Children with fetal alcohol syndrome are likely to experience learning difficulties. The trust will develop a community-based intervention programme using experienced community workers to mentor the project.

The proceeds of the evening's wine auction and sales went to the educational trust. The Duke of Wellington agreed to be the patron of the trust.

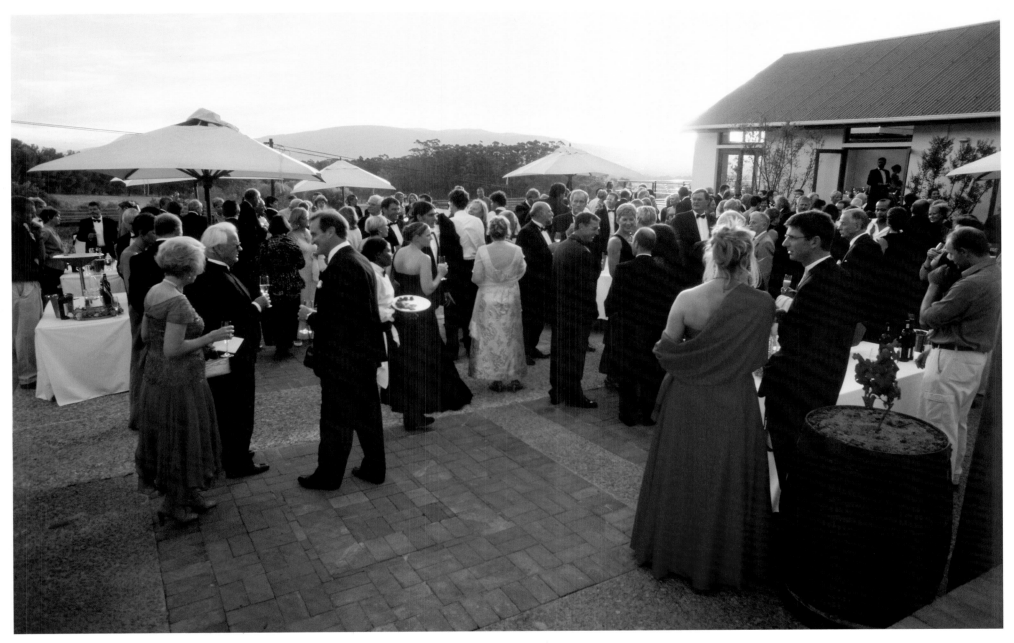

A COUNTRY AFFAIR

As the sun set over the Drakenstein Valley, guests arrived at the Diemersfontein Wine and Country Estate for a gala charity event organised by the Wellington Guild of Fine Wine. The more than 300 guests mingled and dined to the nostalgic rhythms of the Johnny Cooper Brass Band, while the Wellington Guild of Fine Wine treated guests to Wellington's best wines and finest food.

HOUSE OF FINE WINES

Whilst Bellingham is one of South Africa's oldest labels, it's also one of its most dynamic and inspired. The recently completed Bellingham cellar in Wellington is a state-of-the-art modern winery accentuated by clean architectural lines punctuated by tall palm trees. It's here that the legacy of Bellingham is continued by the current generation of winemakers who have an enduring passion to craft world-class wines.

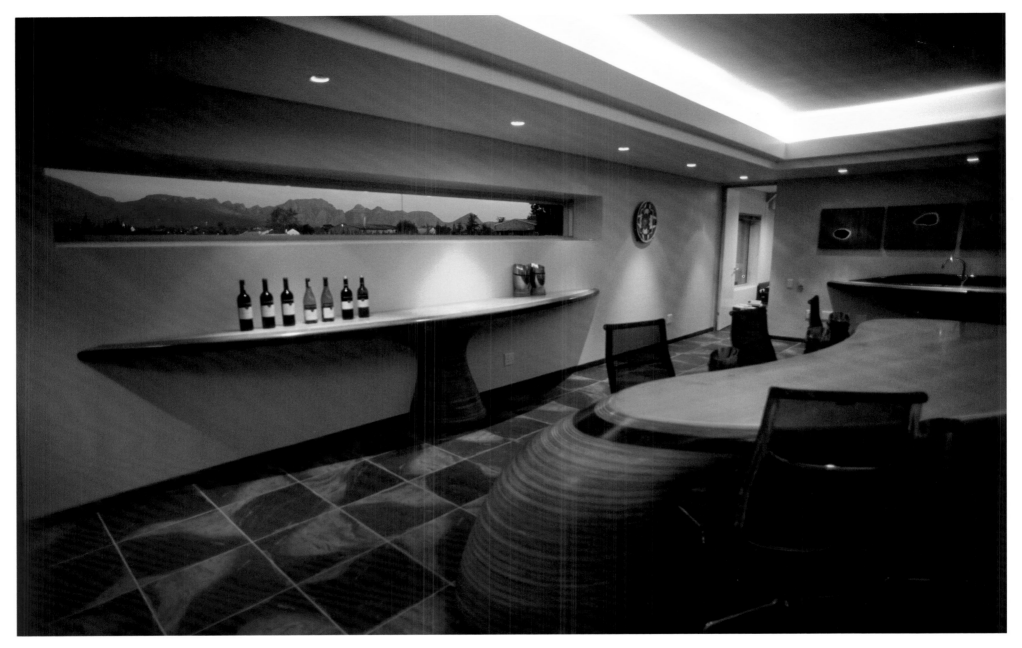

ENTERTAINING IN STYLE

DGB's sophisticated yet functional VIP visitor centre in Wellington accommodates distinguished guests for wine tastings, conferences and entertainment. A narrow window framing the distant Hex River Mountains in long horizontal lines accentuates the sweeping vineyard setting. DGB, producer of Douglas Green and Bellingham, is one of South Africa's largest quality wine producers with over four million cases of wine being distributed annually.

AN EXPERIMENT IN ELEGANCE

The tasting room at DGB's production facilities in Wellington echoes the organic shapes and earthy tones of the surrounding landscape. This elegant centre provides the perfect setting for savouring the wine producer's world-class wine brands: Bellingham and Douglas Green.

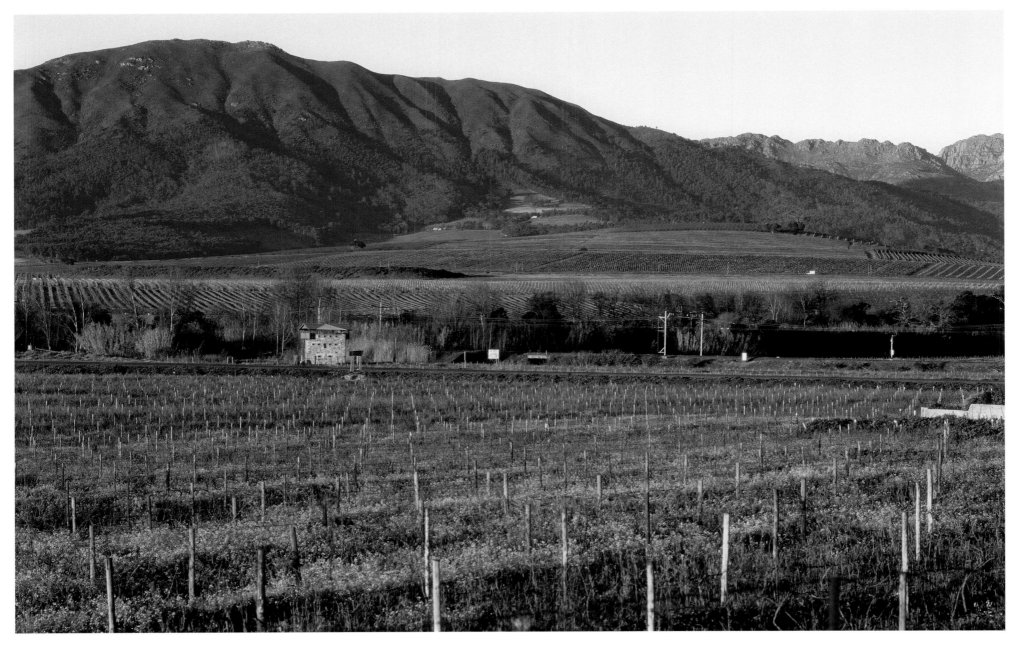

A VIEW OF HISTORY

The visitor centre of DGB (the producer of Douglas Green and Bellingham) in Wellington looks out onto one of the southernmost relics of the South African War (1899–1902). The British built the blockhouse to protect the nearby railway line, an important supply line for British troops fighting in the interior. Beyond the blockhouse lie the gentle slopes of the Groenberg – the nursery of the winelands. Here vine nurseries cluster along the mountain's warm slopes, which provide ideal growing conditions for the young grafted vine cuttings. An estimated 90 per cent of all vines planted in the Cape winelands originate from these nurseries in Wellington.

STANDING SENTINEL

An estimated 8 000 blockhouses were built during the war to protect strategic supply and communication infrastructure from being sabotaged by Boer commandos. Railway lines and bridges were especially vulnerable. Most blockhouses were little more than temporary structures made from corrugated iron sheeting. Wellington's stone and cement blockhouse was one of 18 permanent structures built towards the end of 1901 to protect the railway line between Paarl and Richmond in the Karoo.

HILDENBRAND WINE AND OLIVE ESTATE

Reni Hildenbrand moved to Wellington to fulfil a lifelong dream of living in the countryside and making her own wine. In 1991 she bought Klein Rhebokskloof, one of the oldest farms in Wellington. Hildenbrand, a trained architect, added a German touch to the restoration of the eighteenth-century manor house and outbuildings. When the historic wine cellar's old cement wine tanks were restored and new stainless steel tanks added, the heavy cast-iron doors of the old tanks were retained as a decorative feature. Hildebrand's handcrafted wines and extra virgin olive oil are bottled under the Hildenbrand Estate label.

RESTORING THE MUSIC

Chari du Toit restores violins, cellos and other stringed instruments in his studio in Wellington. His father also restored violins and encouraged him to master the craft. Du Toit is one of only a few violin restorers in the country and regularly attends specialised workshops in Europe to stay abreast of his craft. His clients include music students from music schools, colleges and universities. Charl du Toit is also a trained theologian and served his Wellington congregation in Bovlei for many years before deciding to devote his time to his music and restoration work.

DE COMPAGNIE POTSTILL BRANDY

De Compagnie is one of a growing number of brandy distillers in the Cape winelands. Apart from its wine range, the estate makes a boutique brandy using Chenin Blanc grapes. The farm's small copper potstill was first licensed in 1849 and is probably one of the industry's smallest registered stills. The brandy is double distilled and matured for a minimum of five years in French oak to allow the amber distillate to develop its characteristic cinnamon and citrus aromas.

The farm lies in a secluded valley formed by the Groenberg and Hawequas Mountains at the foot of the Bain's Kloof Pass. The historic pass with its dry-stone walls snakes along narrow rugged contours and for many years was the most direct route to the interior and towns such as Worcester and Ceres.

A particularly dangerous bend in the road is called Brandewyndraai (brandy bend). Legend has it that a wagon loaded with raisins and brandy overturned while negotiating the bend. History does not indicate whether the driver survived, but the wagon's load was flung over the edge of the pass and down into the valley below. To the delight and consternation of farmers and labourers alike, much of the brandy landed in the mountain stream that to this day provides drinking and irrigation water to the surrounding farms.

DE COMPAGNIE

De Compagnie was originally part of a much larger wheat and stock farm granted in 1705 along the frontier of the early Dutch settlement at the Cape. The farm lies 5 kilometres from Wellington. When Johann Loubser and Riana Scheepers bought the farm in 2002 they renamed it De Compagnie, which coincided with the commemoration of the foundation of the Dutch East India Company (*Vereenigde Oost-Indische Compagnie* (VOC)) 400 years earlier in 1602. De Compagnie is a boutique winery with 16 hectares of vineyards in production. At the end of summer the grapes are harvested by hand, 50 crates at a time, to ensure that the vintage is picked at optimum ripeness and quality.

OUDE WELLINGTON WINE AND BRANDY ESTATE

Oude Wellington Wine and Brandy Estate is a boutique winery at the foothills of the Hawequas Mountains in Wellington. The farm was originally known as Onverwacht and some of the buildings date to 1790. Rolf and Vanessa Schumacher bought the farm in 1995 and immediately set about restoring the Cape Dutch farm buildings and thatched outbuildings. The cozy brandy cellar hosts the estate's restaurant, which is famous for its fine country cousine. Oude Wellington's wines are made by Vanessa Schumacher. The estate produces a highly regarded Cabernet Sauvignon that reflects the region's warm climate and excellent soils, as well as the easy-drinking Currant Abbey – an anagram for Ruby Cabernet. Oude Wellington distills a smooth husk brandy (grappa) and a fine vintage brandy called Dr Schumacher.

WORCESTER WINELANDS

The Worcester Wine and Tourism Office is housed in Stoffberg House on the town's historic Church Square. The low, thatched house was built in the early nineteenth century and is one of the two remaining gabled houses facing Church Square. The town of Worcester was founded in 1820 and named after Governor Lord Charles Somerset's brother, the Marquis of Worcester. Today Worcester lies in the heart of one of the largest wine-producing areas in the winelands and is known for its brandy, fortified Muscadel and Hanepoot wines. Most of the vineyards in the area have been established on riverbanks in the fertile alluvial soils.

WILLOW CREEK OLIVE ESTATE

Willow Creek Olive Estate lies in the picturesque Nuy Valley between Worcester and Robertson, and has been in the Rabie family since 1793. The valley's unique microclimate, with very low rainfall and calcium-rich loamy soils, provides the ideal growing conditions for olive trees. The award-winning oils that are produced in this Mediterranean climate are complex and robust. Although olive trees are hardy and drought resistant, the trees require careful watering regimes to produce high-quality table olives and olive oils.

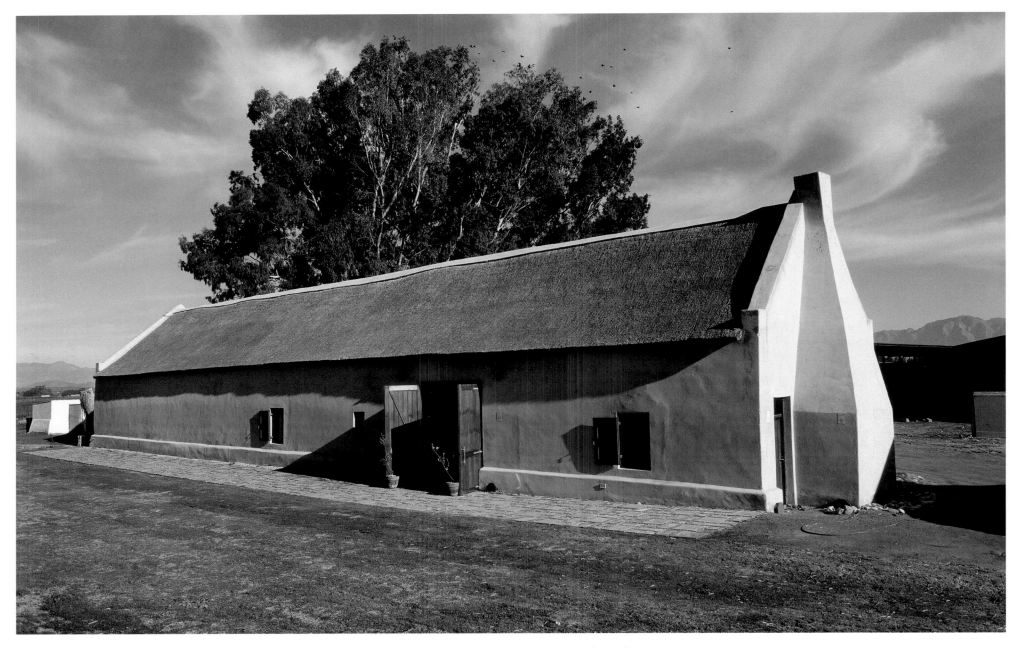

PERFECTING OLIVE OILS

Willow Creek Olive Estate's olive cellar dates back to 1844 and has been renovated to comply with the demands of a quality-driven olive oil estate. The estate released its first olive oil in 2002 and has since received numerous local and international awards for its oils. Willow Creek produces two olive oils: a robust Frantoio Leccino blend with a distinctive peppery aftertaste as well as a more delicate oil, both characterised by an aroma of freshly cut grass, apple and almond. The estate also produces stoned and pitted table olives including a rosemary and garlic flavoured olive.

LA ROCHELLE

La Rochelle's Victorian house was built during the early 1900s at the height of the Little Karoo's ostrich boom (1865–1913), when the fashion industry had an almost insatiable appetite for ostrich feathers. The boom brought untold wealth to the region and the new ostrich 'barons' built themselves elaborate houses to reflect their new-found prosperity. The La Rochelle farmhouse is unusual in that it has an extensive cellar that was used as a storage place for household items and as a pantry. Ostrich chicks are still raised on the farm. Today farming operations have diversified into growing wine grapes. La Rochelle has 46 hectares under vines and delivers its grapes to a co-operative cellar near Worcester.

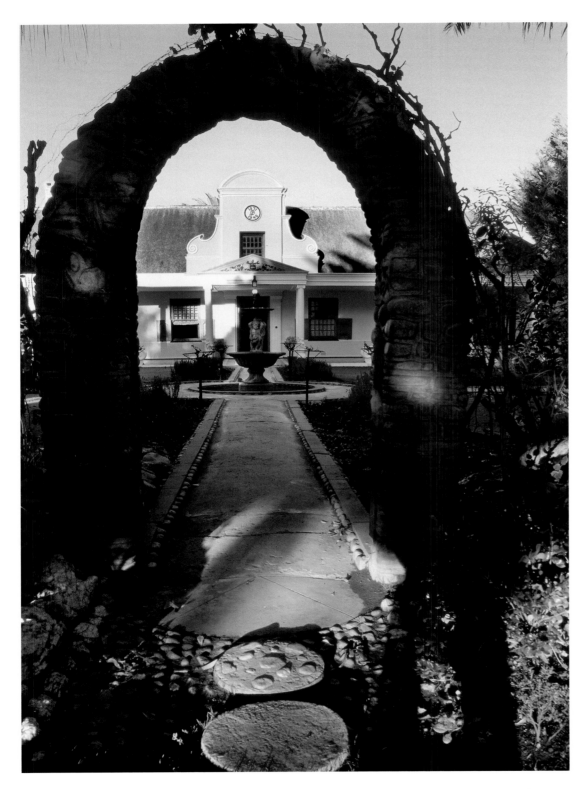

NUY VALLEY GUEST HOUSE

The Nuy Valley Guest House on Werda farm is approximately 15 kilometres from Worcester on the road to Robertson. It was built in 1871 and has retained the old-world charm of a bygone era. Accommodation consists of 19 luxury en suite rooms, some with a stunning view over the valley. Self-catering facilities are available in the 1871 Dutch House and unique budget rooms for backpackers can be found in the old wine cellar. The family-owned establishment boasts the private Conradie Boutique Wine Cellar where award-winning wines can be tasted.

At harvest time visitors can experience the routine and bustle of a working wine and citrus farm. The guesthouse is an ideal springboard for exploring the Breede River region. The nearby Nuy Wine Cellar is one of the smallest co-operative wine cellars in the winelands and is well known for its Red and White Muscadel wines.

THE TRANQUILLITY OF AUTUMN

The early morning view from the Nuy Valley Guest House is dramatic yet tranquil. The late autumn light adds a warm glow to the valley. In winter the mountains will be topped with snow. The guesthouse is situated on the farm Werda in the narrow Nuy Valley at the foot of the Langeberg mountain range near Worcester, and is surrounded by 85 hectares of vineyard. The origin of the word 'Nuy' is uncertain, but it may be derived from the River Nuy in Holland. The guesthouse is situated on a working farm that has been in the Conradie family since 1915.

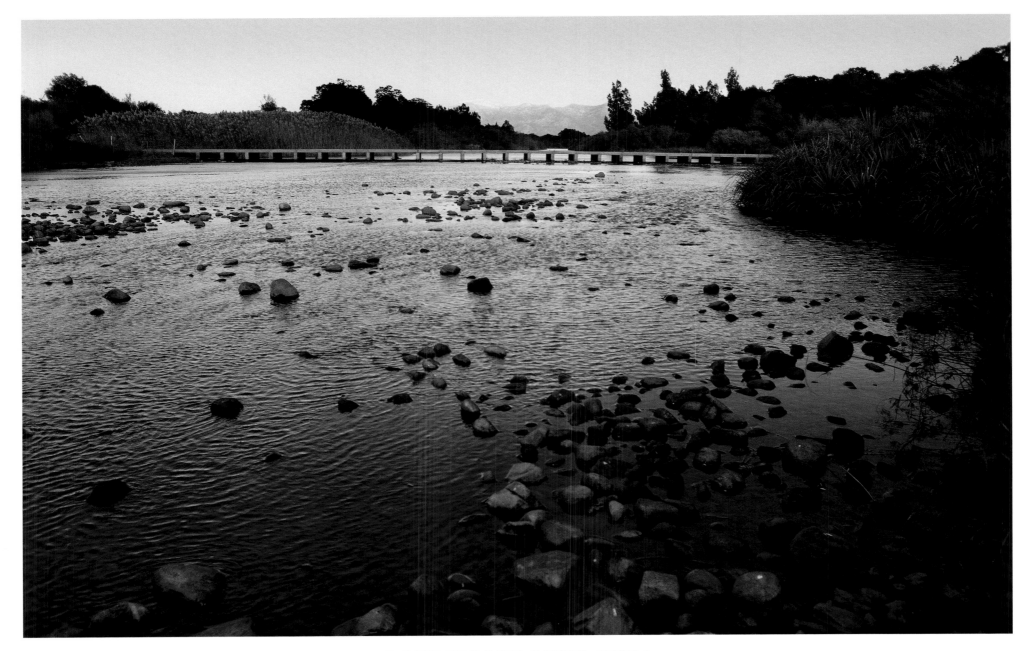

RONDEBOSCH RIVER IDYLL

This is the Worcester country idyll of Bertie van der Merwe and his sons, Alvi, a GP, and Johan, a lawyer. The 5 000-hectare piece of beautiful mountain- and riverside land along the Breede River has some 320 hectares of vineyard under 13 grape varieties producing about 5 000 tons of grapes. But besides the usual wine tastings, sales and cellar tours, there is a dairy and cheesery to visit for provisions for an impromptu picnic (though visitors can also bring their own hampers) and, for the more active and adventurous, walks, canoe trips and 4x4 excursions organised by prior arrangement.

ROMANCE AND DEDICATION

The Rondebosch winery owned by the Van der Merwe family is a seamless blend of romance and dedicated winemaking. The cultivation of his 320-odd hectares of vineyard is overseen by a dedicated viticultural consultant, resulting in some 5 000 tons of quality fruit mostly sold in bulk. But more recently, an investment in new cellar equipment and the services of veteran ex-Nederburg cellarmaster Newald Marais has heralded the family's move into making their own wine from special vineyard and tank selections. Their Alvi's Drift bottlings join a collection of fine wines maturing in the hallowed confines of the atmospheric Rondebosch underground cellar.

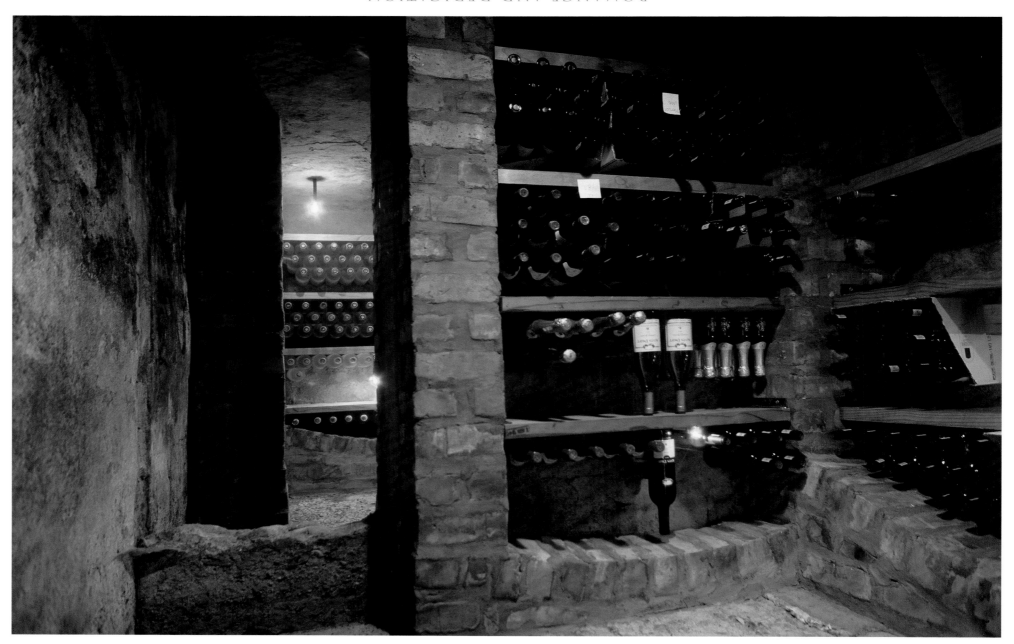

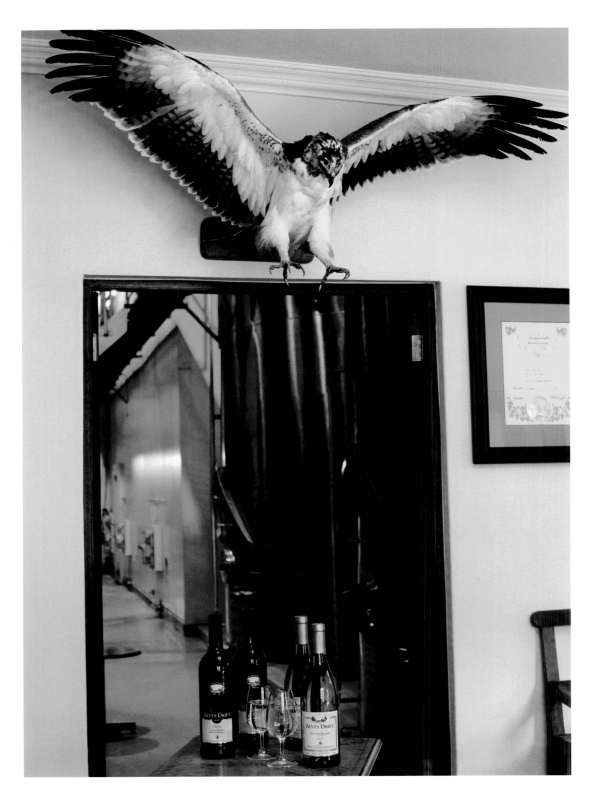

WINE AND WILDLIFE

Testimony to Rondebosch Cellar co-owner Dr Alvi van der Merwe's passion for wildlife is this proud specimen of a massive martial eagle mounted above a mirror in the tasting room. His own personal 'wildlife conservation project' on a fenced 3 000-hectare section of this spectacular Breede River Valley property is to be doubled to cater for special 4x4 and game-viewing excursions. Visitors may be lucky enough to see lynx and leopard on the rocky mountainside, a rich assortment of birdlife along the riverbanks, as well as ostrich, zebra, springbok and such rare African antelope as hartebees, eland and gemsbok.

OVERHEX PRIVATE CELLAR

Overhex Private Cellar is one of the largest privately owned cellars in the winelands and is situated about 5 kilometres from Worcester. The cellar is owned by George Smit, Gerhard van der Wath and Kobus Rossouw and sources grapes from vineyards throughout the Breede River Valley. The semi-arid Karoo conditions and a moderate climate, prevailing winds, cool night temperatures and rich soils create an ideal, natural environment for the cultivation of low yields of high-quality, flavourful wine grapes. Overhex produces award-winning wines and in 2004 received the award for the South African Champion Muscadel at the South African Young Wine Show.

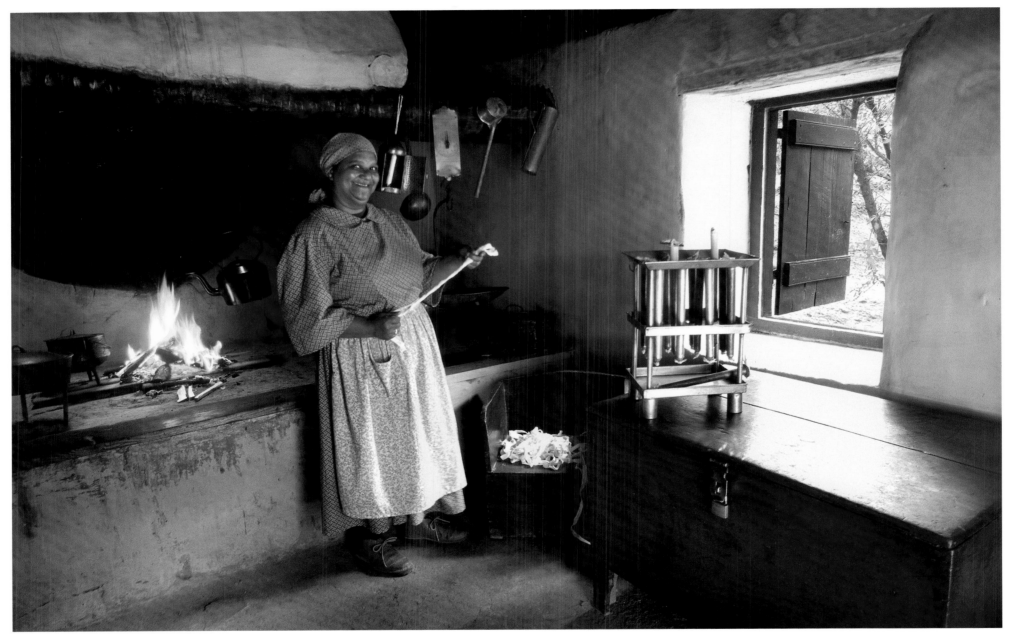

KLEINPLASIE LIVING OPEN AIR MUSEUM

Long before electricity became commonplace, pioneer families made their own soap and candles. Candles were made from animal fat – those made from the fat of cattle were yellow and those produced from goat fat were white. At the Kleinplasie Living Open Air Museum outside Worcester, history is kept alive as the lifestyle, activities and agricultural practices of the early pioneers who settled across South Africa's vast interior are demonstrated to tourists eager to learn more. Here a range of activities associated with the early days of the Cape's farming economy, from blacksmithing and bread baking to tobacco rolling and the distillation of witblits, are re-enacted.

RE-VISITING HISTORY

Early pioneer farmers achieved a remarkable level of self-sufficiency, and many farms had their own mills. An old horse-powered mill – a gift from the farm Karbonaatjieskraal in Touws River – can be seen at the Kleinplasie Living Open Air Museum in Worcester. Used to grind wheat, the mill was driven by two horses or mules, blindfolded to prevent them from becoming dizzy. If a farmer did not have his own mill he could mill his wheat at a neighbour's, but the unwritten rule was that he had to provide his own horse power.

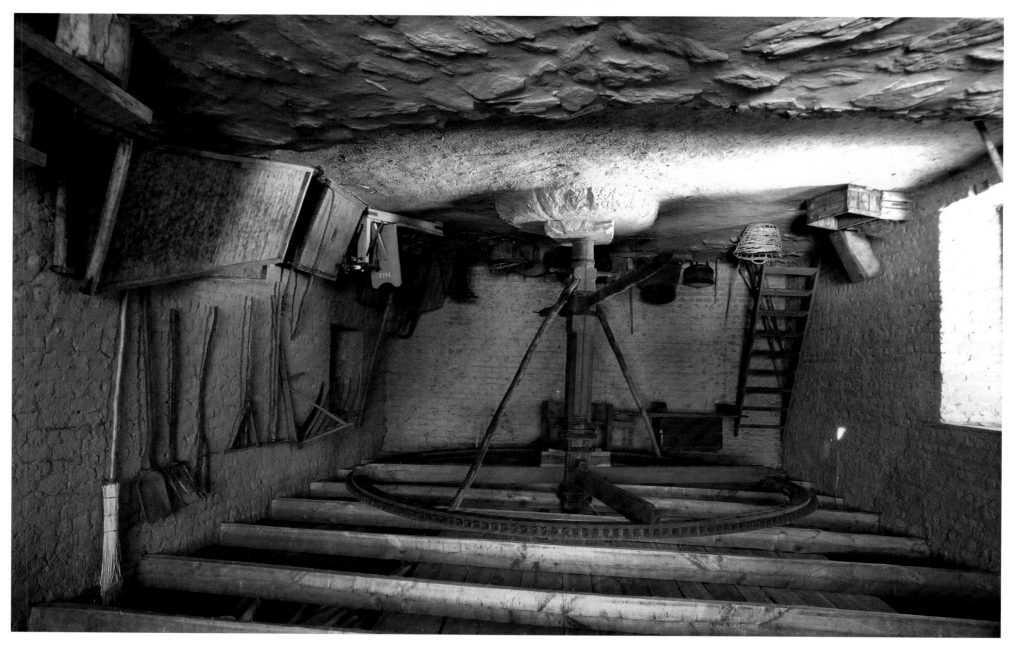

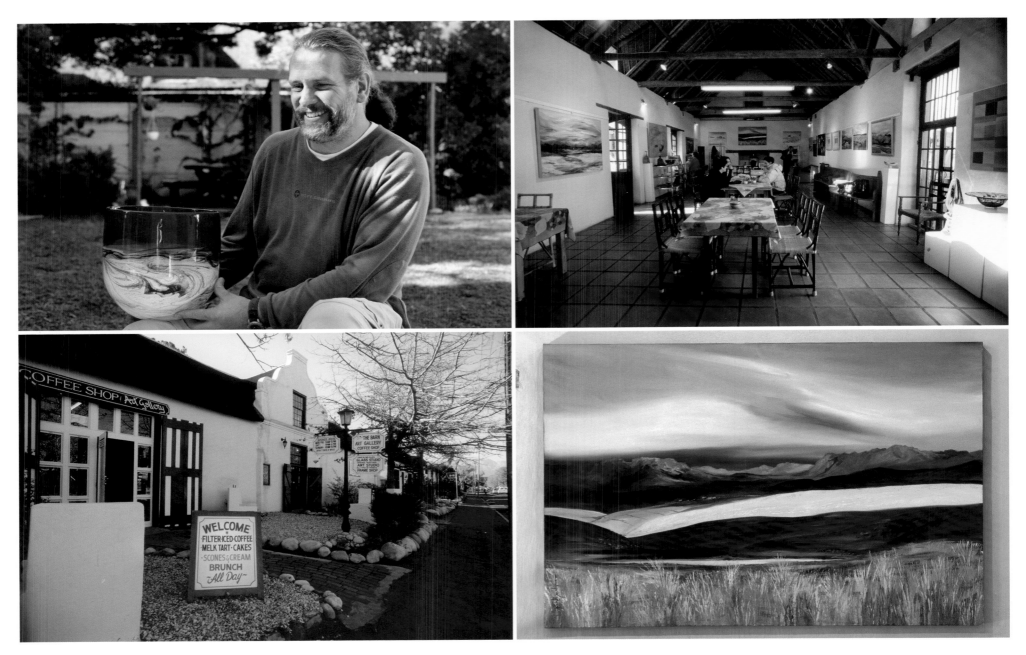

THE BARN

The Barn in Worcester dates to 1790 and was originally a wine cellar. The building was restored in 1992 by renowned glass blower David Reade and his artist wife Lorna, and converted into their art gallery and studio. The Barn also has a coffee shop and an à la carte restaurant that is open in the evenings. Visitors to The Barn will be able to view David Reade blowing glass from the hot furnaces in his studio. He specialises in architectural glass and sculpture, and has received commissions from all over the word. Lorna Reade paints in most mediums and her work depicts the Cape and southern Africa.

A WORLD-CLASS BRANDY DISTILLERY

Brandy still lies at the heart of KWV, originally founded in 1918 as an umbrella organisation for Cape wine producers. It was later given statutory powers over the local industry, but now functions as an independent wine and brandy producer. From its massive, hi-tech dedicated brandy production facility in Worcester – one of the largest in the world – KWV supplies blending wine spirit and potstill brandy to merchant producers. KWV's own 10 and 20 Year Old have both received the London International Wine and Spirit Competition trophy for best brandy world-wide. The cellar, with its rows of gleaming copper potstills and racks of wooden casks, is well worth a visit for tastings and tours providing fascinating insights into the art of brandy making.

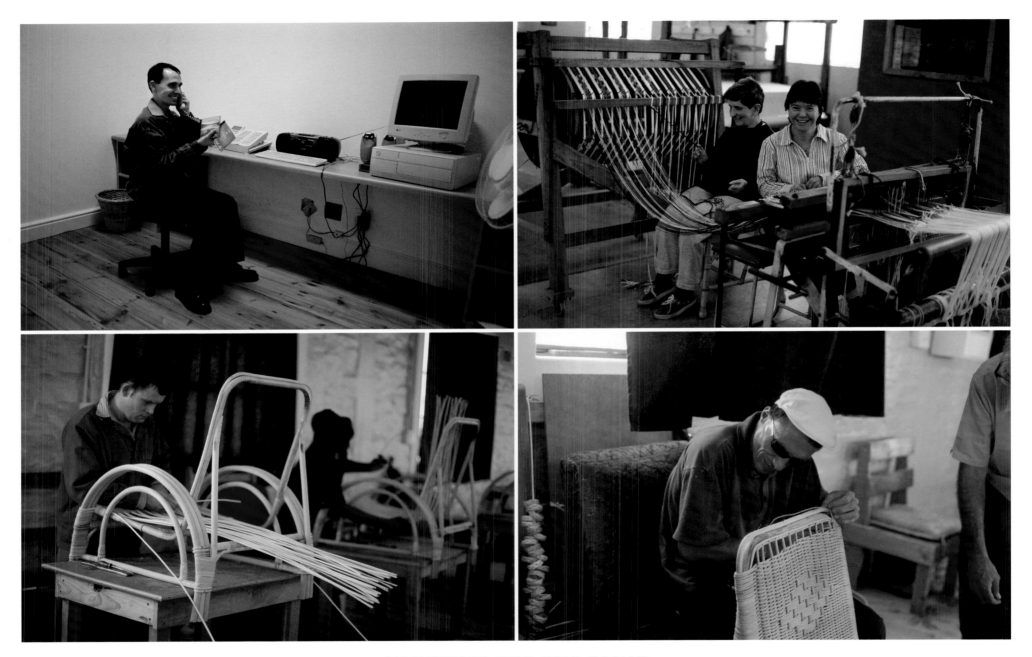

INSTITUTE FOR THE BLIND

Worcester is home to the Institute for the Blind, a non-profit organisation that caters for the needs of the blind, the partially sighted and those who have multiple disabilities. The Institute's Pioneer School for the Blind, founded in 1881, provides specialised tuition for learners as well as opportunities to take part in sport and cultural activities. The Institute also provides accommodation and work opportunities for adults, and has secured contracts with industries for carpentry, weaving, spinning and packaging projects. Attie Rademeyeren and Esmé van Wyk have been taught to weave, while Ferdie Kommer and Chris Carstens (with the cap) do cane work and Len Viljoen manages the switchboard. The Pioneer Press produces literature and music in Braille and books in large print and on audio tape.

INSTITUTE FOR THE DEAF

The Institute for the Deaf was established in Worcester in 1881 and is concerned with the early identification and assessment of people with hearing difficulties, and provides hearing aids, care, education and vocational training. The Institute includes protective workshops, a college and a school, the De La Bat School for the Deaf. A distance learning facility has also been set up in conjunction with Stellenbosch University. Adults like Tina Constantinou and Timoteus Andrews are taught crafts such as pottery and sandblasting on glass. Students like Albertus van Wyk and Dowayne Gravett receive practical instruction in carpentry, while art students like François Gouws have access to an art studio.

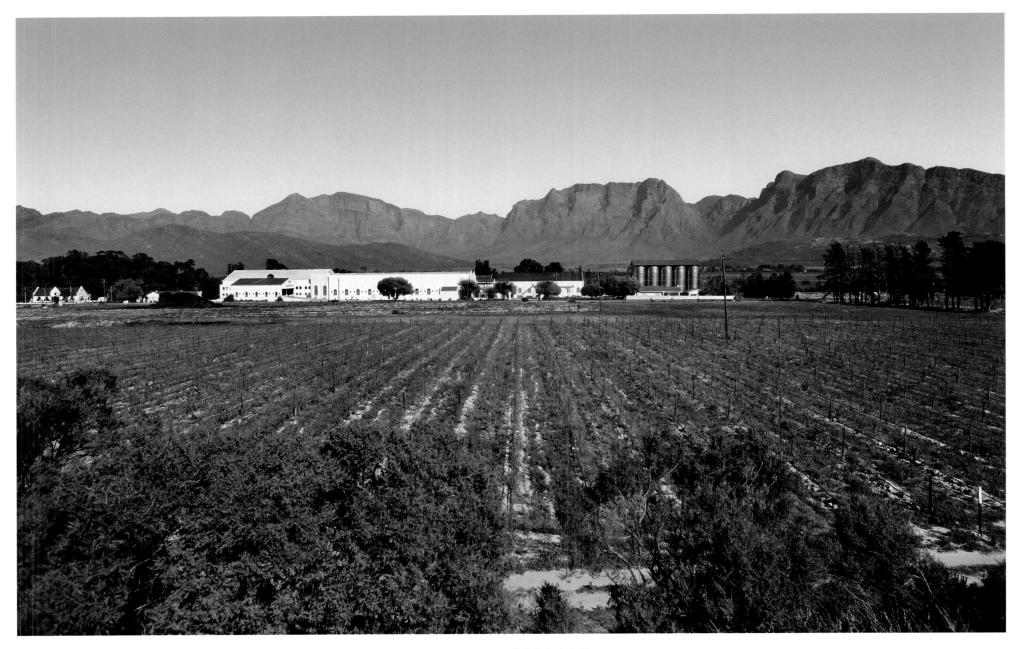

BOTHA CELLARS

Botha Cellars is about 20 kilometres from Worcester in a narrow valley at the foot of the Hex River Mountains. In winter the surrounding mountains are covered in snow, and in summer they cast deep shadows across the valley. It is a secluded valley with fertile slopes, deep alluvial soils and an above-average rainfall. A wide range of wines is produced, because of the varying soil types found there. Botha Cellars, established in the late 1940s, has a capacity of 30 000 tons, and produces award-winning white and red wines, as well as fortified wines. The cellar is situated on the scenic tourist route between the vineyards of Tulbagh and Robertson, and is a popular stopover for a wine tasting.

OPSTAL ESTATE

Opstal Estate lies in the Slanghoek Valley near Rawsonville. The grapes are grown on a 100-hectare farm on the banks of the Slanghoek River in the centre of this spectacular valley. Current owner Stanley Louw (seen here), is a sixth-generation descendant of the first owner of this family estate. The homestead dates back to 1847 and was simply called Opstal bij de Fonteine (House at the Springs). It was at this time that its first owner, JC or Lang Jan Rossouw, a stock farmer, planted his first vineyards. Wine was always made in the private cellar on the farm and in 1950 Opstal began making wine for its own label. Today Opstal Estate exports its fine wines to the Netherlands, Germany and the United Kingdom.

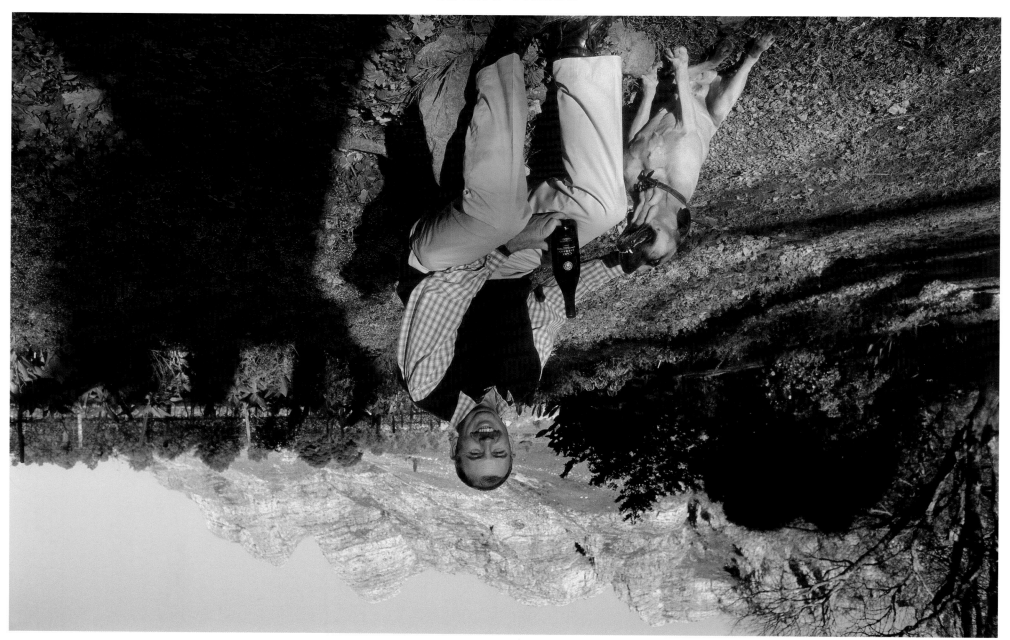

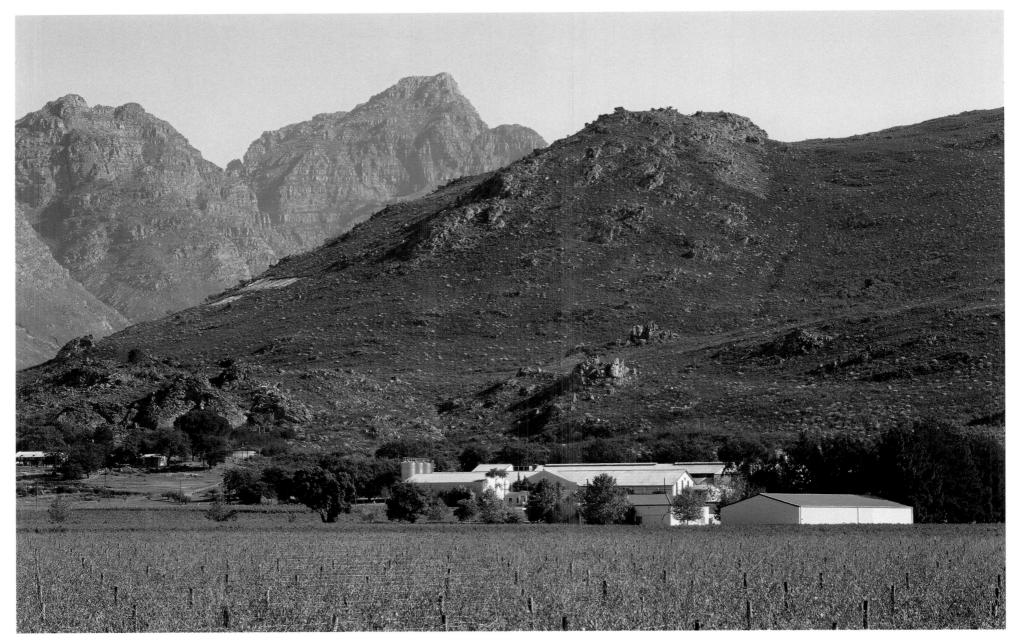

BADSBERG CELLAR

Badsberg Wine Cellar is a co-operative winery that sources grapes from the vineyards of Rawsonville, near the hot-water springs of the Goudini Spa. Since its establishment in 1951, it has seen a gradual shift away from dessert wines to red varietals such as Pinotage, Merlot and Cabernet Franc, and white wines such as Sauvignon Blanc and Chardonnay. The cellar is situated in a conservancy that includes the surrounding farms and mountainside, and its labels depict the rare March flower which is indigenous to the area. The red, upright flower-heads resemble bright shaving brushes, and appear in autumn to seed before the winter rains. An illustration of the flower-head by the Flemish botanist, De L'Obel, was published in 1605.

BREEDEKLOOF

Once used as a cattle post by eighteenth-century European settlers, the Breedekloof area today produces award-winning wines that have excelled in both the local and international markets. Cellars in this area are also known for creating high-quality wines at affordable prices. The Breedekloof Wine Route is one of the youngest in the Cape winelands and includes 18 wineries. The Breedekloof includes the Goudini, Slanghoek, Breede River and Rawsonville areas, and is one of the largest fruit-growing and wine-producing regions in the Cape. The Goudini Spa, with its hot springs which reputedly have therapeutic qualities, is a popular holiday and conference destination.

NEW CAPE WINES

New Cape Wines is based in the Breede River Valley between Villiersdorp and Worcester and is a specialist exporter of fine South African wines. The company was founded in 2000 and uses Brandvlei Cellar's facilities to blend and bottle wine. The wine is sold under the Eagle's Cliff and Dwyka Hills labels. The Eagle's Cliff label depicts a rare black eagle – one of a pair that nests in the cliffs overlooking the valley's vineyards. The Dwyka Hills range is named after the glacial rock formations – found in the Breede River Valley – that were created by rivers and slow-moving ice more than 300 million years ago.

STETTYN WINERY

Stettyn Winery's Vin de Paille is produced from Hanepoot grapes that are sun-dried on beds of straw. The grapes are then hand-pressed and matured in small French oak vats. The wine, with its rich overtones of raisins and apricots, is an ideal dessert wine. Stettyn Winery is a co-operative wine cellar in the Breede River Valley and sources grapes from vineyards on the outskirts of Worcester. The winery produces a Shiraz-Cabernet Sauvignon blend and a Pinotage. Its Sauvignon Blanc is released under the Millstone label – a reference to the Stettyn mill built in 1891. The restored millhouse is in full working order and loaves of fresh farm bread are still baked from its flour.

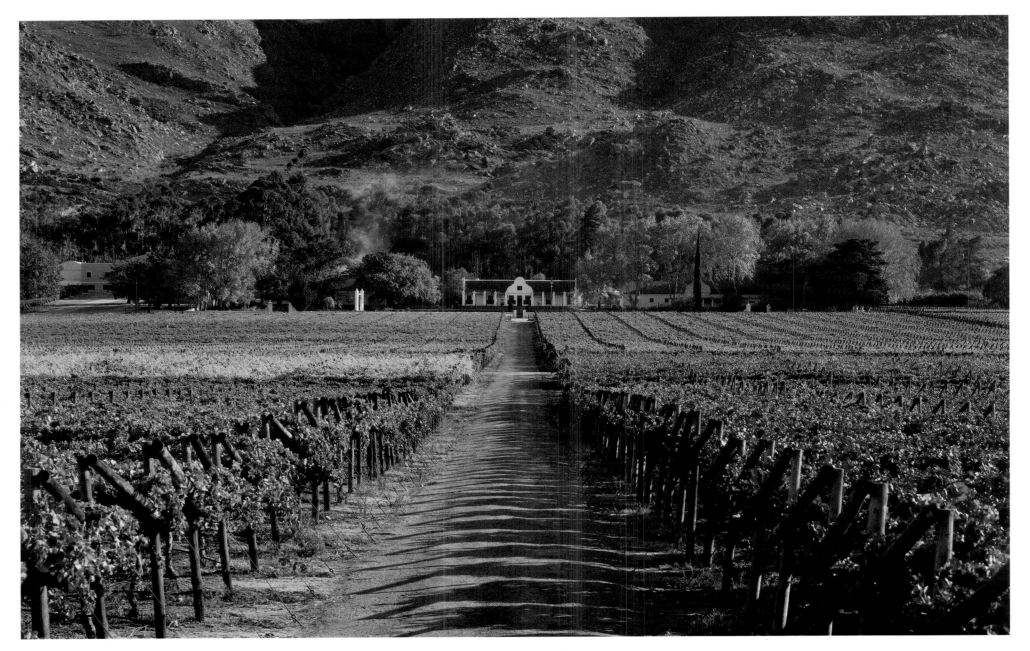

THE PINES

The Pines homestead, home of table grape farmer De Villiers Graaff and wife Gaedry, nestles beneath the Hex River Mountains at the northern gateway to the Cape winelands. A wine farm until 1972, the property was subsequently converted to produce export table grapes. With the past decade's global demand for quality wines, however, the owners, AJ Reyneke and De Villiers Graaff, are replacing ageing vines with wine varieties. An old cellar is being re-commissioned and, once in production, will be the first private Cape winery to greet road travellers from up-country.

THE PINES WINE CELLAR

The old wine cellar on The Pines table grape farm in the Hex River Valley dates back to the 1930s and is of considerable historical significance. With the intention of establishing wine grape varieties on the property, owners AJ Reyneke and De Villiers Graaff are reconditioning the unusually decorative, gabled concrete fermentation tanks. One has already held its first red created by winemaker Leon Dippenaar: a Shiraz from grapes sourced from another Graaff family farm, De Grendel, near Cape Town and made in the old-fashioned way using traditional equipment, with handling kept to a minimum. The wine will be bottled under the original name of the farm, Vendutie Kraal.

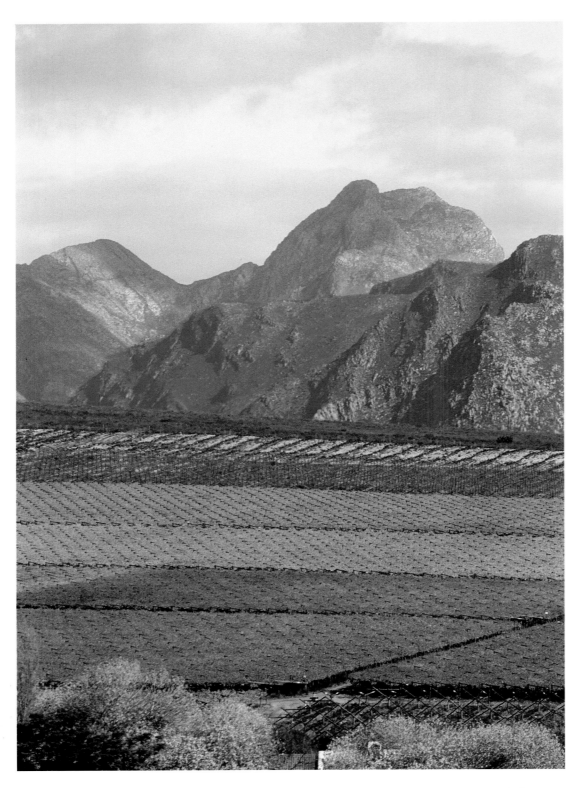

HEX RIVER VALLEY

The narrow Hex River Valley provides the most dramatic scenery in the Cape winelands – brilliant red and yellow vineyards in autumn, and towering purple mountains topped with snow in winter. The valley is not haunted or inhabited by witches, however. The name 'Hex' is a reference to an X-shaped confluence of three rivers near Sandhills in the southern part of the valley. In 1715 official documents referred to this confluence as the Ex River. The nearby town of De Doorns derived its name from the many thorn trees early stock farmers found in the area. The 'brandy boom' in the late nineteenth century required a great deal of firewood to stoke the potstills, and the thorn trees have all but disappeared.

DE DOORNS WINE CELLAR

A farm fence is draped with blooming bougainvilleas, their orange and cerise bracts glowing against the green trellising of a table grape vineyard. The De Doorns Wine Cellar lies in the heart of the picturesque Hex River Valley, about 30 kilometres from Worcester. The majestic Matroos and Quadu Mountains rise almost vertically to form a dramatic backdrop to hectares of vineyard. The De Doorns Wine Cellar was established in 1968 and is one of the largest co-operative cellars in the Breede River Valley. The cellar is also unique in that most members are table grape farmers with only a small portion of their farms planted with wine grape varieties. The cellar receives both wine grapes and discarded table grape berries.

237

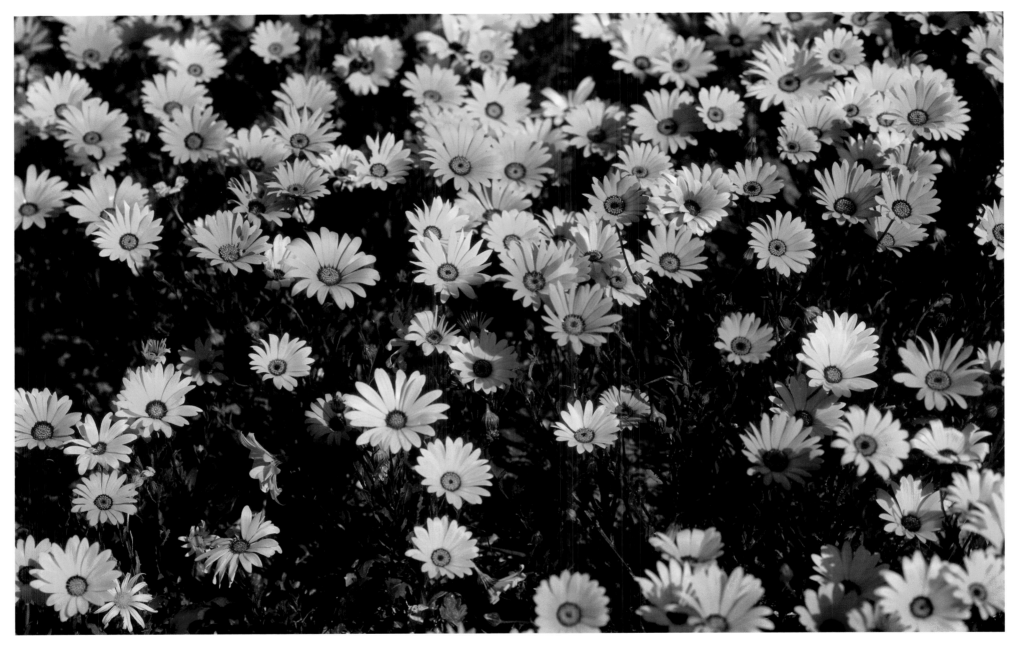

FLOWER COUNTRY

An unsung side-attraction of the emerging new Cape wine regions is the rare beauty of the indigenous Cape floral kingdom. In the Little Karoo it's the aromatic bush scrub with its hidden succulents and showy orange aloes. On the south coast it's the fragrant coastal *fynbos* ruled over by the country's national flower, the protea. Up the west coast the usually windswept sandy flats and brown-black *renosterveld*-covered hills are transformed in spring into fields of gold interspersed by the vivid oranges, bright whites and pulsating pinks of trailing gazanias, Namaqualand daisies and *vygies* bursting into bloom. It's nature's celebration of new life that humans must but toast with a glass of fine Cape wine.

ROUTE 62

Exploring the Cape winelands' interior is all about going nowhere…slowly. Route 62 has been established as the 'back road' alternative to the N2 Garden Route speedway between Cape Town and Port Elizabeth. Branching off from the N1 highway north to Johannesburg, the east-west R62 links the wine routes of Tulbagh, Robertson, Worcester and the Klein Karoo, guiding the traveller through such historic, picturesque towns as Tulbagh, McGregor, Montagu, Barrydale and Calitzdorp. While it's wine that initially attracts, it's the quiet country charm of quaint cottage accommodation, delectable deli foods, fresh farm produce, arts and crafts, outdoor activities to absorb the wide open spaces, and quirky 'down-on-the-farm' humour that keeps bringing 'em back.

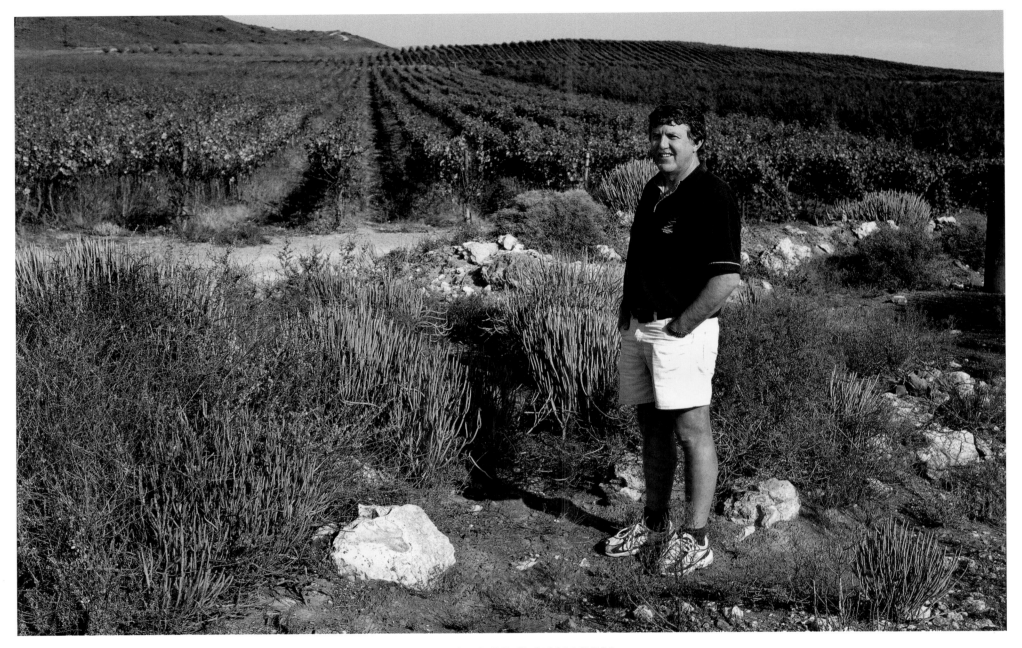

LANGEBERG WINERY

Paul Marais is the current owner of Langeberg Winery. The Chardonnay vineyard outside Robertson on the road to McGregor is set against the pastel colours of a Little Karoo landscape. The Marais family of Robertson can trace their family history back to 1688 when Charles Marais disembarked from the Voorschoten and set foot in Table Bay. In 1885 the family farm Wonderfontein was the first in the district to successfully apply for a licence to distil brandy.

NEW VINEYARD

Paru is a 420-hectare farm on the outskirts of Robertson on the road to McGregor, and is owned by Paul Marais and Rupert de Vries of Langeberg Winery. This newly prepared vineyard was deep-ploughed to a depth of 1.5 metres and will be planted with Sauvignon Blanc. More than 60 000 vines will be planted in an east-west direction to give the ripening grapes enough exposure to sunlight, but at the same time allowing the leafy canopy to shade the grapes and protect them from sunburn. The unusual circular markings in the soil are caused by limestone deposits in the soil. Langeberg Winery produces superb Chardonnay, Sauvignon Blanc and Merlot wines, as well as dessert wines.

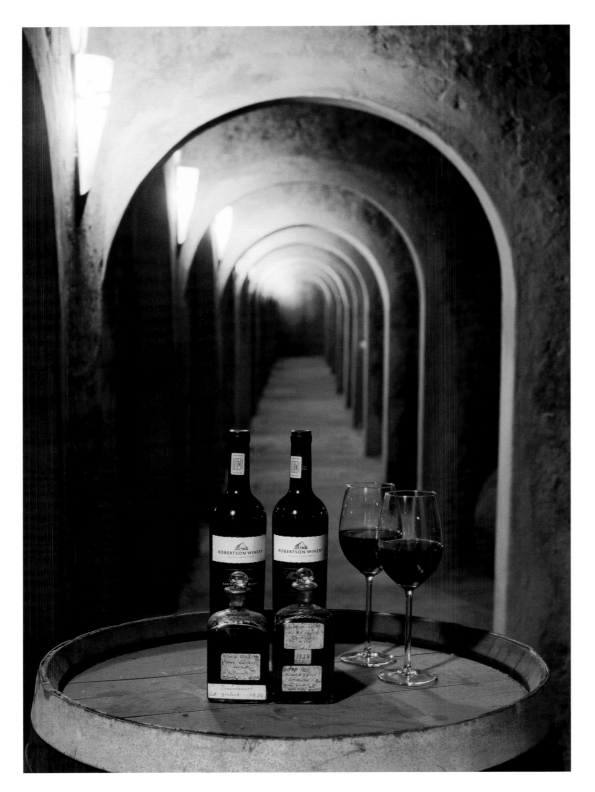

ROBERTSON WINERY

Beneath a quaint old mission church in the heart of Robertson some very special wines are maturing in cool, dark vaults. These are made at the Robertson Winery, of which the little church is now a part.

In 1822 the Scottish minister Dr William Robertson settled in Over Het Roode Zand (literally, across the red sand) and established the small congregation that worshipped at the little church. When the town was founded in 1852, the community named it Robertson in appreciation of his work. Just under a century later the local farmers joined forces to form the Robertson Winery, making and storing their wine in the then derelict church.

Today Robertson Winery sources its grapes from 35 family-owned farms in the fertile Robertson Valley and the winery has significantly increased in size, with additional buildings spread around the original church building.

In 2003 Robertson Winery launched a premium range of single-vineyard wines to showcase the region's unique meso-climates. The Retreat Sauvignon Blanc 2004 is made from grapes produced in south-facing shale soils high in the Riviersonderend Mountains. There the berries are cooled by moist sea breezes, resulting in a fresh and fragrant wine with a firm acidity. The vineyards cultivated on the cool south-facing slopes of the Wolfkloof at the foot of the Langeberg Mountains are the source of the winery's smoky, black cherry-charged Wolfkloof Shiraz 2003.

OF HORSES, WINE AND ROSES

The wine estate Zandvliet, the domain of the fourth generation of the De Wet family, combines the aesthetics of fine wine production, a racehorse stud and a half-century-old homestead complete with gable, vine pergola and iceberg rose borders. The cellar's métier is Shiraz, Cabernet Sauvignon and Chardonnay. International viticultural consultant Phil Freese of Sonoma, California, guided new plantings on some 100 hectares of virgin red, gravelly Karoo ground on cool, low-lying hill terroirs. Experiments with French and American oak barrels have given rise to two benchmark variations of Shiraz labelled Kalkveld (literally, chalkland) in recognition of the limestone-rich soils, while the palate-pleasing Astonvale range has spearheaded Zandvliet's highly successful export business.

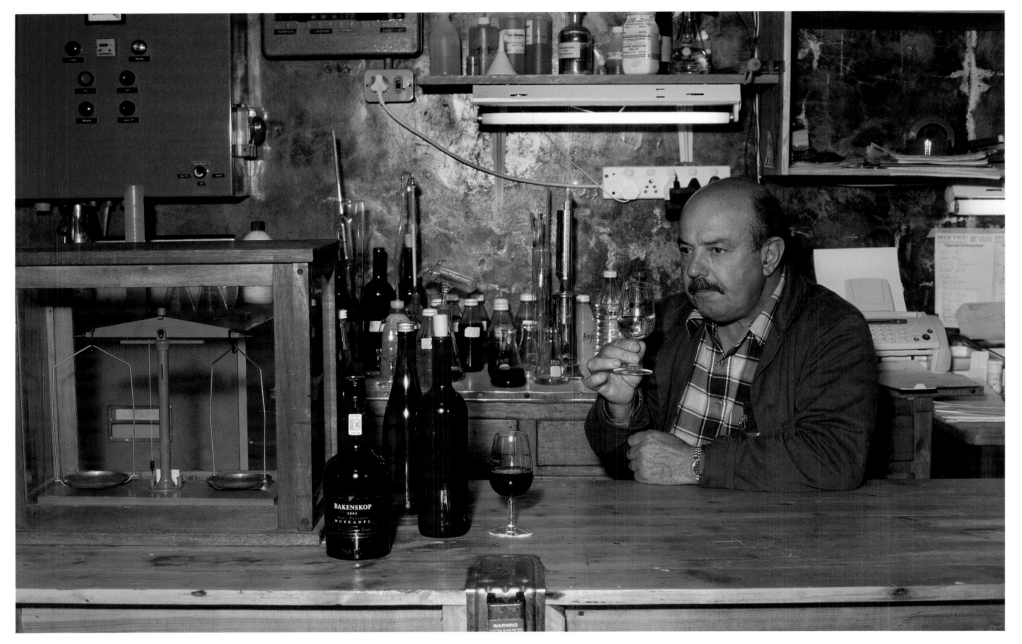

JONKHEER WINERY

The three Jonker family farms lie on the banks of the Breede River near Bonnievale. The family has been farming in the Robertson Valley since Klaas Jonker bought the first family farm in 1912. In 1921 an irrigation canal transformed the semi-arid valley – with an average rainfall of a mere 200 millimetres per annum – into a fertile landscape filled with vineyards and orchards. Today the Jonkheer label is associated with dessert wines such as the Bakenskop Muscadels and Muscatheer made from Muscat de Frontignan. Under the watchful eye of winemaker Erhard Roothman, the winery also makes a highly rated port-style wine called Buccanheer (Touriga Nacional). Proceeds from their Hendrik Boom label – a reference to the Cape's first gardener – are given to HAKA (Help Aids Kids of Africa).

ASHTON VINEYARDS

The small farm community town of Ashton lies on the cusp of the broad, green swathe of the Breede River Valley winelands and the more rugged, austere Klein Karoo wine region. Local wine growers deliver to the Ashton Winery, which draws on some 2 000 hectares of mainly Cabernet Sauvignon, Ruby Cabernet, Shiraz and Chardonnay. While some surprisingly serious rich and fruity barrel-matured reds are produced, this is where visitors should look out for inexpensive, quaffing wines and especially the traditional sweet dessert wines from Muscadel, which, sadly, are waning in popularity.

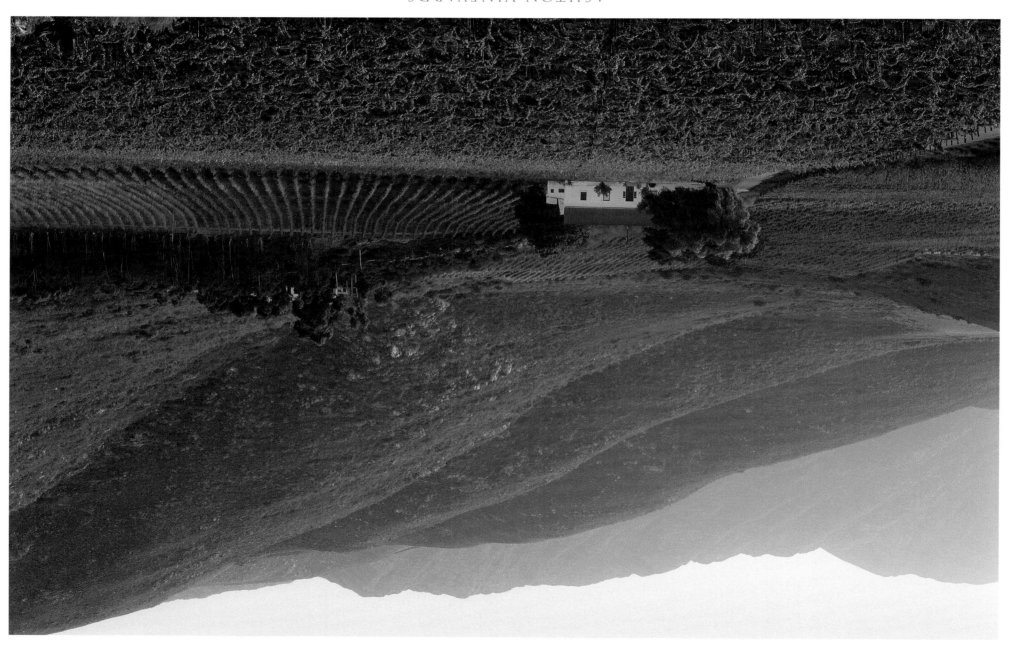

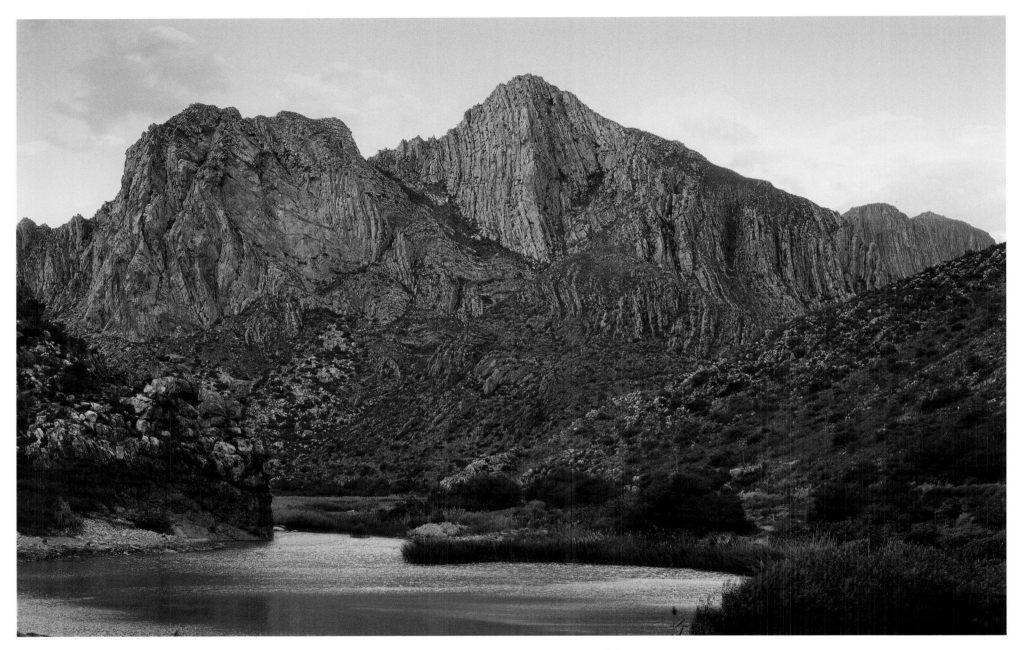

COGMANS KLOOF PASS

Until 1877 the only access through the Langeberg to Montagu was through the narrow gorge of the Kingna River. In winter this route was flooded and impassable. Thomas Bain was commissioned in 1872 to build the Cogmans Kloof Pass between Ashton and Montagu with the help of 32 labourers. The pass includes the Bain's Tunnel, which was blasted through the mountainside using gunpowder. The pass was upgraded in the 1950s, but the old Bain's road with its dry-stone retaining walls is still visible as it follows the contours of the mountainside. During the 1981 floods, Bain's road was reopened and gave Montagu residents access to Ashton and much-needed supplies.

MONTAGU COUNTRY HOTEL

The Montagu Country Hotel was built in 1875 during the height of South Africa's ostrich feather boom. Located midway between Cape Town and Oudtshoorn on what is now known as Route 62, the hotel was a favourite stopover for those who made the two-day coach journey between the towns. Today the hotel is graced with a beautiful Art Deco façade and has a pub called the Dog and Trumpet which is filled with memorabilia of the early days of His Master's Voice gramophone records. The hotel is owned by Gert Lubbe, whose 1956 Cadillac Coupé De Ville is an icon of Route 62. The scenic R62 passes through countless small historic villages and long valleys walled by high mountains.

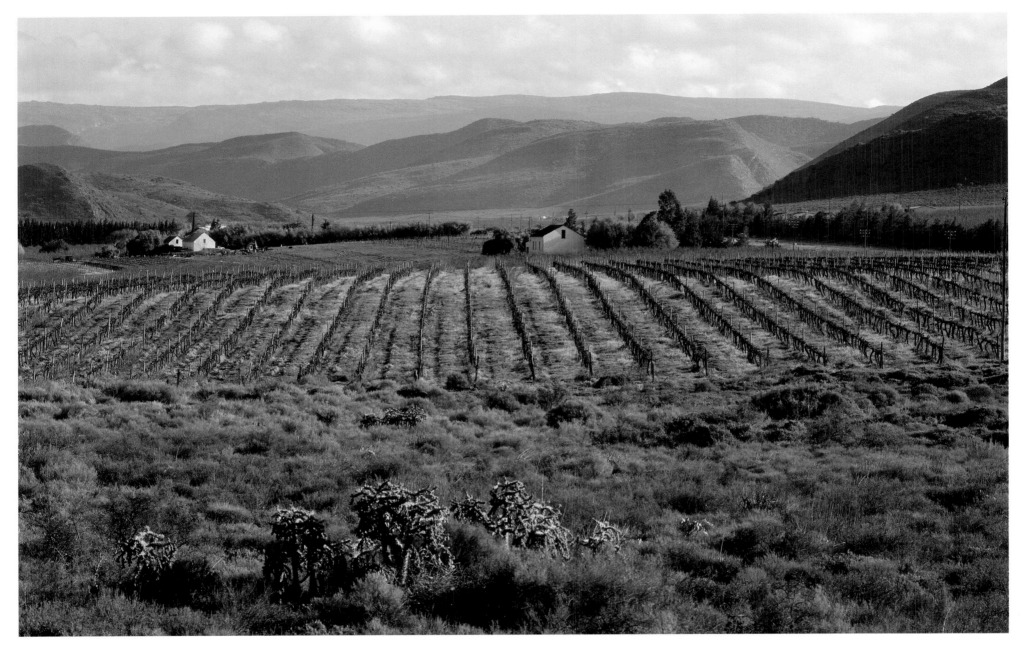

MONTAGU

Leaving the vast Breede River Valley behind, the R62 meanders along at the foot of the Cogmans Kloof's sheer cliff faces, adorned, in early spring, with an indigenous floral tapestry featuring the vivid orange *krans* aloe. Through a dramatic rock archway lies Montagu, a picturesque country hamlet renowned for its hot springs, historic eighteenth- and nineteenth-century buildings and increasingly colourful community of local fruit and wine farmers and arty city escapees seeking rural tranquillity. Red Muscadel dessert wines are a speciality of the local co-operative cellar which sources grapes from vineyards spread across spacious adjoining valleys. The cellar's natural wines made from top varietals are also making their mark.

WIDE OPEN SPACES

Travelling east into the Klein Karoo wine region, broad vistas open up and an entire new viticultural landscape can be explored. The destination is Calitzdorp with its rugged, arid environment reminiscent of the Douro in Portugal, home of the world's definitive port wines. Like their continental counterparts, local wine growers are realising their stony, shale-like terroir's potential to produce world-class wines. Specialist port varieties (Touriga Nacional, Souzão, Tinta Roriz, Touriga Francesa) join the more common Tinta Barocca in blends representing traditional styles (Ruby, Tawny, Vintage, LBV, Vintage Reserve). The challenge for Cape vintners, however, is finding an alternative name after recent European Union legislation supported Portugal's claim to sole rights on the generic term 'port'.

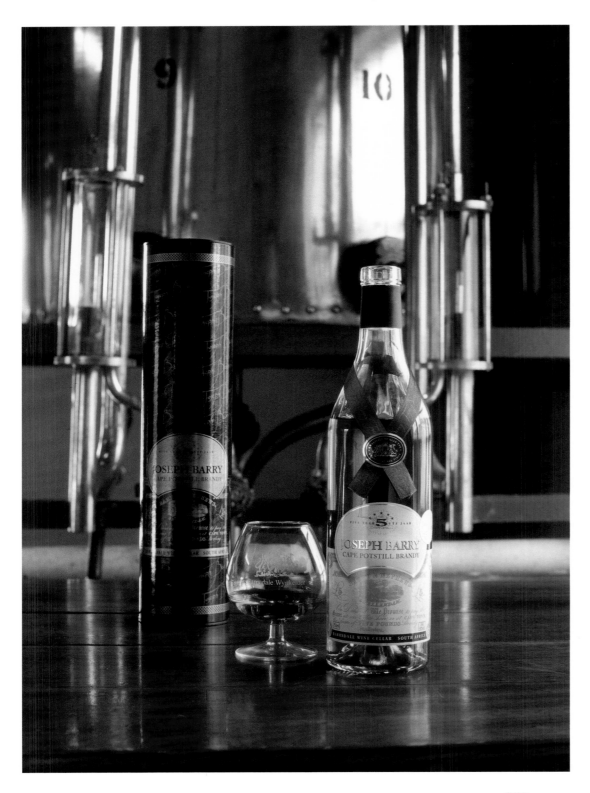

BARRYDALE WINE CELLAR

Joseph Barry Potstill Brandy has the unusual distinction of having a replica of an old banknote as its label. The Barry & Nephews five-pound note was issued by the Swellendam Bank and was accepted as legal tender in Cape Town and throughout the Breede River Valley. The bank was founded by Joseph Barry, a merchant who monopolised trade in the Overberg and Little Karoo during the first half of the nineteenth century. His company, Barry & Nephews, also owned a steamship, known as the *Kadie*, which ferried goods between Cape Town and Port Beaufort at the mouth of the Breede River. In 1854 Barry became a member of the Cape legislative council and during the South African War (1899–1902) he was a commandant of the local commando. He died in 1865. Today little has remained of his empire.

Joseph Barry Potstill Brandy is produced by the Barrydale Wine Cellar. The small village of Barrydale lies in a sheltered valley at the foothills of the Langeberg mountain range. The cellar launched the Joseph Barry label in 1994. The brandy is distilled in Woudberg potstills and matured in French oak for five years. The amber-coloured brandy is distilled from Colombard and Ugni grapes. The cellar also produces red and white wines sourced from grapes from the Doorn River and Buffelsjag River areas, as well as the Tradouw Valley.

JOUBERT-TRADAUW PRIVATE CELLAR

In the heart of the Tradouw Valley between Montagu and Barrydale on Route 62 lies this fledgling winery, established by Meyer and Beate Joubert on one of three adjoining family farms (father Cobus is chairman of nearby Barrydale Co-operative Cellar). The simple Tuscan-style winery with its honeyed walls, stone cladding and medieval doors and shutters (hewn from weathered railway sleepers and secured with a local craftsman's hammered ironwork) metamorphosised from old storerooms. Besides the Jouberts' handcrafted Cabernet Sauvignon-Merlot blends, Shiraz and Chardonnay, the tasting room offers deli treats (cheeses, olives, cold meats, local jams/honey) and an interleading cosy, sun-drenched indoor/outdoor eatery.

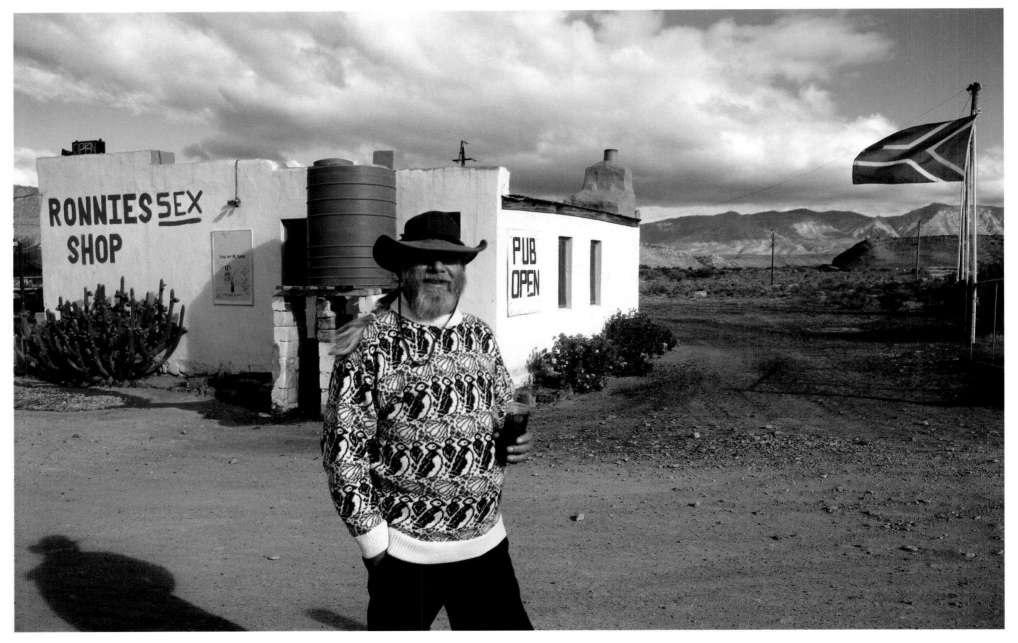

RONNIE'S SEX SHOP

A few years ago Ronnie Price painted 'Ronnie's Shop' in red capital letters on the side of a building he was hoping to convert into a farmstall. One evening his friends played a prank on him and added the eye-catching 'sex' tag to the sign. Price was not impressed, but continued with the renovation work. Friends would pull over to help him, or see how the work was progressing. Sometimes work would stop for a quick barbeque or a cold beer. At some point it made more sense to convert the building into a pub. Today the pub is hugely popular with tourists travelling the stretch of the R62 between Barrydale and Ladismith. Needless to say, Ronnie has gained celebrity status in the region.

A VISITOR'S DELIGHT

In among the dry, arid mountainscapes of the Little Karoo the winelands traveller will be pleasantly surprised to discover little oases of fertile, green farmland. Newly invigorated wine growers are converting arable slopes upon which their ancestors once sowed, to vines, while selectively retaining orchards for premium quality fruit. And with the new-found wine culture comes other attractions for the visitor: home-grown produce offered at delis, farmstalls and the tables of roadside eateries and intimate inns. An emerging appreciation of indigenous flora and fauna has also encouraged farmers to establish mountain-hiking, biking and 4x4 trails.

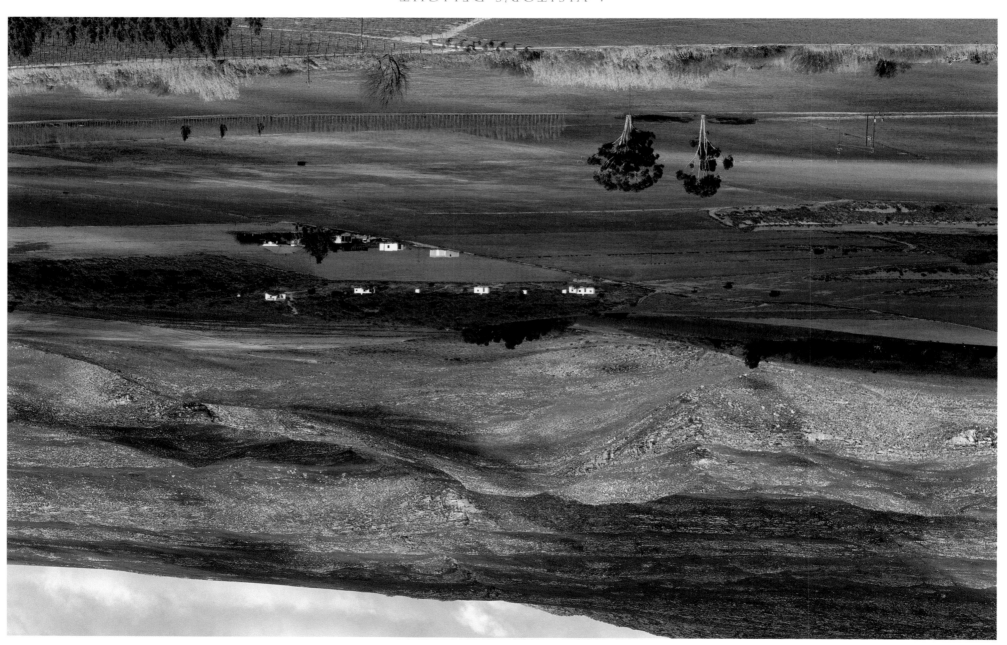

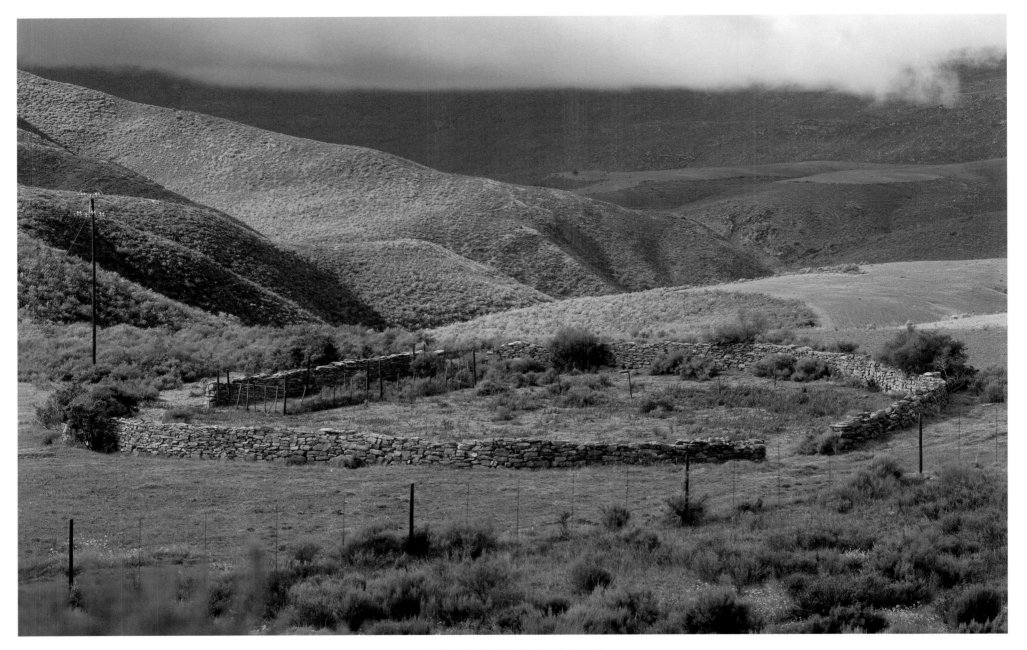

TRADOUW VALLEY

East of Montagu towards Barrydale the R62 winds down through the Waboomsberg's rolling foothills into the Tradouw Valley, where the viticultural potential of a 15-kilometre stretch of the Tradouw wine ward is being explored. Stone-walled sheep pens and valley-floor orchards attest to other farming activities, but it's Merlot, Shiraz, even cool-climate Sauvignon Blanc and Pinot Noir, that have locals re-invigorated. The narrow Tradouw Pass through the Langeberg range to the south-east acts as a funnel, blasting distant cool coastal winds up the valley, creating morning mists ideal for slow summer ripening. A low annual rainfall (not much above 300 millimetres) provides a natural stressed soil environment to concentrate flavour in the small berries.

WAITING IN ANTICIPATION

The relaxing of decades-long restrictions on where to plant wine grapes has brought a resurgence of interest in vine cultivation in the Cape. Vineyards are creeping up the west coast, down towards the south coast, eastwards up the Garden Route, in parallel across the Little Karoo, and within Cape Town itself (up the Constantiaberg Hills, even on inner-city sites). Based on knowledgeable assessments of what comprises a great terroir, the Cape has become the vintner's oyster. Add to this South Africa's new democratic political dispensation, an export boom and Cape Town's position as a new international tourist hotspot, and it explains why each vintage introduces another 40-odd independent vintners.

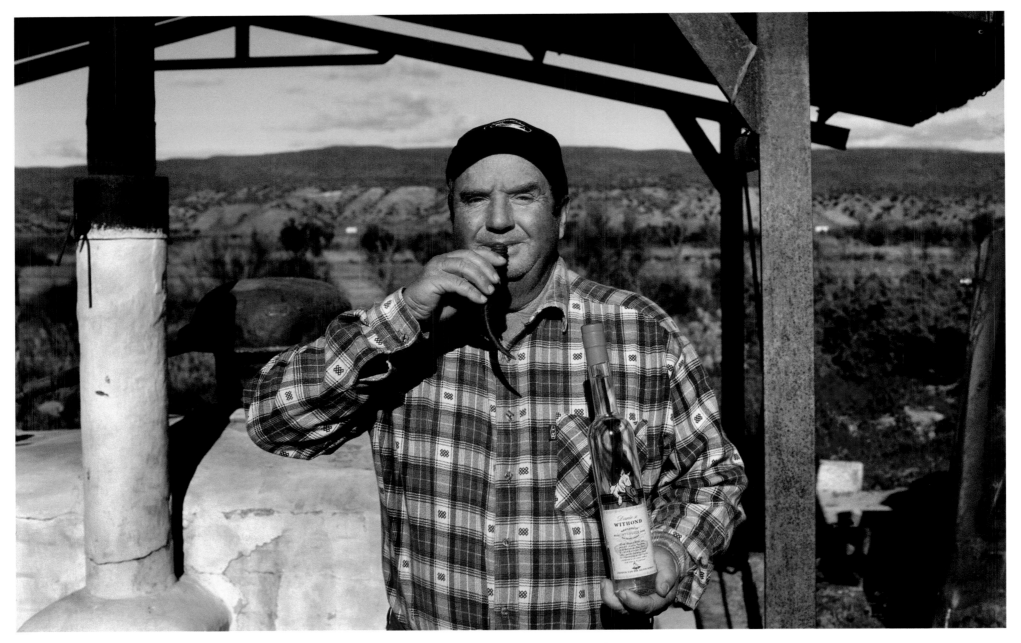

GRUNDHEIM WINES

The farm Sandkoppies lies at the foothills of the Rooiberg on the outskirts of Oudtshoorn, and is home to Grundheim Wines. The Grundling family, originally from Germany, have been farming here for five generations. Grundheim produces a potstill brandy as well as a witblits made in a traditional copper potstill. The White Dog witblits label depicts a seated white bull terrier holding its master's hat, symbolising the Karoo practice of referring to witblits as *withond* (white dog). Another practice in these parts, according to legend, is that farmers attending boisterous parties were encouraged to drink their witblits from the hollow horn of the springbok – as demonstrated by Grundheim owner Danie Grundling – to save on their hosts' wine glasses.

SCHOONBERG

Schoonberg lies in the Klein Karoo's new ward, Bo-Langkloof, and is about 20 kilometres from the coastal town of Sedgefield. The vineyards are planted at an altitude of about 800 metres above sea level, and are the most easterly vineyards in the Cape's winelands. Planted on the north-facing slopes of the surrounding hills, the vineyards are among the coolest. The average temperature of about 16 °C allows for a slow ripening period which means that the grape harvest only starts at the end of March. Depending on the season, Cabernet Sauvignon can be picked as late as early May. Schoonberg recently launched its maiden release Cabernet Sauvignon 2002.

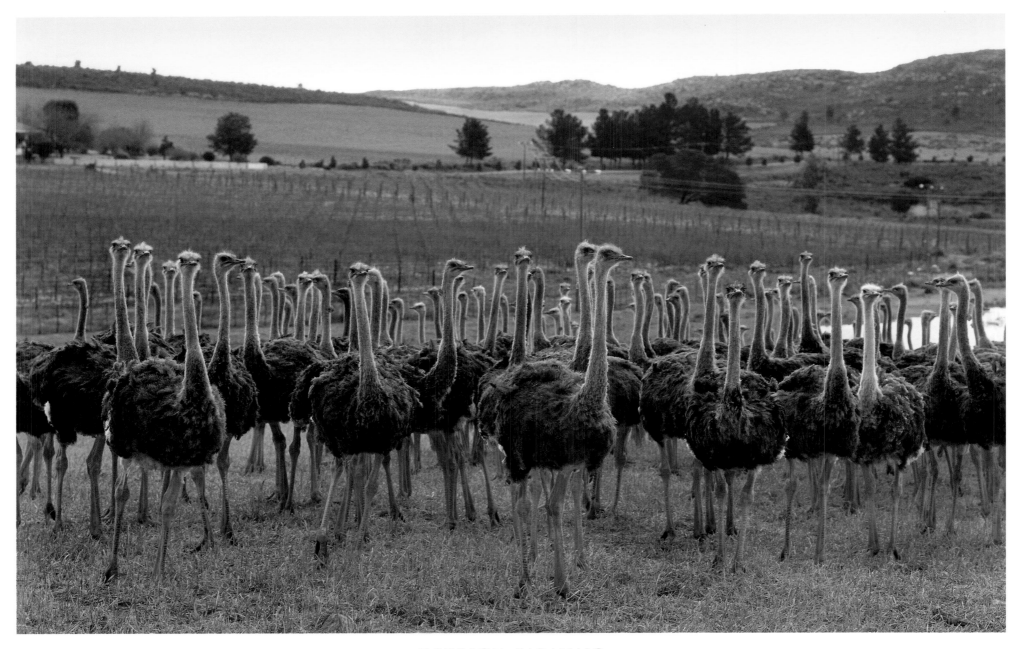

OSTRICH FARMING

Ostriches are a familiar sight throughout the winelands, especially on farms in the Little Karoo where they are bred commercially for their cholesterol-free meat, feathers, skin and gigantic eggs. In the late nineteenth century farmers in the southern Cape became wealthy on the proceeds of a flourishing export business in ostrich feathers. The fabulous Victorian mansions that were built on ostrich farms during this period were known as *volstruispaleise* (ostrich palaces). However, fashion changes, and by the end of World War I the demand for ostrich feathers had dwindled and the boom period came to an abrupt halt. Today many farmers in the Little Karoo successfully combine ostrich farming with wine farming.

SWARTLAND WINERY

Swartland Winery lies 3 kilometres outside Malmesbury in the heart of the country's wheat-producing region. In spring the countryside is a patchwork of colour with green wheat fields interspersed with swathes of yellow canola fields. The winery was founded in 1948 by a group of farmers. Legend has it that they held the winery's first meeting in the town's outdoor cinema. The 68-member cellar sources 80 per cent of its grapes from dryland vineyards, mostly untrellised bush vines. Swartland is a leading co-operative cellar, and bottles its premium range under the Indalo label. *Indalo* is the Xhosa word for 'nature's way'. The adjective *swartland* is a reference to the indigenous black *renosterbos* (rhino bush) that was once endemic to the area.

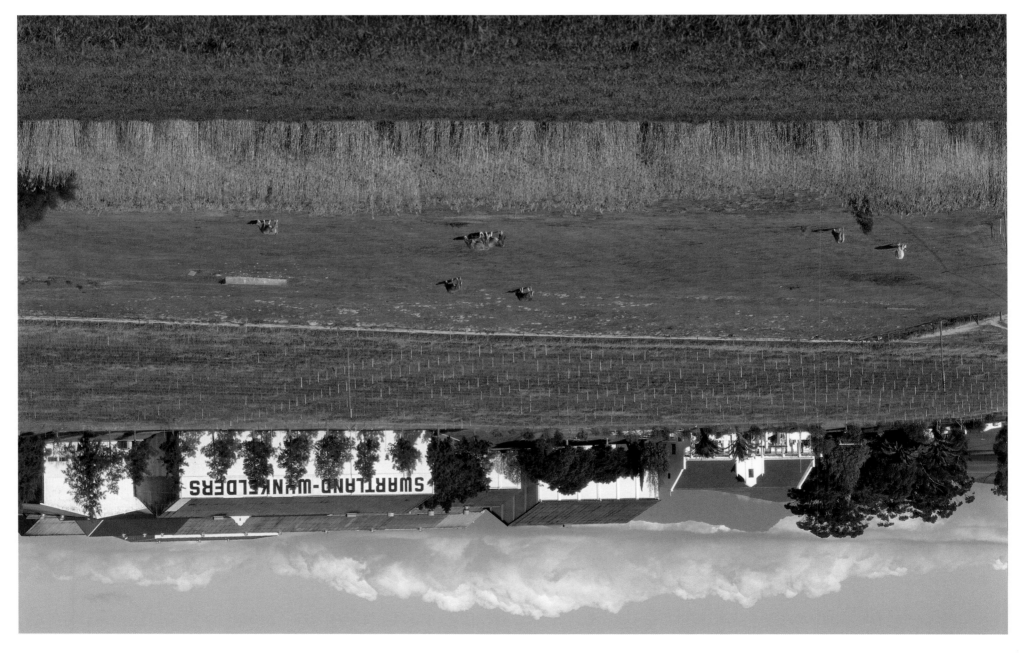

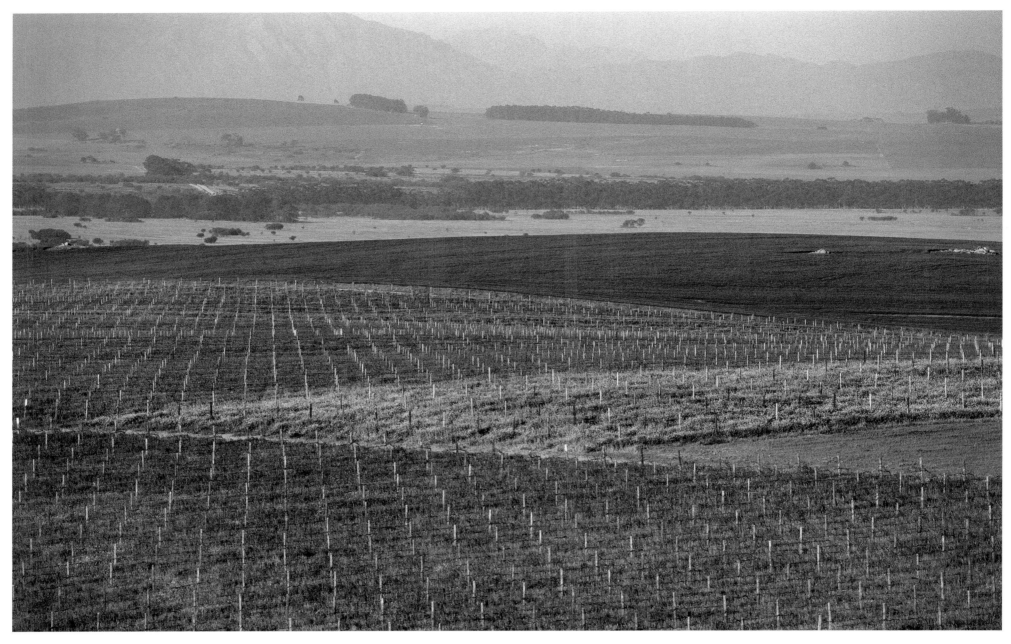

TUKULU WINES

A partnership between Distell, a group of black entrepreneurs and the Maluti Groenekloof Community Trust, Tukulu Wines is part of Papkuilsfontein's black empowerment project. The wines are produced from grapes grown on the 975-hectare Papkuilsfontein farm in the Dassenberg district of Darling on the slopes of the Kontreiberg. Papkuilsfontein lies 25 kilometres from the sea – close enough for the cool sea breezes to bring welcome relief in the hot, dry summer. Excellent terroir provides the farm with deep fertile ground, an above-average rainfall for the region, as well as undulating hills to protect the vineyards from the drying effects of the Southeaster.

PRUNING SEASON AT PAPKUILSFONTEIN

Wine grapes can be trellised or grown as bush vines, sometimes called goblet-trained vines. The vines are trained into a freestanding trunk with short 'arms', carrying a few fruit-bearing spurs. Dryland vineyards are often established in this way. Vines are pruned in winter, usually in two phases. The earlier pruning in late May and June takes place soon after the leaves have been shed and entails removing all of the vines that will not be needed for spurs in the new growing season. The final pruning only takes place towards the end of July and in August.

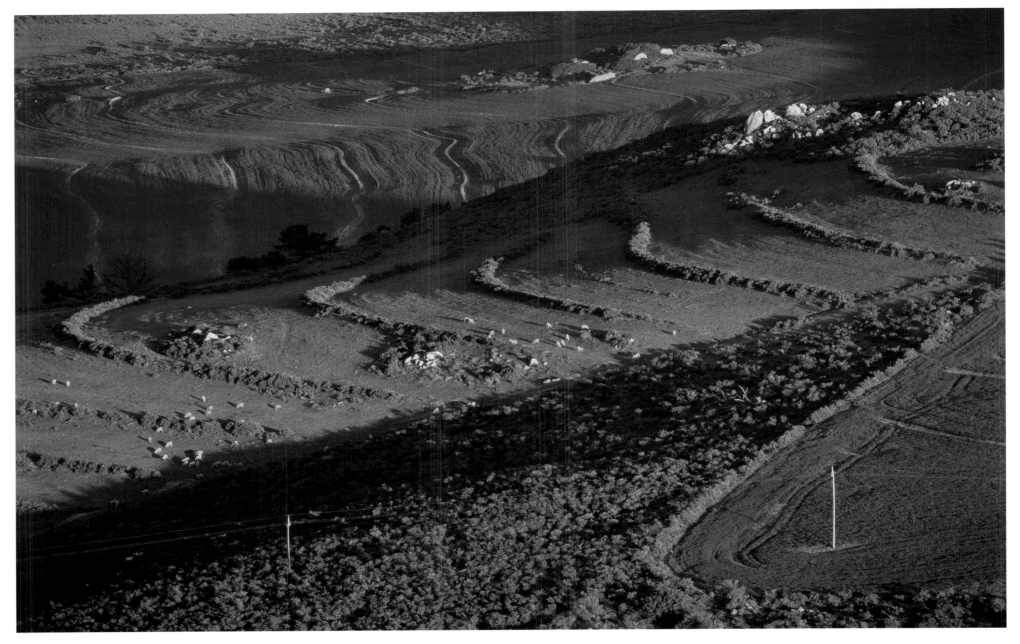

THE GREEN HILLS OF DARLING

The Groenekloof ward falls in the district of Swartland in what is predominately a wheat-growing area. Other agricultural activities include sheep and dairy farming as well as the cultivation of wine grapes. The nearby town of Darling is famous for its spring flowers and is home to one of the largest orchid nurseries in South Africa. Pieter-Dirk Uys, satirist and cabaret artist, has converted the town's railway siding into a small theatre called *Evita se Perron* (literally, Evita's (railway) platform).

PAPKUILSFONTEIN

Papkuilsfontein lies in the Groenekloof ward near Darling. The ward, with its cool temperatures and above-average rainfall for the West Coast region, has been identified as a very promising wine production area. The farm's red soils are described as having high potential with good water retention properties and are well suited to the dryland vines planted at Papkuilsfontein. Approximately 20 per cent of the farm's grape crop is devoted to Tukulu Wines, with the balance taken up by Distell for other premier brands in its portfolio.

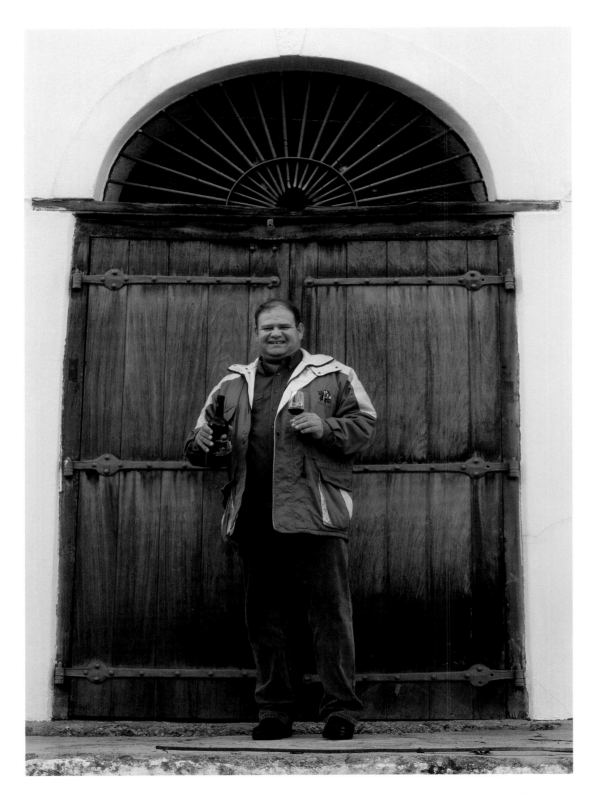

ALLESVERLOREN

The Kasteelberg near the town of Riebeeck West rises like a lone fortress among the rolling hills of the Swartland. Allesverloren Wine Estate lies at the foot of the Kasteelberg and is the only wine estate in the Swartland wine-of-origin district. The vineyards are planted on moisture-retentive gravelly shale soils at an altitude of between 171 and 370 metres above sea level, and produce robust red wines. In the late afternoon the vineyards are shaded by the mountain and cooled by a westerly wind. The different meso-climates provide ideal conditions for the estate's signature wines.

Winemaker Danie Malan is the fifth generation Malan to make Allesverloren's wine. Daniel François Malan bought the farm in 1872, and it has been in the Malan family ever since.

The name of the farm – 'all is lost' – is something of an anomaly. It is a reference to an incident in the distant past. The owners left the farm to attend church and buy provisions in Stellenbosch, and returned to the farm to find the house burnt down and all the cattle stolen. For them all was indeed lost. The Malans, however, have brought only good fortune to the farm.

OUDE KERK

The *Oude Kerk* (Old Church) in Tulbagh dates to 1795 and shows a departure from the Cape Dutch buildings seen elsewhere in the winelands. The gable is ornate and decorative, with an air of barely restrained flamboyance, and is decorated with garlands of flowers, roses, stars, pineapples, shells and palm trees. It is possible that the slave artisan builders who did the work were allowed a freer rein than usual, as the local parishioners had no clear picture of what a 'Cape' gable was supposed to look like. The parish was founded in 1743.

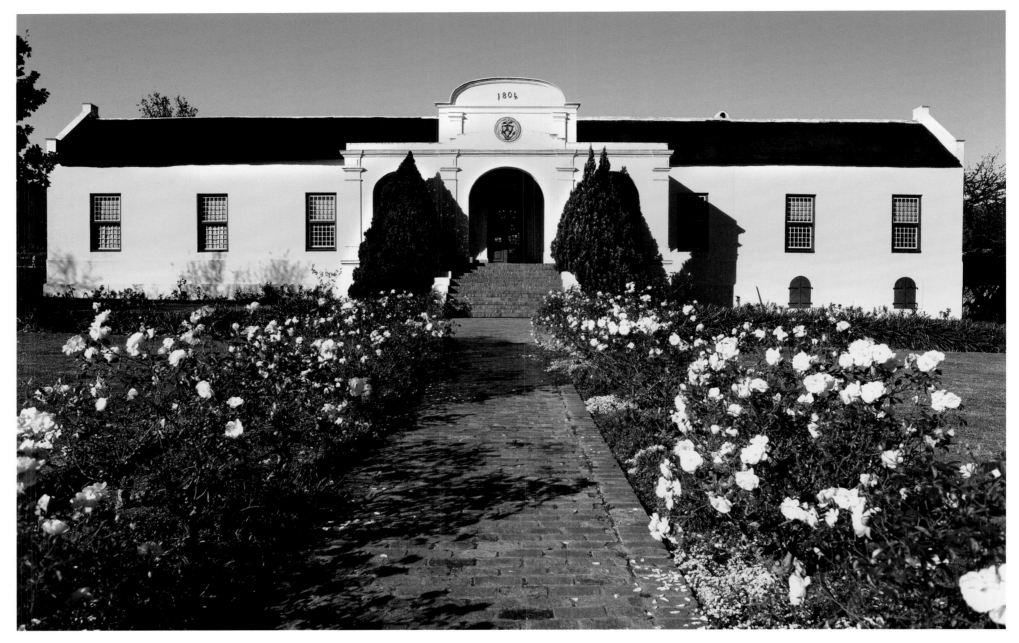

DROSTDY-HOF

Drostdy-Hof winery was established in 1964 outside the town of Tulbagh in what was then South Africa's oldest private sherry cellar. The cellar is named after the historic De Oude Drostdy, Tulbagh's old magistracy, and was completed in 1806. The building's neo-classical style reflects the French background of its architect, Louis Michel Thibault, who received many public and private commissions during the late eighteenth and early nineteenth centuries. Later, during the English occupation of the Cape, the seat of local government moved from Tulbagh to Worcester and the town lost its strategic importance. The drostdy building was sold in 1823 and became a heritage site in 1974. The building was eventually leased to Drostdy-Hof and is today used as a museum of cultural history.

A TASTING ROOM WITH A DIFFERENCE

Drostdy-Hof has converted the historic Tulbagh magistracy's underground jail into a unique tasting room. Visitors are led down a narrow staircase into the rustic room filled with old wine barrels. In addition to housing the famous wine producer's tasting room, the historic De Oude Drostdy is also a museum boasting a comprehensive collection of early Cape furniture and household items. The first wines under the Drostdy-Hof label were released in 1973 and the cellar is known for producing contemporary, easy-drinking wines from grapes sourced from vineyards throughout the wine-growing regions of the Western Cape.

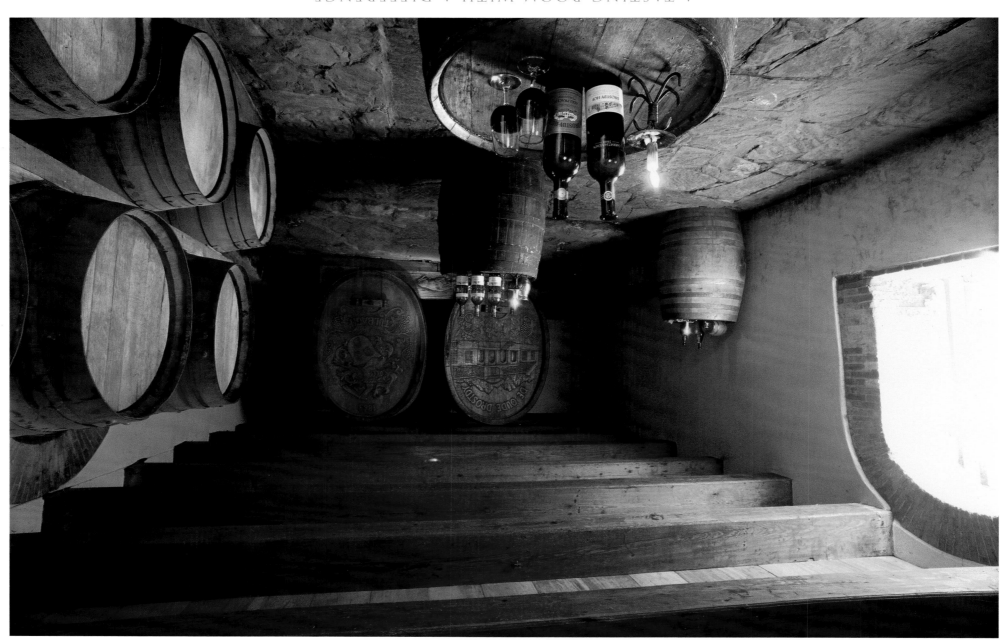

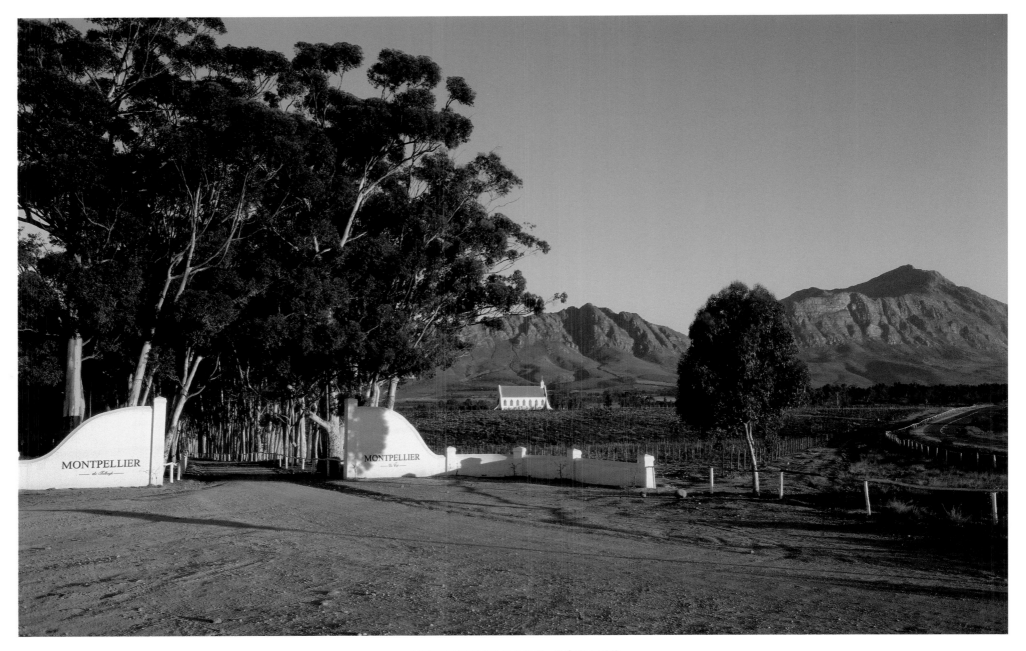

MONTPELLIER ESTATE

Montpellier Estate lies on the banks of the Klein Berg River outside Tulbagh. The land was originally granted in 1714 to Jean Joubert, the son of Pierre Joubert, a French Huguenot and refugee from the town of Montpellier in Lanquedoc. Although the first owners grazed cattle on the property, there is some evidence that they also planted vines. An account submitted by an unknown French labourer in 1716 reads as follows: '[F]irst eight days pruning the vines, then fifteen days digging in the vineyards, then three days picking up the pieces.' By 1800 the farm was producing a steady supply of wine, mostly for distillation purposes. Estate owner Lucas van Tonder is committed to building on Montpellier's proud tradition of producing fine wines.

A VINEYARD CHAPEL

In the 1780s, a French traveller, François le Vaillant, visited the remote Tulbagh Valley, which had gained a reputation for growing some of the best wheat in the Cape. Le Vaillant wrote, 'The harvests are plentiful and we saw abundance everywhere...beautiful landscapes with dwelling houses, the one lovelier than the other, and the variety of style gave charm to the valley.' While the wheat fields have long since been replaced by vineyards, the charm of the Tulbagh Valley has remained. At Montpellier Estate, a small chapel lies in the centre of a dramatic panorama of vineyards and towering mountains. The candle-lit church is a popular venue for weddings.

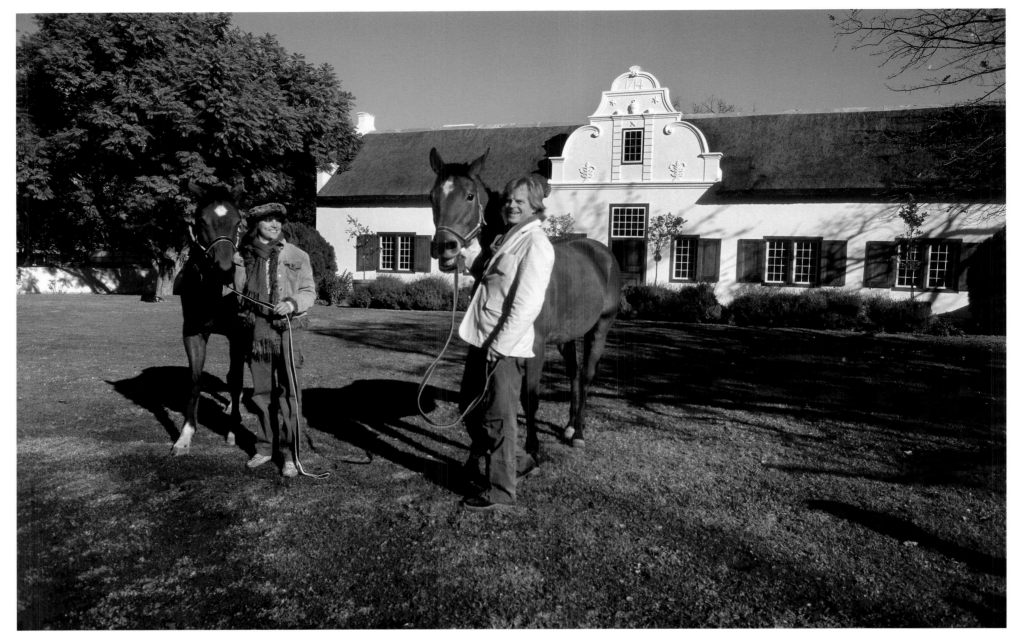

MONTPELLIER MANOR HOUSE

The first dwelling built on Montpellier outside Tulbagh was a modest three-roomed cottage made from mud-bricks, and consisted of a bedroom, a central living room and a kitchen. As the farm's fortunes improved, the house was enlarged and a more formal-looking *holbol* gable was added in the late eighteenth century. The building was damaged during an earthquake in 1969 and required extensive restoration work. More recently, the manor house has been transformed into a luxurious guesthouse, offering guests a welcome escape from city life. Thoroughbred race horses are also stabled at Montpellier, as well as riding horses for guests. Lucas van Tonder's horse appears to be enjoying the occasion.

A SENSE OF OCCASION

Montpellier owner Lucas van Tonder celebrated his 40th birthday on his historic farm. It was a perfect winter's day with blue skies and sunshine. A happy group of friends and family gathered at the estate, and Van Tonder received a string of phone calls from friends around the world. The best of Montpellier's wines complemented the delicious potjiekos that had been simmering on a fire all day long. Later, the group of friends lit a barbeque fire on a floating platform on one of the two dams on the property, swam in the cold water and drank a toast to Lucas van Tonder and the setting sun.

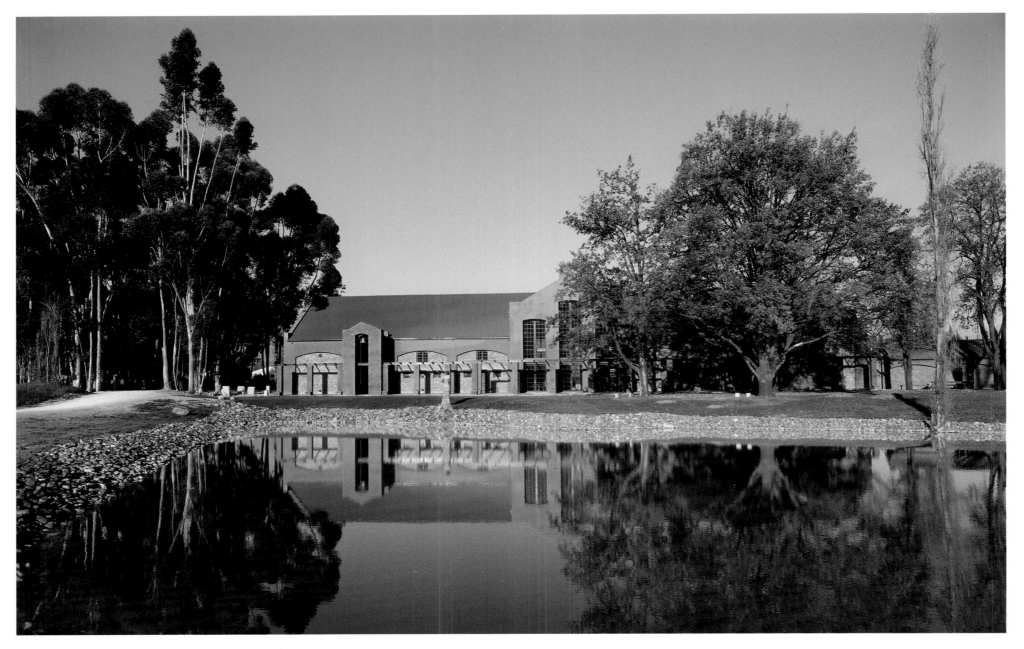

SARONSBERG CELLAR

Saronsberg Cellar near Tulbagh is a contemporary interpretation of the Cape Dutch architectural style that characterises farm buildings in the Cape winelands. The cellar has an elegant design and incorporates the earthy colours found in the surrounding landscape. Vertical spaces and high windows reflect the wide skies of the Tulbagh Valley. New vines were planted using the best clones and most appropriate rootstock for varying microclimates and soil types to allow winemaker Dewaldt Heyns optimal blending opportunities in this state-of-the-art cellar.

273

SPOILT FOR CHOICE

The Tulbagh Valley, surrounded by majestic mountains, offers a unique diversity of microclimates. These range from mountain slopes to boulder-encrusted fields and mid-valley shales. It presents Saronsberg owners Nick and Mariette van Huyssteen and winemaker Dewaldt Heyns with a wide choice in vineyard site selection. Here they fully utilise the diverse terroir to produce premium wines of distinction. Saronsberg wines are a perfect marriage of nature's gift and the honest toil of 45 people who nurture and cherish the vine's precious fruit. Saronsberg's wine is more than just wine: it's an expression of humanity's myriad emotions.

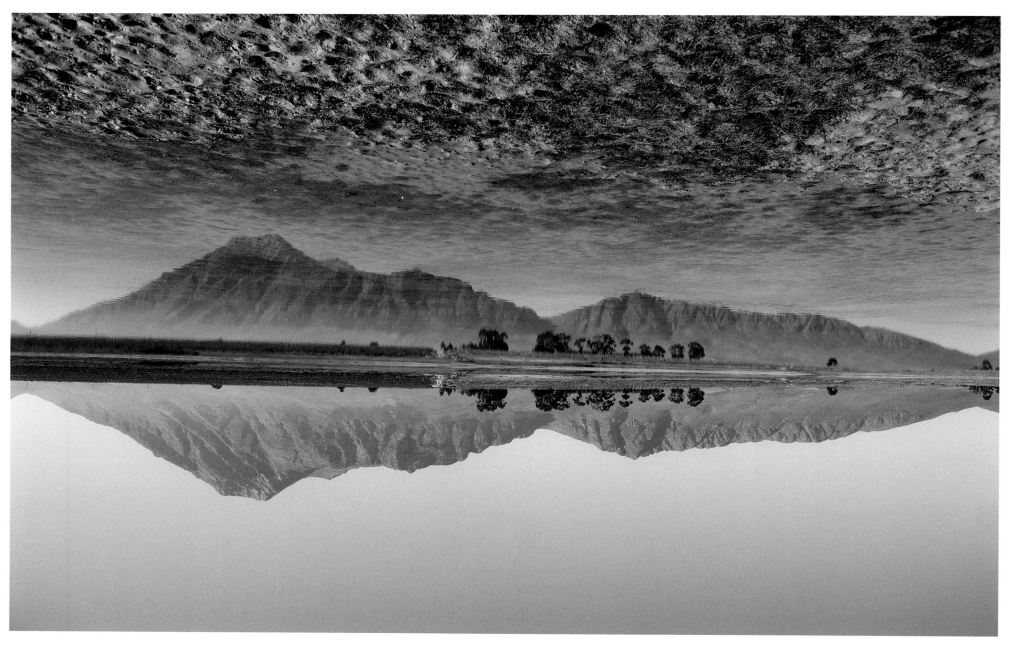

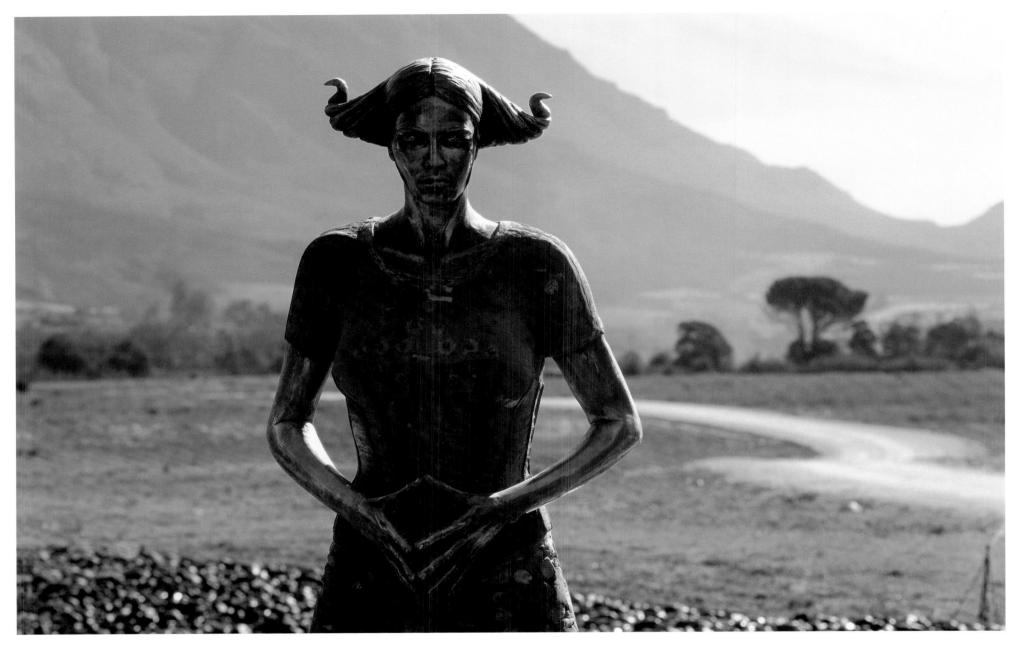

EARTH GODDESS

Art enthusiast Nick van Huyssteen commissioned Angus Taylor to create a sculpture to complement the cellar at Saronsberg and its surroundings. The result is *Uit Klip Uit Water* (literally stone from water), a 2.5-metre sculpture representing the earth goddess. Situated on the embankment of the dam in front of Saronsberg Cellar, the figure appears to be emerging from the water. From the waist down the sculpture is carved from Tulbagh stone while the upper body consists of concrete and aluminium, echoing the finishes of the cellar interior.

TOASTING THE FRUIT OF THE VINE

Saronsberg's winemaker Dewaldt Heyns raises a glass to the historic Tulbagh Valley's vineyards and wines. At the end of summer Saronsberg's grapes are hand-picked during the cool hours of the morning and then force-cooled to 4 °C. Bunches are then sorted by hand and the stems removed. During a final sorting, unripe and damaged berries are removed before the grapes are gently crushed to release the juice. From here small tanks of pressed grapes are hoisted into the fermentation tanks. The use of pumps is avoided to prevent the extraction of hard tannins from the skins.

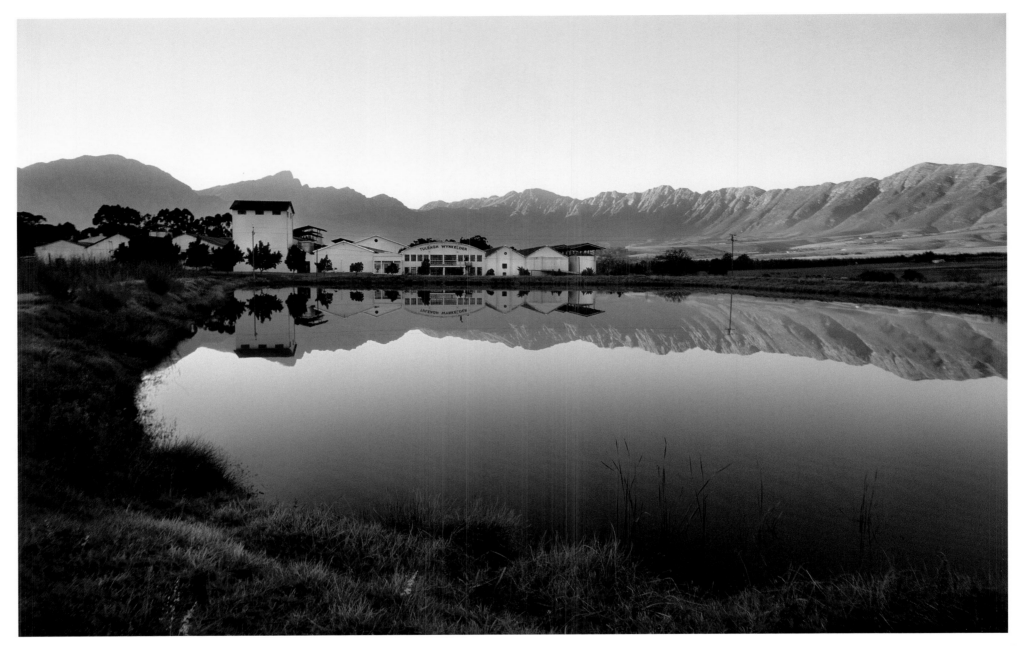

TULBAGH WINERY

Tulbagh Winery lies at the foot of the Witzenberg Mountains in Tulbagh. Founded in 1906, it is the oldest co-operative wine cellar in the Cape winelands and has the distinction of being the first to produce and market sparkling wine. The cellar's first sparkling wine was released in 1937 under the Winterhoek label. By the outbreak of World War II the cellar was exporting wines from Tulbagh, but war brought its own problems, including a shortage of bottles. For a short period the winery had permission to sell its wines in tomato sauce bottles! In 1950 the Queen Mother launched the *Windsor Castle* with a bottle of Tulbagh Winery's finest sparkling wine.

BRINGING HOME GOLD, SILVER AND BRONZE

Tulbagh Winery's cellarmaster Carl Allen and assistant winemaker Yvette van Niekerk toast their success. The winery has a long tradition of innovation and excellence and has received a number of accolades for its wine. At the 2004 Michelangelo International Wine Awards the cellar won gold for its Klein Tulbagh Merlot 2003 and silver for its Merlot 2002 and Pinotage 2003, and at the 2004 International Wine and Spirit Competition in London it was awarded bronze for the Klein Tulbagh Cabernet Sauvignon 2002 and the Klein Tulbagh Shiraz 2002. The winery produces a range of wines under the Klein Tulbagh, Tulbagh, Village Collection, Secluded Valley and Paddagang labels.

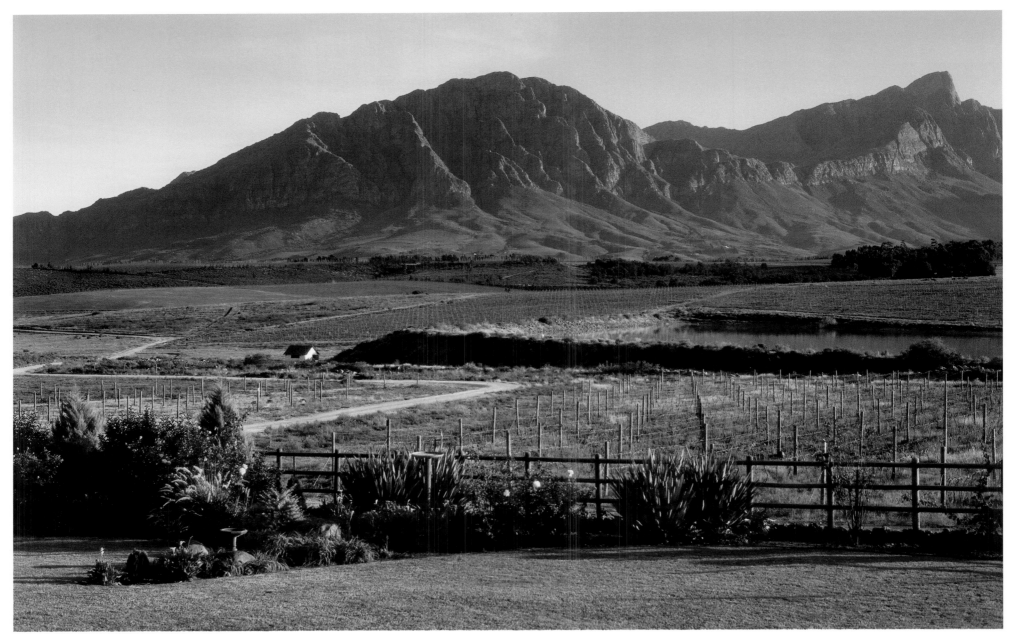

BLUE CRANE VINEYARDS

The blue crane is South Africa's national bird. These regal birds are regular visitors to Anita and Henk Jordaan's farm, Blue Crane Vineyards, near Tulbagh, where they feed on small frogs and insects in the surrounding vineyards and veld. In winter the mountains that surround the farm are capped by snow. In summer the vineyards enjoy long, warm days and cool nights. The Jordaans bought the farm in 2001 and immediately set about selecting the best clone varietals and establishing the vineyards using the latest techniques in soil preparation, trellising and irrigation. Shiraz was planted on a north-facing, sandy, boulder-bed slope, and Cabernet Sauvignon, Merlot and Sauvignon Blanc on south-facing slopes, situated so as to protect the grapes from the sun.

CITRUSDAL CELLARS

Citrusdal Cellars was established in 1957 and sources grapes from 1 200 hectares in the Olifants River Valley and small pockets of vineyards above the snowline in the Cederberg. The cellar's flagship wines are bottled under the Cardouw and Ivory Creek labels. Cardouw – Khoekhoen for 'narrow road' – is produced from the high-altitude grapes. The Ivory Creek label is a tribute to the herds of elephant that once dwelled in the Olifants River Valley. The presence of large numbers of elephant in the valley was recorded by a Dutch traveller, Jan Danckaert, who in 1660 witnessed a herd of about 300 elephant in the area. Citrusdal Cellars also produces an Italian Chianti-style wine.

KAGGA KAMMA

Kagga Kamma is a private nature reserve in the southern section of the Cederberg mountain range. The reserve's luxury units are built of stone and, like caves, appear to blend into the mountain side. Lunch is often served in the open air and dinner under a star-lit sky. Expert rangers are available to take guests on guided tours to see the ancient rock paintings found on the walls of caves and overhangs in the area, and to view game such as black wildebeest, antelope and zebra. The sky in these parts is exceptionally clear, offering city dwellers an ideal opportunity to observe the constellations of the southern hemisphere. Kagga Kamma's small observatory is equipped with a 10-inch telescope.

AN ANCIENT ART TRADITION

Ancient rock paintings, believed to be the work of the indigenous San people, are found throughout the Cederberg. The paintings can be seen in clusters on the walls of caves or shallow well-lit overhangs along perennial water courses. Archeologists believe that these caves and overhangs were close to or part of domestic shelters. It is estimated that almost all of the rock paintings found in the Western Cape were done within the last 7 000 years. Most of the paintings in the Cederberg are monochrome, and they usually depict people in a trance state. Others show animals and hunting scenes. Images of handprints are also common and were probably done by Khoekhoe herders.

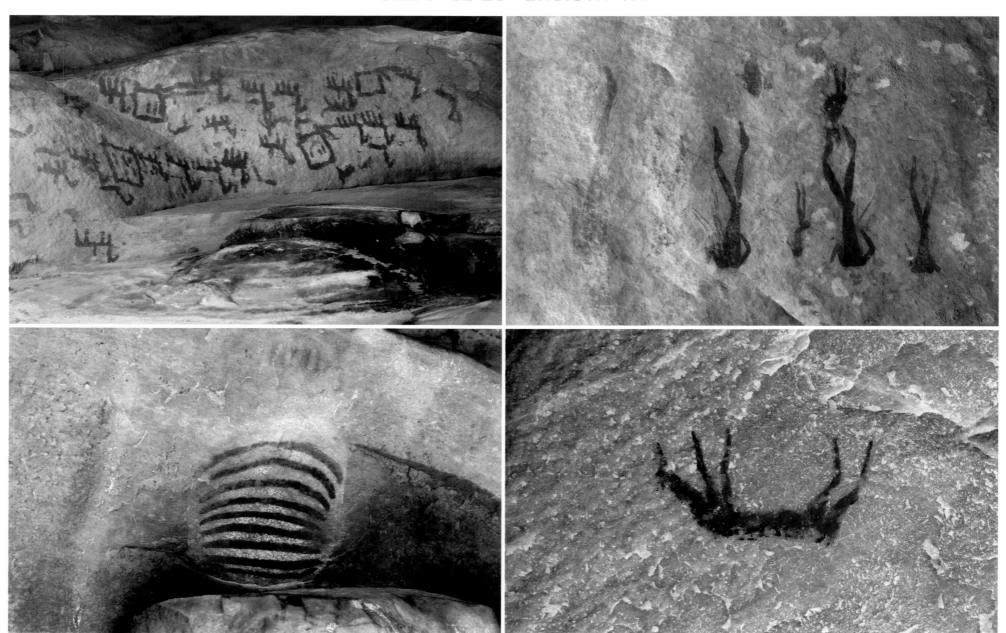

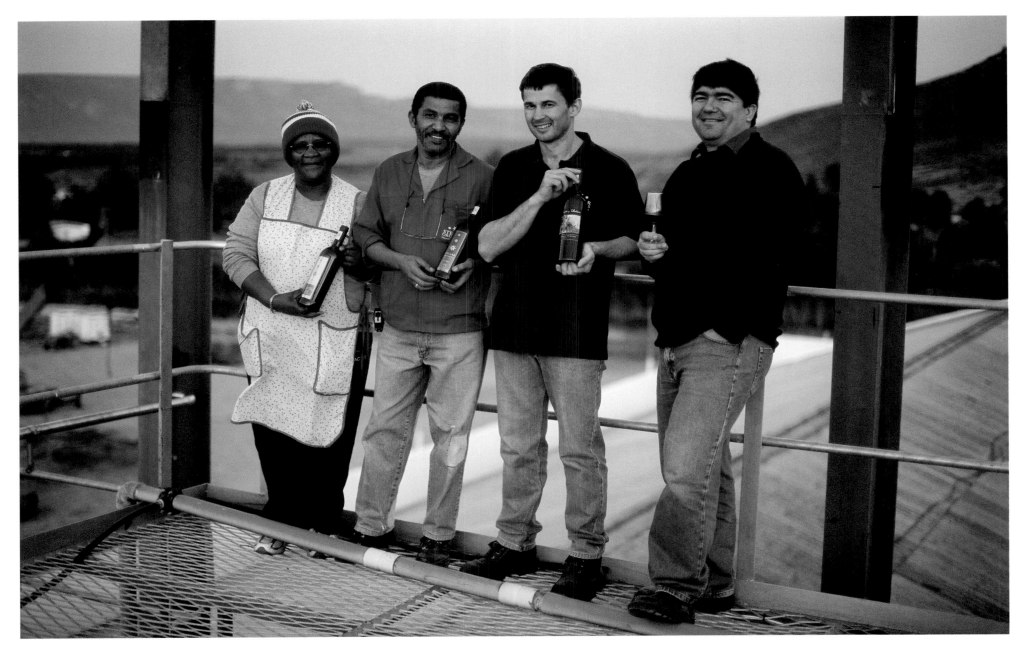

ORGANIC SYNERGY

Stellar Organics Wine Cellar is a Fairtrade-accredited winery and is committed to providing farm workers with equal opportunities for training and advancement. The Stellar team includes Marie Malan (head of farming), Martin Thuys (assistant winemaker), Willem Rossouw (operations manager and owner) and Dudley Wilson (winemaker). Malan's managerial skills were spotted while she was employed as a domestic worker by the Rossouw family. She now manages a team of up to 200 people in season. Thuys, a qualified carpenter and builder, first worked as a teacher until he was asked to help build the cellar. He and his team now assist with all winemaking operations. Stellar's cellar does not have a roof, and the wine – true to the label – is made under the Namaqualand night sky.

STELLAR ORGANICS WINE CELLAR

Irrigation canals criss-cross the contours of vineyards throughout the Trawal farming community in the sparsely populated Namaqualand in the Northern Cape. Stellar Organics Wine Cellar in the Trawal area is committed to producing organic wine in an environmentally responsible manner. The vines are mulched with indigenous vegetation, and no chemicals, pesticides or herbicides are used in the vineyards. Where possible all the cellar's waste products are recycled or re-used. Grape skins from the wine press are composted and used to fertilise the vineyards. The cellar's waste water goes through an aeration and a micro-organism treatment before being recycled as irrigation water. Stellar Organics was started by a group of established table grape and wine farmers who pressed their first wines in 2000.

RISING STARS

The efforts of Dudley Wilson, winemaker at Stellar Organics Wine Cellar, have reaped some spectacular benefits. The winery's Stellar Organic Shiraz has received numerous international accolades while its Stellar Organic Colombard 2002 won a gold at the 2003 Classic Wine Trophy. The winery bottles wine under five labels: the premium Sensory Collection, Stellar Organic, Live-A-Little, Moonlight Organic and Firefly. The cellar processes over 1 200 tons of organic grapes sourced from five organic farms concentrated along the northern boundary of the Olifants River wine region. These vineyards provide the diverse yields required to create Stellar's various styles of wine, from the full-bodied, new oak-influenced reds to the fruit-driven, unwooded ranges. Stellar also produces a range of organic verjuice and grapeseed oils.

STELLAR INSPIRATION

The night sky in Namaqualand is crystal clear. The Southern Cross, also known as Crux Australis, is visible in the southern hemisphere sky and is used to calculate due south. In 1750 a French astronomer, Nicolas Louis de la Caille, was sent to the Cape to measure and describe the stars of the southern hemisphere. He lived in Cape Town for two years and catalogued the position and brightness of about 10 000 stars. He also identified a number of constellations, including Mons Mensa, which he named after the famous Table Mountain near his observatory. It is the only constellation in the sky to be named after a geographical feature on earth. The large Magellanic Cloud provides a permanent table cloth to the celestial Table Mountain.

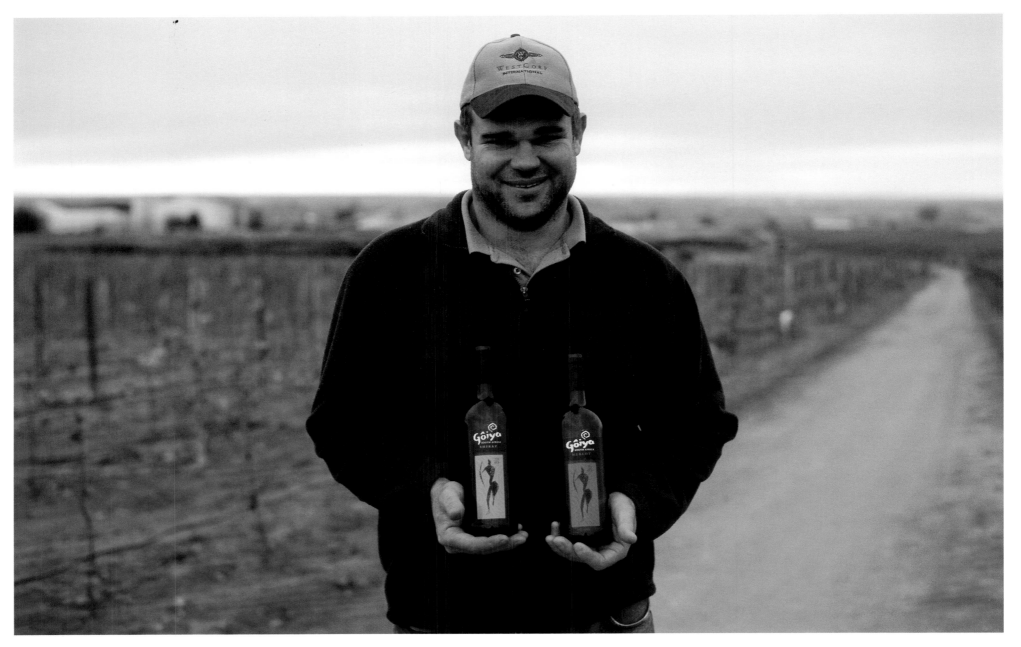

WESTCORP INTERNATIONAL

WestCorp International near Vredendal is one of the largest co-operative wine cellars in South Africa and was formed in 2002 following the merger of the Vredendal and Spuitdrift wineries. The winery is situated 300 kilometres north of Cape Town and 20 kilometres inland from the Atlantic Ocean in the Northern Cape region known as Namaqualand – a region famous for its spectacular display of wild flowers in spring. Since the merger, the Spuitdrift and Vredendal cellars have operated as specialist red wine and sparkling wine cellars respectively. Westcorp enjoys extensive overseas demand for its wines, and its flagship ranges – Namaqua and Gôiya – are leading brands in the United Kingdom.

INVESTING IN WINE QUALITY

Traditionally the home of wine made in bulk for everything from bag-in-the-box ('vin de cardboard') to brandy, the Cape's far-northern winelands along the Orange River are being developed to push the envelope on quality for bottled wines. Nearly R20 million has been spent in cellars and vineyards to this end. Growers and viticulturists are collaborating to identify sites on less fertile soils (stony, sloping ground) in relatively cooler areas (Groblershoop, for one). The team of winemakers at Orange River Wine Cellars' five separate wineries are encouraged to vinify promising parcels of grapes separately. The focus is primarily on red varieties, which are more forgiving than whites in such hot conditions.

QUIVER TREE

The magnificent quiver tree is perfectly adapted to the arid regions of the Northern Cape and Namibia. The tree grows to between 3 and 5 metres in height and can withstand long periods of drought. The tree's trunk tapers upwards from a broad base, giving it a squat appearance. Rosettes of leaves appear at the ends of its branches, and it produces erect yellow flower spikes in June and July. Simon van der Stel, Commander of the Cape, recorded the tree in 1685 while on an expedition to the legendary Copper Mountains of the Nama people. On this trip he noted that the San hunters used the bark of the tree to make quivers for their arrows.

NEW WINES FROM UP NORTH

Wine growers and winemakers in the viticultural area of the Orange River are focusing on niche wine production to up the ante on quality. The exciting results from a programme of specific vineyard site development and identification, followed by the subsequent separate vinification of these grapes, can be found in a new range created to carry these special bottlings by Orange River Wine Cellars. Called River's Tale, it currently includes a Red Muscadel, a Shiraz and a Cabernet Sauvignon-Shiraz-Pinotage-Ruby Cabernet blend. Part of a massive recent investment in cellar and vineyard is to extend the business of supplying South African supermarkets and liquor chain stores with value-for-money housebrands to wooing international buyers.

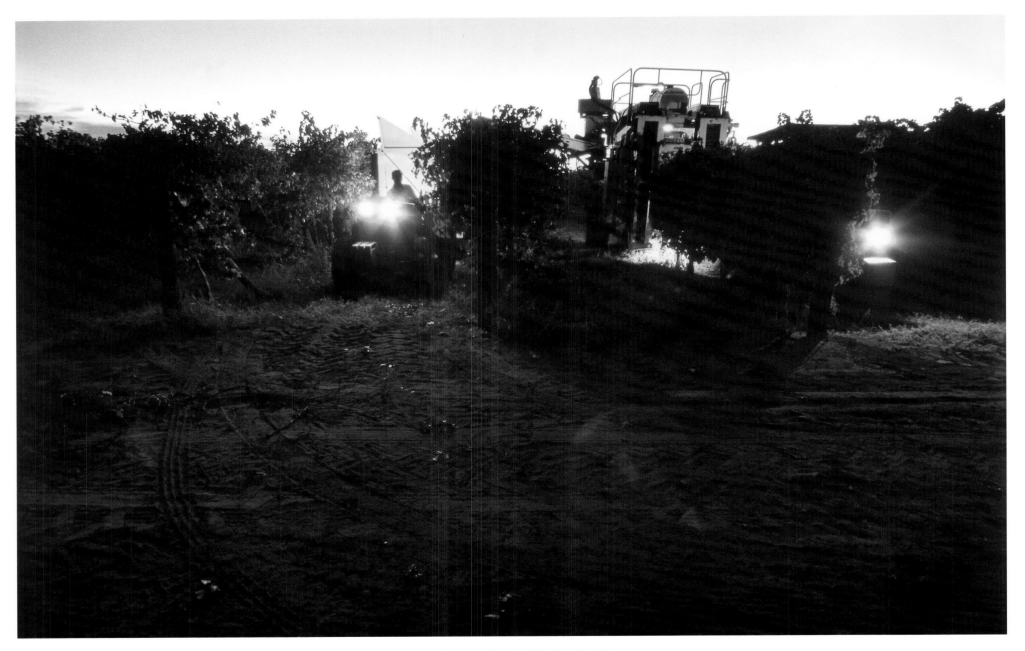

NIGHT HARVESTING

The headlights of a URM Vinestar harvesting machine are turned on as dusk settles over the vineyards along the Orange River in the Northern Cape. Working during the cooler hours in a semi-desert area, where daytime temperatures remain high, means that the grapes can be harvested at lower temperatures, and require less pre-cooling at the cellars. The grapes can also be harvested quickly – the harvesters can pick as much as 35 tons in an hour – and at optimal ripeness. Andrag Agrico import the harvesting machines from Australia.

BRINGING IN THE HARVEST

Dirk Malan is a viticulturist who works as a consultant in the Lower Orange River area. He also owns his own farm, Malanshoek, near Keimoes. The farm lies on one of the many arable islands in the Orange River. Malan was one of the first people in the area to see the benefits of automating the harvesting of wine grapes, and bought the Vinestar harvester. Farming is a family business that involves his wife, Hettie, as well as his three daughters. At Malanshoek the Malans planted the first Chardonnay and Shiraz vineyards in the area, as well as the popular varietal Sultana, which is used for raisin production. Hettie Malan also manages the Malans' guesthouse and ecotourism business called Kalahari Water.

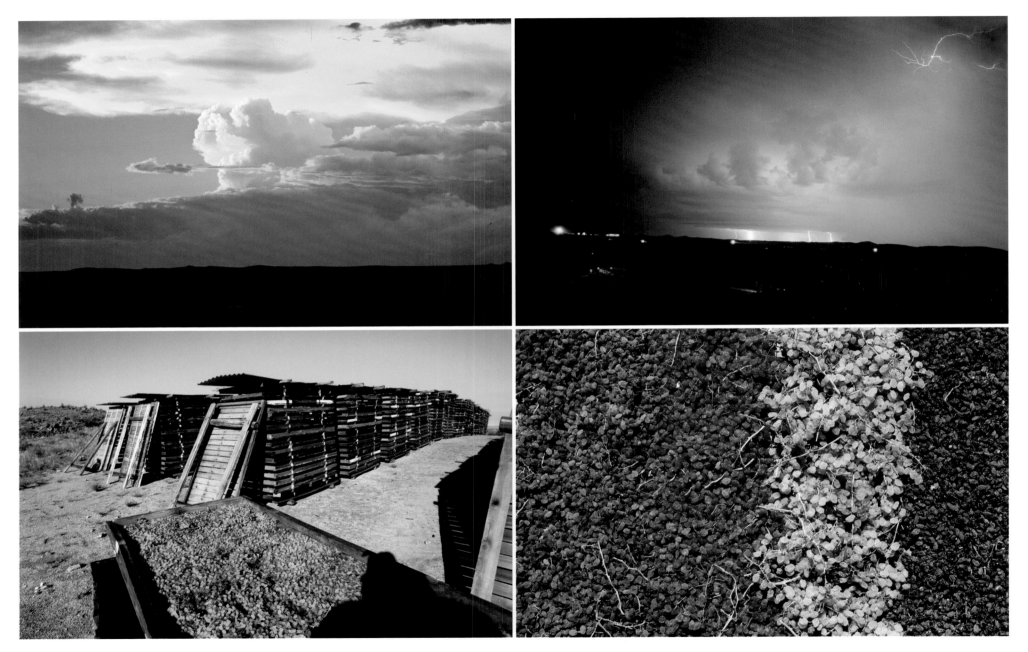

DRIED FRUIT OF THE VINE

Clouds that have stalked the sky all day brood and muster on shifting winds. The storm gains momentum and then erupts in a display of lightning that sears and dances across the night sky. Despite the occasional rain storm, the hot climate in the Orange River region is ideal for the production of sun-dried raisins. The raisins are dried in the open air in stacked wooden trays, allowing the air to circulate through the layers. The bands of colour (bottom right) indicate different drying methods rather than grape varieties. In the Orange River Valley many hectares of vineyards are dedicated to the production of raisins: more than 40 000 tons of sultana grapes are produced each year for the local and export market.

ORANGE RIVER TERROIR

The topography of the dry, hot area along the Orange River in the Northern Cape varies dramatically. On one side of the river the terrain is almost flat and vines are planted in deep, well-drained alluvial soils. On the opposite bank the vineyards may be terraced in light, sandy soils, red and and rich in iron oxide. In other parts in the region, vineyards have been established in soils of pebbled limestone and quartzite. Vineyards in the east produce delicately flavoured grapes with higher natural acids and lower pH values, while those in the west produce fuller and more voluptuous fruit. It's from these diverse vineyards that Orange River Wine Cellars, one of the largest co-operative cellars in the world, sources grapes for its excellent wines.

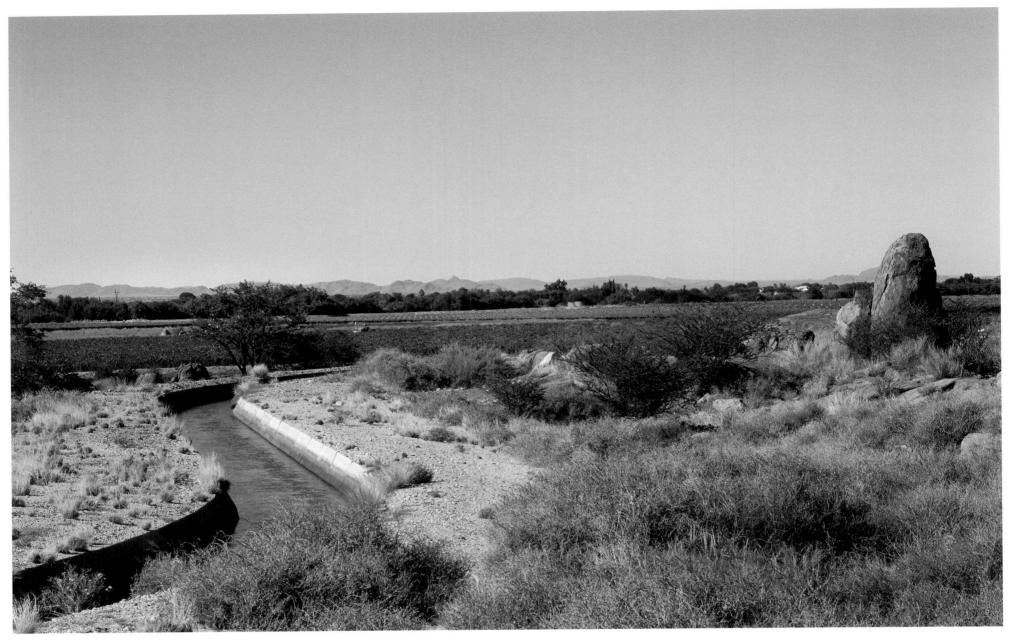

A RIVER RUNS THROUGH IT

The Orange River, South Africa's largest river, originates in the lofty Drakensberg in the east from where it follows a course of more than 2 000 kilometres to the Atlantic Ocean. In the semi-arid Northern Cape hundreds of kilometres of canals radiate from the river, carrying life-giving water to the interior. The result is a vivid landscape of alternating green vineyards and varying soils. The Lower Orange is the fourth largest wine production area in the Cape with more than 15 000 hectares under cultivation. The Orange River area is traditionally associated with white varietals, although reds such as Ruby Cabernet, Shiraz, Merlot and Pinotage are also gaining ground.

COLLECTING FUEL

The smile on this woman's face is as warm as the fire she makes each evening at sunset from the wood she gathers in the veld. Daily she re-enacts a ritual performed by the early pioneers who chose to settle along the banks of the Orange River. Long before the riversides were planted with vineyards, indigenous people and stock farmers flocked to the area, attracted by the river's constant supply of water and its lush banks which afforded ample grazing for their cattle. Others who were drawn to this oasis in the Northern Cape included explorers, missionaries and renegades from the Cape. In the nineteenth century, the Orange River's maze of small islands provided stock thieves with a convenient place to hide their stolen cattle.

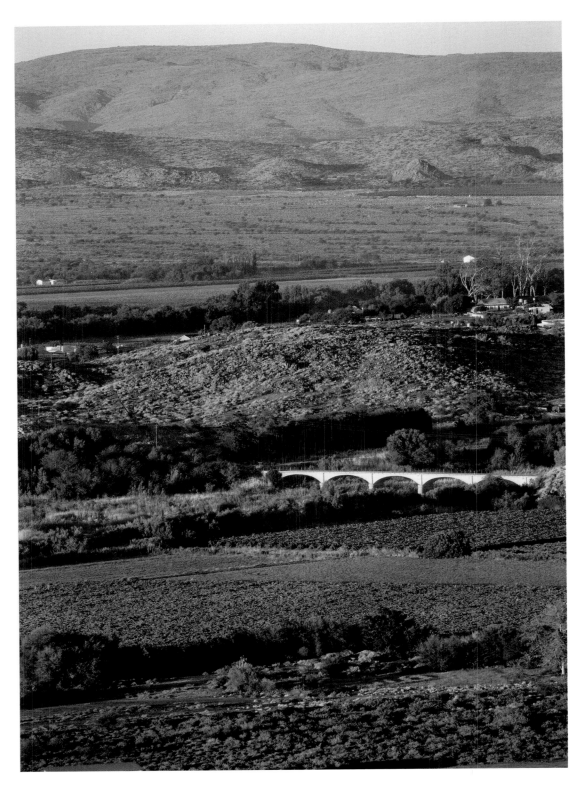

A RIVER'S GIFT

The Lower Orange River is the most northerly wine production area in South Africa and the vineyards in this region are dependent on an extensive irrigation scheme that draws water from the Orange River. Vines flourish in soils which are deep and fertile in places, and rocky and meagre in vineyards located further away from the river. Yields vary depending on the vineyard locality and status.

Orange River Wine Cellars was established in 1965 and has its headquarters in Upington. It sources grapes from a production area along the banks of the Orange River, from the Augrabies Falls to the Boegoeberg Dam – more than 3 400 hectares in total along a 350-kilometre stretch of river. The types of wine produced by the five wineries that comprise Orange River Wine Cellars vary in style and complexity according to terroir, topography and soil.

ORANGE RIVER WINE CELLARS

Orange River Wine Cellars produces natural and dessert wines at five cellars in Upington, Keimoes, Kakamas, Grootdrink and Groblershoop along the banks of the Orange River. Grape juice cellars are situated in Kakamas, Grootdrink and at Kanoneiland. The cellars represent 920 members who produce an average of 80 000 tons of grapes annually. The most important cultivars are Colombard, Chenin Blanc, Chardonnay, Shiraz, Cabernet Sauvignon, Pinotage, Ruby Cabernet, and Red and White Muscadel.

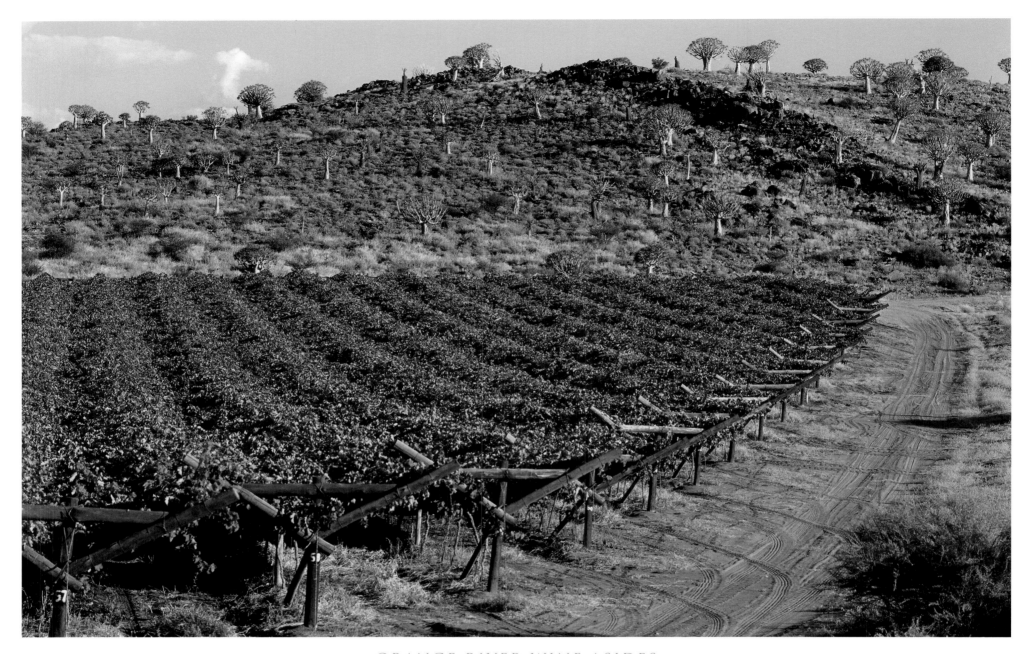

ORANGE RIVER WINE ASIDES

A trip up to the Orange River wine region is an ideal opportunity to experience the grandeur and beauty of the surrounding landscape. The former Kalahari Gemsbok Park, now the Kgalagadi Transfrontier Park, is a vast semi-desert wilderness home of predators and raptors. It offers camping and self-catering bungalow facilities and guided 4x4 trips. The Augrabies National Park is a South African National Parks Board rest-camp with simple but charming bungalows built around an impressive waterfall on the Orange River (now known as the Gariep River).

TRELLISING TELLS A STORY

In areas like the Orange River, where both wine and table grapes are cultivated, trellising systems indicate what's what. Table grapes are usually trained onto large wire trellises, often supported by wooden cross-poles sometimes spanning the rows to form a shady canopy to protect bunches against sunburn. Wine grapes are mostly grown on three-wire trellises with the stem pruned into two branches split horizontally along the first 'cordon' wire and shoots supported by the upper wires. This system facilitates labour-intensive canopy management where quality growers manicure each vine and monitor water supply through drip irrigation. In arid areas with sandy, low-potential soils or stony ground, plants are cut back and left to grow as low bushes.

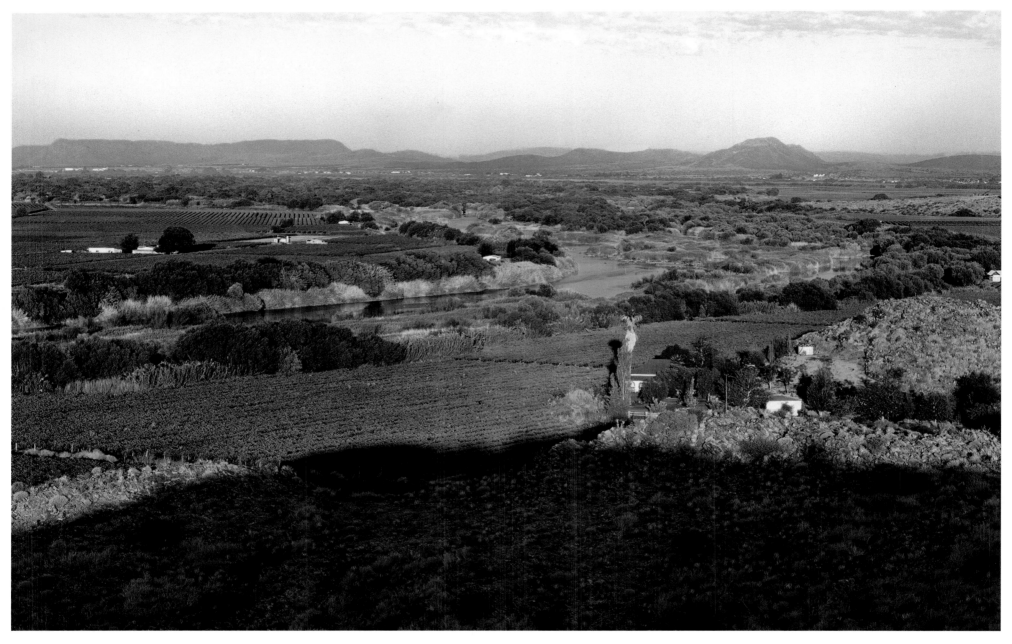

KALAHARI WATER

Kalahari Water is an ecotourism development near Keimoes on one of 120 islands in the Orange River. It's a vivid, green oasis in the landscape of quiver trees and red sanddunes of the southern Kalahari. The river's intensely farmed islands are loosely connected to the mainland by bridges giving access to the farmers who cultivate them. The Orange River is the largest river in South Africa and sweeps through this desert landscape en route to the Atlantic Ocean. In places it appears placid and sluggish, in others its dramatic and turbulent power is evident. This is an area that is ideally suited to adventure tourism such as 4x4 trips into the desert, mountain-biking and canoe trips down the river.

SELECT BIBLIOGRAPHY

Böeseken, Anna & Cairns, Margaret. 1989. *The Secluded Valley – Tulbagh: 't Land van Waveren 1700–1804*. Cape Town and Johannesburg: Perskor.

Brooke Simons, Phillida & Proust, Alain. 1992. *Nederburg, The First Two Hundred Years*. Cape Town: Struik.

Brooke Simons, Phillida & Proust, Alain. 2000. *Cape Dutch Houses and Other Old Favourites*, Cape Town: Fernwood Press.

Crouse, Philip. 1998. *Stellenbosch*. Cape Town: Human & Rousseau.

Fridjhon, Michael. 1992. *The Penguin Book of South African Wine*. Johannesburg: Penguin Books.

Ginn, Peter, McIlleron, W. Geoff & Milstein, Peter. 1989. *The Complete Book of South African Birds*. Cape Town: Struik.

Hobson, Tanith & Collins, John. 1997. *South Africa's Winelands – A Visitors' Guide*. Cape Town: Struik.

Hughes, David, Hands, Phyllis & Kench, John. 1988. *The Complete Book on South African Wines*. Cape Town: Struik.

Oberholster, Arie (editor). 1987. *Paarl Valley 1687–1987*. Pretoria: Human Sciences Research Council.

Parkington, John. 2003. *Cederberg Rock Paintings*. Cape Town: Krakadouw Trust.

Rust, Winnie. 2001. *Bain's Kloof and Other Mountain Tales*. Wellington: Wellington Museum.

Sleigh, Dan. 1996. *Forts of the Liesbeeck Frontier*. Cape Town: Castle Military Museum.

WINELAND/WYNLAND magazine.

WINE magazine.

INDEX

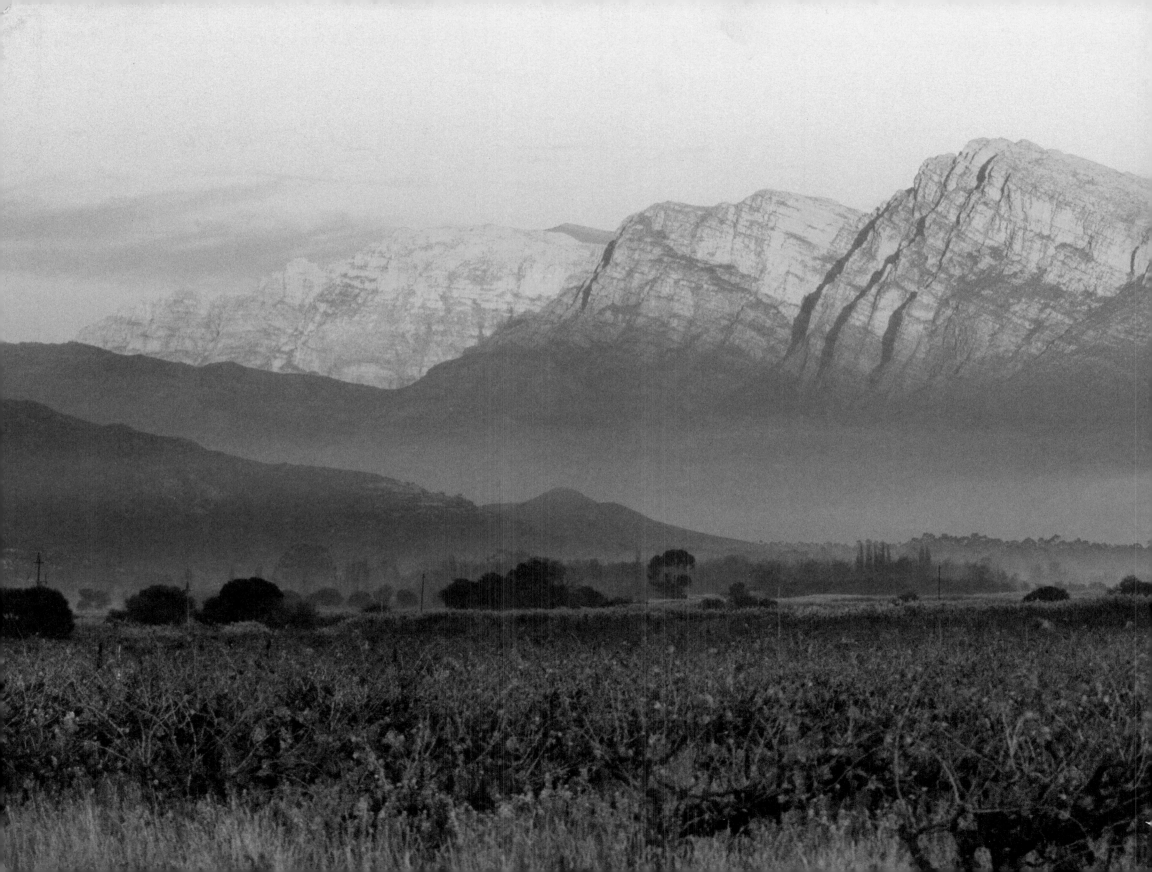